This is the first systematic and detailed study of Pausanias' view of Roman involvement in Greece. It begins with an assessment of Pausanias' life and writings, placing them in their contemporary political, historical, literary and cultural context. Pausanias' attitudes towards the art and artists of the pre-Roman period are also considered, and his attempts to define and analyse the past examined. Much of the book is devoted to the assessment of Pausanias' attitudes to the political Republican leaders Mummius, Sulla and Julius Caesar, emperors from Augustus to Marcus Aurelius, and benefactors such as Herodes Atticus. The study reveals the complexity and sophistication of Pausanias' critique of the actions and attitudes of prominent Roman personalities engaged with the Greek world.

This book will be of value to scholars and students working on Greek and Roman history and on classical archaeology and art. It also contains material for those interested more generally in Rome and Greece, in ancient art and religion, and in travel in the ancient world.

PAUSANIAS' GREECE

PAUSANIAS' GREECE

Ancient artists and Roman rulers

K. W. ARAFAT

Lecturer in Classical Archaeology, King's College London

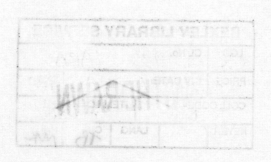

CAMBRIDGE
UNIVERSITY PRESS

Published by the Press Syndicate of the University of Cambridge
The Pitt Building, Trumpington Street, Cambridge CB2 1RP
40 West 20th Street, New York, NY 10011-4211, USA
10 Stamford Road, Oakleigh, Melbourne 3166, Australia

© Cambridge University Press 1996

First published 1996

Printed in Great Britain at the University Press, Cambridge

A catalogue record for this book is available from the British Library

Library of Congress cataloguing in publication data
Arafat, K. W. (Karim W.)
Pausanias' Greece : ancient artists and Roman rulers / Karim Arafat.
p. cm.
Includes bibliographical references and index
ISBN 0 521 55340 7 (hardback)
1. Pausanias – Knowledge – Greece. 2. Greece – Civilization. 3. Rome –
Civilization. 4. Greece – Antiquities. 5. Rome – Kings and rulers.
6. Emperors – Rome. 7. Rome – Relations – Greece. 8. Greece –
Relations – Rome. I. Title.
DF27.P383A73 1996
938–dc20 95–32378 CIP

ISBN 0 521 55340 7 hardback

VN

For Hector Catling

Contents

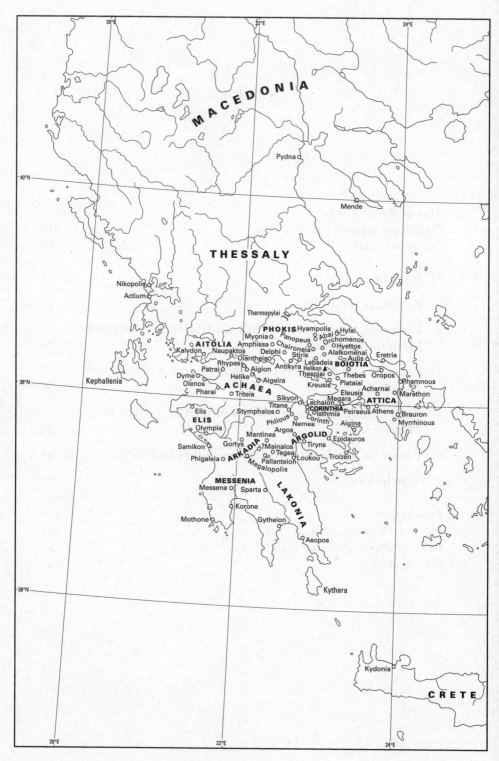

Map of Roman Greece

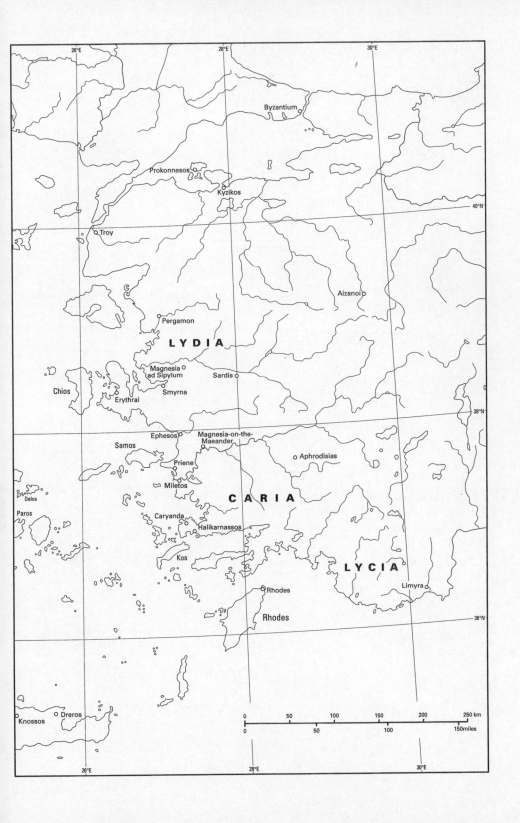

Preface and acknowledgements

The origin of this study lies unashamedly in its author's fascination with Pausanias, who has been (to borrow a phrase used by Sir John Beazley of the Berlin Painter) 'a friendly presence' in the study, in the lecture room and on site for ten years.

Chapter 2 is adapted from Arafat (1992), parts of which have also been used in chapter 1 (with the kind permission of the British School at Athens). References to Pausanias are taken from the Teubner edition of M.H. Rocha-Pereira, vols. I–III (2nd edn, Leipzig 1989–90). Unless otherwise specified, translations of Pausanias are taken from Frazer vol. I, and of other authors from the Loeb editions, in both cases with modifications. Transliterations are mainly Hellenized, but some inconsistencies result from the retention of familiar forms.

The researching of this book, as well as its writing, has been immeasurably enhanced by the companionship of Catherine Morgan who (if I may return the compliment) 'bore the rigours of fieldwork with fortitude'. I also owe much to my parents for their unstinting support, expressed in so many forms. I have benefited greatly from the patient encouragement of Pauline Hire of Cambridge University Press, and from the comments of the anonymous referees. The help of the staff and volunteers of the Library of the Institute of Classical Studies in London has considerably facilitated my work.

I would particularly like to thank Antony Spawforth for advice and support at all stages and Ewen Bowie for many perceptive detailed comments as well as a broader view. Geoffrey Waywell and Richard Hawley also read the entire manuscript at an earlier stage and improved it. I have gained much from discussions with Charlotte Roueché, Jane Rowlandson, Michael Silk, Michael Trapp and Ruth Webb, and from their comments. I derived much from two *periegeseis* in September 1994: of Olympia with Ulrich Sinn, accompanied by keen discussion of many of the issues raised here; and of Aizanoi (on

the trail of a Panhellene) with Jennifer Tobin, to whom I am also indebted for advice on Herodes Atticus.

This book owes much to the students who participated in my courses on Pausanias at King's College London between 1991 and 1994, and to those students who patiently tolerated my frequent use of him on site during the undergraduate courses of the British School at Athens in 1985, 1986, 1988, and 1991. Their questions prompted many of my lines of enquiry, and made me amply aware of a gap in Pausanias studies which needed filling. Whether this book answers their need, only they can tell, but I thank them for confirming my belief in the complementary nature of teaching and research.

The British School at Athens afforded me, as it has so many others, a unique opportunity to broaden my horizons and to understand Greece, ancient and modern. My first teaching was undertaken on the BSA course of 1985 at the invitation of Hector Catling, and his gentle and purposeful encouragement has continued unbroken since then. I count it a privilege that my two years at the School (1983–5) were spent under his directorship, and it is as some small return that I gratefully dedicate this book to him.

Abbreviations

AA	Archäologischer Anzeiger
AAA	Athens Annals of Archaeology
AJA	American Journal of Archaeology
AJP	American Journal of Philology
AM	Athenische Mitteilungen
Annuario	Annuario della Scuola archeologica di Atene
ANRW	Aufstieg und Niedergang der römischen Welt
AR	Archaeological Reports
BAR	British Archaeological Reports
BCH	Bulletin de Correspondance Hellénique
BICS	Bulletin of the Institute of Classical Studies
BSA	Annual of the British School at Athens
CAH	Cambridge Ancient History
Cl. Ant.	Classical Antiquity
CQ	Classical Quarterly
CR	Classical Review
CRAI	Comptes Rendus de l'Académie des Inscriptions et Belles-Lettres
CSCA	California Studies in Classical Antiquity
Ergon	τὸ Ἔργον τῆς ἐν Ἀθήναις Ἀρχαιολογικῆς Ἑταιρείας
Frazer	J.G. Frazer, Pausanias's description of Greece I–VI (London 1898)
GRBS	Greek, Roman and Byzantine Studies
HSCP	Harvard Studies in Classical Philology
IG	Inscriptiones Graecae
JHS	Journal of Hellenic Studies
JRA	Journal of Roman Archaeology
JRS	Journal of Roman Studies
Papahatzis	N. Papahatzis, Παυσανίου Ἑλλάδος Περιήγησις 1–5 (Athens 1974–81)

RE	Pauly-Wissowa, *Real-Encyclopädie der klassischen Alter-tumswissenschaft*
REG	*Revue des Études Grecques*
REL	*Revue des Études Latines*
SIG	*Sylloge Inscriptionum Graecarum*
TAPA	*Transactions of the American Philological Association*
YCS	*Yale Classical Studies*

Introduction

In the course of describing his travels in mainland Greece in the second century AD, Pausanias explicitly and implicitly reveals many of his attitudes and preferences towards the past and the present which governed, and arose from, those travels. In this book, I consider how Pausanias approached and carried out the task he had set himself. The major part of the study concerns his attitudes to the Romans in Greece, but his attitudes to the past are also considered, and it is a central tenet that Pausanias' examination of the present is indistinguishable from that of the past, indeed that the former was shaped to a significant extent by the latter. Pausanias himself is the starting point of this study: it is not a study of Greece and Rome, nor of provincial attitudes, Roman buildings, or individual emperors. It would not be possible (even if it were my intention) to look at all that the Romans built or dedicated in Greece nor at their pervasive impact on life in the province of Achaia.[1]

There have been several full-scale commentaries since the pioneering (and still, in some respects, unsurpassed) work of Sir James Frazer. The ever-growing wealth of archaeological evidence (mostly confirming the value of Pausanias) increasingly renders the compilation of a comprehensive commentary an impractically burdensome task. In tandem, there have been many articles and monographs on aspects of Pausanias, including several in recent years, of which that by Christian Habicht is the broadest in scope.[2] That, like this, is a personal view; it is hard to see how it could be otherwise, for Pausanias is an author who provokes a response, to whom it is hard to remain indifferent.

[1] Following modern standard usage, 'Achaia' refers to the Roman province, 'Achaea' to an area of the northern Peloponnese (cf. Alcock (1993) 233 n.17).

[2] E.g. Bultrighini (1990), Bearzot (1992), Elsner (1992), (1994), Habicht (1985).

As modern readers, we may approach him as an Ur-Baedeker,[3] or use his work as an archaeological handbook for excavations, and we may reproach him for not discussing what *we* would like him to discuss. Specialists in history, literature and archaeology have found in him much to stimulate and infuriate alike. But these strands in Pausanias' work are inseparable, and he cannot fully be understood without consideration of his background, of the regions about which he wrote and in which he was brought up, and of the context, literary, historical and political, of his life and writings. Much has been written on imperial Greek literary attitudes to Rome, and how they are reflected in, for example, Aelius Aristides or Lucian (notably in Jonas Palm's survey, which includes what is still by some way the most detailed consideration of Pausanias' attitudes towards Rome, albeit only twelve pages in length).[4] But we must meet him on his own territory, and that is the Greece and Asia Minor of the second century AD. It is the territory of the Roman province of Achaia, or rather a part of that province, that he guides us through, but his origin in Asia Minor provides a constant backdrop to his writings.

Pausanias' work is by far our best surviving example of a *periegesis*, a genre of descriptive writing which is mostly lost. The fact of the preservation of Pausanias' text may have caused its importance to be exaggerated: one index of that importance is its accuracy, which can be continually re-assessed as more archaeological discoveries occur. But it is not the only measure, and if a series of other comparable texts had been preserved, they might have proved equally important even if in different ways. The purpose of this book is not to assess Pausanias' accuracy – not, that is, to create another archaeological or historical commentary – but to examine his working methods, the cultural background against which he wrote, and the attitudes apparent in his work. The particular focus is on Pausanias' personal attitudes: they are personal because he made them so, by writing in the first person, by laying great stress on autopsy, by frequently weighing arguments, and by giving reasons for preferring one view or another. In the same way, he not uncommonly expresses his own

[3] There has long been a divergence between those seeing him as an ancient Baedeker and those who are not content with this neat (but surely erroneous) categorization; refs in Elsner (1992) 6 n.13, but he is wrong to say that only Veyne (1988) 3, 101, 'openly contests' this view (cf. Alcock (1993) 174): those who previously did so include Robert (1909); Robinson (1910) 213, (1944) 166; Strid (1976) 11; now also Dihle (1989) 260, (1994) 249.

[4] Palm (1959) 63–74 (interestingly, more space than he devotes to most other writers). Forte (1972) 418–27, the only other attempt, is much more superficial.

opinion, or his uncertainty as to the truth of a particular story or ascription.

There are two inextricably linked elements to this study: in chapter 2, I examine Pausanias' attitude to antiquities, his consideration of the pre-Roman period in Greece, the terminology he uses, and how his preoccupations are reflected in his choice of which objects, buildings, and cults to describe. In chapters 3 to 6, I look at his attitudes to the events, personalities and art of the Roman period from Mummius to Pausanias' own time. While these elements are distinct, they are also complementary: both are structured in terms of individuals, respectively artistic and political, rather than in terms of events. But while the examination of the Roman period is structured in terms of rulers and their actions, with a chapter on benefactors, the pre-Roman period (particularly before the Persian wars) is examined through the personalities and genealogies of artists, and the sequence of artistic developments associated with them. This structure reflects Pausanias' own methods: as he makes a consistent attempt to distinguish one period from another, so does this book, through setting the art, architecture and cults which Pausanias documented against the differing contexts of their own times.

Chapters 3 to 5 consider an aspect of Pausanias' work hitherto not adequately studied, namely his writings on, and attitudes towards, the rulers of Roman Greece from Mummius to Marcus Aurelius. Mummius' destruction of Corinth in 146 BC was by any reckoning a crucial event in the history of Roman Greece, and thus Pausanias regards it; his writings on the history of the Hellenistic period to 146 BC have recently been examined in detail by Cinzia Bearzot[5] in a valuable study which explains much of the background to the period with which I am concerned. I examine Pausanias' attitudes to the influential figures of this period – Mummius, Sulla, Julius Caesar, and the emperors whom he mentions – through his references to their activities in Greece, and how they reveal Roman attitudes to the sites and objects of Greece. And I consider what we can learn of Pausanias' view of the very institutions of the Republic and the Empire themselves. A brief chapter considers the few private benefactors whom Pausanias mentions, most notably the sophist Herodes Atticus.

Throughout, Pausanias' account is examined in conjunction with other literary sources and with the archaeological record, in order to

[5] Bearzot (1992). Also useful on this period is Palm (1959) 63–5.

consider those works which he cites, and those which he does not but which are known from other sources, since the omissions in Pausanias can be as significant as the inclusions in illuminating his working method, and above all his individuality and personality. It is hoped that in this way a coherent view of what is distinctively Pausanian will emerge.

It is a truism in Pausanias studies that he is less interested in the present than in the past, and this study will not disturb that view. But it will argue that the imbalance is considerably less than has generally been perceived. In fact, although Pausanias has comparatively little to say of most emperors, as of most Republican leaders, he has much more to say than has been hitherto acknowledged. A fuller understanding of Pausanias' methods of narration and description, and of his own attitudes, seen in comparison and contrast with those of other writers, will lead to a broader understanding of the way the Roman Empire was viewed by some of its subjects, and of the attitudes of the Romans to their own art and institutions as well as to those of their predecessors.

Two related issues are relevant here: perceptions of the emperors current in Greece and Asia Minor, particularly after their deaths; and the role of imperial benefactions and patronage in building in the provinces.

While these issues will be repeatedly addressed in chapters 3 to 5, an illustration of how Pausanias' narrative can give rise to the question of contemporary perceptions of the emperor may usefully be given here. During his tour of Corinth, Pausanias says that 'Augustus was emperor of Rome after Caesar, the founder of the present city of Corinth' (2.3.1). It seems remarkable that he had to introduce Augustus and spell out his place in the sequence of Roman rulers. The inference that Augustus was somehow unfamiliar to Pausanias' intended readers may seem highly improbable, however logically it may appear to follow. The phrasing may simply be intended to stress Caesar's role as the founder of Corinth. But it may indicate exactly such unfamiliarity, or perhaps that such popular perceptions of Augustus as there were among the people Pausanias was writing for effectively constituted folk-history by his day. In that case, Pausanias may have felt that he had to spell out exactly who Augustus was as well as why he was relevant to that particular part of his description. The remoteness in time of Augustus would have been an important factor in forming perceptions of him in Pausanias' day, some 150 years later.

The issue of Pausanias' readership is discussed in more detail later, but here it may be noted that if Pausanias sees himself as, in effect, educating his readers, we may assume that they do not consist exclusively of a highly educated elite.

Arising from the question of what were the contemporary perceptions of Augustus is the further question of how those perceptions could be kept alive. The imperial cult is one possibility, and it will recur throughout this study.[6] Another is straightforward historical or biographical writing, the latter including the dissemination of information in such forms as the copies of the *Res Gestae*. The popular accessibility of the copy at Ankyra (see below, p. 28–9) suggests that such information would have been available to Pausanias and to his readers; whether either took advantage of such availability cannot be known. A third means of maintaining the profile of the emperor in the provinces consisted of the physical reminders of his reign scattered round Greece and Asia Minor, from which a traveller and recorder like Pausanias himself would have been able to glean a fairly comprehensive picture.

Here the second reference in Pausanias to Augustus is instructive: at the Argive Heraion, among later imperial offerings, he says that 'before the entrance stand statues of women who have been priestesses of Hera, and statues of heroes, including Orestes; for they say that the statue which the inscription declares to be the emperor Augustus is really Orestes' (2.17.3). It is interesting that the locals know enough to be able to deny that this statue is a portrait of Augustus; and that Pausanias agrees with them. This, of course, does not mean that they *would* know a statue of Augustus if they saw one: it may mean no more than that they would know an emperor from a hero, irrespective of identity (this passage is discussed further on p. 126 below).

Pausanias' perceptions of Augustus and the other emperors whom he discusses form a substantial part of this book; but they need to be set against the role of the emperor in this period, and particularly the role of the emperor in relation to the provinces. In other words, while there is a concentration on Pausanias as a Greek from Asia Minor in the Roman system, attention is also given to how Rome views, and deals with, Greece and the Greeks.

A fundamental, but perhaps easily overlooked, issue is that of how active any emperor was, how personal his involvement, and how far

[6] Although imperial cults generally ended with the death of the relevant emperor, some aspects of the worship of Augustus continued (Price (1984a) 61).

he impinged on his subjects. As Fergus Millar has shown, the emperor's role was essentially to respond to petitions from his subjects, rather than to take the initiative himself.[7] In general, the emperor would have undertaken minimal intervention in the affairs of the provinces; this is true also of the governor. Thus emperors would not have had a 'Greek policy' – apart from Hadrian, the exceptional nature and extent of whose interest in Greece will become apparent in the course of this book – and the personal involvement of the emperor in daily life and in provincial building programmes would have been limited.[8]

Most imperial benefactions in the provinces took the form of responses to initiatives from local donors, and owed most to the motivations of such donors, who would wish to associate their gifts with the ruling emperor for reasons such as the advancement of their own careers. In the case of buildings put up at public expense, from the late first century AD, it became standard practice that a licence from the emperor had to be issued before they could be erected.[9] This also should not be taken to imply that the emperor initiated such buildings.

The buildings which Pausanias mentions in connection with each of the emperors – and those which he does not, but which are known from other sources – form an important part of this book. But they are seen alongside the wider view Pausanias gives us of each emperor. The greater part of this book is structured around the biographical aspect of Pausanias' writings, looking at the key Roman figures he mentions and their activities as they affected Greece. However, the comparison with the biographical writings of Suetonius and Plutarch is in fact minimal. Biography, with a particular emphasis on character, was their main purpose, whereas the biographical information that Pausanias gives us is mostly incidental, arising naturally from his description or discussion of particular monuments or buildings. Indeed, occasions will be remarked on where he apparently deliberately passes over an opportunity to comment on an individual's actions or character. Whether this gives his account greater objectivity, even reliability, than those of Suetonius or Plutarch, is better assessed as each example occurs, but the selectivity of his remarks requires examination of the criteria which he employs in making them.

[7] Millar (1977). [8] Millar (1977), (1987); Mitchell (1987b).
[9] Garnsey and Saller (1987) 37.

The starting point and linking thread of this study is the commonly expressed belief that Pausanias writes with disdain for modern art and buildings, and prefers 'old masters'. It will be argued that this is a simplification and that he does not have a universal disdain for things modern, but a layered, more subtle approach, which affects what he chooses to refer to, and how he does so. Through such references we can gain an understanding of the varied opinions he held of each of the individual Romans he discusses, and an overall picture of how he regards Rome as a whole and how he contrasts it with the past.

As a complementary process must be admitted the perceptions of Greece, particularly of the Classical period, commonly held in Pausanias' day. How far it can be said that Rome encouraged respect, perhaps an exaggerated respect, for the past of Greece will become apparent, but at the least, Pausanias' own views must be seen against the background of those most in evidence in other sources of the period. Here the comparative (and in some cases actual) contemporaneity of the events and personalities Pausanias was treating allowed, almost necessitated, a greater stress on individuality. In this, as in many central aspects, his writing must be seen as a product of its age, and of his position as a native of Asia Minor under the Roman Empire.

While Pausanias' uniqueness as a surviving source in itself guarantees his continuing importance, he should not be treated as an isolated phenomenon: his cultural and historical background must constantly be borne in mind when reading his work. This theme recurs throughout the following chapters, but here two fundamental points may briefly be noted. First, Pausanias grew up and worked in a world shaped by the Romans, and by Hadrian in particular. Secondly, he was from Asia Minor, not mainland Greece, which was the subject of his travels and writings. These factors have central implications for his writing, and must be examined in detail if his world and his attitude to it are to be comprehensible. The period he lived in, and his geographical origin, were crucial in forming his attitudes by providing him with an education of a particular kind, with an interest in travelling to Greece, and with the pervasive influence of the Roman Empire. This is not to suggest educational determinism since, as I shall argue, I believe that although Pausanias had the same type of education as his contemporaries, his writing differed from theirs in several important respects.

In the following sections, these themes will be examined as a means

of setting the scene for detailed consideration of Pausanias' approaches to pre-Roman as well as Roman Greece, and to the notable individuals of the Roman Republic and early Empire.

ORIGINS AND BACKGROUND

Pausanias' origins and background will be examined under three closely related headings: (i) Pausanias and his work, (ii) historical background, (iii) cultural background.

(i) Pausanias and his work

The few facts and inferences that can be gleaned about Pausanias' life have been gathered by several scholars.[10] The picture of his work that is now accepted (and is followed here) is that we have it complete in ten books, written between the 130s and c. AD 175–80. This conclusion is primarily inferred from Pausanias' own work, which includes hints about the chronology as well as the geography of his travels, many of them in the form of cross-references between books.

There may also be inferred from Pausanias' writings what is arguably the most significant fact for understanding him and his work, namely that he was a native of Asia Minor (in all probability Lydia, and specifically Magnesia ad Sipylum), and not mainland Greece.[11] On his travels in mainland Greece he was, in Christian Jacob's phrase, 'un *xénos* venu d'ailleurs'.[12] Pausanias was enabled by his origins to distance himself both from Rome and from mainland Greece itself, and it is in this light that his approach to Greece, ancient and modern, should be seen.[13]

Pausanias' writings must also be set against his objectives, raising the question of what exactly he set out to encompass: the key here is his stated intention to cover *panta ta hellenika* (1.26.4). Some difficulty

[10] Habicht (1985) 8–19; Regenbogen (1956) 1012–3; Frazer i.xv–xxii.

[11] Frazer i.xix; Habicht (1985) 13–17 with refs, including a response to Diller (1955) 270, who sees Lydia only as Pausanias' residence at the time he wrote; Musti (1987) xix; Jacob (1980–1) 44.

[12] Jacob (1980–1) 44; similarly, Susan Walker classes Pausanias among 'foreign visitors' (Walker (1984) 252). These sentiments find ready parallels in the works cited in the previous note.

[13] I disagree with John Elsner's view of Pausanias as exceptional because he 'chose to travel in and write about *his own native land*' (Elsner (1992) 7, his italics); the passage that Elsner cites in support of this position (9.36.5) gives no hint that Pausanias thought of mainland Greece as his home. Also '*his own land*' (Elsner (1992) 9, cf. 28); 'his homeland' (Elsner (1994) 244).

has been felt here by Frazer and Habicht, both of whom give more than a simple rendering of this expression: Frazer translates it as 'the whole of Greece, or, more literally, all things Greek', and Habicht repeats Frazer's translation, adding '"all the Greek matters" would be closer to the actual wording'.[14] Both the phrasing and the context make it clear that Pausanias is 'thinking aloud' and hurrying to end a historical digression in order to continue the task he has set himself. That task was to write about 'the whole of Greece'; as Habicht rightly concludes, 'Pausanias clearly intended to describe Greece in its entirety'.[15] This view finds further support in Herodotos 1.5.3–4, the phrasing of which is closely followed by Pausanias.[16] Such deliberate imitation constitutes a demonstration of Pausanias' own learning; the allusion would not have escaped his readers, nor would Pausanias have wished it to. But this is not just empty mimicry, since Pausanias is following Herodotos also in making a programmatic statement at an early stage in his work.

Thus Pausanias intended to describe the whole of Greece, although it is clear that he did not in fact accomplish this objective.[17] The intended scope of Pausanias' work is remarkable not so much *per se* – his older contemporary Dionysios the Periegete, for example, set himself to write about the entire inhabited world (see below, p. 23 n.57) – as for the immense detail that he combines with that scope. Much of this detail derives from his constant emphasis on the local, the differences between the various parts of Greece, their practices and traditions. The use of local elements is central to Pausanias' working method: the use of local myths, the interest in and recording of local cults, the stress on local identifications of statues and sculptors, and the frequent citations of written sources, local informants and guides (all covered by the word *exegetai*),[18] all bear witness to a determination on Pausanias' part to ascertain what lies at the heart of the communities he is visiting.[19]

[14] Frazer i.xxv; Habicht (1985) 6. Elsner offers a variety of meanings, not all of which are compatible with the Greek (Elsner (1992) 5, 11, 14, 22; (1994) 245, 252; cf. Alcock (1993) 120).
[15] Habicht (1985) 6; also, p. 3: 'the whole of Greece is his topic'; Frazer's 'he professes to describe the whole of Greece . . .' (i.xxv) is misleading, as Pausanias is merely giving an earnest of intent. There are other occasions when Pausanias tells us he must end a digression and return to his main theme (e.g. 1.4.6). [16] I thank Michael Trapp for pointing this out to me.
[17] On what Pausanias does and does not cover, Habicht (1985) 4–5.
[18] Frazer i.lxxvi–vii, with ancient references; Jacob (1980–1) 46–8; Veyne (1988) 5, 132–3. As an example of Pausanias' use of local informants for an area's history and tradition, Roy (1968).
[19] Eisner's view that Pausanias 'pays no attention to . . . local color' is surely untenable (Eisner (1991) 32).

Pausanias' prime interest was in the city and its sanctuaries,[20] a very specific type of site at which one would expect to find correspondingly specific types of art, communal symbols of state religion and therefore of state identity. At least part of Pausanias' interest in sanctuaries is therefore derived from his evident concern with what constitutes a city. Hence his interest in symbols of community identity, which inevitably involved antiquity and concentrated particularly on sanctuaries, which were the focus of the community *par excellence*. If the citizens of a town were interested in their community's history, it would be to the sanctuary that they would go to see the manifestations of that history. Antiquity legitimizes a site, and in dealing with sanctuaries Pausanias would inevitably be dealing with antiquities and their significance.

Thus Pausanias' interest in religious matters is in part an inescapable consequence of his interest in civic identity and its manifestations, since it is within cult buildings (and especially temples) that so many such symbols were stored. This does not, however, result in a mere catalogue of cult buildings: other structures in sanctuaries and civic centres which had little or no religious function are also described, perhaps for their importance in communicating civic identity, government and history (the Stoa Poikile in the Athenian Agora is a case in point, with its paintings of the battle of Marathon). It would therefore be unwise to deduce from the number of shrines described that Pausanias' prime interest was in religion; equally, however, it is necessary to be sensitive to the complex of personal, religious and cultural interests which might have been combined with such historical concerns to determine the choice of sites and monuments and the manner of their description.

In view of the arguments adduced in the preceding paragraphs, I am reluctant to see Pausanias as a pilgrim.[21] In addition, pilgrimage implies a journey by a devotee in pursuance of a primarily religious objective, whereas Pausanias visits the shrines of a multitude of gods and heroes, certainly with a considerable interest in religion but not with one single identifiable religious objective, nor as a devotee of so many deities. Indeed, the extent of the complementary interest in non-religious matters marks Pausanias out as *pepaideumenos* rather than pilgrim. The breadth of Pausanias' objectives is reflected in –

[20] Snodgrass (1987) 77.
[21] *Contra* Elsner (1992), esp. p. 20 seeing 'the whole of Pausanias' account as a pilgrimage'; also, Hornblower (1994b) 51 n.130.

perhaps the cause of – the fact that Pausanias looked at whatever interested him, and visited wherever interested him.[22]

It is also frequently apparent that Pausanias is very interested in the local aspects of what he saw, including many cults. Precisely because these were particular to their own specific area, a traveller like Pausanias could not have immediately entered into them except in his own home city where the practices would have been familiar ones. Therefore, even if he had been a mainland Greek, there would in many places have been an aspect of what he saw that was alien.[23]

Thus the community and what lies at its heart forms the core of his search: he is not simply recording what he sees, but considering it in context, and that means learning what he can of the political and religious history of the particular area he is writing about. It is more than likely that the strongly local element beneath (but not far beneath) the Roman face of the Asia Minor in which he was brought up was in fact primarily formative on his own emphasis on locality and the local. And in such local historical investigation, he is following an established tradition (described approvingly by, for example, Dionysios of Halikarnassos, *On Thucydides* 5, who gives many examples of local historians).[24]

If this Roman aspect began as a veneer, it was deeper and more pervasive by Pausanias' own day, having been strengthened by Hadrian, and its effects were everywhere visible. This is not a case of a simple opposition of 'Greek' and 'Roman', nor is it a pattern that is hard to parallel in other Roman provinces. As Martin Millett has said in another context: 'we must thus see Romanization as a process of dialectical change, rather than the influence of one "pure" culture

[22] Although Eisner's view, expressed apropos of mediaeval pilgrims, that 'the typical pilgrim tended to pass through the world without noticing it – that, in a sense, was the premise of the pilgrimage' (Eisner (1991) 41) is overstated, it does make the important point of the pilgrim's narrowness of focus, and that cannot be claimed of Pausanias.

[23] On Pausanias' religious attitudes, Habicht (1985) 23, 151–9. His devotion to Asklepios has been argued for by Levi ((1971) 2.2), even to the extent of calling him a doctor, although Habicht has neatly refuted that suggestion, while agreeing that he does show signs of devotion to Asklepios (Habicht (1985) 9 n.48). The cult of Asklepios had a considerable revival in Pausanias' time and was closely bound up with the sophistic movement, not least in Asia Minor and specifically Pergamon, the home of his contemporary, Galen, and the city where Aelius Aristides was treated, bequeathing us a valuable account of his experiences; it also saw the emergence of the iatrosophists 'who gave displays of rhetoric on medical subjects' (Jones (1978) 74; Bowersock (1969) 19, 59–75). On the rites of the Asklepieia in the Greek and Roman periods, Graf (1992). For the sources, Edelstein and Edelstein (1945), esp. 2.251–5 on the Roman period. On Pausanias' almost certain initiation into the Eleusinian mysteries, see below, p. 99. That Pausanias is a religious man is clear; that he is a pilgrim is not.

[24] Further, Bowie (1974) 184–8.

upon others'.[25] To seek out the pre-Roman world in addition was a harder task; and it was one which Pausanias set himself also. He kept an open mind, looking at both ancient and modern, but the stress on the local adds an extra dimension to the study of the contemporary, since it was his entrée to the less obvious, to the recorded as well as the still practised which he could observe for himself. Pausanias' identity as a Greek from Asia Minor, not a mainland Greek, is, then, essential to understanding his approach to the objects and sites he describes in what is, for him, Greece but not home.

(ii) Historical background

The extent and prosperity of the eastern Roman Empire in Pausanias' lifetime and the immediately preceding period meant that he would have been brought up with a daily awareness of Roman imperial buildings and practices, laws, tax regulations, magistracies, games and cults. In short, the world he inhabited was one most recently shaped by the Romans, and in particular by Hadrian, whose reign saw more building in the provinces than that of any other emperor. Even though the period of Pausanias' maturity, of at least the majority of his travels, was after Hadrian,[26] his contemporaneity with Hadrian's later life would have enhanced his awareness of the emperor's buildings (as is clear from the discussion of Hadrian in chapter 5).

An important cultural and political development of the period was Hadrian's creation of the Panhellenion, an organization of cities of Greece and Asia Minor (and a few in North Africa) inaugurated in Athens in AD 131/2.[27] Hadrian's impact on mainland Greece is attested by Pausanias himself, not least in the well-known phrase that the Megarians 'were the only Greek people whom even the emperor Hadrian could not make to thrive' (1.36.3). While the Megarians had long been regarded as of meagre significance (e.g. Callimachus, *Epigrams* 25 Pfeiffer[28]), Hadrian's apparent lapse is not presented as a

[25] Millett (1990) 1.

[26] On the evidence for placing Pausanias' date of birth AD c.115, and the likely dates of his travels, Habicht (1985) 10–12; also, Frazer I.xv–xviii. Pausanias' awareness of the imperial cult would have been fostered not least by its presence at Magnesia ad Sipylum, but also by the cult in many other cities in western Asia Minor (Price (1984a) xxiv–v, maps IV–V).

[27] Spawforth and Walker (1985, 1986); Spawforth (forthcoming); Follett (1976) 125–35. The Panhellenion is not mentioned by Habicht or Elsner. For a summary of its activities, Spawforth and Walker (1985) 82–4, 103. [28] I thank Roland Mayer for this reference.

topos, nor as a slight on him since the reason Pausanias gives for the Megarians' situation is their impious murder of the herald Anthemokritos. In other words, the Megarians' plight was of their own making, and Hadrian brought prosperity to all the Greeks as far as he could.

Although Pausanias does not make explicit reference to the Panhellenion, its creation is of inestimable significance for understanding Hadrian's greater plan for Greece and the East. By its foundation, he created a network which linked many cities in Greece and Asia Minor. It gave Athens the pivotal role as the centre to which all other cities looked,[29] but also brought Asia Minor a much more active and integrated role in the eastern Roman Empire. It is against the background of the creation of the Panhellenion that Pausanias wrote, and his work, indeed his world, must have been shaped to a notable extent by it and, arguably, for it (below, pp. 31–6, on Pausanias' possible readership). That it had an impact far inland into Asia Minor is attested by, for example, the Hadrianic bridge built at Aizanoi in Phrygia. A distribution map of the membership of the Panhellenion shows how familiar it would have been in Pausanias' home area – most notably through the membership of Lydian Sardis – even though there is no evidence for the membership of, or an association with, the Panhellenion of his probable home town of Magnesia ad Sipylum.[30] This omission, like the more striking ones of Ephesos, Pergamon and Smyrna, 'perhaps reflects no more than the arbitrary character of the evidence for the Panhellenion'.[31] In fact, the interest in antiquarianism in the period among the Ephesians, Pergamenes and Smyrnaians is attested, and can be related to the stimulus of the Panhellenion.[32] There are other gaps in our knowledge of the Panhellenion, such as our uncertainty over the selection criteria for membership;[33] nonetheless, the general significance of the Panhellenion, and of the milieu it created, for someone of Pausanias' date and geographical origin is clear, and it will be returned to on several occasions in the following pages.

[29] *Pace* Bowie (1974) 197, 'Athens was of no political importance whatever.'

[30] For distribution maps of the member states of the Panhellenion, Spawforth and Walker (1985) 80, and Alcock (1993) 167. For Aizanoi, most recently Wörrle (1992); also, Levick (1988).

[31] Spawforth and Walker (1985) 81.

[32] Spawforth and Walker (1986) 92–4, referring, *inter alia*, to 'a benevolent interest in old Greece's most historic cities among members of the Ephesian elite in the wake of the Panhellenion's foundation'; and to the works of the Pergamene Charax 'articulating the same pre-occupation with the local traditions of Greek cities as can be found in the milieu of the Panhellenion'. Cf. Alcock (1993) 17. [33] Spawforth and Walker (1985) 82.

(iii) Cultural background

Among the many factors which made up the cultural background of the period, the most pertinent are those with which the highly educated men of the period, such as Pausanias, would be most familiar. The most relevant in the present context is the interest in, and admiration for, the past, specifically the fifth and fourth centuries BC. Such archaism will be examined in greater detail below, but one phenomenon which owes much to it has already been discussed, namely the Panhellenion, whose political scope and influence were outlined in the previous paragraphs. Hadrian, in creating the Panhellenion and centring it on Athens, was associating himself with the core of old Greece, his Rome with the high point of Classical Athens, and himself with the founder of Athens, Theseus. In his emphasis on the past, an idealizing concentration on what was seen as the greater glory of Greece, Hadrian was acting in accordance with the established and broader cultural trends of the period. It is against the background of this archaism that Pausanias must be seen.

Another central cultural trend of the time is the popularity of oratorical performance. Closely related is the phenomenon of the sophist, the teacher of rhetoric 'whose attainment was of such a level as to give public performances'.[34] The emergence of the sophist as 'a virtuoso rhetor with a big public reputation'[35] was the most distinctive contribution of the movement known as the Second Sophistic. The name is that given by Philostratos, who dated the movement from Aeschines in the fourth century BC to the end of the early third century AD (*VS* 481), although its effective starting point is the third quarter of the first century AD with Niketes of Smyrna (*VS* 511–12).[36] It is in the latter, more restricted but more commonly employed, sense that the phrase is used here.

The sophists were a conspicuous but limited category of *pepaideumenoi*, the educated men of the period trained in rhetoric and in the culture of the Greek past. For the sophists, as for the other *pepaideumenoi*, reference to the past, especially to Classical Athens, was central. The sophists' knowledge of the past was a matter for rhetorical display – and it could be, and often was, feigned (e.g. Lucian, *Rhetorum Praeceptor*

[34] Bowie (1974) 169.
[35] Bowersock (1969) 13; on 'Performers and occasions', Russell (1983) 74–86.
[36] E.g. Bowersock (1985), esp. 655–6 on the date; also, Anderson (1993), (1990); Bowie (1974), (1982); Bowersock (1969); Lippold (1956).

18). To simplify a complex subject, two types of rhetorical production may briefly be characterized, namely declamation and epideictic.

Declamation, often preceded by a less formal discourse, could be either a symbouleutic speech set in a (sometimes fictitious) historical context (known in Latin as a *suasoria*), or a forensic presentation of one or both sides of an often improbable judicial case (*controversia*). The *suasoriae* gave advice to well-known people of the Roman past, addressing questions such as what Hannibal should do at Cannae, or whether Sulla should retire from public life (Juvenal 7.162–4, 1.6, respectively); or they advise familiar figures from the Greek past, such as Perikles or Demosthenes, and as late as Alexander (who is, for example, advised on whether to cross the Ocean, Seneca, *Suas.* 1). But advice is not offered to Greek figures later than Alexander.

Epideictic speeches were designed to be given at festivals and funerals, and could praise people or lament their deaths; or their subject might be institutions, buildings, or cities, usually contemporary, hence they might well make reference to Rome.

The sophists' speeches were not required to contain historically accurate information, but to be credible, and were subject to elaboration, the more skilful the more applauded. The very language they used was Atticizing, harking back to that of Classical Athens, in particular the prose of the fifth and fourth centuries used by the great orators. It is unlikely to be a coincidence that most of the cultural elite, including the Julio-Claudian and Antonine emperors, had attended rhetorical schools. The influence of these schools is most evident on Hadrian, who founded his own such school in Athens (Aurelius Victor, *de Caesaribus* 14.1.3), and from whom so much of the emphasis on the past of Greece stemmed.

That Pausanias was a product of these trends is undeniable: he was certainly one of the *pepaideumenoi* but, in the absence of evidence that he taught rhetoric, we cannot call him a sophist. However, I suggest that, while the cultural climate equipped him with the education and the motivation to undertake his travels and his writing, he departed from some of the norms of his contemporaries to produce a fundamentally different work. Assessment of this claim requires closer examination of the issues raised, and of a variety of aspects of Pausanias' work in the light of them, concentrating on his sources, predecessors and contemporaries, and the importance of autopsy in his work; his approach to the archaizing trends of the period; his language; and his intended readership.

(a) Sources, predecessors, contemporaries, autopsy

Pausanias' purpose and approach are markedly different from those
of other surviving ancient writers on comparable subjects. Our most
informative sources, such as Cicero, Dio Chrysostom, Quintilian,
Pliny, Lucian, and Aelius Aristides, were neither primarily interested
in art *per se* nor in travelling for the purpose of seeing art and its
context.[37] In essence, basing their work largely on received traditions,
they (particularly Pliny) mainly give lists of artists and works, or use
descriptions of art and buildings as a means to an end, not as ends in
themselves. Thus Cicero uses art to reinforce the oratorical or legal
points he is making; Dio Chrysostom writes as an orator and
philosopher, Quintilian as a rhetorician; Pliny writes about marble
sculptures as an offshoot of his interest in geology, and bronze
through his interest in metallurgy,[38] and he has an obvious interest in
the received biographies which he details; and authors such as Lucian
and Aelius Aristides write according to the conventions of the Second
Sophistic, the movement of which they are prime exemplars, using art
as a means to their end of impressing their audience with their ability
to produce elaborate descriptions, or *ekphraseis* (see below, pp. 20, 27).

Pausanias differs fundamentally from these traditions in three
particular respects: first, his concern is with artistic objects in the
widest sense, including sculptures, buildings, paintings and other
works. Indeed, it is striking for modern scholars, who inhabit a world
where Greek paintings and wooden objects have not survived in
quantity, to note that Pausanias' description of the paintings in the
Lesche of the Knidians at Delphi (10.25.1–31.12) takes up nearly one
third of his description of the Apollo sanctuary, and that his
description of the chest of Kypselos in the temple of Hera at Olympia
(5.17.5–19.10) is as long as that of the temple of Zeus, including the
lavish detailing of Pheidias' cult statue. Secondly, Pausanias was
clearly concerned with context, with sites, their history and their
historical topography as well as with objects, with seeing the totality
and juxtaposition of objects at a particular site rather than simply
isolated objects in collections. Thirdly, and centrally to the two aims
already outlined, although he, like the other writers mentioned, used
secondary sources and received traditions, he applied personal

[37] On art criticism and art history in antiquity in general, Pollitt (1974) 9–84, including
sections on Pliny (73–81) and Quintilian and Cicero (81–4). On Pliny, Jex-Blake and Sellers
(1896) introduction, esp. xiii–xiv, xlvi–vii. On Lucian, Jones, (1986); Delz (1950), with
reviews by Oliver (1951) and Hopper (1952). [38] Jex-Blake and Sellers (1896) i.

observation to the objects he describes and, as will become apparent in this discussion, he regarded this autopsy as an essential and integral part of his approach to his chosen task. Indeed, on occasion he tells us when he has *not* seen an object or monument (e.g. 1.38.2, 8.10.2); while this practice finds a parallel in Herodotos (1.183.3), whom Pausanias has already been seen to imitate, this is no reason to doubt the autopsy either of Pausanias or of Herodotos himself.[39]

Autopsy is, in my view, the single most distinctive feature in Pausanias' work, and it is therefore important to establish that it is a fundamental underlying principle. The overwhelming strength of the archaeological evidence has long indicated that this is so; and the fact that Pausanias' style incorporates many literary manners and allusions docs not indicate that he is guilty of fabrication: rather, it constitutes further evidence that in many respects he is a man of his age. Reference has already been made, and will again be, to written sources, and there is no doubt that Pausanias made use of such sources, knowledge of which would be expected of someone of his background. Included in such writings may well have been catalogues and descriptions of paintings and statues, of temples and their contents, as well as the biographies of painters and sculptors familiar from surviving works, particularly Pliny. It is, therefore, possible to argue an extreme view that Pausanias' work was essentially derivative, a purely literary exercise. On this theory, he would have visited few, if any, of the sites he describes.

However, I suggest that Pausanias' autopsy is clear, not only from the exceptional detail of his descriptions, but also because visiting Greece was an integral part of his education, and it would be remarkable if a man of his background did *not* visit Greece. If parts of Pausanias' account match – or, indeed, differ from – surviving accounts of sites, buildings or statues, we should not be surprised, nor take this as an indication that he did not in fact see what he claims to have seen. Perhaps an analogy may serve: a description written by a modern visitor to Olympia museum (for example), with an intelligent and informed interest in the art and architecture of ancient Greece, will in all likelihood bear close resemblance to the published guides to

[39] Habicht (1985) 142. On the critical tradition regarding Pausanias' autopsy, most notably Wilamowitz' disbelief, Habicht (1985) esp. 165–75; Frazer 1.lxvi–xcvi, esp. lxxiv–lxxxii. Jacoby (1944) is a late example of this tradition, stigmatizing Pausanias' description of the Kerameikos and written, significantly, without knowledge of the first four of the German *Kerameikos* volumes which were appearing around this time (1939–43).

the museum. However, the order of the descriptions may differ, the displays may have been altered between the differing dates of the guides, and between their publication and the time of our putative visitor's report. Equally, our author may make mistakes: some may be misunderstandings, some may be errors committed in transcribing notes at a distance (both chronologically and geographically) from his visit. Yet that is no indication that he did not see what he described. Likewise, neither discrepancies nor similarities constitute significant evidence against the autopsy which Pausanias claims for himself. To take one such example, Pausanias was presumably familiar with Herodotos' reference (Hdt. 1.25) to a silver bowl on an iron stand dedicated at Delphi by Alyattes; but the fact that Herodotos mentions the object should not lead us to doubt that Pausanias saw the stand for himself, described its technique, and observed in person that the bowl was no longer on it (10.16.1; further, below, p. 46).

Another factor is pertinent to an assessment of Pausanias' autopsy, namely Pausanias as a purveyor of historical fact. He is generally regarded as mediocre to bad in this respect;[40] however, it is not my purpose to assess or document this, since I am concerned with his attitudes rather than his accuracy. His recording of history is necessarily at a different remove from his recording of the objects, temples and cults he observed for himself. It might be said that the inclusion of historical elements in his work is in itself a statement, an expression of opinion by its selectivity, but I would argue that he is obliged to include a certain level of history by his evident feeling that it is necessary to give the reader the context of the objects he is describing. And on occasion he expresses his views on historical matters strongly, as when he takes issue with the popular view of the development of Athens from Theseus to Peisistratos (1.3.3).[41]

[40] Representative views have been expressed by Pearson (1962), esp. 408, 412; Salmon, taking his cue from Pearson, refers to 'the romance that passes for Messenian history' (1977) 85 n.8; Larsen calls Pausanias' account of the period from 146 BC to Augustus 'full of mistakes' (Larsen (1938) 306). More favourably, Daux (1975) concerning Pausanias' account of the Amphictyonic League (see below, p. 137); Hejnic (1961) esp. 111–18. Authors of a more ostensibly historical inclination have attracted greater criticism, e.g. 'pride of place among untrustworthy literary texts may go to Polybius' generalisation about the Greece of his day' (Garnsey (1988) 66). Also on the historical aspects of Pausanias, Bearzot (1992), Bultrighini (1990), Segre (1927), Ebeling (1913).

[41] Habicht says that here 'Pausanias almost sounds like Thucydides' (Habicht (1985) 110); as Michael Trapp points out to me, Pausanias here may well be consciously following the precedent of Thucydides' disdain for the received opinion on Harmodios and Aristogeiton (Thuc. 1.20).

Pausanias' writings on history come into a different category from the rest, since he cannot have had autopsy of most of the events he describes, and probably had autopsy of none. The most likely consequence of this is that he is at the mercy of his sources, whether they be local guides or ancient writers. In discussing the Messenian wars at the beginning of his most historically oriented book, he gives us an unusually detailed insight into the sources he uses and into his working methods by comparing two accounts, that of the Cretan Rhianos of Bene and that of Myron of Priene (both perhaps of the later third or early second century BC), and giving his reasons for following the former (4.6.1–5).[42] Frazer argues that Pausanias, despite his professions, did in fact follow Myron closely: significantly, Frazer picks out as the decisive factor Pausanias' style in this passage, which he characterizes as 'totally foreign to his usual dry jejune manner'.[43] Whether or not one concurs with this judgement, it is important to note its derivation from the difference in style between the historical passages based on secondary sources and the descriptive passages based on autopsy.[44]

Habicht has drawn a distinction between passages such as that discussed in the previous paragraph and the briefer references to history, concluding that 'except for some long and elaborate digressions (in which he seems to follow closely a single historian), Pausanias does not copy any historian's work, but usually writes history from memory'.[45] In the absence of so many of the historical sources that would have been available to Pausanias, this theory cannot be proved. However, it finds implicit support in the conclusion drawn in the previous paragraph, since the great majority of the historical references which Habicht sees as written from memory occur not in the historical passages, but in the descriptive ones where the history is, if not incidental, at least not central.

A further possibility which may be considered is that Pausanias followed the sophistic practice of his day in embroidering historical events which he and, perhaps more importantly, his readers could not have witnessed. The key was to make the embroidery credible, as it

[42] Pearson (1962); Frazer III.411–12; Veyne (1988) 25, 137 n.38.

[43] Frazer III.411. Pearson also believes Pausanias followed Myron.

[44] Writing of 7.7–17.4 on the history of the Achaean confederation, Ferrary sees many serious errors of historical fact, attributing most of them either to the deficiencies of Pausanias' source, or to his inaccurate recounting of that source (Ferrary (1988) 200–5). This supports the point made, since in writing of art, Pausanias in most cases had the opportunity to observe for himself rather than rely on secondary sources. [45] Habicht (1985) 98.

was with the *ekphraseis* noted above. An ideal opportunity for this sort of verbal display is the sack of Corinth by Mummius: description of the sack of a city had long been subject to conventions, varying according to what emotion the speaker wished to provoke in his hearers.[46] Such conventions were also central to the *progymnasmata* or standard school exercises of the period. But Pausanias' account of the sack of Corinth does not in fact conform to these conventions.[47] The concentration on effect, so characteristic of *ekphrasis*, involved in this instance bringing to the fore the horrors of a sack; and, although one line in Pausanias' description might qualify ('most of the people found in [Corinth] were massacred by the Romans, and Mummius sold the women and children', 7.16.8), we do know of comparable treatment by Republican Rome of the inhabitants of sacked cities (e.g. Aemilius Paullus enslaved 150,000 Epirotes in 167 BC (Plut. *Aem.* 29.3)).[48] But even if this line is taken as rhetorical rather than historical, the fact that it is only one line is telling, and there is nothing else to suggest conformity with the convention.

In his description of the sack of Corinth, therefore, as I shall argue is the case in other respects, Pausanias does not indulge in the sort of sophistic embroidery which would have been possible, and probably expected in other contexts. That Pausanias could write in this manner if he wished is clear from his description of the sack of Kallion in Phokis, which is amply laden with gruesome details (10.22.3–7). However, it is an account of an event which occurred in 279 BC, and in which the Gauls – barbarians by any ancient standard – were culpable; the likelihood is that Pausanias believed what he tells us, and that he was drawing on an earlier account,[49] rather than regurgitating a conventional account in the manner of one of the *progymnasmata* he had learned at school.

I have attempted to distance Pausanias from the sophists in his approach and in his writing, and further arguments will be adduced (below, on archaism, and on readership). But I would suggest that a similar comparison should be considered with the writers of history, since the genre in which Pausanias is writing is in many respects closer to their work than to that of the sophists, and we do not know enough

[46] Webb (1992) 45. [47] Paul (1982).

[48] 'The enslavement of war-prisoners was the main source from which Rome drew its slaves for most of the middle and late Republic' (Harris (1980) 121–2). On slaves as instrumental in the introduction of Greek education into Rome, Kaimio (1979) 195, cf. 22.

[49] Possible sources are discussed by Frazer v.341.

about the conventions of the genre of *periegesis* to know how far
rhetorical elaboration was ever considered appropriate to it. Here
over-precise distinctions should be avoided, since poetry, oratory and
historiography were all seen as aspects of rhetoric: Cicero, for
example, regarded epideictic as including eulogies, descriptions,
histories, exhortations and sophistic orations (*Orator* 37). The aim
was, as A. Woodman has put it, 'to elaborate certain data in such a
way as to affect or persuade an audience or readership'.[50]

Within the bracket of historiography a range of stances can be
found, from the rhetorical to the sober and restrained. As an example
of the former, Plutarch writes that 'the most effective historian is he
who, by a vivid representation of emotions and characters, makes his
narration like a painting' (*Mor.* 347A). In the same passage, Plutarch
takes Thucydides as the exemplar of this approach, saying admiringly
that he 'is always striving for this vividness (*enargeia*) in his writing, it
is his desire to make the reader a spectator, as it were, and to produce
vividly in the minds of those who peruse his narrative the emotions of
amazement and consternation which were experienced by those who
beheld them'. At the other end of the scale stands Lucian, who
disdains exactly the rhetorical approach so liked by Plutarch. For
him, historians should write 'with truthfulness . . . rather than with
adulation and a view to the pleasure of present praise' (*Hist. Conscr.*
63). And in his account of a fantastic journey, he is careful to make
clear to the reader in the preface that none of what follows is true (*Ver.
Hist.* 1.4).[51]

Thus writers of history must be seen in conjunction with the
broader trends of the period. A wide spectrum of approach is
apparent, from the overtly rhetorical to the scrupulously accurate.
Pausanias stands with the latter: while this will be frequently
apparent to his readers, one example will serve here to contrast the
approaches to one incident which typify the differences between
Plutarch and Pausanias. Writing of the killing by Sulla's troops of
Athenians in the Kerameikos, Plutarch devotes forty-two lines to it
(*Sulla* 14.1–5), conjuring up a picture of the sound of trumpets and
screaming, of unknown numbers massacred, of blood flowing through
the gate and covering the entire suburb. He writes here in the manner

[50] Woodman (1988) 100, and in general on these issues. He discusses the Cicero passage at
95–8, and gives other sources at e.g. 41–2, 116 n.158, 198.
[51] Georgiadou and Larmour (1994), esp. 1449, 1505–6. On *enargeia* and historiography,
Walker (1993); on other aspects of *enargeia*, Webb (forthcoming).

of one following his own prescription for historiography just cited. This prescription also recalls the conventions for the description of the sack of a city.

In marked contrast, Pausanias' account of this incident consists only of the words 'Sulla shut up his Athenian adversaries in the Kerameikos and ordered them to be decimated' (1.20.6). The difference between these two writers could hardly be more starkly apparent, and it shows Pausanias characteristically distancing himself from the rhetorical end of the span of historians, as he did from the rhetoric of the sophists.

A further aspect of Pausanias' historical writing which will, I believe, become clear in the course of this study, is that he takes an interest in the biographical details of the individuals he discusses only insofar as it is relevant to his purpose to do so. There are several occasions on which he effectively passes over an opportunity to make a point about an individual, apparently because that does not suit his purpose.

The three factors enumerated above (scope, context, autopsy) leave no doubt that Pausanias' attitude to antiquities was one of great and genuine interest, and that in this respect he was exceptional. And yet these three vital differences from the contemporary tradition do not add up to a statement of Pausanias' interests and methods, nor even of the tradition to which he properly belongs. His is in part the role of recorder of art and art-history like Pliny (most closely), but also of *periegetes*, a tradition going back at least to Hellenistic times and the works of writers such as Douris of Samos (c.340–260).[52] Robert Eisner says that 'the oldest guidebook for the whole Mediterranean is a work of Skylax, c.350 BC',[53] but this is misleading in one crucial detail: Skylax is known to have undertaken his voyage in the late sixth century, whereas the *Periplous* that has been preserved under his name is a good century and a half later.[54] Its accuracy as a record of its author's travels is, therefore, dubious at best; it may rather be an imaginative reconstruction – one might even call it (or at least its attribution to an earlier author) archaizing – and it certainly cannot stand at the head of the tradition to which Pausanias belongs.

Skylax is, however, potentially important for his origin, Caryanda

[52] On Douris and the tradition of art-criticism in the Hellenistic and early Roman periods, Frazer i.xxxiii–iv, lxxxii–xc; Jex-Blake and Sellers (1896) lvi–lxvii; Pollitt (1974) 9–10, 60–6, 73–84. Habicht ((1985) 2) dates the beginning of periegetic writing to the third century.

[53] Eisner (1991) 31, giving no references.

[54] How and Wells (1928) 1.319 ad Hdt. 4.44. Habicht (1985) 3 on *periploi* as a genre; on the *Periplus maris Erythraei* of the first half of the first century AD, Casson (1989) most recently.

in Caria, placing him in Asia Minor, like Pausanias. The same is true of Skylax' contemporary, Hekataios of Miletos, whose *Periodos Ges* in two books is ill-preserved, and whose *Genealogiai* was a work in four books in which he wrote on myth and legends. Between the *Periodos* of Hekataios and the work of Pausanias stands that of Herodotos – or at least the elements of *periegesis* in Herodotos. That Herodotos was influenced by Hekataios is accepted; so too that Pausanias was influenced by Herodotos, and to a much greater degree.[55] All three were from Asia Minor, Herodotos being a native of Halikarnassos in Caria (incidentally, the home region of Skylax). Domenico Musti notes the persistence of what he calls the cult of Herodotos in Asia Minor and, in a detailed consideration of the relationship between the two, says that 'l'opera di Pausania costituisce il caso più impressionante di rinascita erodotea che si conosca nella letteratura greca'.[56]

The periegetic tradition, then, had already had a long (and, at least in the case of Herodotos, distinguished) lineage in Asia Minor by Pausanias' day, with Herodotos clearly a figure of particular significance to him.[57] Like Herodotos, Pausanias stresses the value of autopsy.

[55] E.g. Kleingünther (1934) 43–65. Nörenberg (1973); Habicht (1985) 3 and n.7, 97–8, 133, 167–8 with refs; Musti (1987) xxi–iv; Jacob (1980) 68, (1980–1) 35–6; Pfundtner (1866). The (probably) Hadrianic writer Kephalion wrote 'a world history . . . nine books named after the Muses, written in the Ionic dialect, the model being Herodotus' (Bowie (1974) 177).

[56] Musti (1987) xx.

[57] The above discussion of periegetic writing and literary influences on Pausanias is not intended to be comprehensive. Among other figures, Polemon of Ilion (early second century BC) is the most important (Preller (1964); Dihle (1989) 259, (1994) 249). Frazer, in a detailed examination of Pausanias in the light of the fragments of Polemon (I.lxxxiii–xc), concluded that Pausanias did not copy him (*pace* Jacob (1980–1) 36) and that similarities were the inevitable result of visits to, and personal observation of, the same places and objects: 'the very frequent omission by Pausanias of things mentioned by Polemo, and the not infrequent adoption by him of opinions which contradict those of Polemo, go to prove either that he was unacquainted with Polemo's writings, or that he deliberately disregarded and tacitly controverted them' (I.lxxix). Frazer's conclusions are supported by Musti (1987) xxxi. The second- or first-century BC writer Herakleides of Crete included descriptions of Greek cities and their customs (Eisner (1991) 31). Dionysios wrote a *periegesis* of the inhabited world in the second century AD (his most recent editor dates him to between 130 and 138 AD: Tsavari (1990) 12; so too Bowie (1990) 77–8, Jacob (1981) 30; Brodersen (1994) 10, and Bulloch (1985) 605, call him Hadrianic; Howatson (1989), s.v. 'Dionysius Periegetes'). Although surviving fragments denote a writer with very different preoccupations from Pausanias ('avant tout un manuel de géographie', Jacob (1981) 57), perhaps because of the much greater scope of the project attempted, the writings of a contemporary periegete are of interest. There are also examples of *periegeseis* by writers who practised the genre only incidentally, such as Plutarch's Περὶ τῶν ἐν ταῖς Πλαταιαῖς δαιδαλῶν, as Bowie rightly notes (Bowie (1974) 185 with n.52; further, below). That Pausanias was acquainted with the writing of geographers seems clear from the phrase 'those who profess to know the dimensions of the earth' (1.33.5). One such may have been his exact contemporary Claudius Ptolemaeus (most accessible in the Loeb tr. of F.E. Robbins). On minor geographers, including later ones, Diller (1952).

Like Herodotos also, he is concerned with what makes one place different from another, and he is ready to express his own opinions when he feels it appropriate.

(b) Archaism

Although I have distanced Pausanias from contemporary writers, this is not to suggest that his is a rare spark of interest in the past in the second century AD. While the narrative of Pausanias is deeply personal, it is also a product of the society into which its author was born and in which he lived. To an educated man of means of his age, antiquities were an integral part of his culture, and to a man of Pausanias' inclination, study of them an integral part of his education in its broadest sense.

This was no historical accident: a convincing explanation for the creation of this cultural climate has been suggested by Antony Spawforth and Susan Walker in their two articles on the Panhellenion.[58] An already existing interest in the past of mainland Greece among the educated class of Asia Minor, among whom Pausanias would have counted himself, was stimulated (and to an extent exploited) by the creation of the Panhellenion. Spawforth and Walker refer to this phenomenon as 'Greek cultural archaism', and say that 'stimulated by Hadrianic policies, recollection of the past should be viewed as a dynamic element in Greek urban life under the Antonines'.[59] As they put it, the founding of the Panhellenion encouraged 'a contemporary perception of the Greek past and the Roman present as complementary rather than mutually exclusive'.[60] With this background, Pausanias' style of writing, more discursive than that of other sources, is to be expected; so too is his great interest in antiquities, since in forging those connections between 'the Greek past and the Roman present', it was essential that he considered the development of the artistic and cultural manifestations of that Greek past.

It is against this background that the well-known letter of Pliny the Younger to Maximus should be seen: in it, Pliny advises Maximus that when in Greece he should 'recollect each city's former greatness, but not so as to despise her for having lost it' (*Ep.* 8.24). So too, Nero's phrase, used while declaring the freedom of Greece in AD 66: 'would that I were making this gift while Hellas was still at its height'

[58] Spawforth and Walker (1985), (1986). [59] Spawforth and Walker (1986) 104.
[60] Spawforth and Walker (1986) 104. The opposite view is hinted at by Snodgrass (1987) 76–7.

(further, see below p. 142).[61] Both of these expressions reflect 'a typical enough Roman perspective'[62] but, vitally for present purposes, both date from before the time of Hadrian, who made all the Greeks thrive except the Megarians (1.36.3). Thus expressions of the decline of Greece in the period before Hadrian have a truer ring to them than those after Hadrian's time; and it is in the latter category that Pausanias' own writings come, when there had occurred a genuine revival of the physical and cultural embellishment of Greece.

The quotations just cited from Pliny the Younger and Nero show that 'cultural archaism' long antedates Hadrian and the Panhellenion. Indeed, it is increasingly apparent in Greece from the time of the Flavians, often in some attempted re-creation, or mock re-creation of the past. Such manifestations included many of the games which sprang up in imperial Greece, and many of the local festivals such as that at the sanctuary of Artemis Orthia near Sparta which featured boy-whipping, a re-creation of the Roman period passed off as 'authentic'. Pausanias witnessed this and attributed it to Lykourgos (3.16.7–11), but elsewhere he talks of the abolition of the Lykourgan customs by the Achaeans and their 'later' restoration by the Romans (7.8.5; 8.51.3).[63] Thus what he saw was, as he became aware (if he did not realize it at the time), a revival in a Roman form of a late Classical Greek custom – a prime example of the archaizing trend in Roman Greece.

Archaism as a phenomenon in Greek and Roman art has long been acknowledged by scholars, although they may disagree as to how to recognize it or whether specific pieces exhibit it,[64] and it has long been recognized as central to the main rhetorical movement among the educated elite of Pausanias' day, the Second Sophistic. Here the definition of 'archaism' is important, not least because I believe that a lack of clarity of terminology would contribute to a misunderstanding of Pausanias' role in this cultural environment.

Archaism in one sense means placing particular emphasis on the past, and manifests itself in this instance in eulogies of the Classical period, its art, culture and language, and often in attempts to reproduce them. Archaism can also mean passing something off as a product of an earlier era. In the former sense, while there is an

[61] Larsen suggests that Nero may have derived this attitude in part from his teacher, Seneca (Larsen (1938) 467). [62] Anderson (1993) 102.

[63] On this re-creation, Cartledge and Spawforth (1989) 201–7.

[64] Harrison (1965), Zagdoun (1989).

idealizing concentration on past glories, there is no suggestion that writer or audience (whether reader or hearer) actually believed that they were living in the Classical period, however much this might have been their fantasy. In the latter sense, there is a deliberate attempt to deceive, to pass off, for example, a neo-Classical sculpture as a Classical original, or a new cult practice as a traditional one.

The former aspect of archaism is a standard feature of the works of the writers of the Second Sophistic, the strongest and most relevant manifestation of what Graham Anderson has called 'an ethos in which educated Greeks could seek to foster at least an illusion of past glories of the fifth and fourth centuries BC'.[65] This is repeatedly apparent in the writings of authors such as Pausanias' exact contemporary Aelius Aristides, who employed an idealizing emphasis on the past glories of Classical Greece and wrote in Classical, particularly fourth-century, Greek.

I suggest that Pausanias' work is not susceptible to the charge of archaizing in either sense, and that he should not be seen as writing with the same intentions, or within the same conventions, as Aristides and the other writers of the Second Sophistic. This is a theme which will recur in succeeding chapters, but some fundamental points of difference may be made in the following paragraphs.

The focus of interest in the Second Sophistic was the Classical period, the fifth and, especially in respect of language, fourth centuries BC. The absence in rhetoric of examples taken from after the death of Alexander has already been noted.[66] This is a conspicuous tendency also among the historians of the period.[67] Both historians and rhetoricians (the latter outside the context of declamation) also refer to events before the Classical period, notably the key figures of the period covered by Herodotos, such as Cyrus, Kroisos, or Solon (e.g. Lucian, *Dialogues of the Dead* and *Phalaris*). However, the concentration remains firmly on the Classical period, which cannot be said of Pausanias, whose attention to matters dating from before the fifth century is considerable (as the next chapter shows). Similarly, his attention to matters Roman is sufficient to form the bulk of this study. Nor can it be said that in his references to individuals, Pausanias followed the practice standardly found in declamations of referring primarily to those who were well known, such as the figures just cited.

[65] Anderson (1993) 3; also, 'the Second Sophistic had a cult of the Greek past' (180).
[66] Examples include Philostratos (Gabba (1982) 64); and the extreme case of Maximus of Tyre, whose avoidance of reference to the post-Classical is complete (Trapp (forthcoming)).
[67] Bowie (1974) 178–9.

Intrinsic to the method employed by the sophists were the rhetorical fireworks with which they impressed their hearers – for these were elaborate presentations to an audience. Any subject could be covered by these writers; for present purposes, it is the use (a word I choose purposefully) of the visual arts and architecture that is most pertinent. The most prominent manifestation of these presentations is in the practice of *ekphrasis*, often interpreted simply as description, but at this period a technical term expressing a particular form of verbal representation, which has been characterized as 'the concentration on the effect made on the viewer at the expense of detailed and precise information'.[68] This is not to argue for the exclusion of detail, which is regularly prominent in *ekphraseis*; but there detail is secondary to effect, which constitutes a fundamental difference from Pausanias, whom archaeological evidence has repeatedly shown to be giving exactly such 'detailed and precise information'.

Where we cannot expect to verify Pausanias' evidence through the archaeological record – cult practices, most obviously – we can assume, by analogy with his accurate descriptions of objects and practices, that he recorded what he saw, and not a fossilized 'memory of the past'.[69] In that sense, he is recording the present. To writers whose primary concern was rhetorical impressiveness, accuracy could not be at a premium: indeed, it would obstruct their aim of scoring points, effectively tying their hands (or, rather, their tongues). Of course, in cases where what is described is overtly fictitious, the criterion of accuracy does not apply. Pausanias is set apart by the extent of the autopsy he justifiably claims and by the extent of his accuracy. Even where he can be proved to be inaccurate, I do not believe that he can be shown to be writing what he does not believe, to be idealizing or archaizing in the definition as deceiving given above.

This theme is again relevant to two further factors which set him apart from the trends of the period and which remain to be considered: language and readership.

(c) Language

Perhaps because Pausanias is not generally regarded as a 'writer' in the literary sense, the scholarly attention paid to his use of language has appeared in discrete studies rather than being integrated into

[68] Webb (1992) 53.
[69] Eisner (1991) 32; cf. Jacob (1980–1) 44–5, 'La Grèce . . . n'est plus qu'un immense musée'.

wider examinations of his work.[70] Yet the nuances of his language, and consequently his relationship to the linguistic fashions of his day, would have been readily apparent to his contemporaries. In the same way that it is necessary to examine how far he aligns himself with, or distances himself from, the other cultural trends of his day, so his language must be considered against the background of his era. I shall first consider the linguistic trends of the period, and then Pausanias' own use, and awareness, of language.

A central theme of this book is the balance of Greek and Roman, and here I briefly consider some of the public manifestations of this balance in language in the early empire, both that used in official documents, and that found in literature.

Corinth plays a central role in the transformation of Greece into the Roman province of Achaia, and the language used in its official documents reflects this process. As a Roman re-foundation, it began as a Latin-speaking community, becoming Greek-speaking after a period of bilingualism: the percentage of Greek in surviving records rose dramatically from 3 per cent before Hadrian to 87 per cent after him.[71] This reflects the interest of Hadrian, the most philhellene emperor and, as noted, the first to have 'a Greek policy'. Indeed, the Hellenization of Corinth was already acknowledged in writings of the second century.[72]

Similarities between Corinth and Patrai, another Roman colony, will be considered in chapter 4; here it may be noted that the balance of Latin and Greek undergoes a similar process, the people of Patrai (like the Corinthians, Roman in origin), quickly taking up Greek rather than Latin for most purposes, but for official documents persisting with Latin (as in Corinth), some using it into the fourth century.[73]

The deliberate discrepancy between the uses of Latin and Greek can also be found elsewhere in the provinces:[74] a striking example concerns the version of the *Res Gestae* of Augustus from the temple of Roma and Augustus at Ankyra in Galatia. The *RG* were written in Latin or Greek according to what was felt appropriate to each location,[75] and that in Ankyra was in both, the placing of the two

[70] Strid (1976), on aspects of previous scholarship, 11–14; Rocha-Pereira (1965–6); Szelest (1953); Robert (1909) 201–7 (with Robinson (1910) 215); Rüger (1889); Boeckh (1874); Frazer i.lxix–lxxi. [71] Kent (1966) 18–19.

[72] Aptly noted by Williams (1987) 35; also, Alcock (1993) 169. [73] Rizakis (1989) 185–6.

[74] On the use of Greek in official documents in the eastern empire, Kaimio (1979) 74–86.

[75] Brunt and Moore (1967) 2; Kaimio (1979) 76.

versions differing significantly: as Ewen Bowie has noted, 'the Latin version is engraved high in the most prominent section of the temple, the *pronaos* – too high to read easily without straining eye or neck, but in a suitable pose of ostentation; the version that people were expected to read, the Greek, was at eye-level along the outer side of the *cella*'.[76]

As in official documents, so in literature shifting proportions of Greek and Latin can be seen. Donald Russell, seeing a move from an approximate equilibrium between Latin and Greek in 'literary culture' to a situation 'in which the dominance is very definitely with the Greeks', dates it to the second century AD, the same period as the move towards Greek noted for official language, and attributes it broadly to the same cause, the philhellene Hadrian. Anderson goes further, speaking of 'the virtual eclipse of Latin literature by Greek in the second century AD'.[77]

From the balance of Greek and Latin both in literature and in official writings, I return to the phenomenon of archaism, some aspects of which have already been considered, and which is manifest in the language of the period in both its inscriptions and its literature. In considering the language of inscriptions, it must be acknowledged that dating by letter-forms is by no means infallible.[78] That caveat apart, there are cases of deliberate archaism – of the use of letter-forms which were no longer current – the intention behind which needs to be assessed for each case and may be harder to isolate than is the fact itself. Possible archaism in the inscription on the Athenian Stoa at Delphi is discussed below (p. 74). A clear case of the use of an archaizing script is found in an inscription of the Augustan period from the Athenian Akropolis, on the base for a statue professedly by the Classical sculptor Lykios son of Myron (whose work on the Akropolis is mentioned by Pausanias, 1.23.7; cf. 5.22.3); the archaizing script seems to be intended to associate the inscription more closely with the period of the statue.[79]

The importance of Hadrian in changing the balance of Greek and Latin has been noted; so too his role in the development of the phenomenon of archaism. It is at this period that, as Spawforth

[76] Bowie (1970) 206.
[77] Russell (1990b); Anderson (1993) 10. More generally, Kaimio (1979).
[78] As Rizakis (1989) 185, observes in relation to the inscriptions of Roman Patrai.
[79] Raubitschek (1949) 146–50 no. 135, connecting this with the visit of Germanicus in AD 18; Graindor (1927) 147 n.2, (1924) 14, 37. Bowersock (1979) 73, cites this example, adding the archaizing inscription on the temple of Roma and Augustus on the Akropolis (on which, below). For another possible example, Oliver (1972b) 190–2.

observes, 'Spartan ephebes suddenly adopted – and continued to use intermittently into the third century – a 'hyper-Doricizing' dialect in their dedications to Artemis Orthia, a piece of antiquarianism presumably intended to reinforce the claims of the training to represent ancestral practice'.[80] The same archaism in language is found also in an inscription of Hadrianic date found at Sparta, which refers to a Messenian city as 'Korone'; Spawforth identifies this city with the 'Koroneia' referred to by Pausanias (4.34.4–6).[81] If so, it suggests that Pausanias himself did not use the 'approved' archaizing form.

The language of literature is most pertinent to Pausanias, and thus to my immediate purpose. Here we have to do with the primary linguistic trend of the Second Sophistic, Atticizing:[82] this consists of a 'revival, or attempted revival, of literary Greek as written by the prestigious authors of Classical Athens'.[83] It involved using the grammatical constructions of that place and period and telltale features such as -ττ- rather than the contemporary -σσ-. It is, thus, a form of archaism – conspicuous as such both to those who employ it and to those who do not.

The language of Pausanias led the late eighteenth-century translator and commentator, Thomas Taylor, to say of him that 'the obscurity of his diction is so great, that he may perhaps be considered as the most difficult author to translate of any in the Greek tongue'.[84] Why he thought this is not, alas, made clear, and it is a sentiment that modern scholars would be unlikely to share; the few scholars who have studied Pausanias' language in detail have not done so. His language is likely to strike anyone who compares it with that of, for example, Philostratos (perhaps the best representative of the linguistic style of the Second Sophistic) as less Atticizing. He uses simpler constructions, and -σσ- rather than -ττ-, for example. A certain level of Atticizing is almost inevitable in the work of anyone writing against the cultural background that I have been outlining in this chapter; but in Pausanias it is at a lower level, and he does not employ a high literary style. That this is so may owe something to Pausanias' use of the Ionic Herodotos as a model in other respects.

On occasion, Pausanias shows awareness of some of the subtleties of language: he can recognize 'the Doric tongue' (3.22.1); and 'ancient

[80] Cartledge and Spawforth (1989) 206. [81] Cartledge and Spawforth (1989) 109.
[82] Schmid (1887–97); Gelzer (1979); Frösén (1974); Anderson (1993) 86–100; Trapp (forthcoming).
[83] Webb (1992) 16. [84] Taylor (1794) viii.

letters' (5.22.3). But these are of interest to him not for their language, but for what that language tells him; and that is better discussed in chapter 2.

(d) Readership

Indivisible are the questions of who Pausanias' readers were, and what he was trying to do. Habicht says that Pausanias 'wanted to provide a reliable guide for travellers and to produce a literary piece that would entertain as it informed'.[85] Eisner's view is that 'like Herodotos, he was trying to present a memory of the past, the relics of which he saw crumbling all around him. He was thus trying to do two things at once, to provide both a guidebook and an entertaining or literary essay. The audience he had in mind did not exist in his own day'.[86]

But if, as Eisner says, part of the aim is to provide a guidebook, the 'audience' for that at least certainly did exist, as indicated by the extent of tourism in the period.[87] The audience of some of those who mention art is known: that of Cicero, for example, in his description of Verres' despoiling of Sicily, is a jury – it is there to be impressed, and art-historical accuracy is not only secondary, but is potentially an obstacle to Cicero's presentation of the art as exceptionally valuable, and its thief, therefore, as exceptionally heinous.

By Pausanias' day, the cultural milieu had changed radically from Cicero's: the sophistic movement was one bounded fairly precisely by rules of engagement. One of those was that sophists generally spoke on subjects demanded by the occasion or by their audience (often extempore, at least in part) – while this was admittedly also true of Cicero, it cannot be claimed to be a characteristic of his age, but arises from his personal situation. Here Pausanias differs substantially, in that he has the luxury of following his own interests, which may or may not coincide with those of his audience, some of whom would have been used to talking about the visual arts, as indicated by the practice of the *ekphrasis* of works of art, a conceit in which the audience was vital and complicit.

In obvious contrast to this, Pausanias' writing was the result of a long pursuit of a personal fascination – we do not have enough biographical information to be certain of this, but the length of time

[85] Habicht (1985) 21. [86] Eisner (1991) 32.
[87] E.g. Cartledge and Spawforth (1989) 207–10; Hunt (1984); and witness Eisner's own book. Such tourism can be dated from the second century BC (Kaimio (1979) 40, cf. 205).

he took over his travels and writings alone suggests that it may have
been a lifelong pursuit – whereas the sophists were prepared to display
their rhetorical skills on any subject, not least for the pecuniary
rewards. Sophistic exercises require an audience, preferably one
versed in the conventions and, in all probability, themselves practised
in the skill.

Pausanias' intended readership is harder to define because of the
differences outlined between him and the sophists. For an author
writing a guidebook (and whether Pausanias was doing so will be
considered in the following paragraphs), the group comprising those
for whom it was written must be broader in its composition. Indeed,
one might argue a certain opposition: while the sophists' audience
must be familiar with the conventions and tricks of the trade,
Pausanias' readership is likely to have been a mix, at best equally
sophisticated literati planning a visit to Greece, and quite probably
markedly less well informed than he is, otherwise his book would have
no purpose. And he can hardly have subjected his potential readers –
not listeners – to baffling rhetorical fireworks at the expense of
accuracy in the manner of the sophists.

I suggest, therefore, that Pausanias stands apart from the sophists
who were his contemporaries. Most crucially, this applies to the
subject of archaism, specifically the idealizing form employed by the
sophists. Here I return to Eisner's statement quoted above that
Pausanias 'was trying to present a memory of the past, the relics of
which he saw crumbling around him'. I find it hard to reconcile the
agreed fact that he was writing about objects that he saw for himself
with the idea that he is presenting 'a memory of the past'. An
idealizing author would have restored the temples to their Classical
glory in his mind, and presented their pristine – and fictitious –
appearance to his readers.

Similarly, the cults and practices Pausanias describes are those he
has observed for himself or, as he states, those he has been told of but
not actually witnessed. Some of them may have been modern
re-creations, and he tells us when he believes this to be the case – most
notably the instance of the Lykourgan customs at Sparta. He may
have been taken in by some modern practices passed off as ancient –
even by some such statues – but he presents his account in good faith
and cannot be accused of attempting to mislead. If he were mindful of
the equally educated among his readers whom he would expect to
have undertaken, or to undertake in future, the 'Grand Tour' as he

had done himself, he would not expect to get away with misleading them, unless he followed the conventions of sophistic writing and made it clear that he was writing an extended literary showpiece. And that he conspicuously does not.

Pausanias is in fact presenting not a 'memory', but a very tangible reality of the past; but it is tangible, in the literal sense, only to those who followed him, who used him as a guidebook on the ground. We are back to autopsy since, as Sihler long ago pointed out, 'only the actual traveller it is who everywhere notes what is in ruins or decay'.[88]

The practical difficulties of using on site such a book – consisting, presumably, of ten rolls – may have been considerable, even if the traveller was unlikely to have required more than one roll on any one visit. But there are two factors which suggest that these impediments could be overcome. First, Pausanias himself must have taken sufficient material, including writing equipment (which those who followed him would not necessarily carry), to make the many notes that he evidently did make on the spot, whether recording cult activities, or the local myths, identifications and attributions told him by the *exegetai*, or transcribing inscriptions.[89] Secondly, that Pausanias intended some future travellers to use his work on site seems eminently likely, given the extraordinary care he has lavished on detail and on topographical indicators, and given the geographical arrangement which facilitates such visits.[90]

While the preceding paragraph is concerned with the possible use of Pausanias on the territory about which he writes, there is no reason to exclude the armchair reader back in Asia Minor, or even Rome, as a member of Pausanias' intended readership. The enormous wealth of mythological detail, above all, would be readily appreciable by readers who had never been to Greece, and had no plans to visit. In the same way, many of the literary references and allusions would give it a cosy familiarity, although the very range of such information that Pausanias conveys would inevitably also include much that was unfamiliar. That this is so is not least a consequence of the local

[88] Sihler (1905) xxxii.

[89] Fergus Millar has said of Cassius Dio's recording method that 'it can readily be assumed that these notes were taken down on *membranae* or *chartae*' (Millar (1964) 32). This is likely to be applicable to Pausanias also, since such *membranae* (parchment notebooks) had been current since the end of the Republic and had not yet been superseded by codices (Reynolds and Wilson (1991) 31).

[90] Habicht (1985) 19–20; I agree with the criticism of Levi's re-arrangement made by Elsner (1992) 3 n.2.

element in much of what he relates, since local myths would, almost by definition, tend to be unfamiliar to a wider public.

In the quotations given above, both Habicht and Eisner say that Pausanias intended to entertain, although they place different stresses on this element, Habicht seeing the work as 'a literary piece that would entertain as it informed', Eisner as 'both a guidebook and an entertaining or literary essay'. The apparent dichotomy set up by Eisner's words is an unreal one – there is no reason why one should not entertain as one informs, as Habicht has seen. But one needs some caution in defining 'entertaining' – undoubtedly part of the aim of the sophists, but perhaps carrying with it implications of insubstantiality. 'Entertaining' has shades of Lucian's story of Herodotos reading his histories in the temple at Olympia, a practice to which the audience *in attendance* is essential (*Herodotos* 1–2).[91] We surely cannot see Pausanias performing his work. While this is a further element separating him from the sophists, it is interesting that Lucian should see a historian – the category of writer to whom Pausanias is in many respects closer than he is to the sophists – as performing to an audience. Pausanias' evident interest in what is traditional in Greek religion, and his relentless pursuit of it, surely argues against the notion of entertainment as his primary concern, as do the other differences from the sophists already discussed.

To say that Pausanias' work is a 'literary essay' is also not accurate, certainly in the sense in which Eisner means the phrase. However, the number of references or allusions to literary sources is considerable,[92] a sign of the typical education of a native of Asia Minor in the second century AD. We can speculate that Pausanias was well acquainted with the libraries of Pergamon and elsewhere;[93] but we can be certain that his library work was secondary to his own observations in the course of his travels.

In addition to the suggestions already made concerning Pausanias' readership, another may be considered. The importance of the cultural milieu in which Pausanias was brought up and lived has been stressed repeatedly (and will continue to be), and I suggest that it is

[91] The story may be a sophistic fantasy, a better indicator of the realities of the second century AD than the fifth century BC, although in Herodotos' own time the tradition of the rhapsode lends the story credibility. On how easy it would be for Lucian to invent the story, Nesselrath (1990) 118.

[92] Musti (1987) xxiv, detects knowledge of some 150 authors in Pausanias.

[93] As noted by Jacob (1980–1) 36.

the key to this aspect, as to many aspects, of Pausanias' writings. Here I return to the Panhellenion, an organization well represented in his home territory of Asia Minor. The fact that Pausanias is so complimentary to Hadrian is proof enough of his goodwill towards the world that Hadrian had created, and he is most unlikely to have been unaware of the role of the Panhellenion as an instrument of Hadrian's policy, even though he does not mention it. For these reasons it is surely most probable that Pausanias' readers were, effectively, the delegates to the Panhellenion[94] and those (presumably more numerous) like them in their concerns. Although there was by this period a long tradition of Romans travelling in Greece as part of their education,[95] the interest in such travel reached an unprecedented level in this period, mainly for sophistic education and display or to study philosophy. The creation of the Panhellenion enhanced and facilitated this interest, certainly among the delegates whose duties required them to travel to Athens, and by extension among those sections of the population with similar interests. Indeed, the creation of the Panhellenion may have been not least a response to the growing desire, and ability, of an increasingly rich section of society to travel.[96] This was especially true of Asia Minor, and Pausanias, while the best-documented example of the trend, would have been by no means untypical in undertaking such a journey.[97]

A book like that of Pausanias would have been ideally suited to facilitating future visits to Greece by his fellow natives of Asia Minor. Travellers return home. And they send letters from abroad, or report on their travels when they return. In Pausanias' case, the many references to Asia Minor in his text show clearly where his roots are, and give more than a hint that he expected his readers to be familiar with those geographical areas, as well as with the cultural and educational standards he himself exhibits. In speaking, as is often done, of a guidebook, one should not, I suggest, think of Pausanias' intended readers exclusively in terms of people walking round Greece

[94] Spawforth (forthcoming). As instances of Panhellenes who are known to have travelled may be cited Tiberius Claudius Attalus Andragathus from Phrygian Synnada, who had close ties with Athens, Sparta and Plataiai (Spawforth and Walker (1985) 91–2, (1986) 89–90; Spawforth (forthcoming)); and M. Ulpius Appuleius Eurykles of Aizanoi (e.g. Wörrle (1992); Levick (1988) 14–15 no.31, 176 no.583). [95] Kaimio (1979) 40.

[96] Roueché (1989) 219–220.

[97] Cartledge and Spawforth (1989) 208–9, with an important corrective to Habicht's view of Pausanias as a 'loner'.

with a copy of his work, but also in terms of people at home reading him either in advance of a trip of their own, or for sheer interest.[98] This is, after all, the way that modern travellers use guidebooks: while some buy them when they reach their destination, many look them up well in advance of their trip, to inform themselves by reference to the writings of someone who has already travelled extensively in the relevant area; to enable themselves to plan their own itinerary; and to make the most of a rare, perhaps 'once in a lifetime', opportunity (which would have been all the rarer in a world of less sophisticated transport). This was quite possibly part of the process by which Pausanias himself prepared for his own trip.[99]

In summary, the text seems to me to be intended to inform those at home of what contemporary Greece is like, of what can be found there, and of where it can be found, as well as to give an overall vision of Greece, past and present.

PAUSANIAS ON THE ART AND ARCHITECTURE OF HIS DAY

I move now to the Roman period in Greece, an area of Pausanias' interest which forms the greater part of this book through discussion of Pausanias' attitudes towards the rulers of Roman Greece (chapters 3–5). Since the world Pausanias lived in owed much to Hadrian, most of the Roman period he writes about is in fact quite remote from him, a fact mentioned above in connection with perceptions of early figures such as Caesar and Augustus in his day. Nonetheless, it is distinctly separated from the Greek period, and the purpose of this section is to

[98] Pausanias' actual readership may have been different from that which he envisaged as he wrote: Diller says that 'if [Pausanias' text] was published at all, it was in a limited issue for private circulation among the author's acquaintances' (Diller (1956) 84); 'Pausanias was never widely read' (Diller (1957) 169). It is improbable that this was the author's intention. The reference to Paus. 8.36.6 at Aelian, *VH* 12.61 (the only possible such reference in another author) is almost certainly an interpolation: Diller (1956) 87, points out that 'it is not integrated in the context and such a citation is out of character'. Diller is followed by Habicht (1985) 1 n.1. On the textual tradition, as well as Diller's articles, Casevitz (1992) xxxi–xlvi.

[99] The comparative rarity of the opportunity to travel is one reason why I am hesitant to agree with Elsner that 'Pausanias was describing a *familiar* world, the classic [sic] sites of the Greek mainland' (Elsner (1992) 12, Elsner's italics). Pausanias has an inconsistent 'policy' on things *we* would expect to be familiar to his audience, admittedly a hard matter to judge. Of those objects which we can reasonably assume to have been familiar, Pausanias described some in considerable detail (e.g. Pheidias' Zeus at Olympia), and omitted or barely described others (e.g. the Parthenon sculptures other than the Parthenos). In saying that he was all-encompassing, his inconsistency has to be acknowledged as pervasive and unsurprising in a work of such scope.

ask whether a distinction can usefully be drawn between Pausanias' treatment of objects of the pre-Roman and Roman periods.

Given that Pausanias is of necessity selective in his descriptions, does the antiquity of an object (in which I include buildings) play any part in his selectivity? There are no places in the text where he says that it does – perhaps the closest is when he says that 'the charm' of a statue of Herakles at Erythrai 'is its antiquity' (7.5.5) – but it is tempting to wonder whether modernity was a negative factor for him.

This may be considered here with reference to Olympia, of which his description is exceptionally extensive and accurate, as any visitor to Olympia can still discover (and as Pausanias himself proudly claims, 5.25.1). Yet there is no place in his narrative for the nymphaion of Herodes Atticus, hardly inconspicuous in size or position, and later mentioned by Philostratos (*VS* 551). Renate Bol has recently firmly established the date of the nymphaion as AD 149–53, and it has long been acknowledged that 5.1.2 indicates that Pausanias visited Olympia c.AD 173.[100] There can, therefore, be no doubt that he saw the nymphaion.

The reason for this striking omission is not known (as it could hardly be), but we might reasonably have expected Pausanias to include it in view of its unusual form and size, as well as the sheer detail of his account of Olympia, although it may have been the very quantity of material to record that made him more than usually selective. It is possible that it was, at least in part, the very modernity of the nymphaion which caused Pausanias to omit it.[101] If so, this would not be the first example of a dislike of contemporary works, as Plato reserved especial venom for the artistic trends of his own time,[102]

[100] Bol (1984) 99–100. On the date of Pausanias' visit, Habicht (1985) 9; Papahatzis 3.196–7; Frazer i.xv.

[101] Habicht (1985) 134–5 and n.74. Settis (1968) 43 suggests that the nymphaion was built between Pausanias' visit and the publication of his book on Elis (supported by Musti (1987) lii). For this to be so, the date of AD 173 (5.1.2) must have been inserted while 'writing up'. This is possible, but assumes more than we know of Pausanias' compositional method. Indeed, a strong indication that Pausanias did not add retrospective details of this nature comes from the fact that he says at 7.20.6 that he would have mentioned the Odeion of Herodes in his book on Athens if it had been built at the time of his visit. The fact that he did not simply slip a reference to it into his account of Athens *post factum* suggests that he would not do so at Olympia either. This does leave open a possibility that his work on Athens had been published (whatever that would mean) by the time he wrote 7.20.6; this may be so but it is unprovable, not least because we know nothing of the fate of Pausanias' writings in his own time (Diller (1956) esp. 84). Ameling (1983) 2.128, also disagrees with Settis.

[102] Pollitt (1974) 45.

and Vitruvius railed most vehemently against the style of painting of his day.[103] Although it would be rash to compare too closely three writers so far separated in time and purpose, an apparent disdain for the art of their own period does seem to be a unifying factor.

Another, complementary, reason for the omission of the nymphaion may be advanced: while it is a spectacular gift, it is above all a practical one, of little importance in determining what the sanctuary is really about or in promoting its sanctity. While an ancient building with a practical purpose can be seen as hallowed by time and usage, a modern building of similar purpose has no tradition to fall back on, and as such will more likely be treated as an intruder among the established monuments than as worthy of instant veneration.[104] A building on this scale financed and dedicated (Philostratos uses the word *anetheke*) by a private individual (and, in this case, apparently by his wife Regilla[105]) perhaps ran the risk of being seen as an expression less of veneration than of impiety in such a setting. The nymphaion is also discussed in the context of Pausanias' other references to Herodes in chapter 6.

Since the reason for Pausanias' omission of the nymphaion at Olympia must remain speculative, we are no closer to a definitive answer to the question posed of whether the antiquity of an object plays a part in his selectivity. There is, however, other evidence which can profitably be adduced.

In the last century, H. Stuart Jones observed of Pausanias that 'it is specially noticeable that the objects of interest which he describes belong *either* to the period previous to 150 BC *or* to his own time'.[106] If this is so (and by no means all the objects Pausanias mentions are readily datable), it is interesting to compare this observation with the well-known comment of Pliny, speaking of 295–292 BC, that 'cessavit deinde ars ac rursus Olympiade CLVI revixit' (*NH* 34.52).[107] Since the

[103] 7.5.3–8. This is taken to refer to the late IIb style by Ling (1991) 38; Strong (1976) 94–6; Bastet and de Vos (1979); Zanker (1988) 279. It has also been suggested that the third style is being attacked (e.g. J. Liversidge in Henig (1983) 101).

[104] In defending the nymphaion, it is its practicality which Lucian stresses (*Peregrinus* 19), and he discusses it in order to attack Peregrinus rather than for its own sake. The passage is discussed by Walker (1987) 60–2; also by Jones (1986) 125. On Lucian's attitudes to past and present in general, Jones (1986) esp. 150–9.

[105] This is strongly implied by the inscription on the marble bull at the centre of the nymphaion, which exactly echoes the words Philostratos uses in speaking of Herodes' dedication (Ameling (1983) 2.127–8 no. 112). The bull, with the inscription visible, is shown at Papahatzis 3.305. [106] Stuart Jones (1895) xxvi.

[107] The exact meaning of 'ars' is problematic: Pollitt (1974) 27, sees it as a translation of *techne* (cf. pp. 32–7); Isager (1991) 97–8 and Stewart (1990a) 237–8, as referring exclusively to

156th Olympiad dates to 156–153 BC, Pliny's expressed date for the revival of 'ars' coincides almost exactly with Pausanias' apparent date for the suspension of art worth discussing. This seeming contradiction in dates suggests that there was in fact nothing objectively significant about the date of c.150 BC. It is possible, although not demonstrable, that the sites of mainland Greece received few dedications in the period from c.295–150 BC. Pliny's statement can perhaps be explained by suggesting that he (or his sources) saw a lack of specific named sculptors, lists of whom, with their works, is the essence of his chapters. But Pausanias' concern was far wider, and since sites continued to be built on, and sculptures, paintings and lesser works continued to be produced, his apparent omission of works of this period cannot be explained on the grounds that it arises naturally from the programme of his work.

Bowie, starting from the same point, that Pausanias 'almost completely neglects monuments and dedications later than c.150 BC', says 'the traditional explanation of the phenomenon throws the chief blame on his sources: he was using writers of the second century BC and did not trouble to supplement them by later information'.[108] Bowie rightly responds that this can only be a partial explanation, seeing the cause in the political decline evident in the period and the resultant lack of interest in it on the part of both writers and readers. It may also be added that one did not need writers of the late Hellenistic and early imperial period to know what the works of art and buildings of that period were if one saw those objects for oneself. And Pausanias did exactly that. In other words, while agreeing with the proposition that he is less concerned with work after 150 BC (although it is a basic proposition of this book that the neglect is not as severe as has been believed), I suggest that he does so of his own inclination – after all, as Sihler pertinently remarks, 'Pausanias was

bronzes; Smith (1991) 7, to sculpture as a whole. On the wider implications, Gros (1978), Preisshofen (1979) esp. 269–82, Stewart (1979) 3–33. For present purposes, the important point is that, as Smith says, Pliny's words reflect 'received opinion about Hellenistic art among educated Romans'. On the sculpture of this period, Smith (1991); Ridgway (1990) esp. 209–45; Stewart (1990a) 197–221, (1979) 3–64. On the art of the period as a whole, Pollitt (1986).

[108] Bowie (1974) 188; although Bowie gives no references, three writers probably of this approximate period have been discussed above for their relevance to Pausanias, namely Polemon, Rhianos and Myron. In no case can what Bowie calls 'the traditional explanation' be shown to be supported. Also pertinent here is 1.6.1, which shows Pausanias' own feeling that the later third century BC was a problem in terms of historical writings (the passage is discussed further below, p. 170). In short, he is suggesting the opposite of derivation from sources of this period.

under no contract with posterity to bring his data down to his own time'[109] – and not as a result of a weakness of the sources; to maintain that is to take an excessively literary view of Pausanias, who I have already argued should be distanced from the main literary fashions of his day.

We are back to Pausanias' opinion of modernity. That he was aware of such modernity is clear from the fact that, as Habicht notes, Pausanias uses the expression 'in my [or 'our'] own time' on 144 occasions.[110] Habicht observes, however, that there are only seven occasions on which he uses the phrase in connection with artefacts in datable contexts: the following is based on Habicht's list, with additional comments:

(1) and (2) 7.5.9 'in my day the Smyrnaians had a sanctuary of Asklepios built'. This has been variously dated to between c.151 and c.166.[111] The same building is also referred to at 2.26.9, where Pausanias says 'in our time the sanctuary of Asklepios beside the sea at Smyrna was founded from the one at Pergamon'. Both of these are passing references with no attempt at description. The revival of interest in Asklepios in Pausanias' day, and in his writings, has been remarked on (see above, p. 11 n.23), and his picking out a sanctuary of Asklepios to mention is likely to derive from this general interest. See also (7) below.

(3) 7.20.6 refers to the Odeion of Herodes Atticus, but in the context of a description of Patrai; Pausanias goes on to say that 'in my book on Attica this Odeion is not mentioned because my description of Athens was finished before Herodes began to build the hall'. It is of little significance that in this passage, he simply mentions it with no detail.

(4) 5.21.15 refers to two statues of AD 125, dedicated at Olympia and representing athletes who had been fined for cheating. Appropriately, they are mentioned in the context of the row of *Zanes*, the bronze statues of Zeus erected by the approach to the stadium at Olympia which were made from the proceeds of such fines (5.21.2). Again, there is no description or discussion of them as statues.

[109] Sihler (1905) xxxi.
[110] Habicht (1985) 176; the following owes much to Habicht (1985) 176–80, in which he discusses Pausanias' use of various phrases meaning 'in my time', and concludes that they mean 'since I was born' (176).　[111] Habicht (1985) 10.

(5) 8.10.2 refers to Hadrian's new sanctuary of Poseidon Hippios near Mantinea, AD 117–38; this is mentioned largely to make a point of contrast with the original sanctuary built by the very early artists Trophonios and Agamedes.[112]

(6) 2.1.7 refers to Herodes Atticus' dedication in the temple of Poseidon at the Isthmus of a chryselephantine group of Poseidon, Amphitrite, Palaimon, Tritons, horses, dolphins *et al.*, perhaps dedicated in the 150s AD.[113] This is the only one of these examples to contain a significant element of description.

(7) 2.27.6–7 refers to the buildings 'erected in our time by the Roman senator Antoninus' in the sanctuary of Asklepios at Epidauros. These include a bath, sanctuary, and temple, as well as the restoration of a ruinous stoa and the building of a house for the sick.[114] There is no comment on the buildings as such, just a brief statement of their existence and, in the case of the house, of its usefulness. See also nos. (1) and (2), on the revival of interest in Asklepios in Pausanias' day.

With the exception of the description of the dedications of Herodes Atticus at Isthmia (perhaps treated differently because it is the only cult group in this list, and chryselephantine at that), in all these cases Pausanias simply mentions the presence of these buildings or statues, sometimes using them to make a point of contrast. In short, they appear to arise as a result of the discussion of other buildings or sculptures rather than because of their own virtues or intrinsic interest. The same can be said for Pausanias' mention of the existence of the tribe of Hadrianis 'in my day', arising from his detailed discussion of the monument of the Eponymous Heroes in the Agora of Athens (the implications of this comment are further discussed in the section on Hadrian, below, p. 171).

Many objects are just mentioned in the course of Pausanias' narrative without any discussion, among them modern ones, such as the stoas flanking the Panathenaic way in Athens, built c.AD 100, and characterized by Shear as typical of 'an infusion of new architectural

[112] Trophonios and Agamedes' most famous reputed work was the fourth temple of Apollo at Delphi of the first half of the sixth century BC (10.5.13).

[113] Sturgeon (1987) 4, 76–113, publishing the Roman archaizing marble cult group now on display in the Isthmia museum. Dedications of Herodes at Isthmia, including a colossal Poseidon, and a dolphin honouring Palaimon-Melikertes, are mentioned by Philostratos, *VS* 551.

[114] On the identity of Antoninus, and further consideration of this passage, see below, p. 194.

concepts from abroad',[115] but only mentioned in passing by Pausanias with no indication of date (1.2.4).[116] This may well be a case of familiarity breeding indifference, at least for Pausanias, since the form of colonnaded street had already become familiar in his native land of Asia Minor (and Corinth, the Lechaion road), before this, its first appearance in Athens.[117]

Other modern buildings mentioned include the baths of Trajan, and his hippodrome and Forum at Rome, 'the last of which is worth seeing for its splendour, and especially for its bronze roof' (5.12.6; Cassius Dio (69.4.1) also mentions the baths of Trajan).[118]

It may be concluded from this that Pausanias' attitude to modern objects and buildings betrays a comparative disdain for the contemporary. His approaches to the wider aspects of Rome, and the prominent figures of the Roman period in Greece, remain to be assessed; but first, his attitudes to the past will be considered.

[115] Shear (1981) 369–72, quote from p. 371; Shear 370 n.59 notes the earlier, erroneous ascription to the Augustan period (which is repeated by Geagan (1979) 381).

[116] Also mentioned by the fourth-century AD rhetorician Himerios, *Orationes* 3.12.

[117] Shear (1981) 372.

[118] Although based on Domitianic beginnings, brickstamps dating to the years after AD 104 prove that the completion of the Forum is Trajanic, while the baths are Domitianic (Jones (1992) 94).

Pausanias on the past

The very fact that Pausanias wrote at such length about the sites and monuments of Greece is itself indicative of his most important attitude towards antiquities. That is, that he thought them of sufficient value to be worth recording and, in recording them, he thought it worth travelling extensively in mainland Greece over a period of many years to see them for himself.

Although the context of Pausanias' writings, in the tradition of the *periegesis* and against the cultural and political background of his day, has been stressed in the previous chapter, analysis of his attitude to antiquities involves greater complexities and subtleties than are accounted for simply by the historical context into which he was born.

J.J. Pollitt has observed that Pausanias 'almost never expressed personal preferences or values beyond pointing out that certain work was "worth seeing"'.[1] Similarly Habicht, although he argues that Pausanias has been unjustly neglected,[2] gives little space to consideration of the shades of presentation reflected in Pausanias' writings, that is, to how his narrative reflects differing attitudes to specific works and types of works. In contrast, I suggest that Pausanias had strong personal preferences and values in his attitudes to the objects and sites he describes, and that they are reflected in the subtleties of presentation of the objects described in his narrative. It is those attitudes that I hope to define more closely in this chapter.

There are some points which will be immediately apparent to any reader of Pausanias: his selectivity is perhaps the most striking. Pollitt is right that he occasionally reserved the epithet 'worth seeing' (*theas axios*) for a particular artefact or site (e.g. 1.5.4, 2.27.5, 4.31.10, 8.26.7, 9.2.7). But the infrequency of use of this epithet in itself shows that being 'worth seeing' was far from the decisive criterion in

[1] Pollitt (1974) 10. [2] Habicht (1985) xi–xii; cf. 165–75.

43

Pausanias' selection of objects to record. He reminds us on occasion
that he is choosing which works to present and which to omit, a
practical step in the description of crowded sites.[3] Exactly how
crowded these sites were may be inferred from Pliny's report that
there were three thousand statues in Rhodes in the first century AD,
and that there was probably 'no smaller number' at Athens, Olympia
and Delphi (*NH* 34.37).[4] How many more there would have been by
Pausanias' day can only be guessed.

The works Pausanias omits are those he considers less special than
those he describes: of his omissions at Delphi, he says, 'as to the
athletes and musical competitors who have attracted no notice from
the majority of mankind, I hold them hardly worthy of attention'
(10.9.2). The obscurity of the musicians is one matter, but a wider
reason may lie behind his next phrase: 'the athletes who have made
themselves a name have already been set forth by me in my account of
Elis'. There is implicit here a sense of appropriateness, that Olympia
was the home of Greek athletics, and the fitting place to describe
athlete statues; although it was the site of the Pythian games, Delphi
held primacy in its oracle, not in athletics. In short, Pausanias is
trying to distinguish what would be standard at a particular site from
what would be special to it, and thereby worthy of description.

It was argued in the previous chapter that Pausanias' attitude to
modern objects and buildings betrays a comparative disdain for
contemporary art. In detailing Pausanias' preference for the past,
Habicht notes also the paucity of contemporary or recent writers he
mentions, and his evident admiration for the sculptors of the earlier
period.[5] But while this, like the discussion of the previous paragraph,
documents this preference of Pausanias', it does not account for it.
Although Pausanias does not make the reasons for his apparent
preference for the past explicit, it may reflect a belief that antiquity
legitimizes a site and a cult and that it gives something more than
general appropriateness. This necessarily affects his view of modernity,
and here the discussion of the nymphaion at Olympia is again
pertinent. While part of Pausanias' concern was with modernity in

[3] E.g. 10.9.2 at Delphi; 5.21.1, 6.1.2 at Olympia; 1.39.3 at Athens; 3.11.1 at Sparta; 2.13.3 at
Phlious.

[4] Dio Chrysostom's report that Nero 'removed most of the statues on the Akropolis of Athens'
(*Or.* 31.148) is irreconcilable both with Pliny's account and with Pausanias' seeing so much
from before the mid first century AD. It may, therefore, be disregarded, not surprisingly for a
report by an orator, whose account should not be examined too closely for its accuracy.

[5] Habicht (1985) 117–40, esp. 131–40.

the sense of physical newness, he also had a sense of the different perceptions of how the art related to the site at which it was found. In that light, the appropriateness of a monument to a site was an important factor, and all the more so in the case of a sanctuary, where older monuments were more naturally in place. Appropriateness, therefore, was an important factor in Pausanias' selectivity.

Although Pausanias' primary concern was with objects of past ages, he was also concerned with those past ages themselves. It will be argued in what follows that this is a central motivation behind his descriptive techniques. It is clear that Pausanias did not simply record manifestations of the past, but that he thought about the past. One indication of this is his statement that he has 'investigated very carefully the dates of Hesiod and Homer' (9.30.3). This was probably true – and we cannot know otherwise – although it is reminiscent of traditional claims to scholarship such as, for example, the similar one made by Herodotos (2.53), whom we have already seen to be something of a model for Pausanias. It may be, therefore, that the claim to have studied the dates of Hesiod and Homer is made with an eye to impressing the reader with Pausanias' own scholarly qualities. But even if this is so, such inquisitiveness and scholarly investigation is entirely commensurate with Pausanias' educational background, and with other deductions which can be drawn concerning his interest in the past, to which this chapter is devoted.

Pausanias' interest in the past is apparent also in his treatment of objects, most immediately in his practice of referring to them as 'ancient' (*archaios* or *palaios*) or 'very ancient' (*archaiotatos* or *palaiotatos*). In attempting to assess how this reflects his attitude to those antiquities he details, it is of central importance to ask two basic questions: first, what criteria does Pausanias use to classify something as 'ancient' or 'very ancient', and secondly, how far does he distinguish phases under the overall heading of 'the past'?

CRITERIA

Technique

It is clear from many references that Pausanias was interested in technique and the development of technical skills. He refers to Kallimachos as one who 'though inferior to the best artists in the actual practice of his art (*techne*), so far surpassed them all in ingenuity

that he was the first to bore holes in stones' (1.26.7). While the literal truth of this cannot be sustained,[6] it does bear witness to a tradition about the past which can be seen to be manifest in several other areas of Greek and Roman life. This is the desire for a *protos heuretes* or first founder, a name to which inventions and new developments can be attributed.[7] The clearest example in the context of art is the name of Hippodamos, credited in our sources with the invention of axial town-planning;[8] Pliny's writings on art include lists of inventors and of first occurrences of a very wide range of subjects and practices (*NH* 7.191–215).[9] The tradition extends also to literature, its most notable appearance being as the *raison d'être* of Vergil's *Aeneid*, which is essentially a foundation myth centred on just such a 'first founder'. While the veracity of the tradition concerning Kallimachos must be seriously doubted, the fact that Pausanias is mentioning such a story is itself sufficient to indicate that both tradition and Pausanias saw such an advance in the technical aspects of an art (in this case, gem-cutting) as worthy of note.

A similar case arises from Pausanias' description of Delphi, where he observes that 'of the offerings sent by the kings of Lydia nothing now remains except the iron stand of Alyattes' bowl. This stand is a work of Glaukos the Chian, who invented the welding of iron' (10.16.1; on similar approaches to the origins of bronzeworking techniques, see below, pp. 71–2). This may be derived from Herodotos (1.25), although it is clear that Pausanias saw the stand for himself, in a reduced form since Herodotos' day when it also had the silver bowl (see above, p. 18). Indeed if, as is almost certain, Pausanias was a Lydian himself, he may well have made a particular point of seeing the offering of the kings of Lydia. The stress on the link with a famous man gives additional sanctity to the particular piece or the particular invention. Again, the invention of such a long-established technique is unlikely to be accurately attributable, but there is a perceived necessity for a specific named inventor. Pausanias makes these references with apparent admiration and names the individuals

[6] Stewart (1990a) 39; Wycherley (1982) 187.

[7] Examples include Aristotle's attributions of theatrical developments to Aeschylus, Sophocles, Epicharmus, Phormis and Krates (*Poetics* 3.5, 4.16, 5.4–6); Arafat (1990b) 63; Anderson says that 'Pausanias has a natural penchant for the "first beginnings" of everything, for the early history of a city-state or region' (Anderson (1993) 105); and Jacob notes that 'before visiting a region, Pausanias often traces the history of the region back to the appearance of the first man' (Jacob (1980) 73). On the phenomenon in general, Kleingünther (1934).

[8] Aristotle, *Pol.* 2.5.1–5, 7.10.4. McCredie (1971); Burns (1976); Wycherley (1962) 15–35, (1964b); Martin (1974) 103–6; Garland (1987) 26–7, 181–2. [9] Isager (1991) 36.

concerned as a means of giving them what he sees as their due credit. This is particularly apparent in the reference to Kallimachos, but may be inferred in the second example from his belief, expressed elsewhere, that 'to make images (*agalmata*) out of iron is a most difficult and laborious process' (10.18.6).[10]

These examples make the important point that along with Pausanias' interest in skill and technique comes an interest in the development of that technique, and it is from this that many comments on antiquities arise. It is perhaps here that Pausanias differs from writers like Pliny, whose work contains more on technique. Pausanias is not simply concerned with technique *per se*, but with technique as an indicator of relative date.

While the two examples cited suggest Pausanias' interest in antiquity because they concentrate on the first practitioner of the relevant skill, they say nothing of the nature or depth of that skill. But it is clear from many examples that Pausanias saw the development of skill as indicative of the chronological development of an art. It appears to be technique that was felt by Pausanias to be the most obvious way of distinguishing the ancient from the less ancient and the modern.

Pausanias explicitly cites technical simplicity as a characteristic of a statue in his discussion of the contents of the temple of Hera at Olympia: 'in the temple of Hera there is an image[11] of Zeus. The image (*agalma*) of Hera is seated on a throne . . . The workmanship of these images is rude (*hapla*)' (5.17.1).[12] He then gives a list of other works in the cella of the temple, and concludes by saying 'I cannot tell who made these images, but they seem to me to be also extremely ancient' (5.17.3: *es ta malista archaia*). Although it is not explicitly stated, this may reasonably be taken to confirm that Pausanias saw simplicity as a hallmark of antiquity.[13] The same unstated assumption almost certainly motivated Pausanias' ascription of a statue at Erythrai in Asia Minor: 'from various indications I judged the image (*agalma*) to be a work of Endoios, particularly from an inspection of the workmanship' (7.5.9).

The notion of technical simplicity as a hallmark of the most ancient

[10] Nonetheless, he merely mentions an iron statue of Epaminondas in Messene (4.31.10), not even speculating on its date.
[11] There is a lacuna in the text here, and the word 'statue' is understood.
[12] Pollitt (1974) 142 wonders whether *hapla* means 'uncomplicated? primitive?'.
[13] Pollitt (1974) 142 draws a pertinent parallel with the use of colour in painting. On Pausanias' account of the contents of the Heraion, Arafat (1995).

works is also evident from, for example, this comment on a statue from the Akropolis of Athens: 'he who prefers the products of art (*techne*) to mere antiquity (*archaiotes*) should observe the following: there is a man wearing a helmet, a work of Kleoitas, who has inwrought the man's nails of silver' (1.24.3). The implication is not only that *techne* was lacking in *archaia* but that it consists (at least here) in fine details such as the finger-nails being made of a different material. Pausanias' enthusiasm for this particular statue's technical accomplishment may have been coloured by his belief that the same Kleoitas was responsible for the invention of the starting mechanism for the horse races at Olympia (6.20.14). With the example of Pausanias' discussion of Kleoitas' helmeted man before us, it can more readily be understood that when Pausanias says elsewhere that an *agalma* 'is plainly older, and ruder in style, than the image of Athena at Amphissa' (10.38.7; *archaioteron kai argoteron ten technen*), he intends a link to be made between the antiquity of the statue and its technique. We should infer that the technique is characterized by simplicity; but Pausanias does not state this explicitly, taking it for granted, and apparently expecting his readers to think the same way. And we must remember this in considering other occasions where he speaks of technique. Although the use of technical backwardness (implied in the word *argoteron* in the passage quoted above (10.38.7), but never defined) as the sole criterion for dating is a mis-judgement, we must ask exactly how much of a mis-judgement it is for each style or object. This is important because we use precisely this same idea in creating our own typologies of artefacts; for this reason, such an approach strikes a familiar chord with us.

Here a particularly revealing series of examples cited by Pausanias is pertinent. The word *argos* (used in the passage just cited) appears on several occasions in combination with *lithos*, translated (rightly, I think) by Frazer and Jones as 'unwrought stone'.[14] At Thespiai, for example, he saw 'a very ancient image of [Eros], an unwrought stone' (9.27.1). These examples indicate simplicity of style and technique, and surely refer to aniconic images.[15] To Pausanias this is a sign of an

[14] LSJ also translate *argos* as 'unwrought'; Levi as 'rough', which is more appropriate in the comparative than the positive (as at 10.38.7 cited above, where Frazer similarly uses 'ruder'). Pollitt does not discuss the word. On stones in cult, Kron (1992), esp. 64–9 on *argoi lithoi*. Also, Jacob (1980–1) 50–1.

[15] Pausanias mentions unwrought stones as markers of sacred places at 9.18.2 (the grave of Tydeus), and 9.19.3 (enclosing the place where Teiresias decapitated a snake). He enthuses over 'a wall of unwrought stones that is worth seeing' in front of a temple of Aphrodite on the Sacred Way (1.37.7), perhaps best taken as a reference to Lesbian or polygonal masonry; so too the 'small sanctuary of Poseidon built of unhewn stones' at Antikyra (10.36.8).

extremely early date. This is clear from his comment on the shrine of Herakles at Hyettos in Boiotia: '[Herakles] is represented, not by an artificial image (*agalma*), but in the ancient fashion by an unwrought stone' (9.24.3). The link between unwrought stones and antiquity is made explicit also in his comment on a spring sacred to Hermes at Pharai in Achaea: 'close to the image stand about thirty square stones: these the people of Pharai revere, giving to each stone the name of a god. In the olden time all the Greeks worshipped unwrought stones instead of images' (7.22.4).[16]

As on other occasions, antiquity can confer legitimacy, and this is apparent in the context of unwrought stones, as one would expect of a form Pausanias picks out as particularly ancient. The best example comes in his account of the Areopagus in Athens, where he mentions Orestes' trial there, and an altar dedicated by Orestes, adding that 'the unwrought stones on which the accused and accusers stand are named respectively the stone of Injury and the stone of Ruthlessness' (1.28.5). This is a clear case of the technically simple unwrought stone indicating antiquity, and of antiquity in turn legitimizing, of age sanctioning a judicial procedure, reinforced by the association with the hero Orestes and one of the formative trials of Greek myth-history. Similarly, Pausanias saw what was 'said to be the stone on which nine men of Troizen once purified Orestes after the murder of his mother' (2.31.4), and Orestes is associated with an unwrought stone possessing magic properties at Gytheion (3.22.1).

A comparable case has been argued for the long rectangular stone found by the excavators of the Athenian Agora in front of the Royal Stoa, and associated with the oath-stone recorded in the sources.[17] The identification is hard to dispute, not least because the deliberate diversion of a drain to take account of the stone indicates its fixed position, which can only be accounted for by some such especial function. Whether or not it is, as has been suggested, the lintel from a Mycenaean tholos tomb, it would have had evident antiquity, both to the Greeks of the period when the stoa was built and to later visitors such as Pausanias, and this would have conferred consequent sanctity.

There are also instances where Pausanias refers to unwrought stones (although he does not in fact use the word *argos* in these cases) being used in cults to represent the god, after whom the stone may be

[16] At 8.48.6, Pausanias mentions a square image of Zeus Teleios at Tegea in Arkadia, with the comment that 'the Arkadians appear to me to be exceedingly fond of the square shape'. However, squareness need not designate unwrought, nor ancient, as Herms prove; Kron (1992) 56–9. [17] Shear (1994) 242–5; Kron (1992) 66.

named. Thus at Gytheion, speaking of the stone just mentioned, Pausanias says 'they say that Orestes, sitting down on it, was relieved of his madness; therefore the stone was named Zeus Kappotas ('reliever') in the Doric tongue' (3.22.1).[18] And at Megara, Pausanias saw 'a stone in the shape of a small pyramid: they name it Apollo Karinos' (1.44.2). Uta Kron cites comparable examples, and notes similar stones with an Apolline link, above all the omphalos at Delphi, which is not referred to by Pausanias, although he notes a stone at Delphi on which 'they pour oil every day, and at every festival they put unspun wool on it. There is also a notion that this stone was given to Kronos instead of the child, and that Kronos spewed it out again' (10.24.6).[19] Here the latter clause – perhaps derived from Hesiod (*Theog.* 497–500) and at least a witness to a long-lived tradition – is what gives the stone antiquity and sanctity, not the form of the stone *per se*.

While Pausanias' distinction in the description of the image of Herakles at Hyettos (9.24.3) between a worked and an unworked image is a reflection of a technical difference seen as a means of dating, it is also just possible that Pausanias is alluding to the chronological development of Greek sculpture from soft limestone to harder stones;[20] he would certainly have been aware of it and would have seen many examples of both. On numerous occasions, he shows his interest in, and awareness of, the material of a particular object or building, and it is to this aspect of his observations that I now turn.

Material

There are several occasions on which Pausanias specifies that a statue is of stone, including marble, and of a particular type, whether Thasian or Egyptian (like two statues of Hadrian which he saw in

[18] 'Kappotas' is a *hapax legomenon* and its meaning unclear: in examining its possible etymology, Farnell (1896) 46, translated it 'the falling', and Cook (1940) 939–42 'the fallen', taking it to refer to the stone's having fallen from the sky. However, this does not explain 'therefore' (*dia touto*) in this passage, hence my retention of Frazer's translation. Jacob (1980) 79–80, giving analogous examples in Pausanias, translates the latter part of this passage: 'this is why the stone is named "Zeus' rest"', but this is grammatically untenable: whatever its meaning, the phrase can only indicate that the stone was named Zeus, as Frazer understands it (followed by Levi (1971) 2.80, and Jones (Loeb)).

[19] Kron (1992) 62–3; she refers (p. 69) to stone cults flourishing anew in the later Hellenistic and Roman period, perhaps as a result of the influence of oriental religion, but there is no hint in Pausanias that he thought what he was seeing were new cults.

[20] Adams (1978); Adam (1966).

front of the sanctuary of Olympian Zeus in Athens, 1.18.6), Phrygian or Libyan (1.18.8–9), Parian or Pentelic,[21] white or black.[22]

Pausanias' interest in stone is not confined to that used for statuary: in describing the local stone at Megara he says that it 'is the only part of Greece where this mussel-stone (*lithos konchitos*) is found, and many buildings in the city are made of it. It is very white and softer than other stone, and there are sea-mussels all through it' (1.44.6). It is a mark of the quality of the stucco covering on the temples at Olympia that Pausanias did not remark on the very shelly nature of the marine conglomerate from which they are made.

Again, 'at Panopeus there is beside the road a small building of unburnt brick' (10.4.4); so too, at Stiris in Phokis he notes a sanctuary of Demeter of 'unburnt brick, but the image is of Pentelic marble', sounding a note of unexpected incongruity (10.35.10). He thought the Philippeion at Olympia was 'made of burnt bricks' (5.20.10), an apparent misunderstanding caused by the use of painted stucco over the brick,[23] and also notes at Olympia 'an altar of unburnt brick, plastered over on the outside', newly made for every Olympiad (6.20.11). At Samikon in Elis there was a sanctuary (*hieron*) of Demeter which was 'made of unburnt bricks' (5.5.6; it 'had no

[21] Parian: 1.14.7, 1.33.2–3, 1.43.5, 2.2.8, 2.29.1, 2.35.3, 4.31.6, 5.11.10 (the fender round the pool in the cella of the temple of Zeus at Olympia), 5.12.6, 8.25.6 (an akrolith), 9.20.4. Pentelic: 5.6.6, 5.10.3 (tiles at Olympia), 6.21.2, 7.25.9, 7.26.4, 8.28.1 (the temple of Asklepios at Gortys in Arkadia), 8.30.10, 8.47.1, 9.2.7, 9.4.1 (an akrolith), 9.11.6, 9.25.3, 9.27.3, 10.4.4, 10.32.1 (Herodes' stadium at Delphi), 10.33.4, 10.35.10. All these are referred to as made of *lithos* and, apart from those noted, refer to statues, several by recognized masters (including Pheidias, Praxiteles, Damophon, Kephisodotos, Skopas). *Lithos*, therefore, is used here to denote marble; so too in the building inscription referring to the altar of Athena Nike on the Akropolis of Athens (Meiggs and Lewis (1988) no. 44 line 13). Pausanias has no separate word for marble, although the word *marmaros* had been used by Homer (*Il.* 12.380; *Od.* 9.499), albeit not to mean marble (*pace* Pliny *NH* 36.45–6). The word occurs in the seventh century at Alkman fr. 1.31, but need not mean marble (although this is how it is taken by Page (1951) 42–3). If it does not, it was apparently first used in this sense in the Hippokratic corpus (*Mul.* 2.185) or by Theophrastus (*Lap.* 9.69). The phrase *marmaros lithos* is used by Strabo (14.1.35).

[22] White: 1.22.4 (the roof of the Propylaia on the Akropolis at Athens), 1.32.5 (a trophy at Marathon), 1.34.2, 2.4.1, 2.4.5, 2.7.5, 2.10.7, 2.11.2 (an altar), 2.20.1, 2.21.4 (built trophy or funerary monument – Pausanias opts for the latter), 2.23.4, 2.24.5, 2.29.6 (a *peribolos tetragonos*), 2.31.3 (chairs), 2.34.11, 2.36.3, 3.14.1, 6.20.9 (an altar), 7.5.9, 7.20.9, 7.22.6, 7.23.9, 8.24.12, 8.37.12, 8.48.8 (a relief), 9.2.5 (altar and statue), 9.19.6, 9.39.9 (floor of oracular enclosure at Lebadeia), 9.40.3 (a relief). These all refer to statues, except those noted in brackets, and all of *lithos leukos*. Frazer translates all of these as 'marble' which, in view of the previous note, may be correct but cannot be claimed to be so with certainty.

Black: 5.11.10 (flagstones in front of Pheidias' statue of Zeus at Olympia), 8.24.12 (images of Erymanthos on the Nile, because it descends through 'Ethiopia'), 10.36.3 (a local Phokian stone used for a wall). [23] Dinsmoor (1950) 236. For the Philippeion, Seiler (1986) 89–103.

image'). And he discusses the pros and cons of brick-built walls in his discussion of Mantinea (8.8.7–8).

Pausanias' careful distinguishing of types of stone may also be a means of making clear the contrast between earlier building techniques and those of contemporary Roman practice.[24]

Of other materials, Pausanias notes statues of clay (1.2.5, *agalmata ek pelou*; 1.3.1, *agalmata optes ges*); he usually (as far as we can tell) specifies if a statue is of gold and ivory (e.g. 1.20.3; 2.17.4; 2.27.2; at 1.12.4 he discusses the history of ivory, basing his conclusions on Homer), and he also details several akroliths.[25] So too on occasion he mentions more unusual materials, such as the 'image (*agalma*) of Dionysos made of gypsum and painted' at Kreusis (9.32.1); or the small silver *agalmata* in the Tholos in the Agora of Athens (1.5.1); or a gold *agalma* from Prokonnesos with a face made of hippopotamus teeth (8.46.4).

This interest extends to military equipment: he takes as confirmation of Homer's reports that 'weapons in the heroic age were all of bronze' the spear of Achilles which he saw at Phaselis and the sword of Memnon which he saw at Nikomedia, since 'the blade and the spike at the butt-end of the spear and the whole of the sword are of bronze' (3.3.8). Elsewhere, he details Sarmatian spears 'tipped with bone instead of iron, their bows and arrows are of the cornel tree, and the barbs of the arrows are of bone' (1.21.5), and goes on to note the materials of corselets and their relative uses in battle and hunting.

While the foregoing examples appear to be remarked on by Pausanias purely for their intrinsic interest, there may be more significance to a statue of Augustus he mentions in his description of Olympia (5.12.7). It is made of amber, and he says 'native amber (electrum), of which the statue of Augustus is made, is found in the sands of the Eridanos, and is very rare and valuable for many purposes; but the other electrum is an alloy of gold with silver'. Although it is unspoken, there may be a feeling of the appropriateness

[24] Of course, other writers also make reference to different marbles, but incidentally and infrequently (Larsen (1938) 488–9 for some examples, but tellingly few).

[25] By 'akrolith' I mean the conventional designation of a wooden statue with extremities of stone (usually marble). Examples in Pausanias include 1.40.4, 2.4.1, 6.24.6, 6.25.4, 7.23.5, 8.25.6, 8.31.6, 9.4.1. At 7.26.4, he mentions a wooden statue with ivory extremities, and at 3.22.7 an ivory head of Apollo, the only part remaining of a burnt statue – on the assumption that the statue was not entirely ivory, this may be another akrolith, or the rest may have been clay and gypsum like the first example he gives at 1.40.4. At 4.31.11, he mentions an image of gold and Parian marble, probably an akrolith using gilded wood (cf. 9.4.1). On the term 'akrolith' in relation to *xoanon*, Donohue (1988) 141–2.

of such 'rare and valuable' material for a statue of an emperor, and perhaps of Augustus in particular.

Thus Pausanias showed considerable interest in the material of the objects and buildings he saw. But a particular interest is reserved for wooden statues, even to the extent of noting the best preservative (9.41.7; cf. 1.15.4 on the use of pitch to preserve shields). These are important partly because our own lack of wooden artefacts leaves us more than usually in his debt (and that of the other ancient sources), and partly because it is clear that in his mind there was a very real connection between wood and antiquity (as there was in Vitruvius' mind for temples). This association is also clear from Pausanias' descriptions of objects other than statues: for example in the description of the temple of Hera at Olympia, in the opisthodomos of which he saw the one remaining wooden column, a survival from the earliest building phase of the temple and the only one which had not yet been replaced in stone (5.16.1).[26]

Sometimes Pausanias makes a simple reference to wooden statues,[27] sometimes he specifies the type of wood,[28] and in his discussion of the statue of Kyllenian Hermes which he saw on the summit of the eponymous mountain in Arkadia, he says 'the kinds of wood out of which men of old made images for themselves were, so far as I have been able to learn, the following: ebony, cypress, the cedars, the oaks, yew and lotus', and adds that the Hermes is of juniper (8.17.2, omitting the pear-wood image noted, which was the 'most ancient' image of Hera).

The appearance of these statues was not always that of undisguised pieces of wood: at Thebes he notes a log which had fallen from heaven, adding that 'they say that Polydoros adorned this log with bronze, and called it Dionysos Kadmos' (9.12.4). Haynes calls this 'an aniconic wooden fetish sheathed in bronze',[29] but it is not possible

[26] Dinsmoor (1950) 54, pointing out that the use of wood in this case is not attributable to the early date since stone temples had been built by this date. Coulton suggests that this was 'probably a matter of economics' (Coulton (1977) 43), but if the evidence from fourth-century Epidauros is a guide, the difference in cost may have been small (Burford (1969) 177–9). For present purposes, the important point is that the remaining wooden column would have been seen as particularly old by Pausanias' time, simply by virtue of its being wooden. The same may be applicable to the wooden decorations (?metopes) of the Epidamnian treasury at Olympia showing the exploits of Herakles (6.19.8, a corrupt passage). (The passage concerning the wooden column at Olympia is omitted from Levi's translation.)

[27] E.g. 7.5.9, 7.25.7, 8.37.12, 8.42.3, 8.46.3.

[28] Boxwood (6.19.6); cedarwood (5.17.5, 6.19.8, 6.19.12, 9.10.3); cypress (6.18.7); ebony (1.35.3, 1.42.5, 2.22.5, and p. 57 below; 8.53.11); fig-wood (6.18.7); oak (5.16.1); pear (2.17.5).

[29] Haynes (1992) 12.

to tell whether this was a bronze in the *sphyrelaton* technique (see below, pp. 71–2), with a wooden core (for which, Haynes observes, there is no surviving physical evidence, nor literary evidence bar this passage), or whether the wooden image, unwrought in the manner of the *argoi lithoi* discussed above, was in itself a cult object.

The disguising of wood more regularly took other forms: Pausanias says that 'the Athenians are the only people whose wooden images of Eileithyia are draped to the tips of the feet' (1.18.5), perhaps confirming what we would in any case suspect, that it was standard for females to be draped. His reference to a 'naked Herakles' (2.4.5) implies that other wooden statues were clothed, but at Aigina he saw a naked wooden Apollo, and a clothed Artemis and Dionysos (2.30.1);[30] and such was the swathing of the statue he saw at Titane that 'it is impossible to learn of what wood or metal the image is made' (2.11.6). Such references as these are of great importance for cult practices and the treatment of statues, although, of course, they need not necessarily reflect the practices of the Archaic or Classical periods.

On other occasions, Pausanias refers to wooden statues in contexts which make clear, or at least suggest, that he sees their antiquity as deriving at least in part from the fact of their being wooden. The key word in Pausanias' usage is *xoanon*, of which A.A. Donohue observes that it 'is equivalent to the phrase ξύλου ἄγαλμα'.[31] As Donohue points out, 'Pausanias does not say that all *xoana* are old, but rather that in early times all statuary was made in wood'.[32] There is much evidence in Pausanias to bear this out (there is, in fact, no case where he uses *xoanon* of a statue which is provably *not* wooden[33]), and to illustrate further his view of antiquity when some of the contexts in which he uses the word are examined.

[30] This Dionysos is bearded, but in Aigion he saw a beardless Dionysos and two representations of Zeus, one bearded and one not, of which 'the beardless one seemed to me the older of the two' (7.23.9). While beardlessness is not explicitly stated as his chronological determinant here, it seems most likely that it is so.

[31] On *xoana*, Donohue (1988); the quotation is from p. 140. Also, Papadopoulos (1980) 15–63.

[32] Donohue (1988) 146.

[33] Gardner suggested that there were three occasions on which other writers used *xoanon* to indicate an object not made of wood (Xen. *Anab.* 5.3.12, Euripides *Troades* 1074, and Strabo 9.1.17; Gardner (1890) 133–4). However, in the first case, the point is one of contrast between a wooden and a gold statue, rather than one of comparison of like objects. In the second example, it is likely that an ideal and splendid vision of an imagined heroic past is being summoned, complete with imagined golden *xoana*. In the third example, Strabo refers to the fifth-century marble cult statue of Nemesis at Rhamnous as a *xoanon*; this cannot be a mistake or misinterpretation, and I wonder whether it can be attributed to Strabo's not being such a regular commentator on statuary, in contrast to the practised use of vocabulary by Pausanias.

For example, in his description of Argos he mentions a temple of Wolf Apollo, and explains that 'the temple and the *xoanon* were dedicated by Danaos; for I am persuaded that in those days (*tote*) they were all *xoana*, especially the Egyptian ones' (2.19.3; that Pausanias was confident he knew how to recognize an Egyptian statue is clear from 7.5.5). With the mention of Danaos, we are in the world of legendary figures, and there is also implicit in the word *tote* an all-embracing approach to 'the past'.[34]

How these factors relate to Pausanias' view of the past is discussed below, but what is important to note here is the association of a particular medium – wood – with that past. This association is a, if not the, major reason for the use of wood in sanctuaries, which were areas of particular reverence and which, as noted, were the main concern of Pausanias. To that extent, we must be wary of circularity of argument, since some objects (wooden ones above all) owed their presence in the sanctuary to their being perceived as antique, and are then perceived as antique because they are in the sanctuary. This process of thought and selection would contribute to the lack of interest shown by Pausanias in modern objects. In so far as he is illustrating that the antiquity of wood governs its use at sanctuaries, Pausanias is only reflecting the standard view.

Although the association of wood with antiquity is not always made explicit, it is a reasonable inference that it lies behind most, if not all, of the references to wooden statues.[35] Sometimes this association is made by linking the wooden statue with a legendary figure, as in the case of Danaos or when Pausanias mentions 'a wooden Hermes, said to be an offering of Kekrops' in the shrine of Athena Polias on the Akropolis of Athens (1.27.1).

Kekrops was traditionally the first king of Athens, and one of the Kleisthenic ten tribal heroes of Athens.[36] He was also a key figure in the acquisition by Athena of the Akropolis in the face of opposition from Poseidon (the continuation of this passage is discussed below, p. 70–1).[37] The statue is thus associated with one of the very earliest

[34] There is also the added factor of the antiquity associated with Egypt (e.g. Hdt. Bk. 2), and the cachet value of such an association.

[35] Since my primary concern is with Pausanias' references to wood, I am not here concerned with the belief expressed by Donohue (1988) 140 that Pausanias' use of the word *xoanon* was 'out of step' with that of his contemporaries because he used it to mean only wooden images of gods; this position is disputed by Stewart (1990b). Also, Sourvinou-Inwood (1990).

[36] Kron (1976) 84–103.

[37] Apollodoros, *Library* 3.14.1; Callimachus, *Iambi* fr. 194.66–8 and *Hekale* fr. 260.24–6; Arafat (1990a) 156–9.

phases of Athenian history; the fact that it is wooden reinforces its antiquity (a comparable example is the *xoanon* which was made by Polyidos for the sanctuary of Dionysos at Megara (1.43.5); see below, p. 66).

In his description of the Argive Heraion, Pausanias first mentions two gold and ivory statues, then 'an ancient image (*agalma*) of Hera' (2.17.5) of unspecified material, though not gold and ivory as it is distinguished from the other two statues and it is set on a pillar; the vagueness of the phrase is to an extent qualified by what follows: 'her most ancient image (*archaiotaton* [sc. *agalma*]) is made of the wood of the wild pear-tree; it was dedicated in Tiryns by Peirasos son of Argos; and when the Argives destroyed Tiryns they brought the *agalma* to the Heraion. It is a small seated *agalma*: I saw it myself.'[38] Again, an extant statue is associated with a legendary figure, in this case the son of the eponymous founder of Argos. This particular example is given spice by Pausanias' expressed belief that 'of all the Greeks it is the Argives who most dispute the claim of the Athenians to antiquity (*archaiotes*) and to the possession of gifts of the gods' (1.14.2).[39]

Naturally, the first artists made wooden statues, such as that of Herakles from the sanctuary of Athena Chalinites at Corinth by Daidalos, traditionally the first artist (2.4.5; Daidalos is discussed below, pp. 67–74). Indeed, it is in speaking of Daidalos that Pausanias twice explicitly connects wooden statues with antiquity: first, he says that 'the residence of Daidalos in Knossos, at the court of Minos, conferred on the Cretans for a long time a reputation for the making of *xoana*' (8.53.8). The link of Daidalos with Crete through King Minos is narrated by several authors including Pausanias.[40] This link in itself suggests great antiquity, as is evident from other references to Crete, as, for example, at Megara, where 'the circuit of the ancient wall had been pulled down by the Cretans' (1.41.6). Secondly, writing of a festival held at Plataiai (mentioned also by Plutarch (see above, p. 23 n.57), Pausanias says 'they celebrate a festival called Daidala because people long ago called *xoana daidala*' (9.3.2),[41] and he adds his own view on statuary before Daidalos' day by saying 'I believe that they called them so even before Daidalos . . .

[38] Smallness was not a necessary feature of wooden statues (e.g. 7.5.9; Donohue (1988) 141).

[39] On the particular role of cult in the establishment of Argos' supremacy in the plain, Morgan and Whitelaw (1991).

[40] 7.4.4–5; also, Diodorus Siculus 4.77–9, Strabo 6.2.6, Herodotos 7.170. On the literary and archaeological evidence for the tradition surrounding Daidalos, Arafat (1990b) 52–3.

[41] On the textual problem at 9.3.7, but not affecting the present point, Dillon (1993).

was born ... and I think that Daidalos was a surname subsequently given to him from the *daidala*, and not a name bestowed on him at birth'.[42] Long before Pausanias, the name Daidalos had come to mean 'cleverly wrought', and the subsequent use of the name has an immediate association of quality and antiquity.

Later generations of artists also made wooden statues: Dipoinos and Skyllis, traditionally pupils (or even sons) of Daidalos, made ebony statues ('with a little ivory') for the shrine of the Dioskouroi at Argos (2.22.5; for Dipoinos and Skyllis, see below, pp. 71–3). The ascription of wooden statues to later generations of artists raises the question of how late Pausanias thought wood was used for statuary, an issue with obvious relevance to the apparent association of wood with antiquity.

Named artists of a period which is identifiable precisely by us also made wooden statues, but at the same time it is important to remember that they were in all probability classed as 'ancient' by Pausanias. Examples include one at Aigina: 'the *xoanon* is a work by Myron' (2.30.2).[43] Again, at Troizen, the shrine of Athena Sthenis: 'the *xoanon* of the goddess is by Kallon of Aigina' (2.32.5). The epigraphic interpretation of the inscription naming Kallon on the base of another statue gives a date of c.500 BC.

Although many works cannot be precisely dated, it appears that the word *archaios* is not used of any work later than, approximately, the early fifth century. This is noted by Pollitt[44] in his discussion of the word, but while he is right that the word 'could be used to describe works of art dating from anywhere between the remote, legendary past and the Early Classical period', this should not, I suggest, be taken to mean that Pausanias did not attempt to explore the divisions within that period.

Attributes

Another criterion used by Pausanias in attempting to date an object is any attribute it might have. For example, he describes a statue by Kleon of Sikyon of the athlete Hysmon of Elis at Olympia as having 'ancient (*archaioi*) jumping weights' (6.3.10). He does not give the

[42] On this passage, Morris (1992) 55–6.
[43] This is presumably the fifth-century sculptor of the Diskobolos rather than the possible Hellenistic sculptor of the same name; Ridgway (1970) 84–6, 131.
[44] Pollitt (1974) 156.

date of the statue, but he mentions the artist elsewhere in a
fourth-century context (5.17.3, 5.21.3).[45] However, this leaves open
the question of what *archaioi* means: clearly, its meaning depends on
whether the weights looked *archaioi* in the second century AD, or
whether they did so in the fourth century BC. Pausanias does not make
this clear, and we can but speculate.[46]

 This also applies to his description of another athlete statue at
Olympia, that of Damaretos who won in the sixty-fifth Olympiad (i.e.
516 BC): 'his statue (*andrias*) has not only a shield, as the armed
runners still have, but also a helmet on his head and greaves on his
legs. In course of time the wearing of helmet and greaves in the race
was abolished both by the Eleans and by the rest of the Greeks'
(6.10.4). Although Pausanias names the sculptors of the statues of his
father and grandfather who are part of the same group, he gives no
hint of the date of the sculptures. It may well be legitimate to assume
that the statue would date from soon after the victory, but this is of
limited consequence for present purposes, since the important point is
that Pausanias recognizes that the 'attributes' of the athlete mark the
statue as of a certain period; in this, he is using the visual evidence of
the details of the statue in conjunction with the epigraphic evidence of
the inscription (which, in fact, pertains to the statues of the father and
grandfather). What makes these examples significant is that Pausanias
is remarking on a juxtaposition of old and new elements, further
refining his dating criteria.[47]

 Finally, it should be remembered that such attributes as jumping
weights and shields would be among those more readily accessible to
the average visitor to the sanctuary, exhibiting objective and widely
known criteria for dating, and that they would not have the mystique
of less immediately comprehensible works.

TERMINOLOGY

Having considered Pausanias' main criteria for singling out a
sculpture as 'ancient', the question arises of what he means by
'ancient', or 'very ancient'. He had a sense of the complexities of

[45] As Levi notes ((1971) 2.248 n.165), these references put him near either end of the fourth
 century; but this complication is not relevant here.
[46] An athlete from Mende was also portrayed at Olympia with ancient jumping weights
 (5.27.12) but his date is unknown.
[47] Contemporary archaizing in architecture is discussed by Spawforth and Walker (1986)
 100–1, 104.

dating, exemplified by his study of the dates of Homer and Hesiod (see above, p. 45; whether or not we believe his claim, the very fact that he makes it shows this to be true).

He also has a sense of prehistory, revealed by his statement, apropos of the legendary expedition of the Seven against Thebes, that it was 'the most memorable of all the wars carried on by Greeks against Greeks in what they call the heroic age' (9.9.1). This sense of prehistory is shared also by Thucydides who asks how far we can go back in seeking the causes of events (above all, present events). Although Thucydides goes back a long way, he confesses that 'I have found it impossible, because of its remoteness in time, to acquire a really precise knowledge of the distant past or even of the history preceding our own period' (1.1; tr. R. Warner [Penguin edn]).

Because Thucydides lacked written accounts, not only was the evidence available to him considerably diminished, but he also lacked an absolute chronological standard. Under such circumstances, perceptions of what constitutes 'the past' are likely to vary more according to context. Indeed, perceptions of the past are necessarily different in societies without *widespread* literacy; it is easy to overestimate the extent of literacy, but important not to, since the oral tradition operates within a different understanding of the past.[48] The examples cited show a sense (although not an explicit statement) of two categories of the past: a recorded past and a past before that.

For Pausanias, the 'heroic age' is characterized by a sense of something different; a sense that things were not done in the same way and, for him, were not made in the same way. I have discussed how Pausanias saw objects as made differently; I now consider how else he thought art differed in the 'heroic age'.

One theme which runs through much Greek writing and on into Roman, is that of the Golden Age, when men were stronger and life was simpler. Elements of this are seen in literature, beginning with Homer (e.g. in the description of the cup of Nestor (*Il.* 11.632–7; cf. 1.260–8) or of Odysseus' bow that only he could string (*Od.* 21).

This theme is apparent in Pausanias also, and is an integral part of the subject under discussion. The size of the wall blocks at Tiryns is characterized as Cyclopean: 'each stone so large that a pair of mules could not even stir the smallest of them' (2.25.8). Interestingly, Pausanias on one occasion combines this sense of a past where

[48] See the contrasting views of Goody (1977); Goody and Watt (1968); Harris (1989); Thomas (1992), (1989); Harvey (1966); Cartledge (1978).

superhuman deeds, such as those of Odysseus or the Cyclopes, were common with his interest in statuary, specifically statuary that was in his terms ancient: in his description of Phokis, he says 'in the territory of Magnesia, on the river Lethaios, there is a place called Hylai, where is a grotto consecrated to Apollo. There is nothing very wonderful in the size of the grotto, but the image (*agalma*) of Apollo is very old (*ta malista archaion*) and it imparts strength equal to any labour. Men sacred to the god leap down precipices and high rocks, tear exceedingly lofty trees from their roots, and walk with their burdens along the narrowest footpaths' (10.32.6).

Although the theme of supernatural strength is associated with the 'heroic age', athletic bombast lies behind its appearance in an inscription on a stone found at Olympia weighing over 140 kg. which one Bybon claims to have thrown over his head with one hand.[49] This dates from the early Archaic period, which to us is significantly later than the 'heroic age' associated in our minds with the world before, and reflected in, Homer; however, it will become clear from further consideration of Pausanias' use of the words 'ancient' and 'very ancient' that for him, the definition of 'ancient' would not have been so refined as to distinguish between the 'heroic age' and the seventh or sixth century. In this context, athletics constituted the main link with heroism, exemplified by Herakles himself, the founder of the Olympic games who was responsible for first arranging the games and calling them Olympian (5.7.9). There is in athletics a 'heroic dimension' which is constantly present and can be tapped into, so that one can link oneself to the heroic past by one's behaviour.

Herodotos also has a sense of a heroic age, linked to the present by means of such events as the Trojan war which are seen as direct predecessors of the current wars. Herodotos' discussion of the career of Kroisos may be seen as his starting-point for his narration of the sequence of events leading to the present (1.6). Similarly, Thucydides links the past and present by using the Trojan war as a standard by which to judge the Peloponnesian war (1.10).

In the same way, Pausanias shows an awareness of the past (by his time, of course, a much longer past than that conceived of by Herodotos some six hundred years earlier), but at the same time he is aware of his limitations in defining that past and assigning particular pieces to it in anything other than the most general way. A rare

[49] Dittenberger and Purgold (1896) 723–8 no. 717. The inscription is dated to the seventh century by Fellman (1972) 127 no.117; to the early sixth century by Karageorgia-Stathakopoulou (1976) 255; to the middle of the sixth century by Harris (1972) 142.

example of his linking a sculptor with an historical event occurs in a passage on Olympia where he is discussing a statue of Herakles and an Amazon made by one Aristokles of Kydonia and dedicated by Euagoras of Zankle: 'Aristokles may be reckoned among the most ancient sculptors: his exact date cannot be given, but clearly he lived before Zankle got its present name of Messene' (5.25.11). This is a reasonable inference by Pausanias, not from the style or workmanship of the statue, but from the wording of the dedicatory inscription, which referred to the artist as being from Zankle rather than Messene. Herodotos (7.164) and Thucydides (6.4) date the change of name from Zankle to Messene at 494 BC, although whether or not Pausanias was aware of this date is not made clear. However, he places Aristokles before then without any further attempt at closer dating; this shows him trying to narrow down the date, almost apologetic for not being able to do so, but still finding the past (in this case, the period before the change of name) hard to comprehend and to divide.

On a few occasions Pausanias makes explicit his reasoning for his belief that a particular statue is of some antiquity: for example, in his description of Arkadia, he says 'in the market place at Phigaleia there is a statue (*andrias*) of Arrachion the pankratiast. The statue is archaic (*archaios*), especially in its attitude, for the feet are not much separated, and the arms hang down by the side to the hips' (8.40.1). This is clearly a description of a kouros, one of the earliest forms of stone statue, but one which continues into the early fifth century.[50] In this particular case, there is additional evidence in that the name Arrachion is known from the Olympic victor lists, where his victory is dated to 564 BC, suggesting a contemporary date for the statue. Unfortunately, surviving kouroi from Phigaleia cannot be firmly associated with this one.[51] This example illustrates that, as Frazer's

[50] Richter (1970).

[51] Richter (1970) 77. Ridgway's view that the word *andrias* suggests 'a carved, most likely wooden, image' (Ridgway (1993) 22) is contradicted by the inscription on the base of a stone kouros from Delos of the first quarter of the sixth century (Richter (1970) 51–3, no. 15, figs. 87–90; Jeffery (1990) 292, 304 no. 10 pl.55). Further, Ridgway's view would only be tenable in the case of Arrachion if his statue were wooden, in which case Pausanias would almost certainly have said so. Levi translates the word *andrias* as 'portrait-statue', perhaps an acknowledgement of an unusual word (rather than *agalma*); the word is not in Pollitt's glossary, but Stewart (1979) 9, 38, 109, discusses its use in relation to Classical and Hellenistic sculpture. Pausanias saw the identifying inscription and may have thought the statue a literal portrait of Arrachion, a reasonable view of a contemporary representation of a still-living mortal. The *andrias* of Damaretos (see above, p. 58) may have been bronze, which would be the most natural medium in which to represent armour, including greaves; the verb is used in connection with the statue, as it is with that of his grandson, leaving the question open. Levi's translation in the second instance as 'carved' is unjustified.

translation 'archaic' suggests, and as Pollitt[52] points out, 'like our word *Archaic*, ἀρχαῖος connoted not only the date of a work of art but also its style'.

On further occasions, Pausanias expresses his interest in the attribution of a work to a particular sculptor: in a passage concerned with two statues, at Branchidai and at Thebes, he says 'whoever has seen one of these two images (*agalmata*), and learned the artist's name, needs no great sagacity to perceive when he sees the other, that it too is a work of Kanachos' (9.10.2). Again, in describing dedications of the Akragantines at Olympia, he says 'I guessed that they were works of Kalamis', and then adds 'and the tradition agreed with my guess' (5.25.5).

The implication of this passage is that he came to his own stylistic judgement, and made his own attribution. Although Pausanias' origins and the connoisseurship of his day must have had a considerable effect on his thoughts, it is interesting that not only does he know of 'those who have made a special study of the history of the sculptors' (5.20.2), but that he knows their works well enough to assert that he knows of a sculptor they have overlooked, namely Anaxagoras of Aigina (5.23.3). One might object that he may in fact have simply read the inscription and looked up the name in the index of a sculptural handbook, but on several other occasions (as, for example, in discussing the work of Kalamis just mentioned), his knowledge is sufficient to allow an independent stylistic judgement; in either case, the point of his familiarity with sculptural writings remains valid. The writers of such works may be contemporary or of previous generations, or both; certainly in the latter case, they would have had the advantage of access not only to more originals, but also to written works such as Polykleitos' canon.[53] By Pausanias' time, the practice of collecting Greek sculptures and making copies of those one could not collect was well established.[54] It is by such means as these that someone of Pausanias' date could have become acquainted with the styles and careers of Greek sculptors in the sort of detail that is evident from the discussion in the course of which the students of 'the history of the sculptors' are mentioned (5.20.1–2), where the main issue is whether Kolotes was from Herakleia or Paros.

Pausanias was, of course, an inveterate traveller, as the very writing of his book shows, and his personal acquaintance with the

[52] Pollitt (1974) 157. [53] Stewart (1978). [54] Ridgway (1984); Bieber (1977).

sites and monuments he describes is beyond dispute, and would have been a critical factor in enabling him to make the stylistic judgement necessary to ascribe a statue to a specific named sculptor.

Another example of Pausanias' own judgement of a statue, in this case one he classes as *archaios*, occurs in his description of Aigeira: 'there is an *archaion xoanon* there . . . none of the natives could tell the sculptor's name; but anyone who has seen the Herakles at Sikyon would infer that the Apollo at Aigeira is a work of the same artist, Laphaes of Phlious' (7.26.6). In contrast to the previous example, this shows Pausanias consulting local opinion (and then making up his own mind). Laphaes also occurs in Pausanias' description of Corinth, where there was a *xoanon archaion* by him (2.10.1).

What we have, then, is an awareness of the past largely in very specific terms, a named sculptor or an established style that can be associated with a named sculptor. Pliny's practice of dating sculptors by Olympiads indicates a similar degree of confidence in dating. With this background, the phraseology used by Pausanias in assessing antiquity can be examined more closely.

At the simplest level, antiquity is a matter of what is older: in talking of Megara, Pausanias cites a statue of Aphrodite Praxis, saying it is 'the oldest (*archaiotaton*) in the temple' (1.43.6). The other statues in the shrine are by several famous fourth-century sculptors; but this gives us only the most general chronological framework. Further stages back in Pausanias' conception of the structure of the past are revealed by some of his ascriptions of works to ancient figures. Often these ascriptions are marked by a note of doubt: this doubt is less that of the well-educated, widely travelled second-century AD traveller than that of a man exercising that selectivity which was one of his most noticeable characteristics.

An example of a comparable ascription which Pausanias did believe shows this selectivity working to discriminate between a group of objects supposed to be of the same origin: 'the god whom the Chaironeans honour most is the sceptre which Homer says Hephaistos made for Zeus, and Zeus gave Hermes; and Hermes to Pelops, and Pelops bequeathed to Atreus; and Atreus to Thyestes, from whom Agamemnon had it . . . of all the objects which poets have declared and obsequious public opinion has believed to be works of Hephaistos, none is genuine save the sceptre of Agamemnon' (9.40.11–41.1).

In the course of this narrative, Pausanias details two other objects reputed to be by Hephaistos, a bronze urn at Patara and a chest in

Patrai, but he denies the authenticity of both; his grounds for doing so are that the urn is made in a technique which was invented later, by the Samian artists Theodoros and Rhoikos (see below, p. 72), and that the chest is never put on show. This reinforces two important points already made: the rejection of the urn shows how Pausanias saw technique as a chronological marker (not an infallible one, and not one he used infallibly, as shown by his mention of a chronologically improbable bronze statue of Kylon (1.28.1)); and the chest shows how much store he set by autopsy of an object. The failure to display the chest would also strike Pausanias as suspicious because a city would be expected to put on show something as old as it was claimed to be, so that there was something suspect in keeping it hidden. This reinforces the point that the idea of appropriateness was an important one for Pausanias and for the display of objects.

This passage shows how Pausanias expresses belief in the staff as an authentic work of Hephaistos; and it also shows that he is aware of the dangers of such attribution and does not agree with it unthinkingly. Similarly, he cautiously prefaces his report that a statue of Apollo which he saw near Korone was dedicated by the Argonauts with 'they say' (4.34.7). But a further point must be extracted from this instance, and is not dependent on Pausanias' opinion of whether a specific object is authentic: he has no doubt that the gods made works, and that such works can survive to his day. Perhaps it is an exaggeration to say 'the gods' since Pausanias is here dealing with the patron god of craftsmen; but the fact of belief in the reality of the manufacture of objects by a god is established nevertheless. This is a vital point to determine, since it is an unstated contributory factor to his broad view of the past. The past is continuous, but there are certain features of the past (such as heroes or great leaders) which are more relevant to particular aspects of present circumstances.

For the modern commentator, the mythical or legendary figures of such works as those of Homer or the tragedians people that world of the period before history from which Greek art and literature drew such inspiration from the early Archaic period onwards. In Pausanias' writings, there appears to be no explicit distinction between the generation of the gods and that of the heroes. And he has no hesitation in attributing surviving works to heroic or legendary figures. For example, at Megara, he talks of Demeter's hall which 'they say that Kar built when he was king' (1.40.6). Similarly, also at Megara, Pausanias details several levels of antiquity: of the memorial over the

grave of Koroibos he says 'these are the most ancient Greek images in stone (*agalmata palaiotata*) that I have seen' (1.43.8). As noted (see above, p. 56), at Megara 'the circuit of the ancient wall had been pulled down by the Cretans' (1.41.6), and Alkathous built shrines there.

The association of particular buildings or objects with legendary or mythical individuals is in evidence elsewhere: the example of Danaos has been cited above. In Sparta, 'Odysseus is said to have set up [Athena's] image (*agalma*) and named her Goddess of Paths after he had vanquished the wooers of Penelope in the race' (3.12.4); near Sparta, an image (*agalma*) of Modesty was 'said to be an offering of Ikarios' (Penelope's father, 3.20.10); at Thebes, 'they say that the image (*agalma*) [of Athena] was set up by Kadmos' (9.12.2), and Pausanias saw 'wooden images (*xoana*)[55] of Aphrodite at Thebes so ancient that they are said to have been dedicated by Harmonia, and to have been made out of the wooden figure-heads of Kadmos' ships' (9.16.3); and at a sanctuary of Eileithyia in Athens, 'the women said that two of these images were Cretan, dedicated by Phaedra, but that the oldest was brought by Erysichthon from Delos' (1.18.5; the first part of this passage is discussed above); at Amphissa, 'they say that the image was brought by Thoas from Ilion, and was part of the Trojan spoils; but they did not convince me' (10.38.5; also, see below, p. 72).[56]

These examples have been enumerated at length in order to emphasize the frequency with which Pausanias exercised his own judgement, but not to the point of excluding the reports and beliefs of others – indeed, phrases such as 'it is said' occur frequently. Such instances, therefore, show him as a neutral observer as well as a man with opinions which he does not simply state, but makes a case for. As a secondary advantage, phrases like 'it is said' may reiterate to the reader that Pausanias has diligently undertaken research, which he is able to combine with his own observations and opinions in reaching his conclusions.

[55] In this case, the translation 'wooden images' for *xoana* is justified by the explicit reference to 'wooden figure-heads'.

[56] Jacob (1980) 81 and (1980–1) 52, lists some of the objects associated with legendary characters, or of other legendary origin (including some of those discussed here) but, crucially, omits 'they say' and similar phrases. Thus he refers to the statues made from Kadmos' ships. So too the flutes of Marsyas, but apparently confusing 2.7.5 and 2.7.9, which in fact show that the flutes which 'they say' had been dedicated, had in fact been destroyed by Pausanias' day (the same two points also apply to Meleager's spear in the same passage, also cited by Jacob). The same element of doubt is expressed by Pausanias in his account of the dice of Palamedes (2.20.3), but is again omitted by Jacob.

The most extended example of this is in his discussion of the sanctuary of Artemis Orthia at Sparta (3.16.7–11). Reporting that 'the wooden image is said to be the famous one which Orestes and Iphigeneia once stole from the Tauric land', Pausanias disbelieves this because it differs from the Athenian version of the story, which he finds more credible for reasons which he explains. This comparison of local stories is characteristic of that interest in, and stress on, local elements which was discussed in the introductory chapter, and it again shows Pausanias' own research.

While still within the legendary or mythical, different buildings or monuments are ascribed to different phases of that period: at Megara, 'Telamon, son of Aiakos, married Periboia daughter of Alkathous. I apprehend, therefore, that Ajax, having succeeded Alkathous in the kingdom, made the image (*agalma*) of Athena' (1.42.4; the statue was an akrolith of gilded wood and ivory). Again at Megara, 'beside the entrance to the sanctuary of Dionysos is the grave of Astykrateia and Manto. They were daughters of Polyidos, the great-grandson of Melampous, who came to Megara to purify Alkathous after the murder of his son Kallipolis. Polyidos built the sanctuary to Dionysos and dedicated a *xoanon*, which in our time is hidden except the face, the only visible part of it' (1.43.5; see above, p. 56).

I have quoted these examples at some length because they illustrate several important points: not only is Pausanias dealing with legendary figures, and indeed, in the case of the wall at Megara, with the Cretans who are earlier than any of them, but he is dealing with several generations of them. It is clear on many occasions that Pausanias' best way of establishing a sequence is through genealogy, whether lineal or artistic (the technique previously employed apropos of art by Pliny, who also used Olympiads to structure his narrative). In other words, he is more often attempting to establish a relative chronology than an absolute chronology. This approach has a long and distinguished history, since it was used in Hesiod's *Theogony* and *Catalogue of Women*, in Hekataios' *Genealogiai*, and by Thucydides in his explication of the foundation dates of the western Greek colonies (6.1–5).

Thus antiquity in the sense of prehistory is not one amorphous entity in Pausanias' view but layered and structured, peopled with heroes but, crucially, with several generations of heroes, giving it a relative chronology, however remote and imprecise it may be in absolute terms. Furthermore, it is clear that Pausanias was aware of

the problem of early chronology and had given it much thought, perhaps most strikingly in the passage briefly cited (above, p. 45, with caveat): 'though I have investigated very carefully the dates of Hesiod and Homer, I do not want to state my results, knowing as I do the carping disposition of some people, especially of the professors of poetry at the present day' (9.30.3).

Frazer's 'professors of poetry' is more interpretation than translation, 'poetry' being too broad a rendering of *epos* which refers rather to the style of poetry exemplified by, above all, Hesiod and Homer; thus, the phrase is appropriately used here by Pausanias. Nonetheless, Frazer's interpretation serves aptly to emphasize that Pausanias was an educated man living in an age of textual critics, of questions concerning the authenticity of Homer and Hesiod, to which he could have contributed his own views if he had wished, as this passage makes clear. Knowledge of Homer in particular was one of the fundamental principles of second-century education, and it may be that Pausanias has in mind here the sophists from whom I have distanced him in the previous chapter; if so, this is further justification for seeing him as distinct from that school. Even if he did not have them specifically in mind he is standing apart from the academic fencing that must have characterized the activities of many of his contemporaries. In this era, every educated person could be expected to have a view on the great issues of Homeric scholarship, but how many would have shied away from public debating?[57] It is not surprising that Pausanias' evident curiosity and strongly held views concerning the writers and figures of the remote past should spill over into his commentary on the artefacts of the remote past.

Thus far the discussion has been concerned with Pausanias' view of legendary figures and the objects they made or were associated with. From legendary figures a short and readily available step takes us to legendary artists. As the examples given below indicate, works are often attributed to such artists; this is often another manifestation of that common desire for a *protos heuretes* discussed above in the context of technical developments (see above, p. 46). The most famous of these legendary figures was Daidalos, an Athenian traditionally regarded by later generations as the first artist.[58]

[57] Anderson discusses the interest in Homer as typical of the period and his role as the basis of education, and details 'the questions of Homeric scholarship' standardly treated; interestingly, the date of Homer is not among them (Anderson (1993) 69–85, 174–6, esp. 174).

[58] In general, Morris (1992), esp. 246–51 on Pausanias and Daidalos.

Pausanias' account of the life and travels of Daidalos is given in the
context of his description of Samos: 'that this sanctuary is at all events
one of the oldest in existence may be inferred especially from the
image (*agalma*), for it is a work (*ergon*) of an Aiginetan, Smilis . . . This
Smilis was a contemporary of Daidalos, though he did not equal him
in renown' (7.4.4). Pausanias mentions several works by Daidalos: he
speaks of a work of Daidalos in the same context as the Trojan war:
'when Troy was taken and the Greeks were dividing the spoils, the
xoanon of Zeus of the Courtyard was given to Sthenelos, son of
Kapaneus. And many years afterwards, when the Dorians were
migrating into Sicily, Antiphemos the founder of Gela sacked
Omphake, a town of the Sikanians, and carried off to Gela an image
(*agalma*) which had been made by Daidalos' (8.46.2).

In Corinth, 'the sanctuary of Athena Chalinites is beside the
theatre and near it is a naked *xoanon* of Herakles; they say it is a work
of Daidalos. The works of Daidalos are somewhat uncouth (*atopotera*)
to the eye, but there is a touch of the divine (*ti . . . entheon*) in them for
all that' (2.4.5). Habicht says that the phrase 'a touch of the divine'
shows that 'Pausanias has the discernment, despite the sculpture's
lack of elegance and refinement, to recognize a kind of sublime
inspiration and to value that'.[59] Sarah Morris' interpretation is more
prosaic: 'it . . . reveals the postclassical antiquarian . . . This
pronouncement tells us almost nothing about the appearance of the
statues, except that they looked unusual by Roman standards and
that Pausanias sprang to their defense', and she draws the conclusion
that 'he had heard or read enough about Daidalos to develop some
expectations about his art . . . hence his disappointment upon first
seeing the artist's work.'[60]

Both these interpretations are correct, that of Habicht in a
Pausanian context and that of Morris in the context of the art which is
her concern. But it is also justifiable to give more emphasis to the
strength of *ti . . . entheon*: the phrase should be taken with *de* ('but') to
indicate that the works possess divinity despite their 'somewhat
uncouth' appearance. This divinity derives instead from their antiquity,
of which the association with Daidalos is the best indication.

Pausanias uses a very similar phrase when he says that 'there is
nothing on which the blessing of God rests in so full a measure as the
rites of Eleusis and the Olympic games' (5.10.1, *malista . . . metestin ek*

⁵⁹ Habicht (1985) 131. ⁶⁰ Morris (1992) 248.

theou phrontidos); although no reason for this opinion is given, the antiquity of the mysteries and the games may safely be inferred to have been a significant reason (further, see below, p. 99).

While Pausanias expresses doubts over the attribution of this particular statue to Daidalos, he has no doubt that he has seen works of Daidalos, indeed enough works to know his style – that is clear not least from his saying of a sanctuary of Herakles at Thebes that the *xoanon* 'is believed by the Thebans to be by Daidalos, and that was my impression too' (9.11.4; further, 'it is said' that it was also dedicated by Daidalos).[61] In fact, as is his practice with other sculptors, he does not list the criteria by which he attributes a work to Daidalos; however, he mentions that they are *atopotera*; and he often remarks that they are wooden (indeed, Pliny (*NH* 7.198) claimed that Daidalos invented woodworking). While the implications of *atopotera* are not made explicit, the word suggests compatibility with that simplicity which was noted earlier in this discussion as being one of Pausanias' hallmarks of antiquity; the same is applicable to the chosen medium, wood.

Among the works of Daidalos which Pausanias refers to is one seen only by people consulting the oracle of Trophonios in the sacred wood at Lebadeia: they look at 'the image (*agalma*) which they say Daidalos made (it is not shown by the priests except to such as are about to visit Trophonios)' (9.39.8). Although it is not made explicit, it may well be that the association with Daidalos, and thereby the antiquity of the statue, was important in the context of the ritual of a long-established oracle. Although Pausanias here expresses doubt over the attribution, he goes on to be more positive: 'of the works (*erga*) of Daidalos there are two in Boiotia, Herakles at Thebes and Trophonios at Lebadeia' (9.40.3). He continues with a list of Daidalos' known works: 'there are two other images (*xoana*) by him in Crete, a Britomartis at Olous and Athena at Knossos . . . At Delos there is a small *xoanon* of Aphrodite . . . instead of feet the lower end of the image is square. I am persuaded that Ariadne received this image (*agalma*) from Daidalos, and took it with her from home when she followed Theseus; and the Delians say that when Theseus was bereft of Ariadne, he dedicated the image (*xoanon*) of the goddess to Delian Apollo . . . I know no other extant works of Daidalos.'

There is, then, no doubt for Pausanias of the veracity of Daidalos'

[61] Morris (1992) 192–3 discusses this passage but with no reference to the phrase 'it is said'.

existence and of some of his works, and this last example shows an
explicit link between Daidalos and the contemporary mythical
figures of Theseus and Ariadne; Oedipus, too, was a contemporary of
Daidalos (10.17.4). Pausanias is, however, sceptical to varying
degrees about other works supposedly by Daidalos.[62]

Morris rightly observes that Daidalos is 'largely a literary creation,
with a biography embroidered in classical and later periods'.[63] His
appearances in Roman imperial writings are largely bound by the
rules of contemporary literary conventions, such as those enjoined by
the late third-century / early fourth-century Menander Rhetor, whose
Sminthiac Oration details how one should undertake an *ekphrasis* of a
statue, including among the elaborate claims that can be made for
any given statue an attribution to Daidalos (*On Epideictic* 445.15–19)[64].
While Pausanias does indeed mention attributions of works to
Daidalos, his scepticism over some of them (as at 9.39.8) is the
antithesis of the conventional ascriptions characteristic of the writers
of *ekphraseis*.[65] While the literary aspect must have formed a background
to Daidalos' appearances in Pausanias' text, his autopsy and scepticism
are far greater influences, and again show Pausanias' writings as
distinct from the conventions of his era.

Another notable work by Daidalos which Pausanias saw was a
folding stool on the Athenian Akropolis (1.27.1; also, see above,
p. 55–6). This is particularly interesting because of the context: 'in
the temple of the Polias is a wooden Hermes, said to be an offering of
Kekrops ... among the ancient offerings (*archaia*) which are worthy of
mention is a folding chair made by Daidalos and spoils taken from the
Medes, including the corselet of Masistios, who commanded the
cavalry at Plataiai, and a sword said to be that of Mardonios'. Here
Pausanias brackets as *archaia* a work by Daidalos and spoils from the
Persian wars, much as he has previously bracketed Daidalos and
Theseus and Ariadne. While the folding stool is by a legendary artist,
the military spoils are within the historical period as we understand it

[62] It is worth noting that Pausanias here uses the words *xoanon* and *agalma* interchangeably, an
indication that he does not see either as having strong chronological implications; this
observation is applicable only to his discussion of the works of Daidalos, and the two words
are by no means intended as general synonyms. [63] Morris (1992) xx.

[64] Webb (1992) 52; Russell and Wilson (1981) 359.

[65] Another of the claims Menander Rhetor recommends in the passage cited is that a statue has
fallen from the heavens. This occurs at e.g. Pausanias 9.12.4 in the case of the log sheathed in
bronze which was discussed above (pp. 53–4). However, Pausanias twice in his description
makes it clear that he is reporting what the locals believe, so that I would place this instance
in the same category as the ascription of the statue at 9.39.8 to Daidalos.

and, perhaps more importantly, are relics of a conflict whose authenticity and date were beyond dispute (unlike the Trojan war). Furthermore, Pausanias had a firm enough idea of the date of the Persian wars (if only through reading Herodotos) to dismiss the idea that a statue by Alkamenes had been damaged during them (1.1.5).[66]

The question this poses is whether Pausanias saw the period from some time after the Persian wars backwards as one entity. If so, this would argue against the position put forward above, where Pausanias appeared to be making such distinctions. In Pausanias' 'defence', although for us Daidalos is a legendary figure, from the point of view of Pausanias, he saw a stool made by Daidalos as an object as authentic as the breastplate of Masistios and the sword of Mardonios. The reality of the object may have given credibility to the reality of the artist.[67] This is equally applicable to the staff of Hephaistos at Chaironeia (see above, pp. 63–4).

Along with references to Daidalos, there are references to the next generation of artists – his pupils – most commonly Dipoinos and Skyllis (2.15.1, also citing the tradition that they were sons of Daidalos; Pliny *NH* 36.9, dating them to c.580 BC). For example, Pausanias saw ebony statues by Dipoinos and Skyllis in the shrine of the Dioskouroi at Argos (2.22.5; see above, p. 57). Again, on the Akropolis of Sparta, he saw an image (*agalma*) of Zeus Hypatos 'which is the oldest (*palaiotaton*) bronze image in existence. For it is not made in one piece but the parts have been hammered separately, then fitted to each other and fastened with nails to keep them together. They say the image (*agalma*) was made by Klearchos of Rhegion; some say that Klearchos was a pupil of Dipoinos and Skyllis, others say that he was a pupil of Daidalos himself' (3.17.6).

This passage is of interest not only because of the supposed artistic relationship between Daidalos and later sculptors, but because it again shows Pausanias' awareness of technique, an awareness noted above primarily in connection with the simplicity of style he mentions on several occasions. In this case, he is clearly describing what modern scholars know as the 'sphyrelaton' technique of hammering

[66] On perceptions and use of the Persian wars in the Roman empire, Spawforth (1994b).

[67] Morris argues that the stool was in fact part of the Persian spoils, and had been subsequently attributed to Daidalos (Morris (1992) 249–50, 264–5, 371, 386; Boardman suggests that the stool was 'of eastern or Egyptian type which was introduced to Greece by about 600 BC and which could easily have been associated with a Daedalus for his reputation as a wood-worker' (Boardman (1980) 46). This does not affect my argument, which depends on what Pausanias believed rather than on whether he was right to believe it.

sheets of bronze onto a core.[68] This is indeed the earliest of bronze-working techniques employed on any notable scale (here I exempt the small-scale solid cast bronze figurines of the Geometric and early Archaic periods), and Pausanias' identification of it as such is therefore accurate. Less so is his assertion that this particular piece is 'the oldest bronze image in existence'[69] (supported by the presence here of wooden images which are 'as ancient as any in Greece', reinforcing the 'aura' of the associations); but it is again indicative of the desire to discover an identifiable beginning or starting point for the genre of bronze statues, a variation on the theme of *protos heuretes* (see above, p. 46).[70]

This interest is also reflected in Pausanias' statement that 'the first to fuse bronze were Theodoros and Rhoikos' (9.41.1), echoed later: 'the two Samians, Rhoikos son of Philaios and Theodoros son of Telekles, were the the first who discovered the art of founding bronze to perfection, and they were the first who cast it in a mould' (10.38.6). The latter reference arises in the context of the discussion of a bronze *agalma* on the Akropolis at Amphissa 'which they say was brought by Thoas from Ilion' (also above, p. 65). Pausanias adds 'they did not convince me', explaining that he knows of nothing in existence by Theodoros; but he sees no objection *per se* to the idea of the survival of a statue brought as booty from the Trojan war by a legendary hero, and manufactured by a specific ancient artist.

Just as Dipoinos and Skyllis were reputed to be pupils of Daidalos, so they in turn had pupils: two Lakonian sculptors whose works Pausanias saw in the temple of Hera at Olympia are referred to as pupil and supposed pupil of Dipoinos and Skyllis (5.17.2–3); a third Lakonian sculptor whose work was at Olympia is also called a pupil of Dipoinos and Skyllis (6.19.14).

It was noted above that there is, for the modern scholar, no credibility in the stories of Daidalos' life and works. It follows that there must also be comparable doubt over the authenticity of his pupils, certainly as his pupils and arguably as real sculptors at all. It is not possible that Dipoinos and Skyllis (and others) were in any real sense pupils of Daidalos; whether the three Lakonian sculptors (and

[68] Haynes (1992) 11–23; Mattusch (1988) 41–4; Rolley (1986) 30; Papadopoulos (1980) 75–100. Stewart (1990a) 37 and fig. 17. All aptly cite the sphyrelaton statuettes from the temple of Apollo at Dreros of the beginning of the seventh century as exemplifying the technique Pausanias is describing. [69] Discussed by Mattusch (1988) 41.
[70] On the tradition of the first bronzeworking, Morris (1992) 139.

others) were pupils of Dipoinos and Skyllis is less clear. By the same logic, the probability of the accuracy of the reports concerning the relationship of each later generation to the next becomes greater. It is important to detail this sequence, since it is from exactly this sort of reported artistic relationship that much of our sequence of sculptors is derived, as distinct from the sequence of sculpture itself, which is assessed stylistically on the basis of surviving pieces. If the head of the sequence is as uncertain as it is in the case of Daidalos, we may wonder how reliable the rest is.

The key question here is at what point does the legendary and mythical become the real in the eyes of Pausanias? He believes in the gods, and he believes that the god of craftsmen made objects, a natural assumption. It would, then, be hard for him not to believe that some of those works could survive to his day. With this belief, the logic leading to his ascription of the staff at Chaironeia to Hephaistos is entirely reasonable. But as a god, Hephaistos is in a different category from other artists, indeed cannot be called an artist in the conventional sense. In dealing with real artists, that is, mortal men, different criteria are needed.

Clearly, Pausanias believed in the authenticity of Daidalos and that he had seen works by him, enough to deduce a firm idea of his style. It is for this reason, I suggest, that Pausanias sees the development of sculpture as one straightforward process punctuated by innovators like Daidalos, Dipoinos and Skyllis, Polykleitos, Kallimachos and others. To follow the logic further is to overestimate what can reasonably be extracted from Pausanias: study of the history of art as such was of little interest during the periods to which most of the objects Pausanias saw belong. He is, to that extent, at the mercy of his sources, and can improve on them only when he is informed by an inscription, or when he is bold enough to venture a stylistic judgement or an attribution of his own.

Pausanias' use of inscriptions has been well discussed by Habicht,[71] and it can profitably be further examined in this context. One example may serve to illustrate the value of inscriptions: in describing some statues at Olympia, Pausanias quotes some couplets on the pedestal, saying that they were 'in ancient letters' (5.22.3). Epigraphic study of the lettering indicates a date of c.475–450 BC, slightly later than the Persian spoils which were bracketed with Daidalos' folding

[71] Habicht (1985) 64–94.

stool in the passage discussed above (1.27.1). Epigraphy is a skilled
art at the best of times, and levels of literacy in the Greek world
suggest that the subtleties are unlikely to have been appreciated by
contemporary viewers of the monument.

The inscription on the stoa of the Athenians at Delphi has been
cited as a reason for dating the stoa to the 470s BC, in conjunction with
Pausanias' words (10.11.6).[72] But, as J. Walsh points out,[73] adding
the inscription in the latest up to date letter-forms would reduce
considerably the accessibility of the inscription to the general public,
especially visitors from the other parts of the Greek world, who would
be used to Athenian inscriptions in the received and established
letter-forms. This is a major consideration since consumption by
outsiders was a central motivation for such identifying inscriptions
and, indeed, for the buildings themselves, particularly at an inter-state
sanctuary of the importance of Delphi. Since, therefore, such reduction
in accessibility would obviate the very point of the inscription, Walsh
argues that the inscription is in fact not good evidence for the date.
This indicates the uncertainty that can pertain to something even as
apparently readily datable by modern scholars as letter forms. How
much less comprehensible would the inscription have been to
Pausanias? He says that 'the inscription seems to me to refer to
Phormio . . . and his exploits', introducing a note of doubt and
personal interpretation; unfortunately, it is not clear exactly where
these doubts arise. It may be that the letter-forms caused him doubts,
or uncertainty about the details of the history of that period. His
uncertainty, and his admission of it, reflects a consistent use of the
same logic that led him to describe the folding stool of Daidalos and
the spoils from the Persian wars simply as *archaia*. I do not think we
can expect more from him than that.

A long answer has been attempted to the question of the point at
which the mythical and the legendary become real in our sources. In
summary, Pausanias saw no overriding division between these
categories. If we are to attempt to see ancient art in something
approaching the way it was seen by Pausanias, or more generally in
the ancient world, we must remember that for us, it is easier to date an
object because of the wider criteria available to us, and because of the
more highly developed state of antiquarianism (whether we call it
archaeology or art-history). We are also far readier to assess an object

[72] Walsh (1986) 320, 324–9. [73] Walsh (1986) 325.

without associating it with a name, an important distinction since it is by names, and consequently by genealogies, that the sequences of sculpture given by Pausanias and, more so, Pliny are arranged. We do this perhaps above all with fourth-century sculpture, to a significant extent with that of the fifth century, rarely with that of the sixth and not at all with that of the seventh century or those few pieces of significant earlier sculpture.

Thus our own view of the development of sculpture illustrates a process in essence very like that employed by Pausanias, a process leading to a conclusion that is largely self-evident: the further back something is, the vaguer we become. Thus we can discourse precisely on the later material, and the earlier a piece is, the greater the tendency for it to be regarded and referred to as, in general terms, 'ancient'. Furthermore, we too talk in terms of names when we can; it avoids having to give too many inventory numbers, and gives a human dimension: thus one talks of a Pheidian, Skopaic or Lysippan style. In this, too, we were anticipated by Pausanias.

CONCLUSION

It has been said that Pausanias 'has a strong bias towards the sacred and the antique, and in architecture, sculpture and painting towards the old masters'.[74] This is undoubtedly correct, but it is a conclusion that must be inferred from the descriptions, since Pausanias nowhere makes explicit his vision of the past. But that is entirely consonant with the generally self-effacing nature of his narrative: he does not claim his work as a Thucydidean κτῆμα ἐς αἰεί (Thuc. 1.22), nor does he encourage readers to do what has been attempted here; and yet I suggest that the attempt is justified, not least because of his importance as a source, exaggerated though this may have been by the accident of the survival of his work.

In the introduction to this chapter, the belief was stated that Pausanias had strong personal preferences and values in his attitudes to the objects and sites he was describing, and that they are reflected in the nuances in his presentation of the objects described in his narrative. The evidence adduced has, I believe, shown that Pausanias' attitudes are reflected in several aspects of his work: in his working method, above all his selectivity of which objects and buildings to

[74] Thompson and Wycherley (1972) 204; cf. Habicht (1985) 23: 'no recent artist is praised like the old masters'.

describe; in his preference for the ancient over the modern; in his deeply held religious feelings and the consequent sense of the appropriateness of particular objects, not only to their task but also to their setting.

The role of religion and cult sites in the present discussion was noted in chapter 1 in relation to his evident interest in sanctuaries and in what constitutes a city. The importance of religion to Pausanias is manifest,[75] and it is necessarily a significant factor in the assessment of the art, most of which was produced for religious contexts. While he understands the Greek religious system, he is divorced from the heyday of the art he is describing, and could not experience that intimate connection between art and religion at many of the sites he visited. Exceptionally, however, Pausanias can show a sense of wonder in his comments, such as that on Eleusis and Olympia (see above, p. 68), which seems apart from the ideals of an objective description. Indeed, in the case of Eleusis we owe the lack of a description to this very sense of awe (1.14.3, 1.38.7).[76] But this makes a point of some importance to this study, that we should not treat Pausanias' account as a coldly objective one: he did have opinions, feelings and preferences, which are more often implicit than explicit in his work, and which justify a study such as this.

The aura he felt at Eleusis and at Olympia strongly enough to commit it to writing shows that Pausanias was anything but an unthinking, undiscriminating recorder. But it says something more relevant for us about his attitude to antiquities, since his work shows a linking of intrinsic sanctity with that bestowed by virtue of age (shown also in the comment on the statue of Daidalos (2.4.5; see above, p. 68)).

This was a long-established principle, and one that Pausanias was certainly aware of: for example, when he tells of the later amassing and storing of relics of Greek epic, history and religion in the temple of Athena Alea at Tegea (8.46.1–47.3). In the context of Augustus' looting, Pausanias tells us that Augustus took from the temple at Tegea the 'ancient image (*agalma . . . archaion*) of Alean Athena and the tusks of the Kalydonian boar', but he adds that still in the temple

[75] Habicht (1985) 151–9.

[76] A sense of wonder at Eleusis was long established: Pind. fr. 121 Bowra; Soph. fr. 837 Pearson; *h.Cer.* 480–2; and the prosperity and importance of Eleusis were at their height just after Pausanias' visit with the building of, among other features, the greater Propylaia: Spawforth and Walker (1985) 101–3.

in his day was 'the hide of the Kalydonian boar: it is rotting away with age and is now quite bare of bristles. Also, there are hung up the fetters which the Lakedaimonian prisoners wore when they dug the plain of Tegea, but some of the fetters have been eaten away by rust.'

Similarly, Herodotos tells how these fetters, which were brought by the Spartans to bind the Tegeans they supposed they would capture, were in fact used on the defeated Spartans, and how in his day they hung round the Archaic temple (1.66). While both these cases concern antiquities kept long after the event, there is a difference in display, in that the relics of the boar hunt were kept inside the temple, while the military spoils were hung round the temple to maximize display. Between Herodotos' day and Pausanias', the fetters had apparently been brought inside the late Classical temple which replaced the Archaic one Herodotos saw, but the fact of their survival for so long, and of their display apparently throughout that period, is of great interest.

The Tegea fetters (at least in the intent of those who originally displayed them, if not of those who maintained the display) exemplify the common phenomenon that history has to be justified by producing pieces of material evidence, whether they be the bones of a founder (such as Theseus at Athens or Oresthes (Orestes) at Oresthasion/Megalopolis);[77] or of an eponymous hero, as those of Arkas which were moved from Mainalos to Mantinea at the bidding of the Delphic oracle (8.9.3–4); or of a local hero such as those of Linos which Philip, son of Amyntas, removed from Thebes to Macedonia supposedly in obedience of a dream, and subsequently returned (9.29.8); or those of the local king, Tisamenos, moved by the Lakedaimonians 'at the bidding of the Delphic oracle' to Sparta from Helike where the Achaeans had buried him (7.1.8).[78]

Such material evidence may also consist of other objects such as 'the remains of the wood of the plane-tree which Homer mentions' (9.19.7).[79] Specific objects are always easier to deal with, since something real and tangible which can readily be remembered and recalled when necessary is a more powerful factor than a theoretical concept of history or antiquity. But these specific objects also have to

[77] Theseus: Plut. *Theseus* 36, Paus. 3.3.8. Orestes: Hdt. 1.67–8, Paus. 3.3.6–7, 8.54.4.

[78] Leahy (1955). The removal of the bones of Themistokles from Magnesia to the Peiraeus (1.1.2; Garland (1987) 216–17) was an act of repentance by the Athenians, and therefore comes in a different category from the motivations reported for the other cases of the transfer of bones. Note also the return of the bones of Philopoimen to Megalopolis (8.51.8).

[79] Kept in the temple at Aulis in Boiotia; the passage of Homer referred to is *Il.* 2.305.

remain relevant, another reason why the fetters are of some interest, since they had a meaning as long as old inter-city rivalries persisted, as they did between Sparta and Messene until at least AD 77, and possibly until AD 177/8, Pausanias' own time.[80] That is, the fetters exemplify antiquity with a purpose rather than simple antiquity *per se*.

Although Pausanias does not say so, it is legitimate to ask whether antiquities such as those in the temple at Tegea had become, in effect, icons for the local populace. This was an attitude Pausanias cannot have been unaware of in view of all his travelling, and the numerous occasions on which he seems to have consulted local opinion on the buildings or monuments of a particular area. In the light of all the evidence presented above, it is difficult not to conclude that he himself regarded antiquities as having a special place in the modern world simply because they were antiquities. For him, the past was by no means readily comprehensible, but the attempt to fathom it was worthwhile; the attempt was made by acknowledging, and attempting to define, dividing lines between the firm and recent past and the dim, distant and virtually timeless past.

Anderson, citing Bowie's belief that 'the fantasy of the hyper-educated Athenian must have been to walk out into the countryside of Attica and discover that he was in the fifth century', modifies it thus: 'it is not so much the world of the fifth century, however, as a world in which the fifth century has been relocated somewhere in the vicinity of the Trojan War, since we still find Homer cheek by jowl with Socrates'.[81] Anderson writes with reference to Lucian, *Ver. Hist.* 2.19, but that is set in the underworld and is, as Lucian himself informs us (*Ver. Hist.* 1.4; see above, p. 21), an overt fiction in which one would expect such a juxtaposition of figures from different eras. This would suit the more rhetorically minded of Bowie's 'hyper-educated' of the period (Athenian and otherwise), for whom it would be a perfect opportunity to exercise their skills. But it would not suit those of a more sober inclination, less given to such fiction. Pausanias was among the latter and, rather than revelling in such a mix of periods, would attempt to distinguish periods, not only to separate Homer and Sokrates (as it were), but to assess by how much to separate them.

In the context of his social, political and cultural background,

[80] Cartledge and Spawforth (1989) 136–9.

[81] Anderson (1993) 83, citing Bowie (1974) 197; elsewhere, Anderson says that 'sometimes, it has to be said, Lucian did not have to try very hard to blend conditions of the second century AD and the fifth century BC' (Anderson (1982) 79).

Pausanias, as an educated native of Asia Minor in the second century AD, must be seen as a product of his times. This is apparent in the strong impression his writings give of his feel for the value, even sanctity, of antiquity and its manifestations in mainland Greece; indeed, the very essence of his work, the very fact that he wrote it as he did, bears strongest witness to this. But that is to omit the personal element in his work, his judgements and preferences; he frequently makes these clear, among them that he preferred the antique to the modern. And in that, as in much else, he is his own man.

Pausanias on the rulers of Roman Greece 1: introduction, Mummius and Sulla

INTRODUCTION

The following three chapters consider in detail the writings and attitudes of Pausanias concerning the ruling figures of Roman Greece. The first part of this chapter considers some of the criteria for selection which caused Pausanias to omit, or refer only briefly, to some of the emperors; the latter part concerns Pausanias' attitudes to Mummius and Sulla. Chapter 4 will concern Caesar and Augustus; and chapter 5 those emperors whom Pausanias discusses of the period from Nero to Marcus Aurelius, with particular emphasis on Hadrian.

The starting-point for these chapters is Mummius' destruction of Corinth in 146 BC, seen as a seminal moment in Greek history not only by modern scholars, but by Pausanias himself. There had, of course, been considerable earlier involvement of the Romans with Greece,[1] and Pausanias has much to say on the Hellenistic period to 146 BC,[2] besides his more widely acknowledged interest in Classical and earlier Greece. This was also the period when the Romans developed the habit of despoiling Greece of its art, a practice by no means original to them, as Pausanias was well aware (8.46.2; see below, p. 128), but one at which they became expert. The inglorious deeds of Marcellus at Syracuse in 211 BC are the most notable early example, and among the Romans 'from that time came the very beginning of enthusiasm for Greek works of art and consequently of this general licence to despoil all kinds of buildings, sacred and profane' (Livy 25.40.2; cf.

[1] For a summary history, Alcock (1993) 8–17 (although the definition of the 'early empire' as the period from 200 BC to 200 AD gives pause).

[2] Bearzot (1992); also Habicht (1989) esp. 7–9, 12, (1990) 572, (1992) 76, 85.

Plut. *Marc.* 21.1).[3] Pausanias, however, makes no mention of Marcellus, nor of other Roman depredations of the art of Greece in the period before Mummius (although in describing the events immediately preceding Mummius' sack of Corinth he mentions Metellus' order to his troops not to burn any sanctuaries (7.15.9)).[4]

The method adopted in these chapters (and in chapter 6 on Herodes Atticus and other benefactors) is to consider each figure individually, concentrating on what Pausanias has to say and what that reveals of his attitudes towards them and their activities as they affected the political and cultural life of Greece. While discussion of Pausanias' text forms the major part of this study, it also takes account of other evidence – literary, epigraphical and archaeological – in order to produce a fuller picture of the impact of each figure discussed, to put Pausanias' account in context, and to assess what is distinctively Pausanian.

To the same end, I begin with a brief digression to consider Pausanias' selectivity, and particularly why he differs widely in the attention he gives to particular emperors. In this section, I consider first those emperors whom Pausanias mentions only very briefly (?Tiberius, Caligula and Claudius), then those whom he omits altogether (Galba, Otho, Vitellius, Domitian and Nerva).

THE SELECTIVITY OF PAUSANIAS

It has been argued in the preceding chapters that it is essential to understand the nature of, and rationale for, Pausanias' selectivity in presenting his material, and this is applicable also to the present and following chapters. His selectivity extends to instances where he seems deliberately, virtually or actually, to ignore certain emperors. In the cases of several of these emperors, while little or nothing can be extracted from Pausanias, we hear much about their activities in Greece from other sources. Indeed, it is important to acknowledge the sheer quantity of evidence from other sources, which is an important

[3] Pollitt (1978) is particularly useful on the Romans and Greek art in the period to 146 BC; a different, and highly stimulating, view is taken by Gruen (1992) esp. 84–130. For the sources, Pollitt (1983) 29–58.

[4] These included the looting of pictures and sculptures by Aemilius Paullus after Pydna in 168 BC, described by Plutarch (*Aem.* 32–3; see below, p. 103). Since Pydna was in Macedonia, Pausanias may have felt it irrelevant to his task of describing Greece. If any art or sanctuary suffered when Flamininus and Otilius 'behaved with merciless severity to ancient Greek cities' (7.8.2), Pausanias does not say so (n.b. 'Otilius' is apparently a misnomer for P. Villius Tappulus (cos. 199 BC); e.g. Frazer IV.132).

factor in putting into perspective Pausanias' own comparative silence. Thus, while this section takes us some way from the text of Pausanias, it does give an indication of the facts or stories Pausanias may be presumed to have had available to him, which he might have passed on to his readers had he chosen to do so.

Of the Julio-Claudians, Pausanias pays considerable attention to Augustus and Nero, and his account of them will be discussed in detail below. The treatment of Tiberius, Caligula and Claudius, with which I begin, stands in marked contrast, but is nonetheless of value for what it reveals of Pausanias' interests and working methods.

Tiberius

The only possible mention of Tiberius in Pausanias' text is a very uncertain one: referring to facilitating the passage of ships from the Orontes to Antioch, he says 'the Roman emperor (*autokrator*)[5] had a navigable canal dug with much labour and at great expense, and into this canal he diverted the river' (8.29.3). Citing a tradition (which he calls false), that Tiberius had changed the name of the river to Orontes from Draco, Frazer notes earlier suggestions that Tiberius was the emperor also responsible for the canal; most recently, it has been suggested that Vespasian was in fact responsible.[6]

Although Tiberius showed considerable interest in art, the nature of the interest, if sources like Suetonius and Pliny are to be believed, was such that we need not wonder at Pausanias' bypassing him. For example, Pliny mentions Tiberius' falling in love with ('amavit') a painting by the late fifth/early fourth-century artist Parrhasios, which he put in his bedroom (*NH* 35.70). He also notes that Tiberius developed a particular, and apparently unnatural, affection for the Apoxyomenos of the fourth-century sculptor Lysippos, which had been dedicated by Agrippa in front of his baths in Rome, but which Tiberius also moved to his own bedroom (*NH* 34.62). Pliny adds that 'in the beginning of his principate he had been master of himself'; evidently, this episode provides proof that he was no longer so. Pliny goes on to say that Tiberius was eventually obliged by

[5] Interestingly, Cassius Dio (57.8.1) reports that Tiberius did not like being called *autokrator* by any except his soldiers. Forms of references to emperors are discussed below, pp. 114–16.

[6] Frazer IV.316, tentatively followed by Levi (1971) 2.446 n.217; Papahatzis argues that it was undertaken by Tiberius around the time of Christ, although he gives no supporting evidence (Papahatzis 4.307 n.4, imprecisely dated 'γύρω στά χρόνια τοῦ Χριστοῦ'). Vespasian: Isaac (1992) 35.

popular indignation (expressed in the theatre) to return the statue.

Suetonius says of Tiberius that 'while emperor he constructed no magnificent public works, for the only ones which he undertook, the temple of Augustus and the restoration of Pompey's theatre, he left unfinished after so many years' (*Tib.* 47). And yet, there is evidence of more widespread embellishment of the provinces during Tiberius' reign: his part in the imperial cult is attested by the statue of him next to those of Augustus and Livia at Gytheion, placed in the theatre for the imperial festival (see below, p. 133). And at Corinth, it is possible that Temple E is Tiberian in origin; to this period can be assigned with certainty the temple's reconstruction and the considerable enhancement of its architectural setting. This is plausibly seen by Charles Williams as evidence of 'the escalation of the Imperial Cult in Corinth from the time of Tiberius onwards'.[7] Also at Corinth, the addition of the Imperial Games to the Isthmian calendar during the reign of Tiberius may seem comparatively insignificant, but, as will be discussed below, the games constituted the one thread of continuity after the destruction of Corinth by Mummius and therefore had a special status as an exceptional survival, rather than a revival. In Sparta, Tiberius is associated with building activity at the theatre, itself by that time primarily an Augustan construction (see below, pp. 130–1).[8]

In front of the stoa of Attalos in the Agora of Athens, a bronze quadriga on a pillar, of Pergamene date like the stoa itself, was re-dedicated to Tiberius.[9] The accompanying inscription shows that Tiberius had received divine honours, and was titled *euergetes*, although the nature of the benefactions is not known, and may have consisted of a favourable response to a petition.

In summary, the picture from Pausanias is consonant with that from other sources, literary and otherwise, in reflecting the very limited activity of Tiberius compared to Augustus.[10] The picture Suetonius gives us of an increasingly perverted and withdrawn man is not apparent in Pausanias – Tiberius' character would only have been of interest to him if it had been directly relevant to his concerns, and it would have been out of character for him gratuitously to write of such matters.

[7] Williams (1987) 30. [8] Cartledge and Spawforth (1989) 101–2.
[9] Vanderpool (1959), with details of other Athenian monuments to Tiberius.
[10] Mitchell (1987b) 365.

Caligula

Pausanias' only reference to Caligula occurs in his description of Thespiai in Boiotia:

they say that the first to remove the image of Eros was the Roman emperor (*dunasteusanta en Romei*) Gaius (Caligula), and that it was restored by Claudius only to be a second time carried off by Nero. At Rome it was destroyed by fire. Of the men who thus sinned against the god, Gaius, in the act of giving the watchword, was despatched by a soldier, whose rage he had excited by always giving him, with a covert taunt, the same watchword; while Nero, besides his conduct to his mother, was guilty of accursed and unlovely crimes against his wives. (9.27.3–4)

Unusually, Pausanias here makes a direct comparison of emperors, with Caligula characterized as a sinner as well as a remover of art, who met what is implicitly a deserved bloody fate. The last figure Pausanias so stigmatized is from the pre-imperial period, namely Sulla, who also acted impiously and met an appropriate fate (see below, pp. 104–5). Although these similarities are striking, Pausanias makes no further comparison and discusses Sulla at much greater length than he does Caligula. This reflects Sulla's considerably greater impact on Greece, showing once more that Pausanias discusses these figures only as far as is relevant to his purpose.

Although I am primarily concerned in this chapter with Pausanias' view of individual figures, I have also stressed the importance of considering his references to them in relation to what we know from other sources, and here the case of Caligula is of some interest. Suetonius' account perhaps holds too great a part of our information about Caligula for its accuracy and objectivity to be assessed, but that is fate: had Tacitus' chapters on Caligula survived, we might have had another view. Perhaps the most telling statement of Suetonius' for present purposes is that Caligula gave 'orders that such statues of the gods as were especially famous for their sanctity or their artistic merit, including that of Zeus at Olympia, should be brought from Greece, in order to remove their heads and put his own in their place' (*Gaius* 22.2; cf. Cassius Dio 59.28.3). The impiety of such a deed is apparent to all but one seeing himself as a god, and as Jupiter furthermore (Suetonius also says here that 'some hailed him as Jupiter Latiaris'). Caligula's proposed change of identity for the statue is paralleled in fact but not in spirit by Claudius' replacing the head of Alexander with that of Augustus in a painting by Apelles (see

below, p. 127; cf. the Orestes/Augustus statue, below, pp. 126–7): the crucial difference is that Claudius' deed was for the advancement of Augustus, that of Caligula for his own advancement.

Pausanias, who tells us so much about the statue of Zeus at Olympia (5.10.2, 5.11), shows no awareness of this story. He may have known it, but omitted it simply because its inclusion did not serve his purpose. Caligula's plan was not, after all, fulfilled, and it therefore left no mark on the statue or on the site which housed it. If it may be so put, it was a story of Rome, not of Olympia or Greece. Had the deed been done, there can be little doubt of how Pausanias would have regarded it: the effective decapitation and re-assignment of 'such statues of the gods as were especially famous for their sanctity or their artistic merit' (to repeat a phrase of Suetonius that would have struck – perhaps did strike – a chord with Pausanias) puts this contemplated deed in the category of the heinous.[11]

Suetonius returns to Pheidias' statue at Olympia towards the end of his life of Caligula: 'his approaching murder was foretold by many prodigies. The statue of Jupiter at Olympia, which he had ordered to be taken to pieces and moved to Rome, suddenly uttered such a peal of laughter that the scaffoldings collapsed and the workmen took to their heels' (*Gaius* 57.1). The fact that Caligula got as far as having scaffolding erected by his agents is in itself of interest. Cassius Dio's account is closely comparable: 'the ship built to bring [the statue to Rome] was shattered by thunderbolts, and loud laughter was heard every time that anybody approached as if to take hold of the pedestal' (59.28.4).[12]

Here there are two *topoi*: first, the idea of the portent, which we will meet again apropos of Pausanias' comment on Sulla's coming being foretold by ashen rain (below, p. 97); and, more pertinently to this example, apropos of Cassius Dio's report of a statue of Athena spitting blood in advance of Augustus' arrival in Athens (below, p. 123). Secondly, the intended removal of the statue embodies a practice which will be seen in the rest of this chapter to be a frequent one, to which Pausanias' account is one of the most significant witnesses. In this particular case, the scale of Caligula's enterprise, emphasized by

[11] Incidentally, Suetonius' references to these statues as being of 'artistic merit' and 'by the hands of the greatest artists' do not indicate that Caligula was personally capable of distinguishing meritorious examples from workaday ones.

[12] Forte (1972) 210, misreads the sources here in saying that 'a ship sank while it was bringing the statue of Olympian Zeus to be remodelled at Rome with Gaius' features'.

the size of the statue, effectively demonstrates the characteristic extent of his ambition, and of his impiety.

Of Caligula's building plans, he placed digging a canal through the Isthmus of Corinth 'ante omnium', according to Suetonius (*Gaius* 21, adding that he arranged a survey). Pliny (*NH* 4.10) lists it, along with other attempts, as 'an act of sacrilege'. Julius Caesar and Herodes Atticus also contemplated the project and Nero actually attempted it; their interest will be discussed later, but here it may be noted that Pausanias mentions only Nero's attempt.

The foregoing puts Pausanias' account in perspective: while a reign of under four years allows considerably less scope than do the forty-one years of Augustus, for example, the sole reference to Caligula in Pausanias' writings reinforces the point that little of what Suetonius and other writers say about him and his activities is relevant to Greece, and therefore to Pausanias. This has already been seen to be true of Tiberius, and will be seen to apply to Claudius.

Claudius

The passage cited above concerning Caligula's actions at Thespiai (9.27.3–4) also includes Pausanias' only reference to Claudius. It shows Claudius in a good light, as the emperor who restored a statue of Eros which Caligula had stolen; and it enhances this image by adding that Claudius' successor, Nero, carried it off for a second time, thus presenting Claudius as (in this respect at least) a good emperor between bad ones. This aspect of Claudius' policy is known also from Cassius Dio (60.6.8) and from epigraphical evidence (and cf. p. 87 n.17); the latter also shows that he was regarded as 'saviour and benefactor', perhaps in part because of the return of stolen objects. There may also have been counted among his benefactions the enlargement and remodelling of the approach to the Akropolis of Athens which occurred during his reign, although we should not infer a personal role for him in this.[13] That Claudius was highly regarded in Athens may be deduced from the three bases for statues of him from the Agora of Athens, in particular the one which identifies him with the epithet 'Apollo Patroos', of which Shear rightly observes that 'we may infer that he had been assimilated to that deity in his temple on the west side of the square'.[14] Geagan pertinently adds that Apollo

[13] Oliver (1983) 103, citing *IG* II² 3271; Shear (1981) 367. [14] Shear (1981) 363.

Patroos was 'a divinity of no small significance to the Athenians'.[15]

Elsewhere in Greece, Pausanias in all probability saw the statue of Claudius as Zeus in the Metroon at Olympia, where he notes (but does not identify) statues of Roman emperors (5.20.9) and where, among others, was also found one of Augustus as Zeus (see below p. 120). Thus there is again apparent the association of Roman emperors with Zeus, which can be traced back to the Macedonians, and was to be at its most developed in the case of Hadrian (see below, pp. 162–3). The disapproving Suetonius reports (*Claudius* 25.5) that Claudius contemplated transferring the Eleusinian Mysteries to Rome, but does not say why Claudius thought of doing this, nor why he did not in fact do it. Pausanias is silent on this, as on most matters Eleusinian.[16]

Although we have a few references to Claudius' dealings with art, such as the episode of the Apelles paintings cited, the sources concentrate on his building and engineering projects at Rome and Ostia.[17] His dealings with the provinces are only treated in the most general way; he may have visited Greece in AD 10/11, and he was a Greek speaker (Suet. *Claudius* 42) and familiar with Greek culture, even if mainly for cosmetic reasons.[18] If he had any notable contact with either Greece or Asia Minor, the lack of interest in it in Pausanias' writings is entirely consonant with the other literary sources. His extensive activity in Britain is ignored (in fact, Pausanias' two references to Britain (1.33.4, 8.43.4) make no mention of any buildings or objects).

In summary, there is little reason for Pausanias to mention Claudius; where he does, he is complimentary, not least by the contrast with the emperor immediately before and, more ominously, immediately after him.

Emperors omitted by Pausanias

The emperors whom Pausanias certainly omits are Galba, Otho, Vitellius, Domitian and Nerva. Vespasian receives only one mention (an important one, discussed below, pp. 155–6), and there is one

[15] Geagan (1979) 387. [16] Clinton (1989b) 1513–14.

[17] Pliny (*NH* 36.122) and Suetonius (*Claudius* 20, cf. *Gaius* 21) mention Claudius' completion of the Caligulan aqueduct, the draining of the Fucine Lake, and building at Ostia (cf. Cassius Dio 60.11.5). Claudius also restored several buildings in Rome, and reversed some of Caligula's policies (Suet. *Claudius* 11.3, 21.1–3, Cassius Dio 60.6.8).

[18] Levick (1990) 19, 117–18, 182; Huzar (1984).

possible reference to Titus' destruction of Jerusalem (8.16.5).[19]
Although Pliny (*NH* 34.55, 36.37) shows that Titus fitted inconspicu-
ously into the pattern set by previous emperors with regard to the
collecting and display of Greek art, there is no suggestion of anything
in his reign to interest Pausanias.

The exclusion of Domitian is of more interest: his reign produced
little building in the provinces,[20] and his *damnatio memoriae* (Suet. *Dom.*
23.1) may have been a deterrent, but there were aspects of his
activities in Greece which one would not have been surprised to find
referred to by Pausanias. Epigraphic evidence shows that Domitian
was the first emperor to hold the eponymous archonship at Athens;[21]
he restored the temple of Apollo at Delphi in AD 84 at his own expense;
and in AD 90, in response to a petition from a deputation from Delphi,
he resisted a change in the procedure at the games, preferring to
maintain ancient procedures,[22] in contrast to the unwelcome
innovations briefly imposed by Nero on the Olympic games (see
below, p. 150). Also during this period, a stoa at Megalopolis was
built,[23] perhaps one of the two to which Pausanias (8.30.6) refers; he
gives no date for one, and says that the other was not built by Philip,
although he implies that it was contemporary.[24] Either of these may
be the Domitianic one – if so, Pausanias may or may not have known
– but with so little information available, we can only speculate.
Finally, the Metroon at Olympia, mentioned (p. 87) as containing
statues of Augustus and Claudius (among others) as Zeus, also housed
one which may be Domitian. As Pausanias merely notes these statues
(5.20.9), but identifies none by name, the lack of reference to
Domitian here is of no significance.

In short, Pausanias' silence on Domitian is best taken as simply
reflecting the fact that he impinged little on the world Pausanias was
interested in describing. Thus his treatment exemplifies Pausanias'
policy of not gratuitously discussing individuals whom he does not
otherwise have good cause to consider in the course of his narrative.

The omission of these emperors leaves most of a thirty-year period
untreated by Pausanias. That this is so is entirely commensurate with
what we know of these emperors' involvement in Greece: their reigns
were mostly very brief, and produced nothing relevant to Pausanias'

[19] Neither Frazer nor Papahatzis speculates on his identity, and neither mentions Titus.
[20] The notable exception was Ephesos (Ward-Perkins (1981) 291, 294–5.
[21] Oliver (1983) 103. [22] Millar (1977) 450–1. [23] Frazer IV.322–3.
[24] Frazer IV.322 connects it with Livy 38.34, dating it to 189 BC.

own interests.[25] In other words, Pausanias' selectivity here accurately mirrors his purpose and exemplifies his practice of discussing only material which is relevant to the task he had set himself, or of allowing himself only those digressions which arise directly from such material. We may presume that if his main purpose had been either history or biography, his writings on the emperors would have been very different.

Having considered the attitudes and working methods of Pausanias through those ruling figures of whom he makes little or nothing, I now turn to the greater part of this study, the examination of how he treats those figures whom he discusses in detail, namely the remaining emperors and, first, the Republican rulers.

PAUSANIAS AND THE REPUBLICAN RULERS

In the rest of this chapter, I examine Pausanias' attitudes towards Mummius and Sulla, and towards their actions in Greece. They were not, strictly speaking, 'rulers', since control of the new province of Achaia was assigned to the governor of Macedonia, and Pausanias refers to each as *strategos* (e.g. 1.20.4, 5.10.5 respectively). However, their impact on Achaia justifies the prominence Pausanias gives them.

MUMMIUS

Although the partial subjugation of Greece in the half-century leading to the sack of Corinth by Mummius in 146 BC might lead one to question how significant that event actually was, it is clear that Pausanias saw it as putting an end to one phase of the history of Greece. This was a phase in which he believed Greece had been recovering from the damage done by the Macedonians, whom Pausanias, in common with other writers of his era,[26] regards as responsible for the degradation of Greece (e.g. 3.7.11). It was then that 'like a fresh shoot on a blasted and withered trunk, the Achaean League arose on the ruins of Greece' (7.17.2). However, 'the roguery and cowardice of its generals blighted the growing plant', a self-inflicted inability to continue the advances Greece had made leading Pausanias to add in an exasperated tone that its 'troubles began with the

[25] It is true that Suetonius (*Vit.* 5) refers to Vitellius' stealing some offerings from temples in Rome, and substituting cheap imitations for some others, but, as this is a purely internal affair, it would be of no relevance to Pausanias. [26] Palm (1959) 64.

overthrow of Perseus and the Macedonian empire by the Romans' (7.10.5).[27]

As Pausanias gives us his view of the burgeoning and then withering of Greece in the period before Mummius, so he gives us in ample measure his views on the actions of Mummius, which inaugurated 'the period when Greece sank to the lowest depth of weakness' (7.17.1), and had a contributory effect in forming the Greece of his own day.

Although Pausanias says that Mummius 'dismantled the walls of all the cities that had fought against the Romans' and imposed tribute payments and fines (7.16.6–7), it is on his actions against Corinth that he concentrates his attention. It is my belief that for Pausanias, Corinth was the centre of the influx of 'Romanitas' into Greece and, as such, it was for him both an exemplar and an exceptional case.

Corinth became the largest city of the province of Achaia, and it is no surprise that Pausanias' contemporary, Apuleius, says that Corinth 'caput est totius Achaiae provinciae' (*Met.* 10.18).[28] Patrai is another candidate for the crucial role in the creation of Roman Greece, and it is true that Pausanias has much to say about it (see below, pp. 134–6); however, it is striking that the passage of Pausanias just quoted comes in book seven, on Achaea, and specifically leading to Patrai. This established at least a parallel, if not the priority of Corinth. Closer examination of Pausanias' references to Corinth follows at each appropriate place in the text. For immediate purposes, Mummius is under discussion, and I begin by looking at other writers' views of him.

The ancient view of the sack of Corinth

There is every reason to see Mummius as the one whose destruction of Corinth set new standards of thoroughness, and marked the beginning of the provincial status of Greece. He was given the cognomen 'Achaicus' in recognition of the sack of Corinth (e.g. Pliny, *NH* 35.24).

The sack of Corinth by Mummius attracted the concern of Cicero, who said that 'through a specious appearance of expediency wrong is

[27] Related passages are discussed by Habicht (1985) 108–9.

[28] Apuleius' phrase need not denote 'capital' in the administrative sense, and the notion of provincial 'capitals' is not universally favoured: Engels (1990) 199 n.41; Alcock (1993) 133; Kent (1966) 18. It is symptomatic that Engels (19, 8) and Alcock (18, 156) call it both the probable capital and the capital. Burton (1976) stresses the importance of assize-towns in sharing the administrative duties of a province. It may still be, of course, that a city like Corinth, the largest in its province, was of symbolic and emotional significance.

very often committed in transactions between state and state, as by our own country in the destruction of Corinth' (*Off.* 3.46). He goes on immediately to describe 'a more cruel wrong' committed by the Athenians against the Aiginetans. Here Cicero characterizes Mummius' actions negatively (even, by association with the Athenian action, as an atrocity), and in the *Verrines*, he uses Mummius as the climax of a list of predators who have despoiled Greece of its art. As with the rest of the *Verrines* in particular, and Cicero's work in general, there is a rhetorical imperative operating, in this case to stress the beauty and importance of any city destroyed by an opponent as a means of denigrating the perpetrator as convincingly and as thoroughly as possible. Here the point is to contrast the personally covetous behaviour of Verres with the empty home even of Mummius, the destroyer of Corinth, and despoiler of its art (on Verres' adorning his own home, *Verr.* 2.50). Cicero lists the destruction of art by Marcellus, who is particularly relevant since he had in 211 BC despoiled Syracuse of its art, providing Rome with its first substantial influx of Greek art, as Plutarch observes (*Marc.* 21.1). As in the passage concerning Mummius, Cicero understates the effects of Marcellus' actions on Syracuse in order to throw the harshest possible light on Verres.[29]

Cicero then continues with Scipio and Flamininus, and ends with 'Mummius who destroyed the beautiful city of Corinth, full of art treasures of every kind ... These were men of high rank and eminent character, but their houses were empty of statues and pictures; while we still see the whole city, and the temples of the gods, and every part of Italy, adorned with the gifts and memorials that they brought us' (*Verr.* 2.55). For Cicero's rhetoric to have greatest impact, he portrays the quality of the works taken over the years as the highest possible; the comparison with Mummius is, by implication, the worst credible, a true measure of Mummius' impact.

Vitruvius refers to Mummius' destruction of the theatre at Corinth, and his carrying off bronze vessels which he later sold at Rome (5.5.8).

A theme which runs through the sources on Mummius is that he adorned not his own home, but the city and country (i.e. Italy) as a whole. This is taken up again by Cicero (*Off.* 2.22), and elsewhere, e.g. *De Vir. Illust.* 60: 'Mummius despoiled Corinth of its statues and paintings, filled the whole of Italy with them, and kept none for his own home'; Pliny *NH* 34.36: 'Mummius after conquering Achaia

[29] Ferrary (1988) 576, *contra* Pietilä-Castrén (1978) 123 and n.51, who takes Cicero at face value.

filled the city with statues, though destined not to leave enough at his death to provide a dowry for his daughter – for why not mention this as well as the excuse for it?'

Although not mentioning Mummius' home, Strabo mentions the distribution of the spoils of Corinth: 'The most and best of the other dedicatory offerings at Rome came from there; and the cities in the neighbourhood of Rome also obtained some' (8.6.23). The implications of this statement are significant: the sheer quantity of public monuments in Rome by Strabo's day was enormous, and for the majority of these to have come from one city confirms the impression given by other writers that the 'contribution' of Mummius to the public embellishment of Rome was considerable, and his deprivation of Corinth correspondingly so. By the time of Strabo, these statues would have been in place for over a century, an indication of their lasting impact, consonant with his statement that these were also the 'best' of the public monuments of Rome. So the awareness of Mummius' deeds and their consequences seems to have been high from the time of the destruction of Corinth, and it remained so until that of Pausanias (and no doubt beyond).

Pausanias' view of the sack of Corinth

Pausanias describes the human aspect of Mummius' attack on Corinth, including the massacring of men and the selling into slavery of women and children (7.16.8). The description is, of course, not based on autopsy but neither does it conform to what we know of the conventions for describing the sack of a city (see above, p. 20). As a turning point in the subjugation of Greece, the event needed stressing, and a detailed description of this kind is almost a pre-requisite for communicating its significance. That this is the crucial event in the history of Corinth, and thereby in the transition of Greece as a whole to a Roman province (notwithstanding its formal incorporation in 27 BC), is shown not least by the contrast with Pausanias' low-key description of the acquisition of Corinth by Flamininus (7.8.1–2).

Pausanias' references to Mummius' acts in relation to the art of Corinth concur with those of other authors in principle, but add two interesting details, typical of his own interests. First, in mentioning the art (7.16.8), he refers to those works carried off as Corinth's 'most admired' pieces, concurring in artistic judgement with the other

sources (cf. Strabo's word 'best' cited above). But in the same sentence he adds a note not struck in any other account, namely a religious one: 'their most admired monuments of piety (*anathemata*) and art he carried off'. A better translation for *anathemata* might be 'votive offerings', as Frazer translates the word apropos of Sulla at 9.7.5. Throughout Pausanias' writings, art and piety are frequently inextricably entwined, and the phrase should not imply that *anathemata* exclude works of art.

Although there is no explicit reference in Pausanias to any religious inappropriateness in Mummius' actions, the use of the word *anathema* does sound a note not found in any other account. This may be put down to Pausanias' personal interest in religion, in this case his reporting of the stealing of *anathemata* communicating the sense of violation felt by him and not shared by the other writers. As I will argue below, this is indicative and symbolic for Pausanias of the violation not only of Corinth, but of Greece as a whole, and its replacement by the invading power of Rome. Indeed, talking of the Mummian destruction, he says that 'this was the period when Greece sank to the lowest depth of weakness' (7.17.1). He continues by saying that 'from time immemorial indeed, parts of it had been wasted and ravaged by the hand of God'. He then gives a fairly long exposition of the stages in the decline and fall of Greece, beginning with the Dorian invasion, including such events as the fifth-century plague at Athens and the rise of Macedonia, and continuing as far as Nero and Vespasian (the passage is discussed below). The process is one of degeneration, temporarily halted by the Achaean League (7.17.2), but resuming with Mummius. The place of Corinth in the history of Roman Greece until Pausanias' time is therefore central.

Secondly, and as a counterbalance, Pausanias says 'the less valuable [monuments, Mummius] presented to Philopoimen, the general of Attalos, and in my time the spoils of Corinth were still to be seen at Pergamon' (7.16.8, the continuation of the passage quoted above). He does not mention, and may not have known, that the objects were sold, at least according to Pliny (*NH* 35.24), referring to squabbling between Mummius and Attalos over a painting bought by Attalos and subsequently recognized as valuable by Mummius, who retrieved it. In the same passage, Pliny observes that from the sale of booty from Corinth by Mummius originated 'the high esteem attached officially to foreign paintings at Rome'; if this is accurate, it

is hard to attribute it to any sense of connoisseurship on the part of Mummius.[30]

Pliny's story is similar in essence (and intent) to that told by Velleius Paterculus that 'Mummius was so lacking in culture that, when he had captured Corinth and was arranging for the transportation to Italy of paintings and statues, which were masterpieces by the hands of the greatest artists, he warned those in charge of the transportation that if they destroyed any of the statues and paintings, they would have to replace them with new ones' (1.13.4, tr. Pollitt). It has been suggested that Velleius may have misunderstood Mummius' actions, and that his hostility may have resulted from this ignorance.[31] Whatever the origin of this tradition, it is one to which Pausanias does not subscribe. Indeed, the fact that Mummius retained the more valuable monuments rather than hand them over to Philopoimen suggests that Pausanias at least thought him capable of distinguishing valuable from less valuable,[32] although (as with Pliny's story) it is not at all clear that this reflects on his art-historical rather than his purely commercial judgement.

Pausanias' reference to Corinth's monuments not only being carried off by Mummius, but also being displayed elsewhere, echoes the other writers. However, while they talk of Rome and Italy as the place of display, he refers to Pergamon, in his home territory of Asia Minor, typically placing the stress on autopsy, as is natural for one of his background. Pausanias makes no reference to Mummius' not using the spoils to adorn his own home, in contrast to the sources cited above. This increases the possibility that their mention of it is a rhetorical element designed to heighten the particular emotion they are attempting to evoke. Mummius' lack of self-interest in not adorning his own home is noted with approval; for Pausanias, even if he were aware of the story and believed it, it could hardly have been counted a significant balance to the seminal destruction of Corinth which Mummius wrought.

Since Pausanias' interest was in Greece rather than in Rome, he sees the destruction and despoiling as a Greek would, albeit not as a mainland Greek: 'the old population of Corinth is entirely gone: the present population is a colony sent out by the Romans' (2.1.2). He goes on to mention the founding of the veteran colony by Julius Caesar, and with him a new political system (as he does also at

[30] Pollitt says that Pausanias' account here 'is probably more trustworthy' (Pollitt (1983) 47 n.82).
[31] Pietilä–Castrén (1982) 142. [32] Gruen (1992) 125.

3.11.4). Caesar's refoundation of Corinth acts to some extent as an 'antidote' to Mummius' destruction, and the true importance of Corinth in the process of transition from ancient to modern, Roman, Greece is best assessed in connection with its re-foundation under Caesar.

For Pausanias, the removal of votives and other works of art from Greece, their rightful place, inevitably caused distress and anger, sensitive as he was to the idea of appropriateness and setting. The chiastic parallel of ancient Greek objects transported out of Greece, and modern Roman citizens imported into Greece, here specifically Corinth, is a deliberate and striking one, and Pausanias disdains both halves of the equation. The subsequent Hellenization of both the city and its population was remarked on in the early second century AD (Ps.Dio Chrysostom [Favorinus] *Or.* 37.26). But, although the Hellenizing of Corinth is undeniable, it is, in Charles Williams' words, the result of 'the Greek influences and pressures that culminated in the Hadrianic wave of pan-Hellenism'.[33] It cannot, in short, be attributed to the period of the Caesarian re-foundation, nor be seen as a consequence of it.

It seems to me inescapable that Pausanias is precisely distancing 'the present population', if not scorning them, by referring to them even two hundred years on as 'a colony planted by the Romans'. The clear implication is that he thinks of them as Romans even after some six or so generations, and that mere habitation decidedly does *not* confer the 'Greekness' which would give them the distance from the Romans which he is unwilling to assign to them.[34] A further element here is the 'mock-Greekness' of the Roman remains, the 'falsification' argued for below (pp. 113–14). I suggest that from Pausanias' standpoint, this 'falsification' was every bit as applicable to the population as to the buildings, and that by distancing the present population of Corinth from what he sees as the Greeks proper, he is strengthening the impression of his own distance from the Romans, and thereby emphasizing his own claims as a Greek.

Mummius has another claim to originality in Pausanias' text: 'we know of no Roman before Mummius, whether private person or senator, who dedicated an offering (*anathema*) in a Greek sanctuary'

[33] Williams (1987) 35, also citing this passage, as does Alcock (1993) 169. Williams also adduces (37 n.20) epigraphic support (Kent (1966) 18–9).

[34] I disagree with Elsner's view that 'by virtue of being in that place, according to the Pausanian definition these people had become "Greek"; the place itself had imparted its identity to them' (Elsner (1992) 15). It is not clear what 'the Pausanian definition' is (also, see below, p. 113n.17).

(5.24.4, describing a bronze Zeus dedicated by Mummius at Olympia, and a possible second one; he also dedicated, on the architrave of the temple of Zeus at Olympia, twenty-one gilded shields to mark the sack of Corinth (5.10.5)).[35] Earlier dedications appear to invalidate Pausanias' claim, for example those of Flamininus at Delphi, attested by Plutarch (*Flam.* 12.6–7) who, as a priest at Delphi, would have known. However, Yannis Tzifopoulos has recently argued that Pausanias is in fact correct on the grounds that his word *anathema* has been incorrectly translated, and in this case refers to a specific type of dedication, namely Zeus statues.[36] This very specific meaning requires a use of *anathema* which is not paralleled elsewhere, although the word is regularly used by Pausanias (see above, p. 93); it also requires a different meaning from that used elsewhere in this very passage (as Tzifopoulos himself observes[37]). The issue is not clear-cut but, although I disagree with Tzifopoulos' hypothesis, the question is not of primary importance for present purposes: as I have stressed elsewhere, the focus of my study is on what Pausanias believes rather than on whether he is right to believe it. In this case, genuine ignorance is a highly probable explanation of this omission: it is unlikely indeed that Pausanias would have credited Mummius with being the first Roman to dedicate at a Greek sanctuary if he had not thought this to be true.

A final point arising from Pausanias' account of Mummius and Olympia concerns four portrait statues of Mummius of which the bases are preserved: as Tzifopolous observes, 'The reason for Pausanias' deliberate omission of these four dedications of Mummius, which in a sense glorify the personal achievement of the Roman consul, must lie in his negative opinion about Mummius' excesses after his victory'.[38] While it would be inappropriate to ascribe the omission of all such portrait statues to disdain for the figure portrayed (the example of the imperial statues in the Metroon at Olympia comes to mind), such a motivation in this case seems inescapable and perfectly consistent with the rest of Pausanias' attitude to Mummius.

Pausanias gives the occasion of Mummius' dedications: the shields 'after he had conquered the Achaians, taken Corinth, and expelled its Dorian inhabitants' (his purposefully chosen words again reflecting

[35] Other dedications of Mummius at Olympia included at least two statues of himself, attested by inscribed bases (Frazer III.634–5). [36] Tzifopoulos (1993).

[37] Tzifopoulos (1993) 95.

[38] Tzifopoulos (1993) 99. On the Mummian statue-bases, Philipp and Koenigs (1979).

his distaste at the fate of the indigenous, Greek, population), and the Zeus 'from the spoils of Achaia'. The implication is that such dedications compound rather than expiate Mummius' impiety – after all, the word *anathema* is precisely that used for some of the objects Mummius carried off from Corinth (7.16.8; also at 9.7.5 where Sulla takes *anathemata*, among other objects, from Delphi to distribute among the army (further, see below, p. 102)). Nor should we read any lessening of the implicit condemnation into the fact that some of the maltreatment inflicted on Greece by Mummius was reversed because 'not many years afterwards the Romans took pity on Greece' (7.16.10), suggesting that even the Romans found his repressive actions in Greece too strong.

SULLA

A divine rain of ashes on the Athenians in 87 BC is implied by Pausanias (9.6.6) to have foretold the coming in the next year of Sulla and his peculiarly destructive visit to Athens, and ushers in the strongly religious, almost mystic, aura connected with Sulla, and the highly personal terms in which accounts of his actions are written. It is known that Sulla's own autobiographical writings laid stress on his belief in omens,[39] and it is certain that these writings were influential upon Plutarch, as they may well have been upon Pausanias also. But we cannot tell whether they might have influenced Pausanias only indirectly as part of the received tradition of Sulla's life by his time, nor how much of the perspective goes back to Sulla. I begin by assessing briefly Sulla's own attitude towards Greece; while this takes us temporarily away from Pausanias, it allows Pausanias' account to be seen in context and in relation to other accounts, rather than in isolation. Further sections examine in detail Pausanias' own view of Sulla's actions in Greece (particularly Eleusis and Athens), and of his character.

Sulla's attitude to Greece

There are indications of a positive attitude towards Greece on the part of Sulla, but they need to be considered with caution and not at face value. First, he may well have been an initiate at Eleusis – at the

[39] Lewis (1993) 665–9; as he observes, Augustus and Hadrian also made a point of their belief in omens in their autobiographical writings (669–89, 697–702).

least, he was initiated into one of the mysteries very soon after his arrival in Athens (see below, p. 99). If it was indeed the Eleusinian Mysteries that he was initiated into, this may have been a significant attempt to identify himself with one of the oldest and most secretive aspects of established Greek religion, or simply part of the paraphernalia of being 'in charge' of Athens. We cannot know this but, although several references will be made in this chapter to the relations of later rulers with Eleusis, it is certainly the case that initiation became a common practice among prominent Republican figures, such as Cicero, and perhaps Antony.[40]

Secondly, epigraphical evidence from Oropos in Attica reveals that Sulla had made a vow to Amphiaraos, giving land which he had exempted from tax as a result.[41] Appropriately, Amphiaraos was not the only healing deity with whom Sulla had dealings (see below, p. 99). It was also in Sulla's time that the games to Amphiaraos at Oropos, established since at least the fourth century, began to include Roma.[42] As Sherk observes, 'the decision to extend the games to honour Rome was most wise. This brought the precinct to the attention of Sulla.'[43] Not for the only time, this shows an awareness on the part of local inhabitants of how best to flatter the Romans in order to extract benefactions.

Thirdly, as Christopher Pelling notes, Plutarch suggests that Sulla spared Athenian captives because of Athens' glorious past (*Sulla* 14.5).[44] This is at odds with Plutarch's giving as one explanation of Sulla's 'dreadful and inexorable passion for the capture of Athens' his 'fighting . . . against the shadow of the city's former glory' (13.1, cited below, p. 104). The contradictory uses to which Athens' past is put in these two almost directly juxtaposed quotations say less about Sulla than about Plutarch.

On one occasion, a long-established Greek sanctuary even came to Sulla's aid: 'from Lebadeia and the cave of Trophonios favourable

[40] Antony's initiation is uncertain, as Plutarch (*Ant.* 23.2) refers to 'mysteries' which, as in the case of Sulla, need not refer to the Eleusinian rites (Clinton (1989b) 1506). Antony was, however, honoured by the Athenians, who dedicated statues of Antony and Cleopatra on the Akropolis (Cassius Dio 50.15.2, telling how the statues were struck down into the theatre by thunderbolts as a portent (Habicht (1992) 86); on statues as portents, see below, p. 123). Elsewhere in Greece, Plutarch says that Antony undertook in 42 BC to complete the temple of Apollo, presumably that at Delphi, which had been damaged by Thracians or Illyrians (*Ant.* 23.3; Levin (1989) 1603–4; Jones (1966) 65, wonders if the temple at Megara is meant).
[41] Sherk (1969) no. 23; Price (1984a) 33; Cicero, *De nat. deorum* 3.49; Travlos (1988) 302, 317 fig. 400. [42] *SIG²* III 1064; Mellor (1975) 106. [43] Sherk (1969) 138.
[44] Pelling (1990) 33; however, Plutarch makes it clear that Sulla spared only a few.

utterances and oracles announcing victory were now sent out to the Romans' (Plut. *Sulla* 17.1). The favour shown to Sulla by a healing sanctuary is of particular interest, given the several healing associations in the accounts of his life, culminating in his death, but including his interest in Amphiaraos at Oropos.[45] Perhaps it was this very ambivalence between the semi-mystic associations noted above – the approval of an oracle sits well with the portent of divine rain – and the particularly irreligious behaviour of Sulla that made him such an intrusive feature of the Roman expansion.

Sulla, Eleusis and Athens

Appian tells us of Sulla's travels from northern Greece to Thebes and on to Athens (*Mith.* 30). Plutarch tells us that Sulla had been rapidly initiated into 'the mysteries' on his entry to Athens (Plut. *Sulla* 26.1: 'on the third day he came to anchor in Peiraeus. He was now initiated into the mysteries'). Although this is most readily taken as referring to the Eleusinian Mysteries, this is not certain.[46]

Pausanias does not mention Sulla's travels, which, with the exception of Thebes and Athens, were outside the geographical scope he had set himself, and thus of no interest to him. This may also explain why Pausanias makes no mention of Sulla's later declaration of the freedom of Ilion, Chios, Lycia, Rhodes and Magnesia (Appian, *Mith.* 61). Nor does he mention an initiation of Sulla into the Eleusinian Mysteries.

Pausanias was himself apparently an initiate (it is hard not to interpret 1.38.7 thus),[47] and the Eleusinian Mysteries were important to him, above all for their sanctity (5.10.1). While the rites themselves remained mainly unchanged in the Roman period (as far as we can deduce from our sources), the Mysteries were at their height in Pausanias' day, as the extensive Roman building indicates.[48] Unfortunately for his modern readers, a dream prevented Pausanias from describing the sanctuary and its rites (1.38.7). Although they

[45] On Trophonios as a healer, Pausanias notes at Lebadeia images which may be of Asklepios and Hygeia or Trophonios and Herkyna (a personification of a local river), and the similarity of the images of Trophonios and Asklepios and their common association with snakes (9.39.3–4). Parker (1983) 213 n.31 on bathing in the cults of Asklepios, Trophonios and Amphiaraos. On Trophonios in the Roman period (based primarily on Pausanias), Levin (1989) 1637–42. [46] Clinton (1989b) 1503.

[47] *Pace* Habicht (1985) 156, there is nothing definitive in Pausanias to prove that he was an initiate, although all the signs are that he was (refs in Habicht).

[48] E.g. Alderink (1989).

were perhaps not as significant in Sulla's day, in Pausanias' view, from the perspective of the second century AD, they would have been in all probability of considerable importance. Sulla's initiation, if it occurred at all, would give the effect of Athens being destroyed by one of its own. Had Pausanias chosen to mention this, it would have reinforced the message of Sulla's impiety, but it would be uncharacteristic of Pausanias to attack someone in this way if such an attack did not arise naturally from his subject. And on the subject of Eleusis he is exceptionally quiet, not in fact mentioning the initiation of any individual.

Pausanias makes much of Sulla's depredations of cities and sanctuaries. Sulla most famously destroyed much of Athens, although only one of Pausanias' references to Sulla occurs in his chapters on Athens. We know some of Sulla's actions from Plutarch, who concentrates on the damage he caused in the Peiraeus, including the destruction of Philon's arsenal (*Sulla* 14.7; Strabo 9.1.15; Appian, *Mith.* 40).[49] And we know of the looting of works of art by Sulla's forces,[50] including Lucian's report of the removal of a painting by Zeuxis (*Zeuxis* or *Antiochos* 3).[51] Pliny (*NH* 36.45) tells us that Sulla took to Rome columns (plural, but an unspecified number) from the temple of Olympian Zeus, a long-standing and unfinished monument which was to be of future interest to Roman emperors, most notably Hadrian (see below, pp. 172–5). His intention, according to Pliny, was to use them to adorn the temples on the Capitol; in fact, the most prominent usage was to be on the temple of Jupiter Optimus Maximus which was burnt down in 83 BC, after Sulla's looting.[52] Although Pausanias gives much attention to the temple of Olympian Zeus, it is in the context of Hadrian's completion of it, and he makes no mention of Sulla's removal of columns from it.

Pausanias is one of several sources for the destruction by burning of the Odeion of Perikles. He places the blame for this firmly on Sulla (1.20.4), while Appian, in contrast to Pausanias, says that Aristion and a few other Athenians burnt the Odeion themselves in order to deprive Sulla of wood to use against the Akropolis (*Mith.* 38). Aristion is also mentioned by Pausanias, but as the man who 'persuaded the Athenians to prefer Mithridates to the Romans' (1.20.5; also, see

[49] On the Peiraeus in general, Garland (1987); Travlos (1988) 340–63; von Eickstedt (1991).
[50] Garland (1987) 56, 190; Larsen (1938) 426, and on looting from the Akropolis. On Sulla's possible responsibility for the disappearance of a statue from Athens, Munn (1993) 182–3 n.94.
[51] Pollitt (1990) 151–3, (1983) 64. [52] Abramson (1974), esp. 8–22.

below, p. 207), a view with which Plutarch (*Sulla* 12.1) concurs (and cf. Strabo 9.1.20). In saying this, Pausanias is laying a heavy responsibility on Aristion as it was this favouritism which provoked Sulla's destruction of Athens (so too the deprivation by Sulla of half the territory of Thebes, which had sided with Athens against Rome, 9.7.4). There is a footnote to this tale: in Pausanias' account, it is Sulla's maltreatment of Aristion as a suppliant which caused his own death (1.20.7; see below, p. 105).

It may be that Pausanias was unaware of an alternative version of the story of the destruction of the Odeion, although it would seem strange that it should be known to his contemporary, Appian, whose work may well have been published by then and thus perhaps available to Pausanias. It is possible that he was deliberately suppressing the version he does not give in order to keep Sulla in as bad a light as possible, but we have no means of knowing if this is so. Pausanias notes that the Odeion of Perikles had been rebuilt after Sulla's destruction (self-evidently this was true), and he may not have known the circumstances of the rebuilding. In fact, it was repaired not long after Sulla's time by Ariobarzanes Philopator of Cappadocia (65–52 BC), as we are informed by Vitruvius (5.9.1) and two honorary inscriptions.[53] It is possible that it was also Ariobarzanes who made good Sulla's damage to the theatre of Dionysos (not mentioned by Pausanias).[54]

Pausanias also talks of the removal by Sulla of the shields dedicated to Zeus Eleutherios after Thermopylai in the eponymous stoa in the Agora (10.21.5).

One action of Sulla's of which we do not hear from Pausanias was the removal from Athens of a library consisting mainly of the works of Aristotle and Theophrastus (Plut. *Sulla* 26.1; Strabo 13.1.54). This incident was not the first such example.[55] Strabo says that the library was subsequently sold; he does not say whether Sulla himself was responsible for this but, although he is not portrayed as being as boorish as Mummius, there is no hint in any of the sources that he was personally cultured enough to wish to use it. Indeed, the quotation attributed to him by Plutarch – 'I was not sent to Athens by the Romans to learn its history, but to subdue its rebels' (*Sulla* 13.4) – strongly suggests the opposite. One can but speculate as to why Pausanias did not mention the library: his background would lead

[53] *IG* II² 3426 for the architects; *IG* II² 3427 for honours to Ariobarzanes. Travlos (1971) 387.
[54] Travlos (1971) 538. [55] Griffin (1994) 693.

one to expect him to be particularly appalled by the theft of a library and not to remain silent if he knew of it.

The attention given to the physical destruction of Athens in Pausanias' account is limited. He gives more attention to Sulla's actions against people, such as his locking into the Kerameikos a number of Athenians and subsequently decimating them (1.20.6; Plut. *Sulla* 14.1–5; also, see above, pp. 21–2). Similarly, for the Athenians the Sullan incursion 'cost them such fearful sufferings' (9.6.4).

That Pausanias saw the visit of Sulla as marking a turning point in the history of Athens is clear from his words that 'although Athens suffered thus in the Roman war, it flourished again in the reign of Hadrian' (1.20.7). The implication that Sulla's actions ushered in a period of just over two hundred years of backwater status is clear, with a direct juxtaposition of 'suffered' and 'flourished'. The accuracy or otherwise of this assertion is better assessed when the reign of Hadrian is considered, but here it may be noted that the Hadrianic period is rightly, and not for the only time, seen as a crucial point in Athens' later prosperity, and that the late Republican and early Imperial periods are seen to have been undistinguished in Athens.

Sulla and the rest of Greece

Sulla's impact was felt well beyond Athens, and here too Pausanias has comments: Sulla 'took votive offerings (*anathemata*) from Olympia and Epidauros, and he took from Delphi all that the Phokians had left' (9.7.5). The latter presumably refers to the plundering of the offerings from the sanctuary at Delphi by the Phokians in order to raise a mercenary army during the third Sacred War of the mid fourth century (cf. Diodorus Siculus 16.23). Plundering of offerings was also cited above in relation to Mummius' deprivations of Corinth, where Pausanias refers to his carrying off *anathemata*. As also noted, throughout Pausanias' writings, art and piety are frequently inextricably entwined – here the *anathemata* may be presumed at least to have included works of art.

Elsewhere in Greece, Pausanias refers to Sulla's treatment of Thebes and Alalkomenai as 'similar' to that of Athens (9.33.6), adding that on Helikon is a statue of Dionysos by Myron dedicated by Sulla after he had taken it from Orchomenos. Further, 'he committed yet another outrage at Alalkomenai by carrying off the very image (*agalma*) of Athena' (9.33.6; and below, p. 137). These acts had

consequences, contributing towards the illness that killed him, although the immediate cause of his death is given as his maltreatment of a suppliant (1.20.7).

Plutarch too refers to Sulla's carrying off works from Olympia, Epidauros and Delphi, the latter including the 'little golden image (*agalmation*) of Apollo from Delphi which he always carried in his bosom when he was in battle' (Plut. *Sulla* 29.6). But Plutarch puts this in a different light, saying that Sulla, in order to raise funds for the war, sent for the *kallista kai polutelestata* of the *anathemata* at Epidauros and Olympia, the latter adjective translated by Frazer as 'most precious', although 'opulent' is perhaps preferable. There is no implication of concern for the aesthetic value of the objects, and one should not expect such concern of most people of Sulla's time – and certainly not of the Sulla portrayed by our sources – but we should of someone of Plutarch's and Pausanias' time. Sulla's attitude in this regard is comparable to that of Mummius, whose lack of aesthetic sensitivity has already been discussed. Sulla attempted to strike a different deal with the Delphic Amphictyony, requesting the god's treasure for safekeeping or, it is added, to spend and restore in kind later. That there is no genuine sense of consideration or piety in the manner of the request is clear from Sulla's rejection of the discouraging noises heard by his representative from the god at Delphi (Plut. *Sulla* 12.4–5).

Plutarch concurs with Pausanias in saying that Sulla had many objects removed from Delphi, including the silver bowl of Kroisos (cf. Hdt. 1.51), which had to be cut into pieces to be transported (*Sulla* 12.6). The cutting into pieces of the pithos causes Plutarch to remark that contemporary opinion had been that, in contrast to Sulla, even Titus Flamininus, Manilius Acilius and Aemilius Paullus 'had not only spared the sanctuaries of the Greeks, but had even made additional gifts to them, and greatly increased their honour and dignity' (*Sulla* 12.2). Indeed Plutarch mentions the dedications of Flamininus at Delphi (*Flam.* 12.6–7; see above, p. 96), and his account of Aemilius' triumphal procession makes no reference to the violation of any temple or sanctuary (see above, p. 81 n.4).[56]

And yet, like Mummius, Sulla dedicated objects; however, unlike those of Mummius, Pausanias does not mention his dedications neutrally. Speaking of what he regards as the second finest work of

[56] Levin (1989) 1601–3 on Roman attitudes to Delphi in the period up to Sulla.

Myron (a typically precise distinction, notable for its secondary status in this context), which was dedicated by Sulla at Helikon, Pausanias says 'it was not Sulla's to dedicate: he took it from the Minyans of Orchomenos. This is what the Greeks call worshipping god with other people's incense' (9.30.1) Thus Pausanias' feeling for piety and appropriateness is again apparent: the dedication may be appropriate, but not the dedicator. The idea of Romans, even conquering Romans, dedicating in Greek sanctuaries is not seen by Pausanias as inappropriate *per se*; it is however, in his view, inappropriate to Sulla.[57]

Sulla's character

From Pausanias' words on Athens, we may infer that Sulla's actions and hybris against people were of greater consequence to Pausanias than the damage inflicted on the physical attributes of the city. Plutarch also gives instances of Sulla's personal cruelty, his actions 'causing all men to regard him with fear and horror because of his murdering his dearest friends' (*Comparison* of Lysander and Sulla 2.4). For Plutarch, the destruction was pointless as Athens was already reduced to starvation (*Sulla* 12.1–2), a manifestation of his belief that Sulla 'was possessed by some dreadful and inexorable passion for the capture of Athens', perhaps because 'he was fighting with a sort of ardour against the shadow of the city's former glory', or from sheer anger at being abused by the tyrant Aristion (*Sulla* 13.1). Thus the irrationality of Sulla is forcefully communicated, and should be seen in conjunction with the highly personal accounts of his actions.

Pausanias sees Sulla's actions as a personal failing: 'Sulla's treatment of Athens was harsh and alien to the Roman character' (9.33.6). In the same way, he says that 'Sulla treated the mass of the Athenians with a cruelty unworthy of a Roman' (1.20.7). The former passage continues to note similar behaviour at Thebes, Orchomenos and Alalkomenai. The personal element is followed through to the (literally) bitter end for Sulla, whose death was by horrible lice-borne disease (9.33.6; Plut. *Sulla* 36).[58] The commonly related theme of previous good fortune is a topos also reflected in this connection: 'that was the miserable end of what the world had once esteemed his

[57] For a revisionist view of Sulla's activities in Greece (among other aspects of his life), Keaveney (1982); but note reviews by Briscoe (1985) and Stockton (1984). On Sulla in general, most recently Seager (1994).

[58] On the identification of Sulla's disease as phthiriasis, and why 'lice' is a more accurate translation than 'worms' (as B. Perrin, Loeb edn.), Keaveney and Madden (1982) 90; against phthiriasis (and lice), Africa (1982) 1–7. Also, Carney (1961).

good fortune' (9.33.6). And yet Pausanias is careful to distance any idea that Sulla's death was a form of divine retribution for his cruelty towards the Athenians, attributing it still to divine vengeance but rather for his impiety towards the suppliant Aristion (1.20.7).[59] That Pausanias' account contains an element of personal feeling about Sulla is suggested by the fact that, although Plutarch attributes his death to the same cause, he attributes the origin of the disease to the much more mundane cause of Sulla's fondness for loose living (*Sulla* 36.1).[60] In Appian's account (*BC* 1.105), Sulla dies within a day of contracting a fever (of which he had warning in a dream), and there is no suggestion of impiety or of his meeting an appropriate fate.

Greek history has yielded several examples of bodily mortification among prominent people, such as Cassander who 'hunted to death the whole house of Alexander' and as an implied result, 'he swelled with a dropsy, and that bred worms in his body while he was still alive' (Paus. 9.7.2); and Galerius, who was eaten by worms from inside out (Lactantius, *On the deaths of the persecutors* 33).[61] Self-inflicted death by bodily mortification is perhaps most spectacularly attested by the case of Kleomenes of Sparta, who cut himself repeatedly until he died. Herodotos, in telling the story (6.75), passes on three explanations current at the time for his actions, all some form of impiety. The third of these explanations, that he killed Argive soldiers after taking them from the temple where they had taken refuge, brackets military success and impiety. Pausanias knew his Herodotos, and the parallel with Sulla's bodily suffering for his impiety may be more than coincidental.

The overwhelming impression from Pausanias, then, as from other writers (e.g. Appian, *Mith.* 36, 38–9; Val. Max. 2.8.7), is of Sulla's cruelty and repression. The *raison d'être* for his destruction of Athens was the siding of Athens against the Romans (1.20.4; cf. Plut. *Sulla* 6.12, 13.1), an element of vengeance in Sulla's actions which is not applicable to, for example, the destruction of Corinth by Mummius, and gives it its peculiar force.

[59] The notion of 'retribution' against Sulla is noted by Alcock (1994) 101, but in connection with 9.33.6 rather than 1.20.7. On the moral associations of diseases such as Sulla's, Africa (1982).

[60] Keaveney and Madden (1982) 94–5, opt for liver failure brought on by alcoholism; also, Keaveney (1982) 210–11. This is supported by Seager (1994) 207.

[61] On the deaths of Cassander and Galerius, Africa (1982), pointing out that Pausanias may have taken his account of Cassander's death from Hieronymos of Cardia (cf. 1.9.8), and that 'Cassander's malady may be just a propaganda smear' (p. 6).

Pausanias on the rulers of Roman Greece 2:
Caesar and Augustus

The bracketing of Caesar and Augustus in this chapter derives from
Pausanias' own view of them as, effectively, the founders of the
Roman Empire. He refers to both as *basileus* (e.g. 5.25.1, 2.17.3
respectively), a use of terminology which is discussed in the following
pages, and which clearly places Caesar at the head of the line of sole
rulers, the rest of whom belong to the Imperial period, rather than
associating him with the earlier, Republican, rulers. Such categorization
is more appropriate to the history of Roman Greece than would be a
conventional Republican/imperial divide.

JULIUS CAESAR

Unlike Mummius and Sulla, Caesar appears to have been widely
regarded as a cultured man: Pliny says that he 'gave outstanding
public importance to pictures by dedicating paintings of Ajax and
Medea in front of the temple of Venus Genetrix', the implication
being that he was the first to do so and that he thereby set a fashion
(*NH* 35.26, 7.126). The paintings referred to are by Timomachos of
Byzantium, a contemporary of Caesar's (*NH* 35.136), so this does not
represent a pursuit of antiquity.[1] Suetonius refers to him as 'a most
enthusiastic collector of gems, carvings, statues, and pictures by early
artists' (*Julius* 47), the latter phrase indicating a discriminating
preference for antiques. His practice of taking with him on campaign
'tessellata et sectilia pavimenta' (Suet. *Julius* 46) implies interest in
art *per se*, although not necessarily the art of a previous era. His
building programme, including temples in Italy and beyond (Suet.

[1] On these passages, Isager (1991) 119–20.

Julius 28.1, 44.1–3), is in a different category; nonetheless, it reflects his position as the first ruler to build extensively in the Roman world.

Caesar's patronage of the arts in the widest sense was no altruistic benefaction: when Suetonius refers to Caesar 'adorning the principal cities of Asia and Greece with magnificent public works, as well as those of Italy and the provinces of Gaul and Spain' (*Julius* 28.1), he does so in the context of Caesar's attempts 'to win the devotion of princes and provinces all over the world', and puts artistic benefactions on a par with giving away thousands of prisoners, and sending auxiliary troops. The public art is, then, purely a means to an end, however genuine Caesar's personal interest in the art he collected for himself. There is in these references no hint of piety or of interest in religious art; Suetonius' statement that 'in Gaul he pillaged shrines and temples of the gods' (*Julius* 54.2) should perhaps be distanced from the present context since this refers to the gods of Rome's enemies.

It is not as a destroyer that Caesar is regarded, either by Pausanias or by other literary sources; this in itself marks him off from Mummius and Sulla. He is known to have made the first contribution towards the funding for the 'Roman Agora' in Athens,[2] but these buildings receive no mention in Pausanias; his interest is rather in Caesar as, in his view, the father of the system of government which still prevailed under the Roman rule of his own day. It is no coincidence that all but one of Pausanias' references to Caesar concern Corinth, the city he re-founded as a veteran colony some hundred years after its destruction by Mummius. The picture painted by our sources, and confirmed by archaeology, is of a century of emptiness, apart only from the continuation of the Isthmian games, initially at Sikyon and, after the re-foundation, at the sanctuary of Poseidon at the Isthmus of Corinth, attested solely by Pausanias (2.2.2). As Williams has put it, after 146 BC, 'For 102 years Corinth remained a ruin, probably with squatters, but without a political life. During this interval the land that previously formed the *politeia* of Corinth was the *ager publicus* of Rome, with its use determined by leasing in Rome itself.'[3]

Given this picture, the continuation of the games, to which Pausanias is our only witness, is of greater interest than it might otherwise be, as an exception to the process of cessation and re-foundation. Even here, though, the movement of the games from Isthmia to Sikyon and back compromises that continuity (as Oscar

[2] Hoff (1989a); Shear (1981) 358–60. [3] Williams (1987) 26.

Broneer remarks, Pausanias' phraseology implies, rather than states, that the games were held at Sikyon).[4] Epigraphical evidence indicates that the Isthmian games were returned to Corinth at some time between 7 BC and AD 3. By that time, they included the Caesarea, instituted probably in 30 BC, and alternating with the Isthmian games.[5] Other agonistic foundations of the period included the quinquennial games at Octavian's foundation of Nikopolis after the victory at Actium (Suet. *Aug.* 18.2; see below, pp. 132–3).

A greater issue arises here: Williams has argued for an early introduction of emperor worship at Corinth, 'probably related to the establishment of the Caesarea contests at Isthmia'.[6] If, as Broneer says, the return of the games to Isthmia at some point between 7 BC and AD 3 included the celebration of the Caesarea, and if Williams is right in connecting the introduction of the emperor cult and the establishment of the Caesarea at Isthmia, it appears to follow that the emperor cult was introduced in Augustan times, if not as precisely as between 7 BC and 3 AD. This ties in neatly with the evidence Williams cites for an Augustan temple at Corinth or Isthmia, and with a possible Augustan date for Temple E, which he identifies with the temple to Octavia, sister of Augustus, mentioned by Pausanias (2.3.1).[7] Since Octavia died in 11 BC, if there were any qualms about dedicating a temple to her, these would have been overcome by 7 BC, if that is taken as the earliest date for this institution. While Temple E is certainly an imperial construction, there is evidence that the west end of the forum of Corinth had been planned for Caesar's veterans.[8]

While there is much evidence for the imperial cult at Corinth at all periods after its introduction, there was no cult of Roma until Hadrian's time (in contrast to Athens, for example, which had one probably from soon after the battle of Pydna in 168 BC, and perhaps as

[4] Broneer (1973) 67 n.2.

[5] Kent (1966) 28, favouring 2 BC for the return of the games to Corinth. Broneer (1973) 67 n.2 concurs with the range of dates Kent gives. Most recently, Gebhard (1993).

[6] Williams (1987) 29; also, 'whichever date one chooses [for the construction of Temple E], the date is close to, and possibly related to, the addition of the Imperial Games (Sebasteia) to the already established Caesarea and Isthmian games over which Corinth presided' (29–30, citing Kent (1966) 28 n.25 on the addition of imperial games to the Isthmian calendar under Tiberius).

[7] Williams (1987) 29; Williams (1989) 160: 'the earliest Temple E west of the forum was constructed . . . probably not much after the death of Augustus, or, possibly, as late as the reign of Caligula'; Williams cautiously goes a step further back, saying that 'one might argue that the earliest Temple E was planned under Augustus, even if not constructed and dedicated until later' (Williams (1987) 36 n.9). [8] Williams (1989) 162.

early as the beginning of the second century).[9] As a Roman re-foundation, Corinth had natural loyalties to Rome, and no need to invent loyalties by the religio-political device of the cult of Roma. Here again, we have a sense of Corinth as somehow different, and this remains apparent into Pausanias' day: Price notes that at Pergamon in the early second century AD, 'the successor of a dead member [of a local association] was to provide incense for the funeral. The use of incense at funerals was a Roman custom, which is otherwise found in the Greek East only at the funeral of a Roman lady at the Roman colony of Corinth'.[10]

In other respects, Caesar does not seem to have embellished Corinth, although his abortive plan to cut a canal through the Isthmus would surely have had a major impact on Corinth's potential prosperity (Suet. *Julius* 44.3). The area was surveyed for the project by Caligula (Suet. *Gaius* 21; see above, p. 86), which was subsequently started, but not completed, by Nero (Suet. *Nero* 19.2, below, p. 151). It was also contemplated by Herodes Atticus (see below, pp. 199–200). Pliny, listing attempts to cut the canal, cites the fates of those who attempted the task as evidence that it was 'an act of sacrilege' (*NH* 4.10); this theme is picked up in subsequent discussions (see below, p. 152).[11]

An ambiguity emerges between Caesar as restorer of what Mummius had destroyed, and as completer of the process of transformation from Greek to Roman that Mummius had so effectively started in Corinth, and thus in what became the new province of Achaia. If Caesar's re-foundation of Corinth acts to some extent as an 'antidote' to Mummius' destruction, the position of Corinth in the process of transition from ancient to modern, Roman, Greece is evident in Pausanias.

I suggest that Pausanias regarded Corinth as special, in that he believed it to be the first seat of Roman power in the form that he knew it in Greece during his lifetime. As noted in the discussion of Mummius, he clearly harbours resentment against the replacement of ancient Greeks by modern Romans. In addition, the conspicuous figure of Mummius is central to the process of Romanization and, although his activities affect other sites (such as Olympia), it is on Corinth and its environs that they are centred.

The subsequent re-invention of Corinth, set in train by Caesar and

[9] Mellor (1975) 101–2; the cult in Athens is placed in the third century by Williams (1987) 30–1.
[10] Price (1984a) 90.
[11] On the history of, and evidence for, attempts to cut the canal, Wiseman (1978) 48–51.

followed through by later emperors, is in contrast to the Roman history of either Patrai (in part a veteran colony like Corinth, in part formed by a synoikism of Greeks, unlike Corinth) or Athens (unlike Corinth or Patrai, a city of genuine continuity), and particular study is needed here. Pausanias is often misleading about provincial administration;[12] but at least as important is that he believes what he writes, not that he is right to do so. As previously emphasized, while historical accuracy is important as a gauge of Pausanias' writings, it is for the reader in some respects secondary to his beliefs and the way they affected his writing.

Pausanias and the Caesarian re-foundation of Corinth

Turning to Pausanias' references to the re-foundation of Corinth by Caesar in more detail, it has been noted that the Isthmian games continued after 146 (2.2.2) – the implication is that cessation would have been expected in such circumstances, and that the Isthmian games are an exception, perhaps a unique one. Pausanias' account of the Mummian–Caesarian history of Corinth may be seen in two phases: the destruction and its effects, and the re-foundation.

The destruction is noted as thorough: Pausanias relates that dismantling the walls of fortified towns was standard Roman practice, and that 'Corinth was laid utterly waste' by Mummius (2.1.2; cf. 2.3.7). Of visible remnants, 'the remarkable objects in the city include some remains of ancient Corinth, but most of them date from the period of the restoration' (2.2.6). How thorough the destruction was cannot be fully ascertained until all of ancient Corinth has been excavated (which at the moment seems unlikely to occur as it covered an extensive area and some at least lies under the modern town), but from what has been brought to light, Pausanias' assessment seems accurate. In spite of saying that most of the objects left in his time date from after the Caesarian re-foundation, Pausanias mentions a variety of pre-Roman objects (2.2.6–7), including gilded and painted *xoana* of Dionysos made from the tree in which Pentheus hid to spy on the Bacchai. Also, a temple of Fortune and its image; a shrine to all the gods; and statues of several gods, including Hermes and his temple.

The contrast of past and present, of Greek and Roman, runs through much of Pausanias' writings, not least concerning Corinth.

[12] E.g. Pausanias' statements on the governorship of Greece, criticized by Accame (1946) 7, and Ferrary (1988) 203–4.

However, the standard view of him as disdainful of the present, and particularly of its physical manifestations, is not borne out by his account of Corinth, probably for no more sinister a reason than the lack of ancient buildings and objects on which he himself remarks. Here he mentions the temple of Octavia, sister of Augustus (2.3.1), which was discussed above and identified with Temple E by Williams, and refers to baths, most of which may be presumed to be Roman rather than Greek. Of these baths, he selects two, assigning one to Hadrian and one, 'the most celebrated', to 'Eurykles, a Spartan' (2.3.5), probably the Hadrianic benefactor rather than his ancestor, the Eurykles mentioned by Strabo (8.5.1) as his contemporary, and the leading citizen of Sparta, responsible for much of its embellishment in the Augustan period.[13] In either case, this is another prominent mention of a Roman building, albeit of a type most characteristically Roman. That he should mention this one is attributable to its being 'the most celebrated' of the baths; that at least one, and perhaps both, of the baths he mentions should be Hadrianic is indicative of his special feeling for Hadrian. He mentions no other specific examples of Roman baths at Corinth. A bath was built at Isthmia in the second century, but whether or not before Pausanias' time is unclear;[14] he certainly omits the arch of the second half of the first century AD through which, as Roux observed, he presumably passed on his way to the site.[15] In the same passage, he refers to Hadrian's facilitating the plentiful water supply to Corinth by having it brought from Lake Stymphalos (also referred to at 8.22.3). Later, on the road from the Agora towards Sikyon, he refers to a 'Music-Hall' (2.3.6) – again, no details are given, but it may be that of Herodes Atticus at Corinth (Philostr. *VS* 551) – but this is only a passing mention, and is not a strong contrast with the omission of Herodes' nymphaion at Olympia (see above, pp. 37–8; on this passage, see below, p. 198).[16]

Not only is this objectively a good sample of Roman public buildings, but it covers a broad span of the empire, from Augustus to Hadrian. This is all the more striking in view of his omission of

[13] Cartledge and Spawforth (1989) 104, 111; the latter identification is argued by Frazer III.25.

[14] In the most recent publications on the bath, it is dated 'second century' (Yegül (1993) 95) and 'apparently' second century (Gregory (1993b) 149). Stylistic comparanda with the bath's black and white mosaic 'suggest a date in the mid second century' (Packard (1980) 344). In the latter case, Pausanias may well have seen the bath.

[15] Roux (1958) 92; Gregory and Mills (1984).

[16] Broneer believed in the identity of the buildings mentioned by Pausanias and Philostratos, seeing it as a late first-century AD construction remodelled by Herodes, perhaps after Pausanias' visit (Broneer (1932) 1, 64, 144–6).

buildings comparable to those listed here, such as Hadrian's aqueduct in Athens, the baths by the Olympieion in Athens, and the nymphaion at Olympia. The ascription of these omissions to Pausanias' dislike of modern buildings does not explain their presence in his account of Corinth. It is partly explicable by his introductory observation that 'the remarkable objects in the city include some remains of ancient Corinth, but most of them date from the period of the restoration' (2.2.6), but that still leaves him the straightforward option of omitting the modern objects and buildings.

Why, then, did Pausanias not reduce his discussion of Roman Corinth to the level of that of Roman Olympia or of so much of non-Hadrianic Roman Athens? I suggest that the reason why Corinth could not be ignored or given only minimal attention, however unpalatable its present appearance, was that it was the cornerstone of the Greece that Pausanias was visiting, in that he saw the type of government by which Greece was then ruled as stemming from Corinth and specifically from its re-foundation under Caesar. To omit, or put too little emphasis on, Corinth would be to miss an opportunity to explain the genesis of that system of government, to explain why Greece was in the state it was, and to miss a further opportunity, to evoke a past world, the Greek world of Corinth of which he saw comparatively few physical remains in front of him. This puts Corinth in a different category from the other cities he visited, where he had a wealth of surviving Greek objects and buildings to describe. In those cases, he had no need to evoke a Greek past by reference to what was no longer there, since his purpose was fulfilled simply by description of what was there.

As in Athens, the local inhabitants are given attention by Pausanias: 'the old population of Corinth is entirely gone: the present population is a colony sent out by the Romans' (2.1.2). Similarly, in writing of a portrait at Olympia of Alexander as Zeus, he says 'it was dedicated by a Corinthian, not one of the ancient Corinthians, but one of the modern population on whom the emperor (*basileus*) bestowed Corinth' (5.25.1; on the word *basileus* in this context, see below, pp. 114–16). Similarly, he refers to the Corinthians as 'the youngest of the Peloponnesians' (5.1.2); and to 'the destruction of Corinth by the Romans and the extinction of its old inhabitants' (2.3.7).

Pausanias thus reiterates on several occasions the theme of the lack of continuity in the population. The last reference in the previous

paragraph arises during his discussion of the discontinuation of established local rites, which is explained by the extinction of the inhabitants and which deliberately distances the refounded city from its Greek predecessor.[17] This is what Williams, remarking that the Romans in Corinth 'were not trying to coat their new religious facilities in the colony with any spirit of Hellenism' has called 'editing for contemporaneity'.[18] As he says, the 'colonists were determined to reshape the Corinthian landscape more to their liking. No apparent sympathy was shown for preservation of the Greek temple plan or of the operation of the cult [of Apollo] as known in the Greek period'. While this policy is widely applicable to the Roman period, it seems to have been adopted from the earliest, hence its early place in the discussion, with much of imperial Corinth still to be built.

Although it remains unspoken in this instance, the deliberate cessation of established local rites must have been a source of some concern to Pausanias: not only was he very conscious of the role of religion and cult, but he was equally aware of the importance of the local element in the fabric of the Greece that he saw and described.

It was noted above that Pausanias says that he had very few physical remains of Greek Corinth in front of him; and some of what was there he may have thought too far remodelled by the Romans to count any longer as Greek – the cursory mention of the 'temple with a statue of Apollo', if accurately taken as a reference to the sixth-century foundation on Temple Hill, may well reflect the re-orientation and re-structuring it underwent by the Romans.[19] Williams says that while the Romans 'knew about and tried to revive the Greek sanctuaries of the city', they 'were not concerned to restore them to their original form or recreate their original Greek ritual with any great precision or accuracy. Roman 'modernization' seems to have been much preferred to ancient Greek authenticity'.[20] While this is true, it may be observed that in Corinth (arguably the best case for examining such issues), although some cults were deliberately revived in an attempt to re-create or 're-invent' a past world, or at least to give it a new continuity, this was not done as some idle intellectual exercise, but with real buildings and objects.

[17] This passage is cited by Elsner as evidence that in Corinth, 'the place itself had imparted its identity to' the inhabitants (Elsner (1992) 15), but Pausanias' reference is to the *cessation* of rites in honour of Medea, the opposite of the continuation of them which one would expect if Elsner is right (also, see above, p. 95n.34). [18] Williams (1987) 31.
[19] Williams (1987) 31–2, above. [20] Williams (1987) 32.

One such, perhaps the best case, is that of the 'Apollo' temple just mentioned.

The 'falsification' inherent in the 're-invention' of the Apollo temple would not have appealed to Pausanias: throughout his writings, as I have argued, he is concerned not only with authenticity, but with detaching the layer of 'Romanitas' wherever possible. In other words, he was concerned with seeing what was original and surviving Greek cult as opposed to either Roman cult or a Roman veneer. It may be for this reason that Corinth apparently held limited appeal for him; he has stressed the eradication of its population, and that of its cults and traditions must inevitably follow. And it was, for him, confirmed by their deliberate suppression, as in the cases he cites at 2.3.7. It does not appear to me that in the case of Corinth at least, the revival of interest in Corinthian culture and cult exemplified for Pausanias the 'good' side of Roman interest in Greece.

While the lack of Greek objects may have led naturally to a concentration on the population, the picture of destruction is made more complete by the absence of indigenous inhabitants, and the picture of transformation, of Romanization, made clear by the presence of the imported (and imposed) population of re-settled veterans. In a world where antiquity legitimizes, the cessation of long-established cult, and the portrayal of the Corinthians as 'the youngest of the Peloponnesians' (5.1.2) implicitly undermines the 'authenticity' of Corinth.

Pausanias' attitude to Caesar

Of the personal importance of Caesar to the new city there can be no doubt: Pausanias refers to him as the person who repopulated Corinth (2.1.2), and as its *oikistes* (2.3.1). Further, it was Caesar who, in Pausanias' view, 'instituted at Rome the system of government under which we live' (2.1.2; the sentiment is also expressed at 3.11.4). In other words, not only did Caesar have a decisive impact on Corinth, but he had the same effect (in this respect at least) on Rome itself. It may or may not be so, but Pausanias clearly believed it was so.

Pausanias refers to Caesar as *basileus* (5.1.2, 5.25.1; for the latter passage, see above, p. 112). Both Frazer and Jones (Loeb edn) translate the word as 'emperor', and it is indeed the word regularly used by Pausanias for the emperors, as it is in contemporary literature

and documents (and is so used as early as the reign of Augustus[21]). But it may be objected that Caesar cannot be counted an emperor, and that the translation is, therefore, misleading. However, 'king' would be even more misleading, and no educated writer would interpret the word *basileus*, used in reference to an emperor, as meaning 'king'.[22] Indeed, this is an important point to clarify since sources speak of Caesar's seeking after kingship, despite his insistence that he did not want to be given the title of *basileus* (e.g. Appian, *BC* 2.107–8, 150; Cassius Dio 44.10.1). A much more satisfactory translation of *basileus* here would be 'sole ruler'. This and related issues will be discussed in connection with 3.11.4 (see below, p. 131); but here it may be stressed that this linguistic usage serves neatly to emphasize the similarity between Caesar's position and that of the emperors who followed him and with it, suggests Roman imperial perceptions of him as effectively the first emperor, something his actions could readily be used to justify, as also could the opposition they caused and the manner of his death. But the context of the use of *basileus* by Pausanias in writing of Caesar has the effect of equating his power *and* his rank with those of the emperors proper.[23] There is a danger of over-interpretation here: to provincial Greeks, Caesar was the first absolute ruler, and the niceties of the Roman constitution may well have been an irrelevance. Such continuity would be all the greater given that the Roman system could in this respect readily be grafted onto established Hellenistic kingship in the east.[24]

The implications of this usage for Pausanias' attitude to Caesar are not readily fathomable: perhaps he is simply, maybe carelessly, using an anachronistic phrase from the vantage point of the long-established empire; perhaps he means to elevate Caesar to a position parallel with the emperors. Pausanias uses the word *autokrator* in reference to an emperor (perhaps Vespasian, 8.29.3; see above, p. 82), and possibly of

[21] Millar (1977) 613, citing its use in poetry; for an early prose use, in the second half of the first century AD, Spawforth (1994a) 214. *Basileus* is the standard word for emperor in, for example, Philostratos.　　[22] Millar (1977) 614.

[23] Kevin Carroll, writing of the inscription concerning Nero on the Parthenon (below), suggests that Nero may have seen an equivalence of *basileus* and *imperator*, and that *basileus* would describe the 'rank or position' of rulers, rather than their power (Carroll (1982) 39–40). Spawforth takes the word *basileis* used by Appian (*BC* 2.70) to mean 'commanders' (Cartledge and Spawforth (1989) 95), and such a usage would explain what otherwise would be anomalies. C.P. Jones also notes an equivalence of *basileus* and emperor, but adds that in some literary sources, *basileus* 'may simply mean "great man", like the Latin *rex*' (Jones (1978) 164 n.47; also, 14). Millar (1977) 613, observes that 'no emperor ever used the title *rex*'.

[24] Millar (1977) 361, 448, 611–14.

Titus (8.16.5); it is also used in the inscription of Nero on the Parthenon (see below, p. 154 n.41). It is hard to see how *autokrator* could mean anything that *basileus* does not.[25] Whether or not Pausanias saw Caesar as anything other than, effectively, another emperor, at least he does not show signs of seeing him as a tyrant. That others did see him as a tyrant is implicit in the only literary reference, that of Cassius Dio, to the purposeful erection of bronze statues of Brutus and Cassius close to those of the Tyrannicides Harmodios and Aristogeiton after the assassination of Caesar, 'thus intimating that Brutus and Cassius had emulated their example' (47.20.4).[26] These statues presumably did not outlast Philippi: at least, Pausanias refers to two sets of statues of Tyrannicides in the Agora of Athens (1.8.5), but makes no mention of statues of Brutus and Cassius (or indeed of Brutus and Cassius at all).

AUGUSTUS

More buildings were put up in the provinces under Augustus than under any emperor with the exception of Hadrian.[27] This is in stark contrast to the eras of Mummius, Sulla and, less so, Caesar, and exemplifies the impact the Augustan age had on the cultural and religious life of the provinces, as it did on their political, administrative and financial lives. From this point, we can begin to see patterns of building, to deduce purpose behind them, and to assess the accuracy, completeness, and slant of the various written accounts, including that of Pausanias.

The buildings were extensively available to Pausanias, both in his home territory of Asia Minor, and in his chosen area of interest, mainland Greece. In addition to Pausanias' account and those of other authors we have, uniquely, the emperor's own account of his artistic and cultural benefactions in the *Res Gestae*.[28] The latter

[25] Cassius Dio regularly uses *autokrator* to mean emperor. The encomium ΕΙΣ ΒΑΣΙΛΕΙΑ, possibly by Aelius Aristides, also uses the word *autokrator*, apparently without signifiying a change in meaning; whether one believes it is by Aristides and therefore contemporary with Pausanias (as Jones (1972a), Barnes (1989) 254), or a third- or even fourth-century AD work (as e.g. Stertz (1979) esp. 174), is not material (neither Jones nor Stertz raise the question). Most recently, Librale (1994).

[26] Cited by Thompson (1987) 9. Plut. *Brutus* 24.1 refers to Brutus being well received in Athens. Pausanias makes no mention of Brutus or Cassius. [27] MacMullen (1959) 209.

[28] Brunt and Moore (1967). Whether Augustus detailed any such benefactions in the thirteen books of autobiography he wrote covering the period to 25 BC (when he was, of course, in a lesser position to make such benefactions), cannot now be ascertained (Lewis (1993) 669–89).

perhaps needs to be treated with more scepticism than any other account, since on occasion accuracy may have yielded to a desire to impress, but it is nonetheless invaluable.

Pausanias, Augustus and Asia Minor

Before considering the contribution of Augustus to the embellishment of Greece, and how Pausanias regards that contribution, I begin by examining Augustus' actions as they affected Pausanias' native territory of Asia Minor. Although Pausanias lived long after Augustus' time, and I have argued that the world he lived in was shaped to a considerable extent by Hadrian, the beginnings of the process occurred under Augustus, and it is not least his legacy that surrounded and formed Pausanias.

In assessing any view of an emperor, including those presented in Pausanias' writings, it is fundamental to look at the imperial cult, described by Peter Garnsey and Richard Saller as 'Rome's main export to the empire'.[29] This is all the more true when the view under consideration is that of a writer from Asia Minor since, as Simon Price has observed, 'the evidence for this area is far richer than for any other part of the empire'.[30] A wide variety of literary, epigraphical, historical and archaeological evidence can be brought to bear, and Price's study of the imperial cult in Asia Minor carefully draws these threads together. Much of this section is indebted to his work.

In the present context, it is important to remember that, as Price puts it, 'the imperial cult . . . was probably the most important cult in the province of Asia'.[31] As he also says, the imperial cult 'was particularly common in Asia Minor', largely because it could better be matched to the traditional religious practices of that area, notably divine kingship.[32] The imperial cult was, then, a fundamental reality to someone of Pausanias' background and upbringing; further, it was at its peak, at least if judged by extant altars,[33] in the time of Hadrian, the presumed period of Pausanias' youth. Apart from Hadrian, there are more altars in Asia Minor to Augustus than to any other emperor. The prominence of these altars in Pausanias' day can safely be presumed. In addition, images and reminders of Augustus would have been almost omnipresent in Asia Minor in the form of statues, buildings, and other manifestations of the imperial

[29] Garnsey and Saller (1987) 164. [30] Price (1984a) 20. [31] Price (1984a) 130.
[32] Price (1984a) 78, 235–7. [33] Price (1984a) 69, 216.

presence.[34] Even in the calendar, Augustus was honoured in Asia Minor, his birthday being decreed to be the start of the new year; but, as with so many aspects of the imperial presence in the provinces, the initiative for this honour did not come from the emperor, but from the local inhabitants, in this case the *koinon* of Asia.[35]

Observing that Roman power in Asia Minor was consolidated in the Augustan period, Price notes that 'the cities continued to organize themselves and they, rather than Rome, were the primary centres of attachment for their inhabitants'.[36] Thus the pattern had long been in place by Pausanias' day of an Asia Minor which was firmly Roman in terms of its political structure, but which did not owe emotional loyalty to Rome. Such a political structure need be no more than an enabling framework, and does not dictate the cultural ties felt by the population: as Price remarks, 'the dominant culture of Asia Minor was Greek, at least by the time of the Roman empire'.[37] If this is true of the beginning of the empire (if not earlier), by Pausanias' time the Greekness of the culture must have been unchallengeable. Pausanias would, therefore, have been brought up in a world with a strongly Greek ambience and, more importantly, with a Roman administration dictating many mundane aspects of life but not central to the cultural advancement of educated individuals like himself. This, I suggest, must have affected his approach to mainland Greece when he came to travel; and the sense of appropriateness which I have remarked on before would have sat ill with the Roman aspects of Greece. These were fitting for Rome, but not for Greece or Asia Minor, and Pausanias would not be slow to see Rome as 'other' to the inhabitants of both Greece and Asia Minor.

The picture given by the combined weight of administrative, political, calendrical and religious evidence is of an overwhelming Roman presence in the Asia Minor of the early imperial period and of Pausanias' time. And yet, as Price observes, 'the culture of these communities was Greek, rather than Roman or indigenous, and the cult's basic characteristics were Greek rather than non-Greek . . . Many scholars are captivated by the evidence for Greek culture and

[34] The imperial cult as such may perhaps be excluded since it usually did not long outlast the individual concerned (Price (1984a) 61).

[35] Price (1984a) 56; also, 'Samos, for example, decided to start a new dating system from the apotheosis of Augustus' (p. 75), and Price (1984b). This may have been a smart piece of timing, since Augustus had refused freedom to Samos soon after 27 BC, as an inscription from Aphrodisias shows (Reynolds (1982) 104–6 no. 13; Sherk (1988) no.3).

[36] Price (1984a) 2. [37] Price (1984a) 20.

imagine that it represents the whole cultural picture of the imperial period, but this is to be duped by Greek cultural hegemony. There was another world of local culture, especially in the countryside, to which the imperial cult remained alien.'[38] It seems inherently probable that this is true of mainland Greeks of the imperial period as a whole, and the emphasis on the local would inevitably reflect and reinforce this.

It is very unlikely that someone as aware as Pausanias of the importance of local sources and local variations on established practices and myths would not be aware of the essential differences between mainland Greece and his own home province. These factors cannot but have affected the mode of reporting he adopted and are most apparent in his examination of the Greece that had existed before the coming of the Romans and that had been compromised, in part destroyed, by that coming. In this process, Augustus was central, arguably the founding father.

Augustus and Greece

Before considering in detail Pausanias' view of Augustus and his legacy in mainland Greece, other sources, including Augustus' own uniquely surviving record of his achievements (or, at least, claimed achievements) may be considered. The Augustan era was one which saw much Greek art in Rome, and placed a considerable emphasis on its display. The use of Greek art in this period has been examined in detail by Paul Zanker, who sums up the milieu created by Augustus thus: 'the age of Augustus attached a particularly high moral value to the practice of quoting from Classical art'.[39] Many examples could be given of imitations of familiar Classical statues, both freestanding athlete types and the undeniably religious. The latter aspect is central, with the imperial cult demanding an appropriate image and association, perhaps all the more so in areas distant from the seat of power.

The association of emperors with Zeus is one which could readily be made in art: this was most fully exploited by Hadrian, for which Pausanias is an important source. But the practice among the emperors of drawing this visual parallel begins with Augustus:

[38] Price (1984a) 78–9.
[39] Zanker (1988) 197; cf. 'the acknowledged moral superiority of Greek art of the Archaic and Classical periods' (89).

Zanker observes that 'ever since Alexander the Great, the Hellenistic world had rendered its rulers in the guise of Zeus, and . . . Augustus was no exception'.[40] Although Pausanias mentions no such example, he would have seen one, namely the statue of Augustus as Zeus found in the Metroon at Olympia, a building which was re-dedicated to the imperial cult, as we know from Pausanias' reference to 'statues of Roman emperors' (5.20.9), long since corroborated by excavation.[41]

In fact, although Zeus was exploited as an image of central importance by Alexander, the systematic appropriation of Zeus by rulers goes back to his depiction on coin blazons by Philip II.[42] In the same way, in representing himself as Zeus, Augustus appropriated a fixed image with strong associations and turned it to the ends of political self-promotion, furthered by its long-established intrinsic religious connotations. Thus the use of an established image enabled Augustus effectively to harness antiquity, complete with the sanctity that it bestowed, in advancing his claims to be (in Zanker's phrase) 'the gods' representative on earth'.[43]

As mentioned, the practice of a ruler depicting himself as Zeus is first regularly associated with Alexander. Augustus, in following Alexander's lead in this respect, also evoked the figure of Alexander himself, the great conqueror, a role to which a native of any of Rome's newly acquired provinces would have been particularly sensitive. The value of evoking such an association was considerable in the far provinces of Asia Minor and Achaia; Alexander's purpose seems not least to have been to associate himself with the past of the world he had conquered, and in which he sought to become accepted. With the notion of association with Zeus, other cult aspects of Augustus, and his own version of the imperial cult, come into play, and may briefly be noted here.

As well as with Zeus, Augustus wished to be associated with Apollo, promoting himself as the son of Apollo, or as the 'New Apollo', as we know from both literary evidence (e.g. Suet. *Aug.* 94.4; cf. Cassius Dio

[40] Zanker (1988) 230. On Alexander in Republican and early imperial literature, Isager (1993), esp. 78–80 on Augustus.

[41] Most recently, Hitzl (1991); also, Stone (1985); Price (1984a) 160 fig. 9; Alcock (1993) 190 fig. 69; Frazer III.622.

[42] 'Hitherto there had been but slight allusions to Zeus on some of the minor denominations of Philip's predecessors' (Kraay (1976) 146). To Philip also can be attributed a significant departure from tradition in the first recorded use of gold and ivory for statues of figures other than gods, namely the Macedonian royal family figured in the Philippeion at Olympia (Paus. 5.17.4, 5.20.9–10). Seiler (1986) 89–103. [43] Zanker (1988) 234.

51.1.2), and epigraphical evidence.[44] Augustus also restored an 'ancient temple of Apollo' at his foundation of Nikopolis (Suet. *Aug.* 18.2; cf. 'Actius . . . Apollo', Verg. *Aen.* 8.704).[45] An inscribed statue base of c.AD 2 refers to Gaius Caesar, son of Agrippa and adopted son of Augustus as the 'New Ares', and later, Tiberius' son Drusus Caesar was called 'New god Ares', and both may indicate a re-dedication of the mid-fifth-century temple of Ares to them.[46] None of the above is mentioned by Pausanias.

Much has been said in the preceding pages about the imperial cult and its impact on Greece and Asia Minor. Although Pausanias mentions many manifestations of the imperial cult, the only reference he makes to it is indirect, and scornful: 'in the present age . . . men are changed into gods no more, save in the hollow rhetoric which flattery addresses to power' (8.2.5). Here he is railing against modern *mores* rather than against individuals, and this certainly does not seem to have disturbed his apparent affinity with Hadrian, evidence of whose cult he would have found most commonly among the imperial cults around him.

Augustan building in Greece

Assessment of Augustan buildings in the provinces, including those in Greece, must be made against the background of contemporary building at Rome, for which we have Augustus' own statement of his buildings and re-buildings (*RG* 19–21). His claim to have restored eighty-two temples in his sixth consulship (28 BC) is well-known, as is Suetonius' reference to Augustus' transformation of a city of brick into a city of marble (*Aug.* 28.3). Perhaps more important for present purposes is his statement that after his victory at Actium, he returned to the temples of Asia objects stolen by Antony (*RG* 24.1).[47] The restoration of objects and the restoration of temples are kindred activities, but not parallel, since buildings could not be stolen in the way that objects could, although they could be re-dedicated, as Pausanias knew well (e.g. the Metroon at Olympia just mentioned).

[44] Hoff (1989a) 3 and n.16; Peppas-Delmousou discusses a statue of Apollo on the base of which the title 'New Apollo' appears for the first time (Peppas-Delmousou (1979) 128); also, Hoff (1994) 111); it is subsequently used by Nero (*IG* II² 3278, Sherk (1988) no. 78B, below).

[45] On reflections of Actium, Zanker (1988) 82–5. [46] Shear (1981) 362–3.

[47] Brunt and Moore (1967) 66. Compare Antony's reported wish to repair the temple of Apollo at Delphi (see above, p. 98 n.40).

Pausanias was presumably aware of restorations made by Augustus in his home province. As Zanker points out, the Augustan programme of renewal of eighty ruined temples in Attica (attested by epigraphical evidence) 'seems to be directly inspired by Augustus's campaign for the restoration of temples in Rome'.[48] The form of building in Athens can also be paralleled: the 'Roman Agora' has been described by Homer Thompson as 'looking for all the world like the Imperial Fora in Rome',[49] but it is in fact closer to some of the Kaisareia of the east,[50] a form which would have been familiar to Pausanias. Indeed, it has been suggested on different grounds that it was a focus for the early imperial cult.[51]

Although the reference to Asia in the passage from the *RG* cited above is the only occasion on which Augustus refers to his own buildings in the provinces, his reign did in fact see more extensive building than that of any emperor except Hadrian. Although Augustus nowhere refers to building in Greece, there are many Augustan monuments, too many to list here. The example has been cited of the possible Augustan temple at Corinth or Isthmia (see above, p. 108), but we have no evidence that Augustus himself was the donor.

In his first act following his success at Actium, according to Plutarch, Octavian 'sailed to Athens, and after making a settlement with the Greeks, he distributed the grain which remained over after the war among their cities' (*Ant.* 68.4).[52] He also had himself initiated into the Eleusinian Mysteries (Suet. *Aug.* 93), as Sulla may have been before him (and as rapidly – Plut. *Sulla* 26.1; see above, p. 99); he was the last emperor to be initiated until Hadrian.[53] Augustus' subsequent visits to Athens included a second initiation into the Mysteries in 19 BC (Cassius Dio 51.4.1, 54.9.10).[54]

Relations between Athens and Augustus were not all plain sailing: Plutarch (*Mor.* 207F) says that Augustus spent a winter on Aigina in order to indicate his displeasure towards Athens, from whom he took Aigina and Eretria. Bowersock, disagreeing with Graindor's date of 31/30 BC for this incident, dates it to 22/1 BC.[55] Cassius Dio attributes

[48] Zanker (1988) 261, citing *IG* II² 1035.
[49] Thompson (1987) 10. On the Augustan date of the Roman Agora, Hoff (1994) 108 n.49.
[50] Shear (1981) 359–60. [51] Hoff (1994) esp. 112. [52] Hoff (1989a) 4.
[53] Millar notes that after Augustus' initiation, he heard a case in Rome concerning the privileges of the Eleusinian priests (Millar (1977) 449).
[54] Hoff (1989a) 4–5; Clinton (1989b) 1507–9.
[55] Bowersock (1964), disagreeing with Graindor (1927) 18, 39. Bowersock is followed by Hoff (1989b) 267–8.

Augustus' ire to Athens' taking the side of Antony at Actium (54.7.2), a similar cause to that of Sulla's anger, although Augustus' reaction was considerably more moderate. Interestingly, the same presence of omens that characterized the advent of Sulla in Athens (see above, p. 97) is evident in this case: 'it seemed to the Athenians that the thing which had happened to the statue of Athena was responsible for this misfortune; for this statue on the Akropolis, which was placed to face the east, had turned around to the west and spat blood' (Cassius Dio 54.7.3).[56] For statues in other portentous contexts, see above, pp. 98 n.40 and 85 on Antony and on Caligula, respectively.

There was also an unfortunately ill-documented rebellion in Athens against Rome c.AD 13.[57]

At some point, the temple of Roma and Augustus was built on the Akropolis of Athens, the first physical embodiment in our surviving evidence of the cult of Roma in Athens, although the cult itself had existed there since at least the second quarter of the second century BC (see above, pp. 108–9). Pausanias omits the temple – perhaps the imperial cult was all too familiar – but his omission of it should be set against the fact that it is unrecorded in extant literature.

The inscription on the architrave of the temple of Roma and Augustus dates it to after Octavian's re-styling as Augustus by its use of 'Sebastos' (which, as Pausanias informs his readers, translates 'Augustus', 3.11.4), although no more precise evidence is forthcoming.[58] It is possible that the joint cult of Roma and Augustus had previously existed in the lower city of Athens, suggested by an inscription on a seat for a priest of the cult of Roma and Augustus in the theatre of Dionysos which, unlike that on the temple, does not include the words *ep'akropolei*, suggesting a situation elsewhere in Athens.[59] It is relevant here that thirteen small altars provide 'the most tangible evidence for the existence of the imperial cult in the lower city'.[60]

The inscription on the temple of Roma and Augustus shows that it was dedicated by the *demos* of Athens, not by Augustus himself. This is as one would expect since, although permission to set up imperial cults had to be obtained from the emperor,[61] the initiative would have been an Athenian one. The building of the temple would also have

[56] The passage is discussed by Hoff (1989a) 4; Alcock (1993) 214.
[57] Sherk (1988) no.24, with references; Hoff (1989b) 275–6.
[58] Hoff (1989a), Mellor (1975) 139, opting for 27–18 BC.
[59] Mellor (1975) 106, 140; Maass (1972) 116; cf. p. 121 on an Augustan inscription referring to a priest of Demos, the Graces and Roma. [60] Shear (1981) 363. [61] Price (1984a) 66.

been an Athenian initiative – most likely in the hope of benefactions – and there is no evidence that Augustus had any part in it other than presumably agreeing to it.

Zanker cites the temple of Roma and Augustus as an example of the fact, in his view, that 'the physical setting of the cult of the emperor was usually in the middle of the city, integrated into the centre of religious, political, and economic life'.[62] This is true only to an extent, since the Akropolis cannot be called the centre of political or economic life; the latter was increasingly focused round the Agora which had expanded during the Augustan period from the beginnings made by Caesar,[63] and the political life was still concentrated in the old, Greek, Agora (although admittedly the distinction between the two is to a large extent a false one in functional terms). I would, therefore, play down these aspects in Zanker's statement, which in turn emphasizes the religious aspect. How could it be otherwise, with a temple that not only enshrined the cult of Roma for the first time in Athens, but that gave the cult of Augustus himself 'equal billing' with that of Roma?

Two further aspects of the temple of Roma and Augustus linked it unmistakably with the Periklean buildings: first, the position of the temple, just beyond the east end of the Parthenon, with which it was axially aligned, was of immense significance. It was by the east end of the Parthenon that all who wished to enter would do so; and that many Romans did enter is not only common sense presumption, but may be deduced from the many imperial copies of the Parthenos.[64] A temple next to the east end, the main entrance, would not have failed to be noticed; the east end of the Parthenon itself was used for imperial advertisement/aggrandizement in Nero's time (see below, pp. 153–4). The physical juxtaposition may well have been intended to imply an association between Athena and Roma. Secondly, the architecture of the temple was in deliberately conspicuous imitation of, even homage to, the Ionic order and exceptionally elaborate detail of the neighbouring Erechtheion, the cult centre of the Akropolis. A more obvious example of archaism in the sense of association with the past by imitation is hard to find.[65]

Thus the temple associated Augustus not only with Roma but with the Parthenon and the Erechtheion, and it did so in the place where it would be most obvious. It should not, then, have been possible to

[62] Zanker (1988) 298. [63] Hoff (1989a). [64] Leipen (1971).
[65] The Forum Augustum in Rome of c.10–2 BC incorporated imitations of the Erechtheion karyatids (e.g. Ward-Perkins (1981) 32 fig. 9).

overlook the temple of Roma and Augustus; but, almost as if to eradicate any doubt, it was circular. There are few circular buildings in Greece, and a good proportion of those are of uncertain purpose, at least to the modern scholar: the tholoi at Epidauros (2.27.3) and at Delphi being the most conspicuous.[66] The tholos at Delphi may be the building Pausanias saw in the Marmaria with 'images (*eikones*) of Roman emperors' (10.8.6). The bibliography on the identity of the buildings in the Marmaria mentioned (and omitted) by Pausanias is extensive, and the question is unresolved, as it is likely to remain.[67] In Athens, the tholos in the Agora, dating from c.460 BC, was the closest example, but the temple of Vesta in Rome is more likely to have been the immediate inspiration.[68] There may have been a further prototype in Augustus' mind: the circular Philippeion at Olympia, which was used by Philip and Alexander for their own self-aggrandizement.[69] The appropriation of the image of Zeus was noted above as stemming originally from the Macedonians, and it is by no means impossible that it was in emulation of them that the cult of Augustus as ruler was housed in a circular building in one of the most ancient Greek sanctuaries.

Michael Hoff has wondered whether it is to the same period as the temple of Roma and Augustus that the plan by several unnamed kings to complete the temple of Olympian Zeus and dedicate it to the Genius of Augustus can be assigned (Suet. *Aug.* 60).[70] There is no hint of Augustus' view of the project, nor even that he knew of it; but, had it been completed, it might have served well his promotion of a parallel between himself and Zeus.

Vitruvius is our main source for the history of the temple of Olympian Zeus (3.2.8; 7 *praef.* 15, 17): it had been started in the second half of the sixth century by Peisistratos or his sons but was abandoned soon after, because of its tyrannical associations according to Vitruvius, but its presumably considerable expense may have been a factor. In the second quarter of the second century BC, Antiochos IV

[66] Seiler (1986). The tholos at Epidauros is called *thymele* in an inscription from the theatre (Burford (1969) 63 n.2, 66–8); Lawrence suggests that the word was 'presumably obsolete before Pausanias's visit' (Lawrence (1983) 390 n.4).

[67] E.g. Lerat (1985); Bookidis (1983); LeRoy (1977).

[68] The derivation from the temple of Vesta was suggested by Graindor (1927) 181, on the grounds of shape and Ionic order, and his belief that the temple of Roma and Augustus also housed the cult of Hestia. The lack in the Athens temple of the inner circular wall of the Rome temple suggests that the inspiration is of a general kind more concerned with the exterior than the interior.

[69] The Philippeion had previously been imitated by Ptolemy II for purposes of ruler-worship in the Heroon at Limyra (most recently, Stanzl (1993)). [70] Hoff (1989a) 6 n.34.

Epiphanes (175–163 BC) had introduced the first recorded Roman architect in Greece, Cossutius, and had advanced the project, fitting it with Corinthian columns (its original order is not clear, but was most likely Doric). Antiochos also dedicated in Athens and Olympia (5.12.4). Among his other depredations in Athens, Sulla had removed some columns of the temple of Olympian Zeus in order to help rebuild burnt temples on the Capitol at Rome (see above, p. 100). The damaging of the temple by Sulla, known to Augustus presumably not least because of the adornment of Rome by columns taken by Sulla from the temple, was at odds with Augustus' policy of restoration: as noted, there is epigraphical evidence for his restoring eighty ruined temples throughout Attica.

Pausanias on Augustus 1: art and buildings

In view of all the preceding evidence of his prominence, we would expect Augustus to have a high profile in Pausanias' work, and indeed he is mentioned more frequently than any emperor other than Hadrian.

The first mention of Augustus in Pausanias' narrative is at first sight perhaps the oddest: in his tour of Corinth, he says 'Augustus was emperor of Rome after Caesar, the founder of the present city of Corinth' (2.3.1). The passage has already been discussed for what it suggests about how Augustus might have been perceived in the Roman East around 150 years after his death (see above, p. 4). If it is taken as reflecting those perceptions rather than Pausanias' own opinions, we need to look elsewhere for the latter.

The next reference to Augustus, also discussed in the first chapter, provides some evidence of Pausanias' opinions, but may also reflect early imperial views of honorific statues. To quote the passage again, at the Argive Heraion, Pausanias says that 'before the entrance stand statues of women who have been priestesses of Hera, and statues of heroes, including Orestes; for they say that the statue which the inscription declares to be the emperor Augustus is really Orestes' (2.17.3). The re-use of a statue for another figure is readily paralleled, for example in the Prytaneion in Athens, 'the names on the statues of Miltiades and Themistokles have been altered into those of a Roman and a Thracian' (1.18.3).[71] That the practice of

[71] On the re-labelling of statues by Mummius and later Romans (not least because of the practice of shipping statues without their bases and, therefore, without their identification), Strong (1973) 255–6. Interestingly, at Corinth the practice of re-using statue bases after removing their dedicatory inscriptions ceased between Augustus and the fourth century AD (Kent (1966) 22).

re-attributing honorific statues was widespread is apparent from Dio Chrysostom's criticism of the Rhodians for saving money by erasing and re-cutting the inscriptions on statues (*Or.* 31.9). Although this is considered inappropriate by Dio, in other instances it may evoke heroic images: this seems to be the point behind Claudius' doctoring of paintings by Alexander's court painter Apelles, one of Kastor and Pollux with Alexander, and the other of personifications of Victory and of War, the latter with his hands tied behind his back, riding in triumph on a chariot along with Alexander. According to Pliny, 'both these pictures the deified Augustus dedicated with modest restraint in the most frequently visited parts of his forum. The deified Claudius, however, thought it better to cut out the face of Alexander from both pictures and to add portraits of Augustus' (*NH* 35.94, tr. Pollitt).

But what is striking about the Orestes/Augustus statue is that Pausanias has taken a stance on the truth of the identity of the subject, obviously a source of local discussion despite the inscription. Rather than simply report the controversy, Pausanias (as he consistently, although not invariably, does) makes up his own mind as to the identity of the statue, and here plumps for Orestes, thus implying that the inscription is inaccurate, perhaps deliberately intended to deceive. If so, it deceived neither the locals nor Pausanias. It may simply be that they felt confident in identifying the statue as that of a hero rather than of an emperor, but it may also be that there is implicit a less than reverential attitude for Augustus' supposed image and even for the emperor himself. In any event, it says much for Pausanias' priorities that his art-historical judgement takes precedence over any awkwardness he may have felt here, particularly in the case of an emperor of whom he has a generally favourable view.[72]

A statue of Augustus, made of amber, is mentioned by Pausanias in his description of Olympia (5.12.7); it was suggested (see above, pp. 52–3) that what Pausanias calls a 'rare and valuable' material was especially fitting for a statue of an emperor, and perhaps Augustus in particular.

Pausanias mentions an example of Augustus' removing antiquities from Greece, and his treatment of the example is perhaps more indicative of his attitude towards Augustus than it is of Augustus'

[72] Cecioni (1993), building on Dewar (1988) and (1990), uses this passage to support an apparent link in Vergil between Orestes and Augustus. There is no suggestion that Pausanias saw such a link in the statue. He calls it a statue of Orestes because that is what the locals call it, and says nothing of the inscription being re-cut.

attitude towards antiquities. The passage, concerning Tegea in Arkadia, is worth quoting at length: 'the ancient image of Athena Alea, and with it the tusks of the Kalydonian boar, were carried off by the Roman emperor Augustus, after he had defeated Antony and his allies, among whom were all the Arkadians except the Mantineans. It is known that Augustus was not the first to carry off votive offerings and images of the gods from his vanquished foes, but that he only followed a long-established precedent. For when Ilion was taken and the Greeks were dividing the spoils, the wooden image of Zeus of the Courtyard was given to Sthenelos, son of Kapaneus. And many years afterwards, when the Dorians were migrating into Sicily, Antiphemos, the founder of Gela, sacked Omphake, a town of the Sikanians, and carried off to Gela an image which had been made by Daidalos. And we know that Xerxes, son of Darius, king of Persia, besides what he carried off from the city of Athens, took from Brauron an image of Brauronian Artemis; and moreover, accusing the Milesians of wilfully playing the coward in the sea-fights with the Athenians in Greek waters, he took the bronze Apollo of Branchidai. The latter image was afterwards restored to the Milesians by Seleukos. But down to my time the Argives still preserve the images they took from Tiryns: one of them, a wooden image, stands beside the image of Hera, the other is preserved in the sanctuary of Elean Apollo. When the people of Kyzikos compelled the people of Prokonnesos by force of arms to settle in Kyzikos, they took from Prokonnesos an image of Mother Dindymene: the image is of gold, and the face is made of the teeth of hippopotamuses instead of ivory. Thus the emperor Augustus merely practised an ancient custom, which is observed by Greeks and barbarians alike' (8.46.1–4).

The above passage has been quoted *in extenso* because it is at unusual length that Pausanias makes a single point, in defence of Augustus' following what was standard practice.[73] It is intriguing that Pausanias felt it necessary to offer an explanation at all when Augustus was continuing an established practice, while it is usually departures from established practice that prompt explanations.

[73] He might equally have added the removal by Marcellus of so much Greek art from Syracuse in 211 BC, marked out by Livy as the beginning of the fashion (25.40.2; see above, p. 80). Alcock (1994) 100 calls the removal of statues the 'continuation of a very long-lived trend', but does not mention this passage, nor Pausanias' awareness of this fact. For other instances of Augustus removing artefacts from the provinces, Pliny *NH* 35.131, 36.28.

While Pausanias does not explicitly give his approval to the practice of carrying off artefacts, he hardly condemns it, and his detailing of examples – spanning Greeks, Dorians and Persians – goes back as far as the Trojan war, and effectively uses the past to legitimize the (in this case, recent) present. And there is no further back to go than the Trojan war.

Thus the episode of removal, which one would expect Pausanias to relate with disdain or disapproval, in fact leads to a defensive and unusually extensive tacit justification – one might call it a damage limitation exercise – and betrays a frankly fawning attitude to Augustus. For Palm, Pausanias' attitude here is to Augustus *qua* emperor; the emperor could be identified with Rome, and 'Loyalität gegen den Kaiser war Loyalität gegen Rom'.[74] But this is not simply a matter of deference to emperors *per se*: Pausanias' reference to Nero's carrying off 500 statues from Delphi is in a very different tone (10.7.1; see below, p. 147). Just as the tone of that passage is, as will become evident, indicative of Pausanias' attitude to Nero personally, so the deferential tone of this passage is indicative of his attitude to Augustus personally. It seems at odds with the less than flattering attitude to Augustus revealed by the episode of the re-named statue of Orestes; however, that example is not treated at anything like the same length, and its negative impact is less than is the positive impact of the second example.

As to the buildings of the Augustan period in Greece, Pausanias mentions no certain example, although the temple of Octavia at Corinth may qualify (2.3.1; see above, p. 108). The only other candidate is a temple of Augustus himself in the agora at Sparta (3.11.4); beside it Pausanias saw a temple to Caesar, adding two more to the count of Roman buildings he mentions. In keeping with what we know of the procedure for building temples to the emperor, there is no suggestion that Augustus was personally involved in the building of these temples, although the occasion of the dedication could have been his visit and reception there.

In writing his account of Athens, Pausanias would have seen several Augustan, or partly Augustan, buildings, and he is characteristically selective in his treatment of them. To his omission of the Agora of Caesar and Augustus and the temple of Roma and Augustus

[74] Palm (1959) 67.

may be added the manner in which he notes the mid-fifth-century temple of Ares (1.8.4), the most notable example of the phenomenon of 'itinerant temples',[75] which was removed from an uncertain location (probably Acharnai in Attica) and re-built in the unmissable location of the centre of the Athenian Agora in the time of Augustus. There is evidence to suggest that it may have been re-dedicated to Gaius Caesar and Drusus Caesar (see above, p. 121). Such re-dedication, the Romanization of a Classical temple, was by no means unknown to Pausanias – he cites, for example, the Metroon at Olympia (see above, p. 120) – but he omits this aspect of the Ares temple, confining himself to detailing Greek statues in and around it.

This selectivity may be attributable to his preference for matters Greek, or to the familiarity of temples to the imperial cult. Contemporaneity and familiarity are necessarily closely related. Also, there are many occasions when he does not comment on the structure of a temple as opposed to its sculptural decoration or cult statue. The familiarity of the imperial cult is a possible explanation also for his omission of the temple of Roma and Augustus on the Akropolis.

Pausanias does, however, mention the Odeion of Agrippa of c.15 BC, which also had a central place in the Athenian Agora, but he does so only very briefly, expressly picking out just one object and using the building merely as a topographical point of reference for that object: 'on entering the Music Hall at Athens we observe, among other things, an image of Dionysos which is worth seeing' (1.14.1). There are limited parallels for the form of the Odeion, which may have deterred Pausanias, but they were not in Greece, and it may be that he felt the Odeion was, in Ward-Perkins' phrase, 'an intruder to Athens'.[76] As he also points out, while there are Greek elements (including the archaizing use of fifth-century models), the position of the Odeion was thoroughly Roman in its relationship to the other buildings in the Agora, and that would, naturally, be its most immediately striking feature to any visitor.[77] It must also be noted that Pausanias generally spends little time on architectural detail, particularly in his account of Athens.

Elsewhere in Greece, Pausanias says of the theatre at Sparta that it is 'built of white marble, and is worth seeing' (3.14.1). However, it was 'essentially a creation of the Augustan age, when the site was

[75] Thompson (1962); Alcock (1993) 191–6.
[76] Ward-Perkins (1981) 268; also, Dinsmoor (1950) 319. [77] Ward-Perkins (1981) 267, 25.

completely remodelled'.[78] Whether this would have been apparent to Pausanias or not is unclear; inscriptions may have made it clear, but the architectural style was of a traditional Hellenistic kind. We cannot know whether Pausanias would have mentioned the theatre – never mind praised it – if he had thought it largely a Roman building, although he did mention the analogous case of the stadium at Delphi, made of 'the common stone of Parnassus' until, according to Pausanias, rebuilt by Herodes Atticus in marble (10.32.1, see below, p. 197).

Pausanias on Augustus 2: politics and administration

The majority of Pausanias' references to Augustus are not concerned with artefacts, sanctuaries or sites, but with politics and government. It was noted above that Pausanias sees Caesar as responsible for instituting the political system which persisted to his own day (2.1.2, 3.11.4). The latter passage is worth quoting more fully: 'In the market-place [at Sparta] there is a temple to Caesar, the first Roman who aspired to the throne, and the founder of the present system of government. There is also in the market-place a temple to Caesar's son Augustus, who placed the empire on a firmer basis, and attained a height of dignity and power which his father never reached.'

Thus not only is the link between son and father (Pausanias uses the words *paidi* and *pater*) made explicit, but it parallels the link between the system instituted by Caesar, and its 'son', the system as refined and improved by Augustus. The word here translated by Frazer as 'throne' is *'monarchia* ('monarchy', Jones); similarly, the word *basileia* is translated here (following Jones) as 'empire' rather than 'monarchy' as Frazer. The use of the word *basileus* by Pausanias and his contemporaries has been discussed (see above, pp. 114–16), and it is clear that it means 'emperor', and that *basileia* means 'empire'. A translation of *basileus* as 'king' would be misleading and in the same way, I suggest, Frazer's 'monarchy' is a misleading rendering of *basileia*.

This still leaves the question of what exactly is meant by 'emperor' and 'empire'. While the word *monarchia* is clearly open to a translation as 'monarchy', not least because of contemporary views of Caesar as

[78] Cartledge and Spawforth (1989) 128. This may have been due to Eurykles. Pausanias (3.11.3) says that the Persian stoa at Sparta had been rebuilt in a more magnificent form; he gives no date, but may refer to a Hadrianic reconstruction of a building of c.AD 125–50 (Waywell and Wilkes (1994) 413–14, 432).

seeking after monarchy in the sense of kingship, I believe that
Pausanias had something different, and more literal, in mind here,
which I would suggest is best translated, following LSJ, in a more
literal manner as 'government by a single ruler'.[79] The adoption of
this translation of *monarchia* arises from the fact, as it appears to me,
that it is by no means clear that the implications of the passage are of
intended kingship rather than of the rule of the individual (albeit
absolute rule, but that is setting the pattern for the empire proper).
Further, it stresses the central fact Pausanias is making, namely that
there is continuity in the political system instituted by Caesar and
continued by Augustus and, by implication, by subsequent
emperors.

Sparta, Lakonia and Messenia

The passage in Pausanias from which the preceding discussion has
arisen is written in the context of Sparta, and it is in connection with
Sparta, Lakonia more generally, and Messenia that Pausanias
makes many of his references to politics and administration under
Augustus (3.21.6, 3.26.7, 4.1.1, 4.30.2). In fact, the book on Messenia
is almost entirely historical – how accurately so is not an issue for
present purposes. Strabo (8.6.18) shows that Sparta was in his day
the city most highly regarded by the Romans, and as a contemporary
of Augustus', he must have had the emperor's personal interest in
the city in mind. The cause of Augustus' favour was Sparta's
position as one of only two cities (the other being Mantinea) to have
supported him at Actium. Pausanias says that before Actium, the
Spartans 'sided with Augustus', attributing this to the Arkadians'
siding with Antony (8.8.12), with the exception of the Mantineans
(cf. 8.9.6). The displeasure of Augustus with 'those who sided
against him' (4.31.2) parallels Sulla's vehemence against an Athens
which had defied him (see above, pp. 100–2). Strabo's comment is
given much weight by the exceptional gift of personal *dunasteia* over
the Spartans bestowed by Augustus to the prominent local figure
Eurykles, whose Hadrianic descendant is probably referred to by
Pausanias (p. 193).[80]

The games instituted by Augustus in honour of Actium at

[79] Similarly, Millar (1964) 74, says that 'monarchy in Dio means the established rule of a single
man'.
[80] Cartledge and Spawforth (1989) 98–101; for Eurykles and the imperial cult, 127–8.

Nikopolis (see above, p. 108) were administered by the Spartans,[81] and in Sparta itself, the Caesarean games were probably an Augustan foundation.[82] Here, as in the case of Corinth, the Roman presence is made manifest by, among other features, games, continuing a long-established Greek tradition but in the modern, Roman, manner, and it is not surprising that three further games were established in the first and second centuries; these, as Spawforth observes, 'point to a sustained effort by the Spartans to establish their city as a rival to the traditional agonistic centres of old Greece'.[83] Along with games go festivals; in the case of Sparta (as surely elsewhere), the festival 'incorporated civic sacrifices on the emperor's behalf as well as games, providing the new cult with its ceremonial focus'.[84]

The institution of games and festivals was not the only manifestation of the phenomenon of the 're-invention' of Sparta. Spawforth says that 'a local literary tradition had taken firm root at Sparta by the Augustan period'.[85] There is a considerable importance in this phenomenon, as there is in the increasing sophistication of Spartan education, which mirrored Greek education in general, including its emphasis on rhetoric. Its ultimate product is the series of writers of the first three centuries AD on whom we depend for much of our information about Roman Greece.

Along with Sparta itself, there was imperial interest in the Lakedaimonian cities, including the Free Lakonians, established by Augustus c.5 BC. In the preliminaries to his description of Gytheion, Pausanias says that it 'now belongs to the Free Lakonians, whom the emperor Augustus released from the relation of serfdom in which they had stood to the Lakedaimonians of Sparta' (3.21.6). Spawforth observes that 'although the accuracy of this passage has been doubted, it is confirmed by inscriptions from Gytheum, which portray Augustus and Tiberius as the restorers of the city's "ancient freedom" and posthumously hail the former as "Eleutherius"'.[86]

[81] Cartledge and Spawforth (1989) 99, adding that Sparta 'went on to develop close ties' with Nikopolis.

[82] Cartledge and Spawforth (1989) 184; 'almost certainly' – they are first mentioned in a Flavian inscription. [83] Cartledge and Spawforth (1989) 185.

[84] Cartledge and Spawforth (1989) 184–5.

[85] Cartledge and Spawforth (1989) 177, tracing the Republican origins of this movement.

[86] Cartledge and Spawforth (1989) 100; on the administrative background, p. 149. The title 'Eleutherius' is discussed with reference to Hadrian below, p. 163. An inscription from Gytheion of c. AD 15 detailing a festival of the imperial cult refers, *inter alia*, to painted images of the god Augustus, and Iulia Augusta [i.e. Livia], and Tiberius Caesar Augustus (*SEG* XI 923, Sherk (1988) no.32; Cartledge and Spawforth (1989) 101, 252 n.15; Price (1984a) 109).

Like Sparta itself, the provincial towns also had imperial buildings, such as Asopos, where Pausanias saw a 'temple of the Roman emperors' (3.22.9), an interesting use of the plural which may imply that there was a cult of the emperors rather than just individual cults of each emperor, although the Metroon at Olympia provides an example of a building which contained statues of several emperors (see above, p. 120 and below, p. 157).

Patrai and Nikopolis

While I have argued for the primacy of Corinth's role in the creation of Roman Greece, and for Pausanias' holding this view, I also mentioned that Patrai was another candidate. As Corinth was a Julian re-foundation, so Patrai was an Augustan one, possibly of 16 BC, but in all probability of 14 BC.[87] Chronologically, therefore, Corinth's role is the primary one. The picture Pausanias gives in book seven is of Augustus creating – or, more accurately, and importantly for present purposes, re-creating – Patrai as a Roman colony (7.18.5); it is as a colony that Pliny (*NH* 4.11) and Strabo (8.7.5) describe Patrai, and epigraphical and numismatic evidence supports this.[88] The new colony was formed by synoikism, with the effective annexation by Augustus of Dyme (7.17.5), itself a veteran colony since 44 BC (Strabo 8.7.5);[89] Rhypes, after sacking it (7.18.7); Pharai (7.22.1) and Triteia (7.22.6). To these may be added Olenos, situated between Patrai and Dyme, and in Strabo's day abandoned ('its territory is held by the people of Dyme', 8.7.5; cf. 10.2.22).

The background to the re-foundation of Patrai is, then, one of destruction, as it was at Corinth, but in this case not of a single destruction, and not of a destruction of which the restorer, Augustus, was innocent as was Caesar, the restorer of Corinth. Thus the destruction of Dyme by Sulpicius, mentioned by Pausanias (7.17.5), had occurred at the end of the third century BC (cf. Appian, *Maced.* 7; Livy 32.22.10), and Plutarch tells of its re-settlement with Cilician pirates by Pompey, and claims that it was 'bereft of men and had much good land' (*Pompey* 28.4).[90] Similarly, Pausanias says that Rhypes had been destroyed, in this case by Augustus himself; Strabo, writing, as he tells us, soon after 'the Romans, after their victory at

[87] Kahrstedt (1950) 549. [88] Rizakis (1989) esp. 183.
[89] M. Lakakis and A.D. Rizakis in Rizakis (1992) 100.
[90] On the reliability of this latter claim, Alcock (1993) 132.

Actium, settled a considerable part of the army at Patrai', says that Rhypes was in his day uninhabited (8.7.5). Again, Pausanias says that Triteia was assigned to Patrai by Augustus (7.22.6).[91]

The reason for Augustus' re-foundation of Patrai is not clear to Pausanias, who says it was 'either because he thought Patrai was a convenient place for vessels to touch at in passing, or for some other reason' (7.18.7).[92] His suggestion is common sense in view of Patrai's ideal position for commerce as a western port. The effects of the re-foundation are, however, all too clear to Pausanias: he notes that the synoikism resulted in the depopulation of the area round Patrai in order to populate Patrai itself, and he notes the conferring of freedom on the Patraians alone of the Achaeans. The latter should be remembered when other declarations of freedom are discussed, such as the earlier one of Flamininus and the later one of Nero, or Sulla's gift of freedom to various Greek cities, and Augustus' refusal of it to Samos (see above, p. 118 n.35). The phrase 'he further invested them with all the other privileges which are commonly accorded to a Roman colony' (7.18.7) leaves no doubt about the status of Patrai for Pausanias. Further, he lists Myonia, Oiantheia and Naupaktos as towns 'governed by the Achaeans of Patrai, who received the privilege from the emperor Augustus' (10.38.9).

The resemblance of Patrai to Corinth lies not only in its status as a colony, but also in the movement of population, something on which Pausanias remarks with feeling in connection with Corinth (see above, p. 94–5), but neutrally reports here. Although the population brought into Patrai was not foreign in the sense that the population brought into the newly re-founded Corinth was, it was nonetheless an imported population. Indeed, it may not be unfair to say that the imported population of Patrai bears closest resemblance to the old population of Corinth in that both are displaced Greeks, and in both instances the beneficiaries are the Romans. As Rizakis points out, Strabo's use of the phrase οἱ ἐν Πάτραις 'Ρωμαῖοι (10.2.21) implies a different status from Πατρεῖς, making 'a clear distinction between the two ethnic groups living in the same town: those of the colonists, Roman citizens, and those of the Patraian Greeks'.[93] He adds that

[91] Kahrstedt (1950), rejecting (554) an Augustan date for absorption of Dyme. Alcock (1993) 133–45 on Patrai, Dyme, Nikopolis and the 'manipulations of population and territorial boundaries' (133).

[92] The importance of Patrai as a port is stressed by Rizakis (1989) 180, who notes that it increased after the sack of Corinth in 146. [93] Rizakis (1989) 183.

'this distinction disappears in later documents' and notes the uncertainty over the ethnic and political character of Patrai in the second century AD.

Pausanias' account shows that as at Corinth, where the effective export of Greek objects and the cessation of some long-established cult practices matched the import of Roman settlers, so at Patrai the import of a new population was accompanied by the removal of the paraphernalia and symbols of established Greekness: thus the 'images' (*agalmata*) at Pharai were removed to Rome (7.22.5), and the 'ancient image' (*agalma . . . archaion*) of Athena at Triteia likewise (7.22.9). But, appropriately, the most telling phrase used in this connection is of Patrai itself, where Pausanias says that the image of Artemis Laphria in the sanctuary on the Akropolis had been brought from Aitolia which had, just like Achaea, been deprived of people and objects by Augustus (Pausanias also refers to the depopulation of Aitolia, specifically for the creation of Nikopolis, at 10.38.4).

There is a further element here, not mentioned by Pausanias, who was perhaps unaware of it: epigraphical evidence links the cult of Augustus with that of Artemis Laphria.[94] Strabo (10.2.21) mentions a temple of Apollo Laphrios near Kalydon, itself near the lake which, Strabo tells us in the same passage, was held by the Romans who live in Patrai. It would be interesting to know of any suggestion that the cult itself had been imported, or whether the Artemis Laphria statue was brought because of an existing connection with Patrai and the area, which would make more sense.

Arising from these incidents of the transfer of statues, Susan Alcock says that 'removing a patron god or goddess demonstrates the absolute power of the conqueror, at the same time enacting a community's symbolic destruction. Transferral of cult images also served to undercut former territorial loyalties and to foster new ties.'[95] She makes the further suggestion that the 'transfer of cult statues could also be viewed as a *sharing* of them'.[96] These two statements do not seem entirely compatible, and the latter carries certain, perhaps inaccurate, connotations, since it is hard to see how deprivation of the physical and symbolic centre of the community can constitute sharing with any implication of even approximately equal access: sharing implies leaving part, if not an equal part, but the consequences of enacting such symbolic destruction remain a relationship based upon domination and subordination.

[94] Rizakis (1989) 184; Papapostolou (1986). [95] Alcock (1993) 140–1.
[96] Alcock (1994) 101.

Alcock goes on to add as an example Sulla's removal from Alalkomenai of the statue of Athena (9.33.6; see above, p. 102), saying that 'retribution followed'. Here again, if one is looking at a divine response (not unreasonable in the context, especially in view of the mystic element in the references to Sulla), 'retribution' is an odd response to 'sharing', which is a form of spreading and broadcasting divinity, not constraining it.

The foundation of Nikopolis in celebration of the victory at Actium was facilitated by moving populations from the surrounding area much as it was in Patrai, both at the instigation of Augustus (e.g. 5.23.3). Cassius Dio says that after Actium, Augustus 'founded a city on the site of his camp by gathering together some of the neighbouring peoples and by transplanting others, and he named it Nikopolis' (51.1.3). As at Patrai, games were instituted at the foundation of the colony.[97]

In the case of Nikopolis also the centring of political rights on the new foundation is strikingly remarked on by Pausanias, and associated with Augustus personally: 'it was the will of the emperor Augustus that Nikopolis . . . should join the Amphictyonic League, that the Magnesians, Malians, Ainianians, and Phthiotians should be included among the Thessalians, and that their votes, together with those of the Dolopians (who had ceased to exist as a people), should be exercised by the Nikopolitans' (10.8.3, presumably meaning that the Dolopians ceased to exist as a result of the foundation of Nikopolis). The context of these remarks is a history of the Amphictyonic League, which makes clear the central role of Augustus in its re-organization. Pausanias goes on to mention the structure of the League in his own day, but does not say who was responsible for changes since Augustus. Thus the account is centred on Augustus, which is historically justifiable, since his considerable re-structuring of the League is amply attested by epigraphical evidence.[98]

As Pausanias tells of the effect of the foundation of Nikopolis on the local populations, so too he pays attention to the objects: 'most of the images from Aitolia and Akarnania were taken to Nikopolis by order of Augustus' (7.18.9). This puts in perspective Augustus' restoration of an 'ancient temple of Apollo' at Nikopolis (Suet. *Aug.* 18.2) which, as noted (see above, p. 121 with n.44) was part of his self-promotion as a New Apollo; altruistic concern for the temple *per se* is not likely to

[97] Rizakis (1989) 185. On the games at Nikopolis, see pp. 108, 132–3 above.
[98] Daux (1975) discusses this passage in detail.

have occurred to him. The phrase he uses at *RG* 20.1, 'I restored the Capitol and the theatre of Pompey, both works at great expense without inscribing my own name on either' is a good indication of the standard approach of the period to such patronage.[99]

While there are similarities in the history of Corinth and Patrai as described by Pausanias, the element of the personal involvement of Augustus distinguishes the account of Patrai since, as noted, the damage and depopulation of Corinth had occurred a century before Caesar. The accuracy of Pausanias' history here has been doubted for a long time – Frazer cites Mommsen, for example, as disagreeing with the statement that Dyme was annexed to Patrai[100] – but here, as elsewhere, the accuracy of Pausanias' account is not an issue for present purposes, unless it is apparent that it is a deliberate inaccuracy or distortion. I stressed in the first chapter that autopsy is, in my view, the single most distinctive feature in Pausanias' work, and that therefore his writings on history should not be seen in the same light as those on the objects, temples and cult practices he observed personally. I have also suggested that some historical content is inevitable, and in the present context, to take a minor but representative example, it is not, in his view, adequate to say simply that Triteia and Pharai no longer have images, if he believes he knows an explanation of why they do not. If modern historical research reveals that he is wrong in that explanation, we may hold his informants responsible, or perhaps his lack of informants; but we should be hesitant to read opinion, rather than ignorance, into this.

Shear notes that the political life of Athens was reduced after the death of Augustus, reviving again with Hadrian, and that it received less physical embellishment and fewer imperial benefactions in the interim.[101] Indeed, one might extend this observation to the province of Achaia in general, and link it with the prevailing economic conditions of the time.[102] Since Achaia was not again conspicuously favoured by the Romans until the accession of Hadrian, we should not expect much from any writer concerning that period. If it is true that Pausanias is in general uninterested in contemporaneity, we should perhaps expect that he might well not have written about it even if it had been otherwise.

[99] On the beginnings of the practice of inscribing the benefactor's name on a public building, Hornblower (1982) 280–93. [100] Frazer IV.136.
[101] Shear (1981) 365, 372; on Athens from Tiberius to Trajan, Graindor (1927).
[102] Day (1942) 177–9, on the diminution in the prosperity of Greece, including Athens, between the time of Tiberius and Trajan.

Pausanias on the rulers of Roman Greece 3: Nero to Marcus Aurelius

Apart from Augustus, the only Julio-Claudian emperor to whom Pausanias pays significant attention is Nero, the starting point for this chapter. Pausanias' few references to the remaining Julio-Claudian emperors were considered in the first part of chapter 3, along with the reasons behind his omitting some emperors altogether (namely Galba, Otho, Vitellius, Domitian, Nerva and Titus). The fact that the greater part of this chapter is devoted to Hadrian accurately reflects the distribution of Pausanias' writings on the emperors of this period. I argued in chapter 1 for the importance of Hadrian in shaping the world in which Pausanias grew up, and the points made there should be borne in mind here.

As well as Pausanias' view of Nero and Hadrian, his brief references to Vespasian, Trajan, Antoninus Pius and Marcus Aurelius are also discussed in this chapter.

NERO

Nero may be regarded as the second most philhellene of the emperors whose reigns are covered in this study, after Hadrian. Like Claudius, he was a speaker of Greek. The most celebrated aspect of his philhellenism was his visit to Greece in AD 66/7, particularly his declaration of freedom for Achaia at the Isthmian games.[1]

More than in the case of other emperors extensively treated by Pausanias (and he has more to say on Nero than on any bar Augustus and Hadrian), Nero's character forms a constant theme. The general attitude of the sources towards Nero is hostile, and Pausanias'

[1] On Nero in Greece, e.g. Kennell (1988); Bradley (1978b, 1979); Griffin (1984) 208–20; Morford (1985) 2024–6; Rudich (1993) 186–90; Alcock (1994).

account will be compared with those sources.[2] Josephus documents the range of histories of Nero: 'many historians have written the story of Nero, of whom some, because they were well treated by him, have out of gratitude been careless of truth, while others from hatred and enmity towards him have so shamelessly and recklessly revelled in falsehoods as to merit censure' (*AJ* 20.154).[3] While this must to some extent have been true of all emperors, Nero does appear to have provoked unusually personal reactions. To this, Pausanias was no exception.

Nero's declaration of the freedom of Greece

At 7.17.1, Pausanias talks of the Mummian invasion as 'the period when Greece sank to the lowest depth of weakness'. He then details its woes from the Dorian invasion to the fifth-century plague best known from Thucydides' description, on to the rise of Macedonia, and continuing to Nero's declaration of the freedom of Greece at the Isthmian games. Its date has been much discussed, AD 66 now gaining widespread acceptance rather than 67 as was until recently generally believed; Pausanias' account is of disputed value for this debate.[4]

Notwithstanding difficulties over the date, Pausanias' account is of interest for several reasons, and therefore worth quoting in full:

when the Roman empire devolved on Nero, he gave the Roman people the rich and fruitful island of Sardinia, and, taking Greece in exchange, he set it free. Musing on this deed of Nero, I was struck by the truth of Plato's saying, that crimes of extraordinary magnitude and audacity proceed not from common men, but from a noble nature depraved by a vicious upbringing. But the Greeks could not profit by the boon. For when Nero had been succeeded on the throne by Vespasian, they fell out among themselves, and Vespasian commanded that they should again pay tribute and submit to a governor, the emperor remarking that Greece had forgotten what it was to be free. (7.17.3–4)

[2] On the hostility of the sources towards Nero, Jones (1978) 14, (1971) 18–19.
[3] Pliny gives a thoroughly damning picture of Nero (*NH* 7.45–6, 22.92, 34.84, 34.166, 35.51–2).
[4] The declaration is *SIG* III.814. Levy (1991) concludes from literary, numismatic and epigraphic evidence that it occurred soon after Nero's arrival in Greece in AD 66; he does not mention Pausanias' account. Numismatic evidence also led Amandry to 66 (Amandry (1988) 19–24); Barnes (1989) 252–3 agrees, following Halfmann (1988). Interestingly, in dating it to 67, Bradley (1978b) dismisses Pausanias' account; and Gallivan (1973) 232–4, supporting 67, admits that Pausanias' account suggests 66; Alcock (1993) 16, Sherk (1988) no.71, and Lewis and Reinhold (1990b) 313–4, all date it to 67, with no discussion.

The *quid pro quo* Pausanias mentions (and for which he is our only source) makes economic sense, and does not sound like whim.[5] The comment Pausanias makes here about Nero's character reflects a preoccupation as we have seen; the characterization as 'a noble nature depraved by a vicious upbringing' is as near as Pausanias comes to a compliment to Nero, seen here as a genuine benefactor for his declaration of freedom for Achaia, or at least as extenuating circumstances for his excesses and impieties, so well chronicled by Pausanias.[6] Pausanias' account contains no hint of Nero's feeling about the declaration of freedom, although the declaration itself leaves no doubt that he felt he was giving Achaia a considerable and unique privilege. Further, it is clear that he felt this reflected uniquely well on himself: for example, he says that 'other emperors have freed cities, Nero alone a whole province'.

Pausanias' omission of Nero's own view is in itself perhaps not surprising, but it is an interesting contrast with Plutarch's saying that Flamininus, who had similarly declared freedom for Greece, also at the Isthmian games, in 196 BC, 'took most pride in his liberation of Greece' (*Flam.* 12.5). Plutarch goes on (12.8) to say that while Flamininus had his declaration promulgated by herald (cf. Livy 33.32.4), Nero did so in person – hardly a controversial observation.

Pausanias' reference to Nero's declaration of freedom as 'a boon' (*doron*; the text of the decree refers to the benefaction as a *dorea*, and twice as a *charis*) appears to suggest a genuine enthusiasm for the idea in Pausanias, albeit combined with a sense of inevitability that it did not succeed. The brief mention of Vespasian is colourless, in that it suggests strongly that his hand was forced, and that the Greeks had only themselves to blame (further, see the section on Vespasian, below, pp. 155–6).

The wider passage conveys the notion of boundless decline, long established as a rhetorical device by Pausanias' day, but not always simply rhetorical, dating as it does from the very beginnings of written Classical literature, as the fundamental backdrop to Hesiod's *Works and Days*, and readily paralleled elsewhere. John Elsner has detected

[5] Alcock (1993) 16.

[6] Griffin (1984) 211, citing Plut. Mor. 567F–8 (noted by Bowie (1974) 208 n.107), Philostr. *VA* 5.41 (see below, p. 156), but distancing Pausanias' account from those of the other two authors named, who 'celebrate his liberation of Greece with warm feelings'. Alcock cites the same sources, seeing their view, and that of Pausanias, as 'signs of their appreciation' (Alcock (1994) 106–7). On Plutarch's attitude to Nero, Jones (1971) 18–19; Levin (1989) 1606–15.

in Pausanias 'a sense of inevitable decline and fall',[7] and this passage would seem to bear this out. Indeed, Nero's own phrase, as recorded in the text of his declaration of freedom, 'would that I were making this gift while Hellas was still at its height', concurs with the notion at least of constant, if not necessarily inevitable, decline. This was quoted in chapter 1 (see above, p. 25) alongside Pliny's advice to Maximus to 'recollect each city's former greatness, but not so as to despise her for having lost it' (*Ep.* 8.24). But, as noted there, the fact that Pliny, like Nero, expressed these sentiments before Hadrian's promotion of, and investment in, Greece renders them less applicable to the period of Pausanias' own lifetime, although it would be exaggerated to claim that Hadrian's activities altogether eliminated perceptions of decline.

However, 7.17.1 does not support the notion of Pausanias' 'sense of inevitable decline and fall', since his detailing of decline ends with Mummius, and the subsequent malpractice of Nero is freestanding, of 'a later age' and of his own personal making. For Nero, as the foregoing discussion indicates, Pausanias seems to have had especial dislike, but his misdeeds are not seen as naturally growing from imperial rule; in contrast to Sulla, whose conduct he calls 'harsh and alien to the Roman character' (9.33.6) and 'unworthy of a Roman' (1.20.7), Pausanias does not ask us to judge Nero by reference to his 'Romanitas'.

The idea of 'inevitable decline and fall' also fails to stand up to Pausanias' treatment of the later empire, particularly, as will be seen later in this chapter, the time of Hadrian, which appears to have been thought of by him as precisely the opposite.

Oddly, Pausanias does not mention the location of Nero's declaration of freedom, nor even say that it occurred while Nero was in Greece. Nero's tour, which features so prominently in other sources, is not mentioned by Pausanias, and the reader almost has to search between the lines to deduce that Nero ever visited Greece. The only straightforward statement that he did so occurs in Pausanias' mention of the other engineering project (if it can be called that) undertaken by Nero in addition to the cutting of the Corinth canal (see below, pp. 151–2), namely his unsuccessful attempt to ascertain the depth of the Alkyonian Lake in the Argolid: 'Nero himself made the experiment, taking every precaution to ensure success. He had lines made many

[7] Elsner (1992) 19.

furlongs long: these he joined together and weighted with lead, but he could find no bottom' (2.37.5). Otherwise, only Nero's dedications at Olympia and the Argive Heraion (see below, p. 148) seem to communicate to Pausanias' readers that Nero had ever visited Greece.

From a contemporary Roman perspective, the visit was important since, as Bradley points out, 'Nero's tour of Greece was the first occasion on which the emperor and his court had been out of Italy since Claudius' expedition to Britain . . . no emperor after Nero again left Italy before Domitian went on campaign, almost twenty years later'.[8] However, by Pausanias' time, the travels of Trajan and Hadrian had been so extensive that the travels of an emperor *per se* would have been unremarkable, and he may well have been unaware of the rarity of such travels in Nero's day. A parallel might be drawn with modern-day Papal tours (themselves not dissimilar to imperial progresses), now seemingly so constant that it is hard to conceive that when Pope John XXIII left Rome in October 1962, he became the first Pope for more than a century to do so (and even then, it was only to travel within Italy).[9]

Nero's itinerary in Greece

Although Pausanias does not discuss Nero's itinerary in Greece, it is worth digressing briefly here to consider it, since it sheds important light on Nero's relations with Greece and on how other writers report his visit.

Strikingly, Nero did not visit Athens or Sparta. Cassius Dio (63.14.3) explains that Nero disapproved of the Lykourgan customs.[10] Nero (like Pausanias after him; see above, p. 25) may have felt that these customs were recent creations, and that they therefore did not represent the authentic continuation of ancient traditions. Dio attributes Nero's exclusion of Athens to 'the story of the Erinyes' (63.14.3), avengers particularly of crimes against kindred, who were primarily associated with Athens. Since Nero was at the least under suspicion of kin-murder, it seems credible that 'the story of the Erinyes' would be heeded by someone in his position contemplating a visit to Athens.

Closely connected is Suetonius' statement that when in Greece,

[8] Bradley (1979) 157. [9] Walsh (1980) 225.

[10] Spawforth calls Dio's explanation 'eccentric (but, admittedly, by no means incredible)', Cartledge and Spawforth (1989) 103.

Nero 'did not venture to take part in the Eleusinian Mysteries, since at the beginning the godless and wicked ('impii et scelerati') are warned by the herald's proclamation to go hence' (*Nero* 34.4). This apparent reference to the ban on attendance by murderers may well have been – or, as importantly, have been thought to be – pertinent to Nero, although, as Kevin Clinton observes, 'it is very doubtful that an emperor would have been turned away'.[11] Perhaps Nero felt that uncertainty over his eligibility for initiation would lead to too public an examination of his past. This public lack of association with the Mysteries contrasts markedly with the initiation of many prominent figures of the Republican era and, latterly, that of Augustus (see above, pp. 98, 122).[12]

Here Pausanias may be recalled. His own participation in the Mysteries is probable, and he certainly regarded them in a very special light (5.10.1; see above, pp. 68–9). It is perhaps likely that Pausanias would have been moved by indignation to comment if Nero had been initiated, but that in the absence of initiation, he preferred to keep quiet – the covert reference to murder committed by Nero (9.27.3–4) shows Pausanias' awareness of it, but it would be characteristic of him to comment on what someone had done rather than on what they had not done.

Thus Nero's position as a suspected kin-murderer gave him two reasons to avoid Athens, and we should not be surprised that he did so.[13] However, Nigel Kennell has offered the further explanation that Nero was intent on becoming a *periodonikes* (as Dio relates, 63.8.3), and omitted Athens and Sparta because their games had no part in the *periodos*, even in its extended early imperial form.[14] These differing explanations of Nero's itinerary need not be incompatible, since Nero's intention to become a *periodonikes* would afford good cover for avoiding two cities which he could not visit without giving offence, or incurring divine displeasure, or publicly embarrassing himself.

Thus Nero's omission of Athens, and perhaps of Sparta also, may

[11] Clinton (1989b) 1514; this counters the suggestion of Mylonas that 'Nero avoided a visit to Eleusis and a demand for initiation which might have been denied to him' (Mylonas (1962) 155). That lesser people were sometimes turned away is clear from the experience of Apollonios (Philostr. *VA* 4.18).

[12] Nero did, however, take part in one traditional religious practice by consulting the oracle at Delphi (Suet. *Nero* 40.3). Although Nero's involvement with Delphi had several aspects (below), for Pausanias, his only action there worth recording was to remove five hundred statues (10.7.1).

[13] As a secondary point, if the reason Dio gives for Nero's staying away from Athens is accurate, it is likelier that so also is his reason concerning Sparta. [14] Kennell (1988).

have stemmed in part from necessity as well as preference. In any case, I do not see it as resulting from a calculated policy with broader implications than the personal, and for that reason I take issue with Alcock's argument that Nero's avoidance of Athens and Sparta 'encouraged a new conception of Greece: not as a land of the past, but as part of the imperial present'.[15] Nero's visits to Olympia and Delphi do not seem compatible with this suggestion; indeed, one could argue the opposite, that by not forcing himself on places where he was palpably unwelcome – and, as remarked, it is unlikely that he would have been refused at Eleusis had he chosen to press his case – Nero was showing a healthy degree of respect for long-established institutions, a wise move for one who would be Greek.

Nero and the art of Greece

The theme of violation carried out by Nero is given emphasis by Suetonius' references to Nero melting down sacred images ('simulacra') when he needed money (*Nero* 32.4), reported also by Tacitus, who says that 'Italy had been laid waste for contributions of money; the provinces, the federate communities, and the so-called free states, were ruined. The gods themselves formed part of the plunder, as the ravaged temples of the capital were drained of the gold dedicated . . . at every epoch. But in Asia and Achaia, not offerings alone but the images of deity were being swept away, since Acratus and Secundus Carrinas had been despatched into the two provinces. The former was a freedman prepared for any enormity' (*Ann.* 15.45).

Secundus Carrinas is known from an inscription to have been made eponymous archon by the Athenians, probably with the intention of fending off further deprivations of their art.[16] The freedman, Acratus, is mentioned again by Tacitus (*Ann.* 16.23), when he says that the people of Pergamon rioted in order to prevent him plundering the city of statues and pictures. Here he may be presumed to have been acting under orders from Nero; he certainly is in the account of Dio Chrysostom, who says in his oration to the Rhodians that Acratus 'visited practically the whole inhabited world' for the purpose of plundering, and 'passed by no village', but left Rhodes alone, as a mark of Nero's especial affection for the island, which he regarded as 'more sacred than the foremost sanctuaries' (*Or.* 31.148–9). Related

[15] Alcock (1994) 105 (with no reference to Kennell's work).
[16] *IG* II² 4188. Day (1942) 179–80; Hoff (1994) 116; Geagan (1979) 384.

is Nero's attachment to Helios, for whose island of Rhodes he secured concessions, including persuading Claudius, then emperor, to give it its freedom.[17]

The view of Nero so far built up is reinforced by subsequent references in Pausanias: in the continuation of the passage concerning the statue of Eros from Thespiai (9.27.3, above, p. 84), the story of the Eros ends with its destruction in the fire of Rome in Nero's day. Further, Pausanias here brackets Nero with Caligula as one of 'the men who thus sinned against the god', and adds an illustration of the personal deficiency of each, in Nero's case, that 'besides his conduct to his mother, [he] was guilty of accursed and unlovely crimes against his wives'. This arises out of a discussion of Nero's removal of a statue, one of many such incidents, apparently: Pliny (*NH* 34.84) says that he took many pieces of Greek sculpture and adorned the Domus Aurea with them (contrast this with Mummius *not* adorning his home (see above, p. 91)). The statue was subsequently destroyed while under his 'care'.

The perverse behaviour of Nero towards his mother and wives is not in itself of interest to Pausanias – it is referred to parenthetically between the two elements of the story of the Eros – otherwise we would expect him to write in similar terms of Tiberius, for example, whose personal behaviour is the focus of Suetonius' account of his life, and is attested by other sources. Since, however, Pausanias has next to nothing to say on Tiberius and art, to discuss his character would be an unwarranted digression – this is a feature of Pausanias' working method that is paralleled in, for example, his treatment of Caligula (see above, p. 85). Similarly, we would not expect Pausanias to dwell on Nero's maltreatment of the imperial family.

Olympia and Delphi

For Pausanias, it was Nero's attitudes to sanctuaries and art that were of primary interest, and in those, recurrent themes present themselves. Pausanias' references to Nero carrying off statues are concentrated on the two main Panhellenic sanctuaries, Olympia and Delphi, both of which continued to flourish in the early empire; and this receives support from Dio Chrysostom (*Or.* 31.148–9). Pausanias refers to Nero carrying off some five hundred bronze statues from Delphi, and

[17] Jones (1978) 27–8; Griffin (1984) 210.

to his removal of a number of statues from Olympia (comprising a statue of Odysseus, and dedications by Mikythos, an unstated number, but at least nineteen, since Pausanias enumerates seventeen dedicated, and adds that Nero carried off others (plural) beside those (5.25.9, 5.26.3, 10.7.1, 10.19.2)).[18]

There are issues arising from this list: first, Nero is 'said to have' taken the statues from Olympia, a neutral report by Pausanias, reflecting the uncertainty over the fate of the statues exactly as he often reflects uncertainty over the origins (and occasionally identification) of many statues elsewhere. There is nothing special to Nero here, nor condemnatory of him. This latter point is important, showing as it does that Pausanias has no vested interest in attacking Nero, since he rejects here a clear opportunity to attack him by concurring with the reports of his thefts – instead, he merely reports them, preferring to condemn him only for those misdemeanours of which he is personally convinced.

Pausanias' reference to the removal by Nero from Delphi of 'five hundred bronze statues of gods and men together' (10.7.1) is followed by one to the removal of a statue of Skyllis' daughter, not a private dedication, but one from the Amphictyons (10.19.2). It is the accompanying narrative that is of interest here: Pausanias says that Nero 'robbed Apollo' of the statues (10.7.1), an unusually pejorative term. More strikingly, he prefaces this with an account of 'innumerable plots' against Delphi over previous centuries, ranging from the very beginnings of the sanctuary under Apollo, and including Pyrrhos, son of Achilles, and culminating in Nero's action, the climax of centuries of impious violations of the sanctuary.[19] It has been observed in this study that antiquity is seen as an important factor in conferring legitimacy; it follows that it can also be used, as here, to confer disgrace of a corresponding depth.

In this, as in his treatment of Nero at Olympia, Pausanias' approach is factual, quietly condemnatory, never reaching the level of outrage expressed by, for example, Dio Chrysostom in his Oration to the Rhodians: 'Nero had so great a craving and enthusiasm in that business [sc. plundering statues] that he did not keep his hands off even the treasures of Olympia and Delphi, even though he honoured their temples most of all' (*Or.* 31.148; also, above). Some explanation of the apparent oxymoron in Dio's remark is required, beside the

[18] On Mikythos and a pertinent base which has been discovered, Papahatzis 3.322 n.1.
[19] On Delphi and Rome until Nero, Levin (1989) 1601–6.

rhetorical urge which may well have played its part: the deprivations of the sanctuaries by Nero have been documented above, but beside them should be set his dedications and benefactions.

Pausanias mentions only two occasions when Nero dedicated at a Greek sanctuary: at the Argive Heraion, where he dedicated a golden crown and a purple robe (2.17.6), and at Olympia, where he dedicated four crowns in the temple of Zeus (5.12.8; see below, p. 185 on other imperial dedications there).[20]

The impression given by the fact of a mere two dedications is of a considerable imbalance between these and the scale of removal of objects from Greece. We know of other benefactions, which Pausanias does not mention, such as the gift of HS 400,000 to the Delphic oracle which, according to Cassius Dio (63.14.2), was a reward to the Pythia 'for uttering some oracles that suited him'[21]), but these are greatly outweighed by his depredations. Add his confiscation of temple lands from Delphi and (if it is true) his attempt to stop up the 'prophetic chasm' with the bodies of men he had had murdered (Cassius Dio 63.14.2; Lucian, *Nero* 10),[22] and a decidedly two-faced attitude to Delphi emerges, finding expression in the strong phrasing of Dio Chrysostom.

It may be that the donation to the oracle is related to his request to it, effectively acting as a bribe. Thus it would not be unreasonable to construe Nero's actions as indicative of a man who fully expected to be able to use Delphi to whatever ends, and with whatever means, he felt appropriate. I hesitate to agree with Miriam Griffin's analysis that 'his respect for the Greek gods . . . is confirmed by the offerings he personally deposited in the Greek temples';[23] that seems nearer to what Nero would have us believe, and Pausanias for one did not feel able to.[24]

As Griffin points out 'Plutarch, who regards him as a criminal and a tyrant who nearly destroyed the empire, never mentions his depredations at Delphi where he himself was a priest'.[25] Jones, while mentioning Plutarch as a priest at Delphi, does not address this

[20] Kennell (1988) 241–2, observes that the dedications at the Argive Heraion, as well as those at Olympia, were for athletic victories.

[21] Also *ILS* 8794, vv. 22–4, cited by Griffin (1984) 211.

[22] Levin observes that Plutarch would not have been as lenient in his judgement on Nero if this story were true (Levin (1989) 1605). On Plutarch's attitudes, see below, n.26.

[23] Griffin (1984) 211.

[24] Levin's observation on Delphi, that 'any benefactions of Nero were undoubtedly outweighed by his rapacity' (Levin (1989) 1606) might well be extended to the other areas of Greece he left his mark on. [25] Griffin (1984) 211.

question directly; but if he is right to say of Plutarch that 'like other Greek writers he was influenced favourably by Nero's philhellenism' and that he 'saw Nero's nature as an essentially good one corrupted by flattery',[26] it may be that Plutarch's silence was prompted by this underlying respect (and see above, p. 141 n.6).

Arising from these accounts is an immediate contrast with Augustus: I discussed (above, pp. 128–9) a passage in which Pausanias mentions an example of Augustus' removing antiquities from Greece, gives a list of examples over a long period to convey a sense of antiquity, and concludes that 'the emperor Augustus merely practised an ancient custom, which is observed by Greeks and barbarians alike' (8.46.4). The passage in which Nero's depredations are seen as the latest in a long line of 'innumerable plots' against Delphi (see above, pp. 147–9) provides a virtual mirror-image, although it is not so formally structured as to be called a rhetorical device: in both passages, the removal of objects is given a long lineage, going from mythical into historical times, and in both the emperor is seen as the most recent practitioner. But the technique is used defensively to confer maximum legitimacy on Augustus, aggressively to confer maximum opprobrium on Nero. This is as clear a case as one could have of Pausanias' own personal views colouring his attitude to the events; not, I think it is fair to say, his recording of them – otherwise, he would simply have omitted Augustus' deprivations. Thus I see it as a firm indication of Pausanias' objectivity, and consistent honesty of purpose.

Olympia has featured in this discussion more than previously in this study, both for Nero's removal of objects, and for his dedication of four crowns. But there was a considerable, and recently increasingly well understood, involvement of Nero with Olympia. The extent and nature of Neronian buildings at Olympia is becoming clearer as German excavations reveal a picture in some respects very different from that hitherto accepted.[27] What is clear is that Pausanias mentions none of them. These omissions are most readily explained by Pausanias' general reluctance to discuss matters modern, which forms the starting point for this study; and yet, Pausanias on occasion does discuss modern buildings.

[26] Jones (1971) 33–4, 18–19; on Plutarch and Delphi under Hadrian, Swain (1991).

[27] Sinn (1991). I thank Ulrich Sinn, the director of the excavations of Roman imperial Olympia, for pointing out to me that despite its regular appearance in secondary literature (e.g. most recently Alcock (1993) 190), there is no evidence for the existence of the 'arch of Nero' at Olympia, much less for its supposed destruction after his death.

Interestingly, especially in view of Kennell's argument that Nero's purpose in visiting Greece was to become *periodonikes*, agonistic aspects of his extended tour of Greece, including Olympia, are not mentioned by Pausanias (bar his dedication of his crowns), although other sources make great play of them.[28] Manifold opportunities are afforded by Nero's tour of the games of Greece for illustrating the blacker side of his character: he won the chariot-race at Olympia by blatant corruption (Suet. *Nero* 24.2; cf. Cassius Dio 63.14.1),[29] and added to the programme a musical contest, doubtless for his own benefit as an enthusiastic lyre-player, and 'contrary to custom' (Suet. *Nero* 23.1); other examples could be added.[30]

However, Pausanias bypasses these opportunities, which suggests that his interests lay exactly where we would expect them to, in the artistic and religious aspects of the site, and that he would only comment on individuals if the course of the narrative naturally presented him with an opportunity to do so. This practice tells against the accuracy of Dio Chrysostom's report, in the continuation of the passage from the Oration to the Rhodians (see above, p. 147) that Nero 'removed most of the statues on the Akropolis of Athens' (31.148) which is not matched by any other source, and which I have already suggested should be disregarded (see above, p. 44 n.4); in addition, it sits oddly with the Neronian inscription on the Parthenon (see below, pp. 153–4). As noted, Dio also refers in this passage to Nero's stealing objects from Olympia, Delphi and Pergamon, which is supported by other authors. However, his statement concerning Pergamon that its 'precinct was his very own' is obscure, not least in view of Cassius Dio's statement that it belonged to Augustus (59.28.1); perhaps the association had lapsed after Augustus' death. Tellingly, Dio Chrysostom appends to his list of Nero's thefts of statues from Greece 'why bother to mention those of other places?', implying (not necessarily truthfully) that he knew of many more.

[28] Nero was not the first high-ranking Roman to participate in the games, as Germanicus had done so on his tour in AD 17/18, winning the four-horse chariot-race; on an inscription recording this on a limestone block, perhaps a statue base, Sherk (1988) no.33.

[29] Cassius Dio adds that the bribe of HS 1.000.000 which Nero paid the *Hellanodikai* was later recovered by Galba; so too the HS 400,000 paid to Delphi.

[30] Philostratus *VA* 4.24 on his victories with the lyre, in the heralds' and the tragedians' contests (cf. Suet. *Nero* 24.1), which should be seen in the light of Suetonius' comment that 'the cities in which it was the custom to hold contests in music had adopted the rule of sending all the lyric prizes to him' (*Nero* 22.3). It may be wondered whether his interest in the lyre is a conscious manifestation of his interest in Apollo, and whether his practice of always wearing his hair 'in tiers of curls, and during the trip to Greece also letting it grow long and hang down behind' (Suet. *Nero* 51) was in purposeful imitation of Apollo, whose customary hairstyle this was.

Corinth

While Nero's concentration on his tour was on Corinth, Olympia and Delphi, his approach to the first was very different from that which he adopted towards the latter two. He stayed at Corinth,[31] and there he participated in the Isthmian games, using them as the stage for his declaration of freedom for Greece. He also started to cut the canal – its impact, had he succeeded, is hard to assess, but it was clearly a serious attempt. Otherwise he made no further significant intervention or investment in Corinth, which was a Roman foundation and therefore did not have the continuity and consequent authenticity of Athens, Olympia or Delphi. These were the centres of the *continuing* rather than *revived* Greek culture, however obvious the Roman additions, including his own, such as the addition of the musical competition at Olympia (Suet. *Nero* 23.1, 'contrary to custom'); the gap of 102 years in the active life of Corinth between Mummius' destruction and Caesar's re-foundation precludes such continuity. But its position as the chief city of the province made it an obvious focus for an imperial visit.

The project of cutting the Corinth canal, contemplated by Caesar and by Caligula, who had the area surveyed (see above, p. 86), was taken further by Nero (Suet. *Nero* 19.2; Philostratos *VA* 4.24 says that the canal advanced by four stades before it was stopped).[32] This attempt is referred to by Pausanias in an oblique and revealing manner: 'He who attempted to turn Peloponnese into an island desisted before he had dug through the Isthmus. The beginning of the cutting may still be seen; but it was not carried as far as the rock' (2.1.5; a relief Hercules from Nero's attempt is still visible).[33] The reference to Nero must be presumed to have been sufficiently obvious to Pausanias' readers, and to be intended to make a point – the disdain of even naming Nero is in marked contrast to the first mention in Pausanias of Augustus which is so detailed as even to give the impression that Augustus might not be known to his readers (see above, p. 4).

[31] It is quite probable that he stayed at Corinth longer than elsewhere, but his timetable is uncertain (Bradley (1978b) 71–2).

[32] Note also *Nero, or digging through the Isthmus of Corinth* in the Lucianic corpus, perhaps by one of the Philostrati (Bowersock (1969) 3). Nero's canal in fact extended much further than Philostratos believed (Wiseman (1978) 50).

[33] On Nero and the canal, Levy (1991) 189 n.2, 191. As Bradley notes, the project was not impulsive, but 'had a serious side to it and is suggestive of previous careful consideration' (Bradley (1979) 156). For the Hercules relief, Salowey (1994) 94, pl.29a, raising the possibility that it may represent Nero as Hercules; also, Wiseman (1978) 51 fig. 46.

Pausanias continues immediately with a judgement on the project: 'so Peloponnese is still, what nature made it, mainland'; he mentions two similar projects elsewhere, and concludes 'so hard is it for man to do violence to the works of God (*ta theia*)'. The combination of the failure even to name Nero and the accusation of impiety, in what is (for the sequential reader) the first mention of Nero by Pausanias is a powerful one. The sense of violation has been remarked on in other contexts, as has the sense of appropriateness, here transgressed. There is no such condemnation of Tiberius for his canal near Antioch (8.29.3, above, p. 82); and no mention at all of previous interest in cutting the Corinth canal. It may be that Pausanias deemed Nero's interest worthy of mention because he was the first actually to begin cutting. Whatever the motivation, his account gives an impression less of violation *per se* than of a specifically Neronian violation, as if Nero – unnamed but unmistakable – were the only person ever to attempt this impious deed.

The notion of the impiety of Nero's attempt is strong also in Dio Cassius (62.16.1–2) and Pliny (*NH* 4.10), although the latter applies it equally to all who had attempted to cut the canal. Dio's account is vivid: 'when the first workers touched the earth, blood spouted from it, groans and bellowings were heard, and many phantoms appeared'. This is reminiscent of the portentous events mentioned in relation to Augustus and Caligula, particularly of the statue of Athena spitting blood, also told by Dio (see above, p. 123). In the case of the canal, Dio goes on to say that Nero set an example by beginning the excavation himself.

Sparta

Mention has been made of the investment in Sparta by Augustus in particular, the reward for its support for him at Actium; and evidence was cited for possible benefactions by Tiberius at nearby Gytheion (see above, p. 83). Spawforth refers to 'the formal involvement of the citizen-assembly, in inscriptions of Roman date simply referred to as "the people", shown by decrees of the time of Gaius and Claudius; he adds that 'Pausanias knew of a historic building near the Agora, the Scias, in which the assembly met in his day; and inscriptions show that it continued to be convened into the third century'.[34] There is,

[34] Cartledge and Spawforth (1989) 147, with reference to 3.12.10; Pausanias says the Skias was built by Theodoros of Samos.

then, consistent involvement by successive Roman emperors with Sparta; and this was to continue with the foundation of several new games in the late first and second centuries AD.

Nero, in contrast, had nothing to do with Sparta, and on his visit to Greece he omitted Sparta from his itinerary. Of course, Sparta was not the only significant omission from his tour, as he also omitted Athens, but he did leave his mark on Athens, in contrast to Sparta, which suggests that it was even less favoured.

Athens

Although there is extremely limited evidence for the relationship of Nero with Athens,[35] what there is yields points of considerable interest for present purposes. It was noted above that Augustus called himself the New Apollo and that an inscription also refers to Nero as such, on a small marble base (see above, p. 121 n.44).[36] This is, as Kevin Carroll observes, the only one of the inscriptions associating him with Athens which gives him a title.[37] It does not, however, indicate any specifically Athenian connection.

In contrast, the best-known of the Neronian inscriptions in Athens, that on the east architrave of the Parthenon, does. While the text is clear, some of its implications are open to interpretation, although Carroll has refuted the notion that the inscription indicates the re-dedication of the Parthenon to Nero.[38] As Carroll points out, of the Neronian inscriptions from Athens, only the Parthenon inscription 'gives any hint of benefactions conferred on the city by the emperor'.[39] Carroll, asking whether the inscription was 'an act of flattery made in the hope of future gain', concludes that this partly accounts for it,

[35] Carroll (1982) 65, citing seven or eight relevant inscriptions, including that on the Parthenon.

[36] Suet. *Nero* 53 on Nero's association with Apollo and Helios. Both Suetonius (*Nero* 25) and Cassius Dio (63.20.5) mention his popular acclamation on his return from Greece (at, significantly, the Greek city of Naples): Dio relates that he was acclaimed as 'our Hercules' and 'our Apollo', and Suetonius that he wore the Olympic crown and carried the Pythian.

[37] Carroll (1982) 65.

[38] Carroll (1982) is the most detailed study. The inscription (*IG* II² 3277), which dates from 61/2 AD, reads: 'The Boule of the Areiopagus and the Boule of the Six Hundred and the people of Athens (have honoured) the greatest Imperator Nero Caesar Claudius Augustus G[erm]anicus, son of god, when the Hoplite General for the eighth time, epimeletes, and nomothetes was Tiberius Claudius Novius, son of Philinos, and when the priestess (of Athene) was Paullina, daughter of Capito' (tr. Sherk (1988) 115 no. 78).

 Refuting the notion of re-dedication to Nero, Carroll (1982) esp. 59–63, countering Jones (1978) 33 in particular. Alcock (1993) 182 maintains that the inscription 'informed the viewer that that temple itself was rededicated at one point to Nero'; also, Oliver (1983) 102, (1981) 417. Most recently, Spawforth (1994b) 234–7. [39] Carroll (1982) 65.

adding that 'this motive was involved in most honors conferred by the Athenians'.[40] The attempt to forestall further Neronian thefts of the art of Athens by making his freedman, Secundus Carrinas, eponymous archon (see above, p. 145) was just such an example.

In support of the idea of the inscription as an 'act of flattery' is its prominent position over the entrance to the Parthenon, one of the most famous and hallowed of all Greek temples, and the most prominent and renowned building in the central religious area of the heart of ancient Greece. More loosely, he followed Augustus, whose temple of Roma and Augustus was built just beyond the east end of the Parthenon (see above, pp. 123–4). The Neronian inscription is not only at the same end, the 'business' end of the Parthenon, but is considerably higher than the temple of Roma and Augustus, making it also highly visible, albeit in a different way. This conspicuous advertisement of Nero, and of Athens' respect for him, may tell us something about the Athenians' attitude to Nero, but it tells us nothing about Nero's attitude to the Athenians nor about his attitude to Athens, present or past.[41]

The same is harder to sustain in the case of the theatre of Dionysos – some remodelling was undertaken, and an inscription on the epistyle of AD 61/2 tells us that the theatre was dedicated to Dionysos and Nero.[42] The inscription from the theatre should not be taken to mean that Nero also rebuilt it – dedicator and builder are by no means synonyms – although it does not preclude that possibility. If Nero did not in fact rebuild the theatre, Carroll may be right to say that 'there is no evidence that Nero ever did anything for Athens'.[43] However, the extension of its dedication to include him alongside Dionysos shows that Athens did something for Nero. As in other cases where this can be seen to occur, hope of benefactions is likely to have been uppermost in Athenian minds. Whether or not Nero made any investment in Athens, or was simply the object of blandishments from 'the Boule of the Areiopagus and the Boule of the Six Hundred and the people of Athens' (to quote the Parthenon inscription), he omitted the city from his tour of Greece. If the Parthenon inscription had been intended to flatter Nero with a view to possible benefits to Athens, it appears that it did not work.

[40] Carroll (1982) 67.
[41] See above, pp. 115–6 on the word *autokrator*, which is used on the inscription; it is hard to see why it should have a special significance here, for example as a flattering term.
[42] Sturgeon (1977) 45; Travlos (1971) 538. [43] Carroll (1982) 65.

Pausanias gives Nero's visit to Greece as a whole a very low profile, giving the reader only minimal evidence that it had ever happened. In Athens, the Parthenon inscription and the theatre of Dionysos provided visible evidence of Nero's impact on Athens, but such modern features were never Pausanias' priority and we should not be surprised that he found other features of the theatre and, particularly, the Parthenon much more deserving of description.

An emperor wishing to be seen as being in the tradition of the glorious Greek past, as a descendant of it rather than a reviver of it, could only benefit by associating himself with the most fully authenticated Greek cities, sanctuaries and customs. In this light, the dedication of the theatre of Dionysos at Athens to Dionysos and Nero – whether or not on the initiative of Nero himself – would be an ideal way of associating him as an artist (arguably his favourite guise) with the home of performance. However, one cannot presume an active rather than a purely reactive role on the part of the emperor in the construction or embellishment of provincial buildings. If Nero ever had any intention of performing in the theatre of Dionysos, he had to forego it when he decided to stay away from Athens.

VESPASIAN

The only mention of Vespasian by Pausanias (7.17.3–4; see above, p. 140), concerning his re-imposition of tribute on the Corinthians, includes the interesting phrase that Vespasian said that 'Greece had forgotten what it was to be free.' As observed, the implication is that Vespasian was left with no choice, and that the Greeks were responsible for provoking their own disadvantage in this respect. The reference to tribute has been taken to mean that the real reason behind Vespasian's move was the cost of the administration of the province,[44] and this may have been at least part of the motivation.

This was no isolated act of Vespasian: Suetonius tells us that he revoked the freedom of Achaia, Lycia, Rhodes, Byzantium and Samos (*Vesp.* 8.4).[45] The revoking of Rhodes' freedom – presumably that given by Claudius – is especially interesting in view of the particular favour it enjoyed under Nero (at whose instigation Claudius had given it freedom), to judge from Dio Chrysostom's

[44] Bosworth (1973) 61.
[45] Bosworth (1973) 60–1; Alcock (1994) 103–4. On Vespasian's wider policy, of which this was part, Braund (1984) 187; Luttwak (1976) 26–7, 112–13.

oration to the Rhodians. Rhodes' freedom was later restored, probably by Titus.[46] The occasion of the revoking of the freedom of Achaia is given by Philostratos (*VA* 5.41) as Vespasian's arrival in Greece in late AD 70, also mentioned by Josephus (*BJ* 7.21–2). Pausanias makes no mention of Vespasian's visit to Greece, even when mentioning the revoking of the freedom of Achaia, exactly as he made no reference to Nero's visit to Greece, even when relating his original gift of freedom.

The tone of Pausanias' reporting of Vespasian's reversal of Nero's gift of freedom is in marked contrast to the indignation expressed in the letters of Apollonios of Tyana to Vespasian, in which the actions of the two emperors are explicitly juxtaposed, to the disadvantage of Vespasian: 'you have, they say, enslaved Hellas, and you imagine you have excelled Xerxes. You are mistaken. You have only fallen below Nero. For the latter held our liberties in his hand and respected them . . . Nero freed the Hellenes in play, but you have enslaved them in all seriousness' (*VA* 5.41).

Vespasian is credited by Suetonius (*Vesp.* 8.5–9.1) with both restorations and new works in Rome. As with the objects stolen by Vitellius, they would be of no relevance to Pausanias. Like other emperors before him, Vespasian displayed stolen Greek sculpture, placing in the temple of Peace many Greek sculptures which had been looted by Nero and, in the time-honoured manner, lodged in his own home (Pliny, *NH* 34.84; Josephus, *BJ* 7.158–62, does not name Nero, but clearly has his stolen treasures in mind).[47]

In the provinces, Vespasian is known to have helped pay for building at the theatre in Sparta which had been rebuilt in the time of Augustus, and probably further modified during Tiberius' reign (see above, pp. 130–1).[48]

TRAJAN

Despite the fact that Trajan's reign saw more building in the provinces than that of any emperor bar Augustus and Hadrian,[49] and

[46] Jones (1978) 28.

[47] Pollitt (1983) 155, notes that Pliny was a contemporary of Vespasian and admired his achievements; it is not possible to tell how far, if at all, that determined the form of his references to him. It has been suggested that Pliny is deliberately juxtaposing Nero and Vespasian as opposites in their attitudes to art, almost as a rhetorical device (Isager (1991) 224–9).

[48] Cartledge and Spawforth (1989) 105. Vespasian's name (as *autokrator*) is found on an architrave block thought to be from a stoa in or near the theatre.

[49] MacMullen (1959) 209.

despite his being the only emperor between those two to visit Athens, Pausanias mentions him only twice, in neither case citing any buildings in Greece. One which we might have expected someone of Pausanias' education to show some interest in is the library of Pantainos, built in the Agora of Athens between AD 98 and 102, and bearing a dedicatory inscription to Trajan.[50] But, like the library carried off by Sulla (see above, p. 101), it receives no mention.

In his book on Messenia, Pausanias says that 'the emperor (*basileus*) Trajan granted the people of Mothone freedom and independence' (4.35.3). Typically of Pausanias, his own antiquarian interests are to the fore, as he takes the opportunity to express his belief that Mothone was the Homeric Pedasos (4.35.1), and the action of Trajan is just the most recent in a long string. It is perhaps surprising, given that book four is mainly historical in content, that such a declaration is not given more attention. It is also noteworthy since Pausanias has already said that Nero's gift was revoked by Vespasian, so return of the gift of freedom (however nominal) to one city is of some interest.

At 5.12.6, Pausanias gives us a brief but dense selection of Trajan's activities: after mentioning a statue of him (alongside one of Hadrian) in the temple of Zeus at Olympia, he informs us that Trajan conquered the Getae (i.e. the Dacians) and the Parthians, and that 'of his buildings the most remarkable are the baths called after him, a great circular theatre, a building for horse-races, two furlongs long, and the Forum at Rome, the last of which is worth seeing for its splendour, and especially for its bronze roof' (5.12.6; see above, p. 42).

Trajan's statue at Olympia was, according to Pausanias, 'dedicated by the Greek nation (*hoi pantes hellenes*)'. This is not the first example of a Roman statue in a Greek temple and, with Hadrian to come, is by no means the last (see below, pp. 184–5). However, Pausanias' lack of identification of the 'statues of Roman emperors' he saw in the Metroon at Olympia (see above, p. 120) stands in marked contrast to his naming two such statues in the neighbouring temple of Zeus. It is true that Pausanias' interest in the Zeus temple in general is much greater than that in the Metroon, which was one of the smallest of all Doric temples and quite overshadowed by the Zeus temple, which was among the largest mainland temples, and richly adorned both externally and internally. But Pausanias gives us two contrasting pieces of information about the Metroon, namely that it housed statues of Roman emperors, and that it retained its ancient name

[50] Camp (1986) 190; Wycherley (1957) 150.

nonetheless. The possibility that the statue of the Mother of the Gods that he mentions had been placed in the Heraion raises the possibility of a third, if it is in fact the original cult statue of the Metroon (5.20.2).

For Pausanias to choose as one of the two facts deemed worth mentioning concerning the Metroon the presence of 'statues of Roman emperors' is unexpected. Perhaps it is even more unexpected to mention two such statues in describing the temple of Zeus, which afforded so many more opportunities than the Metroon for choice. The fact that he also chose to name the emperors in this instance must be taken as a sign of goodwill towards the two concerned, Trajan and Hadrian. Had Pausanias not felt favourable towards them he would not have identified them, or even mentioned them anonymously. That Pausanias is an admirer of Hadrian is repeatedly clear; that he appears also to be favourable towards Trajan may owe something to the latter's being Hadrian's adoptive father.

Greece figured little in Trajan's plans and works, his interests being rather in other areas, such as Dacia and Parthia, and it is interesting that in the brief selection of Trajan's activities Pausanias gives, he mentions both of these key foreign conquests of Trajan. He also mentions a series of Trajan's buildings in Rome, again an unexpected interest in the modern, and again indicative of a positive attitude towards Trajan. This may have been strengthened by the fact that, as this passage makes clear, he had visited Rome, seen, and been impressed by, these works of Trajan.

The concentration of Trajan on areas other than Greece, reflected in Pausanias' paragraph, does not mean that Trajan was not personally aware of Greece and Greek artists: a letter of Pliny relates that Trajan's response to Pliny's request for an architect to be sent from Rome to Bithynia was: 'as there is no province that is not furnished with architects of skill and ingenuity, you cannot possibly be in want of one; pray do not imagine it is your quickest way to get them from Rome, for it is usually from Greece that they come hither' (*Ep.* 10.40). The useful, if incidental, inference is that the export of Greek architects at least (and perhaps by implication artists in general) was flourishing in the late first and early second centuries AD, a symptomatic reversal of emphasis from the second century BC when the first Roman architect, Cossutius, was introduced to Athens to work on the temple of Olympian Zeus (see above, p. 126).

This flourishing of Greek art is part of the wider interest in Greece which was growing at the time; it is further attested by the likely

benefaction of some kind by Trajan at Sparta which brought him the title *soter*,[51] a title also attested for him at Athens.[52] In the same connection, the institution late in his reign of the Leonidean games was a re-foundation, a conscious return to part of Sparta's past, and supported with related administrative posts.[53] Acts like these exemplify the growing interest in the past of Greece that was discussed in the first chapter. This process reaches its culmination under Hadrian, to whom I now turn.

HADRIAN

The last paragraph sets the scene for the full development of these themes and preoccupations under Hadrian and the Antonines. The succession of emperors by adoption brought with it a succession of policy and preoccupations, and the interest in the literature and culture of Classical Greece referred to in the previous paragraph as occurring under Trajan became a substantial and widespread movement under Hadrian. There are more altars dedicated to Hadrian than to any other emperor,[54] and more was built in the provinces in his reign than in that of any other emperor.[55] Pausanias is, on the bald statistics, shown as a true representative of the mood of the times, as he refers to Hadrian more often than to any other emperor.

As noted earlier, Elsner has detected in Pausanias 'a sense of inevitable decline and fall'.[56] However, as I have already argued in response, the detailing of decline ends with Mummius, and the picture of Hadrian and his activities in Greece derived from Pausanias (as from other sources) shows a zenith rather than the nadir Elsner's phrase might lead one to expect. As John Wilkes has said, 'it was only with the accession of Hadrian in 117 that Greece found an emperor genuinely sympathetic towards her cultural traditions'.[57] The truth of this is most famously enshrined in the (admittedly much later) description of Hadrian as 'graeculus' (*HA Hadr.* 1.5).[58]

Before looking at Hadrian's involvement in Greece, and at Pausanias' record of that involvement, a consideration of his broader activities in the provinces is appropriate. Perhaps most important to

[51] Cartledge and Spawforth (1989) 105. [52] Oliver (1983) 103, citing *IG* II² 3284.
[53] Cartledge and Spawforth (1989) 106. [54] Price (1984a) 69, 216.
[55] MacMullen (1959) 209. [56] Elsner (1992) 19. [57] Wilkes (1991) 232.
[58] On the *HA Hadr.*, Benario (1980); on the date of the *Historia Augusta*, Barnes (1978) 18, Birley (1978).

stress is the extent of Hadrian's own travels in the provinces: 'hardly any emperor ever travelled with such speed over so much territory' (*HA Hadr.* 13.5). Apart from a short break in Rome in AD 128, he toured from AD 120–131 in Africa and the Eastern provinces, including Greece, and these visits left a substantial impression as well as a physical legacy, in terms of buildings, cults, festivals and games. This was inevitable given the nature of Hadrian, his desire to be associated with the past glories of the areas he was visiting (Greece above all), and his wish to match those glories by creating a comparable modern environment and, equally, by re-creating an image of the past.

In the *Historia Augusta*, it is observed that Hadrian 'gave the name Hadrianopolis to many cities, as, for example, Carthage and a part of Athens' (*HA Hadr.* 20.4–5). The case of Athens will be discussed below, but it is worth noting here that the intrinsic self-promotion of Hadrian, although at its most obvious here, is a recurrent theme in his benefactions to the provinces. It is evident again in his foundation of games at Smyrna called Olympia Hadrianea; here there is the additional point that, as Price notes, these games were founded 'on the model of the Athenian games', reinforcing the association of Hadrian with Athens which will be seen below to have been the cornerstone of his policy of embellishment in the provinces.[59] Although the quotation from the *Historia Augusta* given refers to Hadrian's naming 'many cities' after himself, we should not assume that these were all new foundations. As Millar has pointed out, in the East after Caesar and Augustus, 'genuinely new foundations, involving actual construction, were very rare'.[60]

An oblique form of self-promotion adopted by Hadrian was the use of memorial foundations, such as Antinoopolis in Egypt in memory of his favourite Antinoos, statues of whom have been widely found in the provinces (including examples at Olympia and Delphi).[61] He also built an elaborate funerary monument for his horse Borysthenes in Narbonensis: the parallel with Alexander and Bucephalus cannot have been coincidental (Cassius Dio 69.10.2, 11.2–3).[62]

Apart from buildings, Hadrian also had an impact on religious practices in many provinces, and a few examples will suffice to

[59] Price (1984a) 67–8.
[60] Millar (1987) xiii; Hadrianotherai in Mysia could be added to the examples Millar gives (*HA Hadr.* 20.13). [61] On the Antinoos cult, Price (1984a) 68.
[62] MacMullen (1959) 222 n.5.

illustrate this. At Pergamon, there was a statue to Hadrian as a god in the sanctuary of Asklepios, probably connected with the celebration of the imperial festival there.[63] A suggestion of the divinity of Hadrian was also made at Ephesos, where the initiates of Dionysos put up a statue of Hadrian, apparently on equal terms with that of the god.[64] At Kyzikos, the exact nature of the relationship between Hadrian and Zeus is unclear, but at the least honours were paid to him in the temple.[65] The association of emperors as a whole with Zeus was noted above (apropos of Augustus, and used also by Caligula and Claudius), and will be discussed further in the following discussion of Hadrian and Greece.

Hadrian and Greece

All the evidence we have – including the account of Pausanias – suggests that the philhellenism which had characterized Nero's reign, and had been generally less prominent under the succeeding emperors (with Trajan providing something of an exception), was revived and brought to a peak under Hadrian.[66] This manifested itself in a broad range of activities contributing to the cultural and physical embellishment of Greece – in Pausanias' words, the Megarians 'were the only people whom even the emperor Hadrian could not make to thrive' (1.36.3). As explained (see above, p. 13), this phrase implies no failure on Hadrian's part, since the current state of the Megarians resulted from their impious murder of the herald Anthemokritos.

The extent and scope of Hadrian's activities in Greece are too great to be encompassed fully here, but much can be gleaned from the aspects that Pausanias mentions. While the personal aspect of these activities has been mentioned already, and will repeatedly be apparent in what follows, it must be acknowledged from the beginning of this section that these activities were not a series of whims or fancies, but elements of a coherent and concentrated programme of building and intervention in other spheres, designed as what Spawforth has called 'part of a fairly systematic imperial attempt to reinforce the structures of civic life in the Roman east'.[67]

The importance of the imperial cult and its paraphernalia has been noted at several points in this study, and can be seen in evidence again in Hadrianic Greece. In this connection, a close association with the

[63] Price (1984a) 148. [64] Price (1984a) 118. [65] Price (1984a) 155.
[66] As observed by Syme (1965) 247–9. [67] Cartledge and Spawforth (1989) 108.

long-established religious centres of Greece was beneficial to Hadrian. The value of such association has been noted above as a means of using antiquity and established custom as a means to legitimacy, and to self-promotion as an inheritor of the legacy of the old world, and as promoter of the comparable glories of the new.

The connection of Hadrian with Delphi is repeatedly apparent, particularly from surviving inscriptions; he also constructed buildings there.[68] Although the Panhellenion is primarily associated with Athens, the suggestion of enlarging the Delphic Amphictyony was made to the Amphictyonic League in 125, and may be seen as a kind of forerunner; the idea did not find favour, perhaps due to the inflexibility of the Amphictyony, as Dietrich Willers suggests, making it unsuitable to Hadrian's desire to create a wholly new administrative structure.[69] The relevance of the imperial cult becomes apparent soon with the offer of divine honours to Hadrian by the Achaean League in 126, and the cult titles 'Pythios' and 'neos Pythios'; indeed, many of the altars noted above as being more commonly dedicated to Hadrian than to any other emperor are related to this attempt to unify the eastern provinces. The creation of the Panhellenion involved not just Greece, but Asia Minor also, and its significance in placing Greece at the centre of the eastern provinces is considerable.

The Panhellenion was formally founded in AD 131/2 with the dedication of the temple of Olympian Zeus. The temple is discussed by Pausanias, and will be further considered in the next section, along with the monuments and statues associated with the foundation and the temple. Here attention should be drawn to Hadrian's personal aggrandizement which resulted from the creation of the Panhellenion and its associated buildings: the association of successive emperors with Zeus has been noted, and is nowhere more conspicuous (or more political) than in this case, the completion of the biggest of all temples of Zeus by Hadrian. The imperial epithet 'Panhellenios' is also attested in Athens, although not in the emperor's lifetime.[70]

The link forged between Hadrian and Zeus was, though, by no means confined to this one spectacular building: from AD 128/9, the commonest epithet of Hadrian was 'Olympios' or the variation 'Hadrianos Zeus Olympios'. In Sparta, there was a civic cult of Zeus Olympios in Hadrian's honour, and in Athens he founded games

[68] Flacelière (1971); Jones (1966) 63–6; Robert (1937) 88–9; Price (1984a) 244; Swain (1991).
[69] Willers (1990) 99–100. [70] Benjamin (1963) 59–60.

called the 'Olympia' in honour of Zeus Olympios.[71] The cult title
Eleutherios, previously used for Augustus (see above, p. 133 with
n.86), is applied to Hadrian just once in Athens, on a seat in the
theatre of Dionysos (which was altered under Hadrian) for a priest of
the cult;[72] however, he is honoured in two inscriptions from the
Akropolis as the son of Zeus Eleutherios, perhaps carrying the
implication of his being the brother of Athena.[73]

The remarkable presence in the Parthenon of a statue of Hadrian –
specifically stated by Pausanias (1.24.7) to have been the only statue
in the cella apart from the Parthenos itself – will not only have
reinforced the connection with Athena, but constituted an exceptionally
and unmistakably bold stroke which further associated Hadrian with
the heart of the religious life of Classical Athens.[74] Similarly, a statue
of Hadrian stood in the temple of Zeus at Olympia, next to one of his
adoptive father, Trajan (5.12.6; see above, p. 157; below, p. 185).

It has been suggested that the altars in the provinces as a whole
should not necessarily be taken as a sign of Hadrian's attempt to
advance the idea (and practice) of the Panhellenion, but that they
occur simply as a result of Hadrian's travels in the provinces.[75] In the
case of Athens, the centre of the Panhellenion, where the buildings
and associated matters of the Panhellenion were so substantial and
numerous, it is hard to see that altars were actually needed to
promote the Panhellenion. It may well be, therefore, that the erection
of a series of altars would have been deemed appropriate to mark the
three visits to Athens made by Hadrian (in AD 124, 128, 131).

In the case of Sparta, Hadrian is known to have visited in AD 124/5
and 128/9, and there is considerable evidence of his investment in the
city, its customs and administration.[76] The altars datable to his visit in
AD 124/5 have been seen by Benjamin as a 'reflection of the new
Panhellenic importance that Hadrian bestowed on that city'.[77]

[71] Cartledge and Spawforth (1989) 109, pointing out that Pausanias also saw a Spartan temple
of Zeus Olympios. Waywell and Wilkes (1994) 419. On the 'Olympia', Spawforth
(forthcoming).
[72] On the theatre inscription, Maass (1972) 116, detailing epithets of Zeus applied to Hadrian.
On Hadrian and the theatre of Dionysos, Sturgeon (1977) 45, 48.
[73] Raubitschek (1945); he suggests that 'Zeus Eleutherios' in the inscription denotes Trajan,
Hadrian's adoptive father (130–1).
[74] Graindor (1934) 57–8. The base of this statue may survive (Raubitschek (1945) 129).
[75] Price (1984a) 69.
[76] Cartledge and Spawforth (1989) 109–10, 134–5, on Hadrianic buildings in Sparta, secular
and sacred, but containing mostly uncertain attributions (none mentioned by Pausanias).
Waywell and Wilkes (1994) 419. Hadrian also gave territory to Sparta, as he did to other
favoured cities, e.g. Kephallenia to Athens. [77] Benjamin (1963) 76.

Hadrian held the patronomate, a local magistracy associated with the 'Lykourgan customs' which were revived under the empire,[78] but apparently shunned by Nero (above). A useful parallel is the creation in the AD 130s of a 'Kytherodikes', a name used by Thucydides (4.53.2) for a Spartan official with responsibility for Kythera, a position apparently already obsolete by his day.[79] These are prominent manifestations of the archaizing tendency often seen as the hallmark of the Roman attitude to Greece at this period, and also apparent in the language of contemporary dedications (see above, p. 29).

Hadrian and Athens

As Peisistratos had made Eleusis effectively a gateway to Athens, so initiation into the Eleusinian Mysteries seems to have become a gateway to membership of Athenian society for many Republican and imperial figures. Hadrian is the prime exemplar of this interest, being initiated in AD 112/13 (in which year he was also archon) and taking part in the Mysteries on each of his three visits to Athens (in AD 128 with Antinoos, although it is not certain whether the latter was initiated), more than any other emperor.[80] This association with the most prestigious of the Athenian religious festivals was an essential part of the 'baggage' of any emperor wishing to be seen as a credible member of the Athenian establishment; Nero's awareness of the importance of such credibility in this context no doubt contributed to his decision not to risk scandal by seeking initiation (see above, p. 144). But such association with Eleusis could prove a mutual process, since after being initiated, Hadrian made many gifts to the Athenians.[81]

Spawforth has characterized Hadrian's aim as being 'to endow Athens as the capital of Hellenism'.[82] While the fact that Hadrian bestowed most benefits on Athens does not in itself indicate his motive, the accumulation of such benefits, in conjunction with the central role of Athens in the Panhellenion, supports this view. The particular point of reference for Spawforth's comment is Hadrian's institution of three games at Athens, the Panhellenia, Olympia and Hadrianea. These continued the policy which we have seen since the beginning of the empire of founding games in Greece, as a means of promoting (and doubtless popularizing, on the 'bread and circuses' principle) the founding emperor as well as making Roman influence

[78] Cartledge and Spawforth (1989) 108. [79] Cartledge and Spawforth (1989) 111.
[80] Clinton (1989a) 56–8. [81] Cited by Millar (1977) 37. [82] Spawforth (1989) 194.

ever more pervasive. This policy was maintained by Hadrian, as noted above in connection with the games at Sparta; and one could add the re-introduction into the winter Nemean games by Hadrian of the long version of the horse race (6.16.4).

In the case of Hadrian, there is a further element in the raising of the profile of the Panathenaia, the games which were associated with the earliest phases of Athens' existence, their foundation variously attributed to Erichthonios or Theseus, and of which he was the *agonothetes* in AD 124/5.[83] Their foundation (or re-foundation) in the sixth century BC, traditionally but by no means certainly in 566, and possibly by Peisistratos,[84] was based on the existing games. Under Hadrian, these games were now made iselastic, as were the other three, so that, as Spawforth points out,[85] Athens now boasted four of the six iselastic games in Greece. The significance of this act can perhaps be indicated by remembering that the short period from 582–566 BC had seen the addition of the games at Delphi, Isthmia, Nemea and Athens to those already long established at Olympia; however, of these, the games at Athens were the only ones which had not become part of the *periodos* of iselastic games. There were, in addition, many other, lesser, local games, some of which were of considerable status (such as the Aspis at Argos[86]), and others which are not pertinent to the point being made here because they remained of low status.

Thus the Hadrianic move should be seen as finally and deliberately raising Athens in this respect to equal status with the four great athletic centres. The upgrading of a contest which had been in existence for nearly seven hundred years showed the emphasis Hadrian wished to put on Athens, his sense of the past and its potential use as a means of making an impact on the present; but also his different approaches from his predecessors, and within his own reign. Such a sense of the past is shown by Nero's choosing the Isthmian games to make his declaration of freedom for Greece (and doing nothing comparable for Athens). On the use of the past to promote the present, Hadrian had, as noted, originally suggested an enlargement of the Delphic Amphictyony, but had received little support from the Amphictyons; it is tempting to see his growing interest in the games at Athens as parallel to his locating the Panhellenion at Athens.

Finally, a point about Hadrian's re-organization of the Panathenaia

which, while not made explicit, may in fact be the most significant aspect of it: the games were originally related to the unification of Athens under Theseus – Thucydides (2.15) refers to the feast of the unification of Attica dating from Theseus. Plutarch (*Thes.* 24.3), in the context of the unification of all the inhabitants of Attica into the newly founded city of Athens, credits Theseus with the unification and says that the Panathenaia were founded in honour of this event; and Pausanias (8.2.1) dates the name 'Panathenaia' from Theseus, following the same angle on unification as in Plutarch's account. The coincidence of Plutarch's and Pausanias' account must reflect a common view of their age, which overlapped to some extent with the age of Hadrian.[87] From a contemporary Roman point of view, the common desire to draw the past into the present meant going as far back into the past as possible, to give, as so often, legitimacy through antiquity.

There was a greater antiquity than the era of Theseus: that of the early kings of Attica such as Kekrops and Erechtheus, and indeed Theseus' own father, Aigeus. All of these were also among the original Eponymous Heroes, a group which Hadrian later joined (1.5; further, see below, pp. 168–71). But the parallel of Hadrian and Theseus was a parallel of first founder and latest founder; in the attempt to assert legitimacy through antiquity, such a parallel could hardly be bettered.

And there is still further evidence of a conscious attempt to emphasize the parallel between Hadrian and Theseus. It is surely no coincidence that Plutarch pairs Theseus and Romulus in his *Parallel Lives*, personifying the parallel between Athens and Rome. It is just this parallel which is found on a marble cuirassed statue of Hadrian, believed to be the one described by Pausanias (1.3.2) beside the statue of Zeus Eleutherios in front of the stoa of Zeus, and found appropriately on the west side of the Agora. As Homer Thompson's description makes clear, the parallelism and symbolism are explicit: 'The emperor's cuirass bears the well-known logo: the goddess Athena standing on the back of the wolf of Rome, or, as a cynic might read it, Athens superior to Rome but supported by Rome.'[88] As Shear has put it, 'the combination of these emblematic figures clearly characterizes Hadrian in his relation to the two cities, as benefactor of Athens and emperor of Rome'.[89] Further, the juxtaposition of the statue of

[87] Thompson (1961) 224; Kyle (1987) 15–31, esp. 24–5. [88] Thompson (1987) 14, pl.IIIa.
[89] Shear (1933) 181; on p. 183, Shear says 'no reason exists to doubt that the statue found in front of the Stoa of Zeus is the same one reported as standing there by Pausanias'. Also, Harrison (1953) 73, 'our statue is probably the one which Pausanias saw'.

Hadrian with that of Zeus Eleutherios cannot be coincidental: the regular adoption of Zeus by Roman emperors has been remarked on (see above, pp. 119–20), and will be seen below to be particularly close in the case of Hadrian. The cult title Eleutherios is one attested for Zeus, and once for Hadrian as well as Augustus (see above, pp. 133, 163); the juxtaposition of the Agora statues is a hint of an association between the emperor and this aspect of the god.[90]

If the parallel of Theseus and Romulus, personifying that of Athens and Rome, was current in Roman thinking, Hadrian's desire to be seen as a second Theseus, as the second founder of Athens, had ample external justification, quite apart from his personal philhellenism and ambition. The parallel between Hadrian and Theseus is arguably the best-known aspect of his policy towards Athens, amply reflected in his building programme, to which I now turn.[91]

When Hadrian's extensive building programme in Athens is considered, the account of Pausanias forms a vital part of the evidence; that fact alone is a mark of the interest he shows in both Hadrian and Athens. It is, I suggest, not true of his account of the Roman period of any other city or sizeable town (it is, of course, true of his accounts of several sanctuaries, such as Olympia, Delphi and Epidauros, but that is a reflection of his preoccupation with sanctuaries). The impact of Hadrian on the appearance of Athens will therefore be examined in close conjunction with the text of Pausanias.

Although the attitude to Hadrian displayed by Pausanias (and 'displayed' is a deliberately chosen word, so conspicuous are his attitudes) will be assessed in the Conclusion, it is inescapable when considering his discussion of the contribution of Hadrian to the life and embellishment of Athens. This is already apparent from his first reference to Hadrian, noting the statue cited above as being the one found in the Agora: 'here stands an image of Zeus, named Zeus of Freedom, and a statue of the emperor Hadrian, the benefactor of his subjects and especially of Athens' (1.3.2). Thus, not only are we presented with the parallel, or at least association, of Zeus and Hadrian, but we are left in no doubt that Pausanias sees Hadrian as 'the benefactor of his subjects', and Athens as especially favoured. Of the latter point there can be no doubt: it has already been observed

[90] Benjamin (1963) 58; the association has been strengthened since Benjamin wrote by the establishment of the separate identity of the Royal Stoa and the Stoa of Zeus, thus confirming the latter as the location of the statue; Benjamin (1963) 57–8, citing Raubitschek (1945).

[91] Important recent discussions of Hadrian and Athens are Willers (1989) and (1990), the latter with reviews by Spawforth (1992) and Boatwright (1994); Spawforth and Walker (1985); Boatwright (1983).

that, in Spawforth's words, Hadrian's aim was 'to endow Athens as the capital of Hellenism' (see above, p. 164), and we may see Pausanias' words as evidence of the near-contemporary perception of the benefits brought by Hadrian.

For Pausanias, such benefaction may have been political, civic or religious; but it is relevant mainly (not only) in terms of its physical manifestations. The first of these that he describes are the statues of Hadrian discussed above, not the only ones he notes. He continues to a monument which included a statue of Hadrian, that of the Eponymous Heroes. This is one of the best-known monuments of the Agora in Athens, and one of the most important, providing a unique insight into the workings of the post-Kleisthenic democracy and, more importantly for present purposes, into its changing form during the later Classical, Hellenistic and finally Roman Imperial periods. Its importance and details are known primarily from Pausanias (1.5).[92]

We have already seen how Hadrian placed himself at the heart of the religious life of Athens, and nothing could situate a figure in the heart of the very fabric of Athenian political and civic life like promotion to status of an Eponymous Hero. In the case of Hadrian, his own promotion put him on a par with comparatively recent figures like Attalos and Ptolemy, and ahead of Antigonos and Demetrios of Macedon who had been added in 307/6 and removed a century later in one of the political changes of wind that overtook Athens. Most significantly, it placed him on a par with the early kings and heroes of Athens, and it is here that the order of narrative used by Pausanias is of particular interest.

Pausanias' description of the monument is almost an excuse to retell myths associated with the original Eponymous Heroes: he lists statues of the ten Heroes, then concentrates on Kekrops and Pandion, discussing their identities and lineages. This interest in genealogy, in attempting to disentangle phases in the early history of Athens, is entirely commensurate with the interest in the early history of art discussed in the previous chapter.

To these original Heroes, Pausanias notes the addition of Attalos and Ptolemy (omitting Antigonos and Demetrios who had been removed, as noted, and whose quondam presence on the monument would in all probability have been untraceable to Pausanias), and

[92] The most detailed treatment of the monument is Shear (1970). There are references in Aristophanes' *Knights* (977–80) and *Peace* (1180–4) to an earlier monument: Shear (1970) 203–10; Thompson (1976) 70–2; Camp (1986) 97–100, 163–4, 167, 191.

concludes by mentioning Hadrian. While this may be a simple list (as it is in chronological order), it has the effect of working up to Hadrian, an impression confirmed by the description of him as 'the *basileus* who did most for the glory of God and the happiness of his subjects', adding that 'he never made war of his own free will, but he quelled the revolt of the Hebrews who dwell over above the Syrians [AD 132]' (1.5.5). This neatly combines stress on his piety with his accomplishments, the carefully chosen military deed showing him as a just man who responds to the aggression of others, but does not institute violence.

But there is more to be extracted from this passage: the association of Hadrian with Theseus, the founding father of Athens, has already been noted (and will be again), and the parallel is further strengthened by his position here. After all, he is in the company of Aigeus, father of Theseus, and Akamas, one of the sons of Theseus (as Pausanias notes, 1.5.2). But Theseus himself is not on the monument; is it possible that Hadrian, juxtaposed with the father and the son of Theseus, was conceived of as a modern Theseus? This theme will recur in the following pages.

A further point, consciously exploited or not, was that the original ten Eponymous Heroes were chosen by Delphi after the oracle was presented by Kleisthenes with a list of names. As Pausanias notes, Herodotos 'has told who it was that established ten tribes instead of four and replaced their old names by new ones', an interesting indication that he expects his readers to know their Herodotos as he does (the reference is to Hdt. 5.66, 69), or at least their history. There is no evidence of Delphic involvement in the selection of the later Eponymous Heroes, including Hadrian, but the monument featured tripods at both ends as a reminder of Delphi's original role. Hadrian's interest in, and evident commitment to, Delphi as the seat of arguably the most ancient and most mysterious form of Greek religion could only have been boosted by placement on a monument set up, in effect, in accordance with instructions from Delphi, however devalued the oracle may have been in this period.

Hadrian's elevation to the status of Eponymous Hero brought with it the naming of a tribe, Hadrianis, after him. In fact, after his initial reference to the statues, the tribes are Pausanias' starting point for his discussion of both the original heroes, and of the newly-added Hadrian. His statue on the monument would be prominent and highly visible to all who walked in the Agora, serving as a daily reminder of his existence to the population of Athens, and not just the

members of the tribe named after him. And his statue, raised high –
apparently higher than those of the other Eponymous Heroes[93] – in
the very centre of Athens, would serve as a conspicuous reminder of
his now approved claim to a place alongside the forefathers of Athens.

Hadrian's position as an Eponymous Hero put him on a par not
only with the mythical figures of Athens, but also with the recent
historical figures of Attalos and Ptolemy, mentioned by Pausanias
(1.5.5). Pausanias continues with a further, brief, mention of Attalos
and Ptolemy (1.6.1), followed by a history of Ptolemy (to 1.7.3), and
a paragraph on Attalos (1.8.1). These are historical accounts, with no
relevance to Athens other than the starting point of their being
Eponymous Heroes; and these accounts include no buildings or objects.

However, the first line of this section is the most telling: 'The age of
Attalos and Ptolemy is so remote that the tradition of it has passed
away, and the writings of the historians whom the kings engaged to
record their deeds fell into neglect still sooner. For these reasons I
propose to narrate their exploits' (1.6.1). The secondary interest here
is that Pausanias again reveals something of his working methods,
with the suggestion that he regards his own writing of history as being
necessary when there is no (or insufficient) extant history,[94] showing
an awareness of what could reasonably be expected of his readers.
This alone shows his intention that his work should be read, and was
not for private consumption. It is also curious that he should feel it
necessary to include an excursus on the history of a period in the
monuments of which he shows little interest.

The point of primary interest in the present context is that
Pausanias should feel the age of Ptolemy (made an Eponymous Hero
in 224/3 BC) and Attalos (200 BC) 'so remote that the tradition of it has
passed away' (see above, p. 39 n.108). This is inherently odd, given
that (as the previous chapter shows) he was accustomed to think
carefully about, and to attempt, fine divisions between much earlier
periods. What is most striking here is that this should be written by an
educated native of Asia Minor, and probably a Lydian, a native of an
area which had been within the sphere of the Pergamene rulers. His
statement surely cannot have been literally true. It may, therefore, be
that we are dealing with the deliberate diminution of the significance
of that period, despite the obvious remains in Athens, such as the stoas
of Attalos and Eumenes, and the Attalid dedications on the Akropolis.

[93] Shear (1970) 203. [94] Habicht (1990) 572.

Or perhaps not the diminution of the period as first target, but of the individuals; this, in turn, would promote Hadrian. The process is nowhere made explicit, and there may have been no such conscious line of thought, but the effect fits neatly into Pausanias' promotion of Hadrian which is becoming clear from the discussion so far and which, I believe, becomes yet clearer.

A final point arises from Pausanias' description of the monument: he says that there was a tribe named after Hadrian 'in my day'. The date given by Thompson for the addition of Hadrian is 'about 125 AD'.[95] This would surely be before Pausanias started travelling in Greece, and even the latest possible date of AD 138 is by no means certainly within the span of his travels. As Habicht has shown, however, the phrase is used by Pausanias to mean 'in my lifetime' (see above, p. 40 n.110), and we can therefore deduce that the tribe existed at least during those years in which the lifetimes of Hadrian and Pausanias overlapped. It would be most probable that the tribe of Hadrianis outlasted Hadrian's lifetime, but we cannot infer this from Pausanias. However, as far as Pausanias is concerned, other aspects of Hadrian's impact on Athens had certainly lasted beyond his lifetime, and in all probability would continue to last beyond Pausanias' own.

The passage in which Pausanias discusses the virtues of Hadrian, and his quelling of the revolt of the Hebrews ends with a further reference to his embellishment of Athens: 'the sanctuaries that he either built or adorned with votive offerings and other fittings, and the gifts that he bestowed on Greek cities and the barbarians who sought his bounty, are all recorded at Athens in the common sanctuary of the gods' (1.5.5). The building referred to is the Pantheon, also mentioned at 1.18.9, where it is said that Hadrian built it. Its location is not clear, although the latter passage includes references to the Ilissos area and the library of Hadrian by the Agora.

More important than the location is its function: as well as acting as a Pantheon, Hadrian's building housed records of his own benefactions. Although it is not spelled out, the conclusion suggests itself that the Pantheon was built at least partly for the purpose of displaying Hadrian's benefactions. Nor is this simply an Athenian context, as all his benefactions to Greek cities are recorded, as well as those to 'barbarians'. The fact that the Pantheon housed mementoes of

[95] Thompson (1976) 70.

Hadrian's activities over such a broad geographical span further confirms Athens' position as the centre of the eastern policy of Hadrian, including no doubt the cities of the Panhellenion, but also barbarians and, presumably, Greek cities which did not belong to the Panhellenion.[96]

The core of Pausanias' description of Hadrianic Athens is 1.18.6–9, where he guides the reader round 'the lower parts of the city'. The opening is an unusually thorough mix of modern and ancient: the sanctuary of Sarapis, 'a god whom the Athenians got from Ptolemy' (1.18.4), which is interesting in view of the previous reference to Ptolemy's era as being forgotten; a place where Theseus and Peirithoos met before their expedition to Lakedaimon; and a temple of Eileithyia which featured wooden statues, one said to have been dedicated by Phaidra, the oldest brought by Erysichthon from Delos.

The description continues to the sanctuary of Olympian Zeus, having already established a mood of sanctity, and above all of antiquity – nothing is made of the reference to Theseus, but his juxtaposition with the works of Hadrian is again noteworthy. The note on the two oldest statues of Eileithyia is followed immediately (1.18.6) by two statues of Hadrian which stand before the sanctuary of Olympian Zeus (characteristically, Pausanias says one is of Thasian stone, the other Egyptian).

The following passage is worth analysing in detail, beginning with the cult statue:

it was Hadrian, the Roman emperor, who dedicated the temple and image of Olympian Zeus. The image is worth seeing. It surpasses in size all other images except the Colossi at Rhodes and at Rome: it is made of ivory and gold and considering the size the workmanship is good.

This passage is typically Pausanian in approach, personal view, and use of comparisons. And yet it is untypical in that it is applied to a contemporary work. It may strike the reader as odd that Pausanias should 'introduce' Hadrian here by referring to him as 'the Roman emperor' (although in a less elaborate manner than he uses to introduce Augustus at 2.3.1; see above, p. 4). His readers can hardly have needed reminding of his identity, even though he has not been mentioned since 1.5.5; this is, I suggest, more likely to be a Pausanian

[96] Willers (1990) 61, stressing the political aspect of the Pantheon.

way of emphasizing Hadrian's position and importance, to match the magnificence of the works to be described.[97]

The brief statement that Hadrian dedicated the temple is interesting for what it does not say: the temple had been started in the sixth century BC and, although attempts had been made to finish it, had remained unfinished until Hadrian's time. Although Pausanias later talks of the old sanctuary of Olympian Zeus built by Deukalion, that is separated from the present building, and no mention is made of any historical predecessor. Undeniably, the credit should go to Hadrian, as indeed it does; but on the face of it, one might have expected Pausanias to make some reference to its long history, to Hadrian's bringing to a successful and glorious conclusion a project which was, if ever anything was, a continuous link with the Classical past of Athens. Conceivably, Pausanias was unaware of its long history, but this would be very uncharacteristic for a man of his interests. It is more likely that he did not want to distract attention from Hadrian; it is also possible that the association with the Peisistratids, the original builders, might have been perceived as less than complimentary to Hadrian (although Pausanias does make in passing a favourable remark concerning Peisistratos and Hippias at 1.23.1). Whatever the reason behind Pausanias missing a golden opportunity to detail the history of one of the most prominent buildings of contemporary Athens, its effect is to focus sharply on Hadrian's personal role.[98]

Pausanias turns to the cult statue, saying that it is 'worth seeing', a phrase he uses frequently but here applied for the only time (as far as I can tell) to a contemporary or near-contemporary work.[99] This small reference betrays a significant level of admiration in the attitude of Pausanias to Hadrian, and is in itself sufficient to mark him out from other emperors.

The statue is of Zeus. The temple had, as far as we know, always been intended to be dedicated to Zeus, and this must have been part of its appeal to Hadrian, who followed his predecessors in associating himself with Zeus, as we have seen with the statue of Zeus Eleutherios juxtaposed with that of Hadrian in the Agora (see above, p. 166). The

[97] It is just possible, but surely no more, that there was a potential confusion with Hadrian of Tyre, a holder of the chair of rhetoric at Athens in his day (Philostr. *VS* 585–90; Jones (1972b) 480–7; Millar (1977) 91–2).

[98] The temple is also mentioned by Plutarch, who calls it unfinished (*Solon* 32.2).

[99] The case of the theatre at Sparta, a possible candidate because of extensive Augustan work, can be excluded since Pausanias give no hint that he thought of it as in any sense Roman (see above, pp. 130–1).

opportunity presented was fully taken by Hadrian, whose statue of Zeus was chryselephantine, by his day in itself an archaism, but most closely associated with the cult statues by Pheidias of the Athena Parthenos for the Parthenon, and the Zeus for Olympia (and it may be recalled that Pausanias saw statues of Hadrian in both temples). The parallel with the latter is inescapable, although since the use of chryselephantine statues of the Macedonian royal family in the Philippeion (pointedly, in the Altis at Olympia), the exclusivity of the medium had ceased, and with it (it may be assumed) its hitherto inherent aura of sanctity.

By reviving the use of a chryselephantine cult statue, Hadrian was deliberately striking a pose, calling attention to the temple, and thereby to himself, and using archaism as a means of strengthening this connection. And, crucially, he returned to the Pheidian scale: Pausanias comments fulsomely on its size, comparison with the best-known Colossi – presumably based on his own observations – showing that it surpassed even the Pheidian statues in that respect. Such a scale was appropriate for what was, although Pausanias does not say so, the largest of all Zeus temples. The technique of working with gold and ivory on this scale must have needed to be learned afresh, so that Pausanias' final comment, that the statue was of good workmanship 'considering the size', is in fact less grudging than it may at first appear.

Pausanias continues: 'before the columns stand bronze statues which the Athenians call the 'Colonies' (*apoikoi poleis*). The whole enclosure is just four furlongs round about, and is full of statues; for every city set up a statue of the emperor Hadrian, but the Athenians surpassed them all by erecting the notable Colossus behind the temple' (1.18.6).

The standard interpretation of these 'Colonies' as personifications of the cities which dedicated them has been challenged by Benjamin and Willers, for whom they are statues of Hadrian.[100] Benjamin sees them as dedicated by the colonies, supporting this with the observation that many dedications are known to be from the colonies. She further points out that Pausanias' phrase *apoikoi poleis* is exactly that found in two late inscriptions to refer to cities which were members of the Panhellenion because they had been colonized by Greeks. While this is an apt conclusion, it should not preclude the presence of cities not known to be members of the Panhellenion among those making

[100] Benjamin (1963) 58–9; Willers (1990) 52, the latter answered by Spawforth (1992) 374, and Boatwright (1994) 429–30.

dedications. For Willers, they are dedicated by the member-states of the Panhellenion.

It is most probable, and most fitting Pausanias' phraseology, that the statues should be called 'Colonies' because they were personifications of colonies. In that case, they should represent Athenian colonies. The link with the Panhellenion is not explicit, but is unmistakable in the context of the contemporaneous foundation of the Panhellenion and the dedication of the Olympieion. And as the Panhellenion embraced many cities but was centred on Athens, so the 'Colonies' would most appropriately be statues of colonies emanating from Athens.

These statues of the 'Colonies' would join the set of statues of Hadrian situated around the peribolos of the temenos. Pausanias says that these latter statues were set up by 'every city', and he explicitly distinguishes the Athenians by saying that they outdid other cities by setting up a Colossus behind the temple. A possible interpretation of 'every city' is that these are the cities of the Panhellenion, which was formally founded in AD 131/2, the year in which the temple of Olympian Zeus was dedicated. It is surely stretching credibility not to associate the two events. Benjamin points out that epithets used on the numerous surviving altars to Hadrian imply a link between the Olympieion and the Panhellenion.[101] As she says, the sanctuaries were separate at the time of Pausanias (citing Cassius Dio 69.16.2, who writes of a *sekos* of the emperor Hadrian, significantly called the Panhellenion); but they cannot have been distinct in purpose. The Panhellenion is not referred to by Pausanias, although his mention of the temple of Hera Panhellenia and Zeus Panhellenios (1.18.9, discussed in the following paragraphs) may be taken as a specific reference. At the very least, the use of the epithet 'Panhellenios' emphasizes Hadrian's Panhellenic programme. So too does Hadrian's use of 'Olympios' which, as noted (see above, p. 162), was his most common epithet since, in Benjamin's words, 'Zeus Olympios, chief deity of the Greek peoples, is truly the Panhellenic god'.[102]

Pausanias continues by listing some of the antiquities (*archaia*) in the precinct (*hieron*, 1.18.6; *peribolos* twice, 1.18.6–7), including a bronze Zeus, a temple of Kronos and Rhea, and a precinct (*temenos*) of Olympian Earth. The presence of antiquities could only strengthen the sanctity of the place; the appearance of Kronos and Rhea, father and mother of the Gods (including Zeus) has the same effect; and the presence of Gaia may have recalled specifically her role at Delphi

[101] Benjamin (1963) 59. [102] Benjamin (1963) 59.

(10.5.5–6) and at Olympia (5.14.10). To this is added the swallow-hole
for the flood of Deukalion, the builder of the original temple and
thereby Hadrian's predecessor, whose grave was pointed out to
Pausanias.

The topography of this area is controversial; but it is at least clear
that the above-mentioned buildings are in the same area, even if their
exact disposition is unclear. Whether or not the temple of Hera and
Zeus Panhellenios should be placed in this area is not at all certain;[103]
the other candidate is the partially excavated building on modern
Odos Adrianou (appropriately), which has also been identified as the
Pantheon – the 'sanctuary common to all the gods' that Pausanias
mentions – or as the meeting place of the Panhellenion.[104]

Pausanias' reference to the temple of Hera Panhellenia and Zeus
Panhellenios (1.18.9) is, if it can be taken thus, the only reference of
his which can be connected with the Panhellenion as an institution,
however obliquely. It is possible that this is a cult building constructed
for the institution of the Panhellenion, but such an inference is not
justifiable on the strength of Pausanias' text alone. Linked geographi-
cally in Pausanias' account is the 'sanctuary common to all the gods',
the Pantheon. The Odos Adrianou building is certainly a candidate
for this, although its identification as the meeting-place of the
Panhellenes has been strongly argued. What is clear is that the
ensuing reference, to Hadrian's library and its vicinity, indicates that
Pausanias has moved from the Ilissos area to the area of the Roman
Agora and its surroundings. Whether the temple of Hera and Zeus
and the Pantheon are to be associated with the former area or the
latter is simply not clear from Pausanias' terminology.

The temple of Hera and Zeus and the 'sanctuary common to all the
gods' are said by Pausanias to have been 'built' by Hadrian, and the
library also by association, whereas he says of the temple of Olympian
Zeus that it was 'dedicated' by Hadrian. Wycherley has taken
Pausanias' report that Hadrian 'dedicated' the temple to corroborate
literary evidence that it was unfinished before Hadrian's time.[105] The
literary sources, particularly Vitruvius (3.2.8), leave no room for
doubt that its Augustan state was not its final Hadrianic state, and the
plan by the unnamed kings to honour Augustus with its completion is
further supporting evidence. However, Wycherley perhaps puts

[103] For the sources, and theories on location, Travlos (1971) 291–2, no.162 on both plans;
Spawforth and Walker (1985) 94; Willers (1990) 62–7.
[104] Travlos (1971) 282 'F'; Spawforth and Walker (1985) 97–8; Willers (1990) 18–19.
[105] Wycherley (1963) 166.

excessive weight on Pausanias here, since Strabo, who also refers to it being unfinished, says that Antiochos dedicated it in that condition (9.1.17). This complicates the question of Hadrian's dedication, raising the possibility that he re-dedicated what may have been effectively a rebuilt temple. This leaves an open question the extent of the operation required for the temple to be completed by Hadrian.

Wycherley concludes that 'one is tempted to deduce . . . that Hadrian found the main structure of columns and walls complete'. It is in fact unclear when the temple had been converted to the Corinthian order, but it was certainly no later than the time of Cossutius in the second century BC (see above, p. 126). Thus, while Thompson is right to see the completion of the Olympieion by Hadrian as 'a splendid gesture in deference to the local architectural tradition',[106] this 'deference' has two aspects: that of Cossutius in building in the local tradition, and that of Hadrian in deciding to complete the temple rather than commission yet another new building.

The description of the library of Hadrian is unusually detailed for a contemporary building, albeit not objectively an extensive description: 'here, too, is a building adorned with a gilded roof and alabaster, and also with statues and paintings: books are stored in it' (1.18.9).[107] More significant than its function is the style: Thompson calls it 'an exotic monument, an import from imperial Rome', and notes that it was 'an "arts centre" of a sophisticated kind and on a scale previously undreamt of in Greece', and goes on to say that it was 'a somewhat improved version of the Templum Pacis in Rome . . . An architect in all probability came over from Rome'.[108] In the same way, he sees the area of the library and Agora of Caesar and Augustus as 'looking for all the world like the Imperial Fora in Rome' (quoted above, p. 122).

In the same paragraph, Pausanias refers to 'a gymnasium named after Hadrian; it, too, has one hundred columns from the quarries of Libya'. We should surely infer that Hadrian personally was responsible for the construction of the gymnasium, given that ownership of quarries was in the hands of the emperor (for a possible exception, see below, pp. 196–7), and that the gymnasium was named after him, as was the stoa at Hyampolis in Phokis which Pausanias explicitly says Hadrian built (*oikodomesato*, 10.35.6). Add to these buildings the

[106] Thompson (1987) 10.

[107] Here, as elsewhere, I use 'library' as a conventional designation for this building, since Pausanias says only that in his day books were stored in the building, not that it was built as a library or had been used as one in Hadrian's day. The base for the statues that Pausanias mentions, known also from an inscription, has recently been excavated (*AR* 1992–3, 7).

[108] Thompson (1987) 10; he goes on to describe the building technique employed.

unprecedented form of the arch of Hadrian (to be discussed shortly), and above all the Olympieion itself, and there is an immediate and unmistakably novel impact on the physical appearance of Athens made by Hadrian.

Perhaps a little curiously, Pausanias returns to the area of the Olympieion (1.19.1), to mention an image (*agalma*) of Pythian Apollo and the sanctuary (*hieron*) of Delphinian Apollo. The latter is of interest because it was visited by Theseus when he was 'a stranger as yet to every one'. As Wycherley observes, 'the Delphinion more than any other monument illustrated the immemorial sanctity of the site'; and he adds that at 1.28.10, Pausanias 'reverts to the Delphinion in his list of Athenian law courts appended to the Areopagus and says that Theseus was tried there for justifiable homicide'.[109] Again the importance of Theseus to Athens is manifest and, while no connection is made between Hadrian and Theseus, the two are juxtaposed by the physical location of buildings associated with them as they have been before, and as they will be again (see above, p. 172; below, p. 180). There may be a further parallel here: Theseus is said to have found the Delphinion 'finished all but the roof' (1.19.1); if Wycherley is right that Hadrian found the Olympieion finished to 'columns and walls', the states of the two temples would have been similar.

With this, Pausanias' account of Hadrianic Athens ends, and there arises one of those occasional mysteries that can infuriate Pausanias' modern reader (whether or not they had an effect on his contemporaries). This is his omission of the arch of Hadrian, hardly an inconspicuous monument, and one which he must have seen, along with its inscriptions.[110] One could explain this by calling on the traditional belief that Pausanias was scornful of anything modern, but the thrust of this study suggests that this is an unjustifiable simplification, and particularly inappropriate in this instance since he does in fact mention a good number of contemporary buildings, above all Hadrianic. The explanation may perhaps be found elsewhere.

The arch was put up in Hadrian's honour, rather than by Hadrian himself (not an artificial distinction, as has often been seen in this study). Alison Adams believes that the *demos* was responsible for the erection of the arch;[111] Willers sees the donor as the Panhellenion because of its known donation of two replica arches at Eleusis,

[109] Wycherley (1963) 167.
[110] Bibliography on the arch includes Willers (1990) 72–85; Adams (1989); Travlos (1971) 253.
[111] Adams (1989) 15

although this seems improbable on chronological grounds.[112] Unfortunately, insufficient evidence exists to resolve the question, so that it is best left to one side at present.

Hadrian's arch is, as Adams observes, 'a Roman honorary arch of a type found in the eastern part of the empire',[113] and it would therefore have been conspicuous in Athens, at least to an Athenian. However, a native of Asia Minor like Pausanias, familiar with the genre, would have been less struck by it, and thus less inclined to mention it in his account of the city. This reasoning has already been adduced in connection with his omission of the nymphaion at Olympia and the colonnaded street at Athens (see above, pp. 41–2), and other examples are cited below.

Whatever Hadrian's personal role in the design and erection of the arch – and the standard pattern of petition and response suggests that this would have been minimal – the use of an eastern form admirably suits Hadrian's interest in the eastern provinces and his desire to place Athens at the heart of the area. Indeed, to have the Ilissos area as the heart of that heart. Travlos notes that the orientation of the arch is 'on the line of an extremely ancient road which led from the Olympieion precinct', an interesting reversion to as distant a world as possible if deliberate. Indeed, Travlos observes that the line of the Themistoklean wall is avoided, and that of a much older road followed.[114] This suggests a conscious separation of the line of the Athens of Hadrian from the earlier, and still conspicuous, one; and, if Hadrian were deliberately following the ancient road, a purposeful association with a very early phase of Athens' existence.

The orientation of the arch is important, since its role as a boundary marker was made explicit by its inscriptions, one on each side, as follows:[115]

West: Αἵδ᾽ εἰσ᾽ Ἀθῆναι Θησέως ἡ πρὶν πόλις
East: Αἵδ᾽ εἰσ᾽ Ἀδριανοῦ καὶ οὐχὶ Θησέως πόλις

The inscriptions are usually translated as follows:

West: This is Athens the ancient city of Theseus
East: This is the city of Hadrian and not of Theseus

[112] Willers (1990) 93–6, answered by Spawforth (1992) 374, and Boatwright (1994) 428–9; on the same grounds, the date of 131/2 proposed by Travlos (1971) 253, is also improbable. See also Spawforth and Walker (1985) 93, 102. [113] Adams (1989) 10.

[114] Travlos (1971) 253; Spawforth and Walker (1985) 93, concur with him on the orientation of the arch. [115] *IG* iii 401 (West) and *IG* iii 402 (East).

These inscriptions clearly provide further evidence of the association of Hadrian with Theseus, and of Hadrian as second founder; the east inscription indicates that there were effectively two complementary cities, a Thesean and a Hadrianic.[116] However, Adams has offered a different translation of the inscription on the west: 'This is Athens the former city of Theseus', taking the inscription to mean that the Hadrianic city was effectively a replacement of the Thesean.[117]

The question these translations raise is, then, whether the inscription means that Hadrian replaced Theseus' city, or created a parallel city. The latter is the implication of the passage of the *Historia Augusta* which refers to Hadrian's giving the name Hadrianopolis 'to many cities, as, for example, Carthage and a part of Athens' (*HA Hadr.* 20.4–5). There is a deliberate distinction here between the whole of Carthage and a part of Athens. There is no suggestion of the replacement of an existing city. Perhaps this is too subtle an approach to a document like the *Historia Augusta*, which is giving an overall view of a wide span of imperial activities, but either one accepts the literal interpretation, or one follows Adams' view that the 'archaeological evidence is slight for the baths and villas believed to have filled a Hadrianic quarter', and that therefore 'it seems impossible at present to reconcile the evidence cited above with the statement made in the *Life of Hadrian* that a part of Athens was named after the emperor'.[118]

In this latter point, Adams and Wycherley converge, Wycherley observing that the implication of the inscription of a transitional point between the city of Theseus and that of Hadrian was 'somewhat inept and misleading'. But his reasons for this conclusion differ markedly from Adams': he cites the continuing presence in the supposed Hadrianic quarter of long-established cults and buildings, saying that 'the region beyond the arch was highly venerable, sanctified by many old legends and cults and associated in particular with Theseus and his founding, as Pausanias well knew'.

The preceding discussion has, I think, borne out the truth of this conclusion, and it can be brought to bear on the question of Pausanias' omitting the arch. For Pausanias, buildings such as baths

[116] E.g. Travlos (1971) 253. Wycherley (1963) 163.

[117] Adams (1989) 11, citing an unpublished paper by C.P. Jones in which he takes the argument a step further, saying that the inscription refers to the replacement of Theseus by Hadrian as the city's founder. Day translated the west inscription 'This is the Athens of Theseus, the former city', but discussed the matter no further (Day (1942) 187).

[118] Adams (1989) 12.

and villas would have been of minimal interest,[119] and this area's antiquity and sanctity (the two closely associated, if not indivisible) could not be overcome even by an emperor of the status of Hadrian. If only on the principle of joining what one cannot beat, the next best policy was association with the antiquity and sanctity of the area, and the more antique (and consequently more sanctified) the better. Here the link with Theseus is perfect, and Wycherley's phrasing implies that he feels the association with Theseus somehow excludes Hadrian. I would argue that, on the contrary, it is to Hadrian's advantage, and consciously pursued by him. Theseus has been a recurrent thread in this study of Hadrian, not least due to Pausanias' own references, and Hadrian was able to give the Ilissos area an overlay of his own influence. I would, therefore, conclude that we should see Hadrian as the most recent founder of Athens, complementary to, but not replacing, the first founder, Theseus.

That a parallel was intended to be drawn between Hadrian and Theseus is, I believe, clear from evidence already adduced. The parallel suggests itself on several occasions in Plutarch, notably the founding of games by Theseus in the form of the Panathenaia, later closely linked with Hadrian (see above, p. 165). To this must be added the well-known reference Plutarch gives (*Thes.* 25.3) to Theseus setting up a pillar on the Isthmus as a territorial marker, and bearing the inscriptions 'Here is not the Peloponnese, but Ionia', and 'Here is the Peloponnese, not Ionia'. The form of inscription is surely too close for its recollection on the arch not to have been deliberate; that the story was current not long before, if not actually during, Hadrian's reign is shown by the reference in Plutarch.[120]

There is, however, one small (perhaps coincidental) difference which separates Hadrian from Theseus: the context of Theseus' setting up the marker, according to Plutarch, was his addition of the territory of Megara to Attica as part of his domain. It happens (and probably no more than happens) that Pausanias explicitly distances Megara from the rest of Hadrianic Greece, in the famous saying that the Megarians 'were the only people whom even the emperor Hadrian could not make to thrive' (1.36.3). This latter reference is

[119] There is an occasional mention of baths (e.g. those of Eurykles, or those attributed to Trajan; see above, pp. 42, 111), but there are many cases where he omits them (e.g. above, p. 111); he mentions no villas.

[120] Spawforth and Walker (1985) 93, see the analogy as 'surely intentional'. It is noted by Adams (1989) 10, but the possible analogous intent is not addressed.

perhaps slightly puzzling in view of 1.40.2, where Pausanias mentions a water basin built by Theagenes, the seventh-century tyrant, and says 'not far from this water basin is an ancient sanctuary: at the present day statues of Roman emperors stand in it'. The use of ancient sanctuaries to house statues of Romans is readily paralleled (the Marmaria, and the Metroon at Olympia, spring to mind), but it is odd to find statues of Roman emperors (albeit anonymous ones) in a place where even Hadrian could not produce a resurgence, despite his attempts (1.42.5, 1.44.6, below; this may, however, explain why the statues are anonymous). It may be that the bad relations between Athens and Megara (e.g. Philostr. *VS* 528–30, latterly indicating some reconciliation) contributed to Pausanias' comment, especially if he were influenced in his understanding of recent history by an Athenian source, as was most likely the case given the marked Athenocentricity of the world he was brought up in.

The parallel between Hadrian and Theseus is again evident at the end of Pausanias' first book, where he talks of the Megara – Corinth road: 'the road which is still named after Skiron was first, they say, made passable for foot passengers by Skiron when he was war minister of Megara; but the emperor Hadrian made it so wide and convenient that even chariots could meet on it' (1.44.6).[121] The mention of Skiron would undoubtedly bring to the mind of any educated reader of Pausanias' work the fight between Skiron and Theseus which resulted in making the road passable, much as Hadrian's acts did, albeit by different means. This passage is particularly important because the parallel is unmistakable and yet not made explicit, indicating that we as readers are entitled to read subtleties into Pausanias' narrative, to put ourselves in the position of those he was aiming at, educated contemporaries and subsequent travellers. Of course, the history and passability of roads would be of particular interest to the latter class of reader, and it is to be remembered that Hadrian's arch was on the line of an ancient road.

It is against this background that the question of Pausanias' failure to mention the Hadrianic quarter referred to in the *Historia Augusta* may be considered further. There is ostensibly much to be said for Isaac's view that 'Pausanias is a contemporary source, and his silence regarding Hadrian's "New Athens" is decisive',[122] although it is, as often, over-burdening an argument *ex silentio* to call it 'decisive'. However, this is palpably untrue of the arch, which Pausanias also

[121] A milestone of AD 125 probably marks this widened road (Zahrnt (1979) 112).

[122] Isaac (1992) 357, noting that Cassius Dio also fails to mention the Hadrianic quarter.

omits but which certainly exists. Further, apart from the arch, and the supposed Hadrianic quarter, there are other known Hadrianic buildings in Athens which Pausanias does not mention. Hadrian's modification of the theatre of Dionysos (see above, p. 163) may have included the addition of the high relief decoration of the stage building. While this was a striking novelty in Athens, it has antecedents in Ephesos and Pergamon,[123] and it may be that it would have had greater familiarity to Pausanias than to the Athenians. If so, he would have had less incentive to mention it. The same may account for his omitting the aqueduct begun by Hadrian and completed in AD 140, after his death; although this architectural form was unprecedented in Athens, it had precedents in Asia Minor.[124] Pausanias also omits the basilica which is probably of the early Hadrianic period.[125] The form was familiar in both Asia Minor and Greece, notably at Corinth, where there were three by Pausanias' day, none of which he mentions.[126] I would conclude, therefore, that we should not take Pausanias' silence on the Hadrianic quarter as indicative of its non-existence.

Hadrian and the rest of Greece

A further reference to Hadrian in book one should also be noted: still at Megara, Pausanias says 'the old (*archaios*) temple of Apollo was of brick (*plinthos*), but afterwards the emperor Hadrian built it of white marble (*lithos leukos*)' (1.42.5). As has been noted on several occasions, restoration of ancient or crumbling temples had been standard practice among the Romans since Augustus' day; but in this case, the phrasing is unusually reminiscent of Augustus' famous boast that he had found Rome a city of 'later' and left it a city of 'marmor' (Suetonius, *Aug.* 28.3). Both 'later' and *plinthos* suggest sun-dried brick (LSJ also give 'fired brick' for *plinthos*), and both *lithos* and *lithos leukos* can translate 'marmor' (see above, p. 51 nn.21–2). Whether there is a deliberate reminiscence of Suetonius' phrase in Pausanias cannot be claimed with certainty, but the parallel is nonetheless there, and serves to indicate the parallel benefactions under Augustus and Hadrian. There is a gentle (and doubtless unintended) irony in these references to Hadrian's benefactions at Megara, since the Megarians were the one people who had not prospered through his

[123] Sturgeon (1977) esp. 45–8; she also raises the possibility that the stage building was remodelled under Antoninus Pius rather than Hadrian. [124] Vermeule (1968) 268.
[125] Shear (1973) 136–8. [126] Ward-Perkins (1981) 258–9, 479 n.6.

efforts (1.36.3). Mention of this temple, therefore, unfortunately serves as a reminder of the ineffectiveness of Hadrian's embellishment of Megara in this respect.

Pausanias then turns to Hadrian's activities in other parts of Greece. The first are the bath at Corinth and the aqueduct from Stymphalos (2.3.5), the latter also mentioned in the description of Stymphalos (8.22.3). In itself this is interesting as an example of a contemporary civic building (it was noted above that Hadrian's library, another civic building, was the first mentioned by Pausanias that was in the full sense built by Hadrian). The aqueduct is a piece of engineering which Pausanias presumably felt was sufficiently impressive to mention, and one might also add his reference to the roadstead built at Lupiae near Brundisium by Hadrian (6.19.9).

The greater interest in this passage lies in the contrast between Hadrian's aqueduct from Stymphalos being mentioned twice while his aqueduct at Athens is not mentioned at all. Given that other conspicuous Hadrianic buildings in Athens were also omitted – the basilica and arch most notably – it may be safest to assume that the context is the deciding factor here; in other words, that the aqueduct was a greater feature of Corinth than it was of Athens, and that it was therefore worthy of mention. Certainly, Hadrian's involvement in Corinth was considerably less than it was in Athens (as it was in all cities). It was, however, in Hadrian's time that the cult of Roma was instituted at Corinth (see above, p. 108), belatedly bringing it into line in this respect with cities such as Athens.

Hadrian's building programme in Greece was very extensive, and its exact boundaries often obscure through uncertainties of dating. However, as a representative example of a Hadrianic building which Pausanias omits may be cited his transformation of part of the Asklepieion at Argos into a bathhouse.[127]

Apart from buildings, Hadrian's presence was everywhere visible in the form of the statues of him: I have already noted his statue in the Parthenon, the cuirassed statue of him from the Agora, the inferred statue of Hadrian as Eponymous Hero, two statues of him in front of the Olympieion, and at least one set in the temenos of the Olympieion, and perhaps another set if the 'Colonies' are indeed statues of Hadrian dedicated by the colonies. To these may be added one in the Agora of the Kynaithians (8.19.1), and one in the temple of Zeus at

[127] Aupert (1987) esp. 514–5.

Olympia (5.12.6). The latter, by implication in the pronaos although the cella itself is a possibility, 'is of Parian marble and was dedicated by the cities of the Achaean confederacy'; by it stood one of Trajan 'dedicated by the Greek nation' (also, see above, p. 157). These statues (*andriantes*) are just two of several of Romans at Olympia: one of Augustus has been noted (5.12.7), and there were 'statues (*andriantes*) of Roman emperors' in the Metroon (5.20.9), but none is identified. Neither the literary sources (including Pausanias) nor the archaeological sources associate Hadrian closely with Olympia, perhaps because of his interest in Delphi, a place he is said to have thought of as being of 'antiquity and nobility'.[128]

There is no justification for assuming that Hadrian himself put up any of these statues, and in the case of those (whether one set or two) at the Olympieion, and that at Olympia, we are told explicitly that these were dedicated by others in his honour. We have, in fact, only one reference in Pausanias to a dedication by Hadrian, to that of 'a peacock of gold and shining stones dedicated by the emperor Hadrian' in the Argive Heraion, alongside which was a golden crown and purple robe dedicated by Nero (2.17.6).

The theme of restoration has appeared in this study in several different guises, mainly in terms of buildings, but also with reference to games, festivals, cults and political systems and even, in the case of Corinth, the restoration of the city itself. In Pausanias' account of Hadrian's activities in Greece, his restoration is nowhere clearer than in his treatment of Mantinea: as noted (see above, p. 132), Mantinea had been favoured by Augustus since it alone of the Arkadian cities sided with him at Actium. Hadrian's way of favouring Mantinea was a particularly conspicuous one: 'the emperor Hadrian took from the Mantineans the name they had borrowed from Macedonia, and restored to the city its old name of Mantinea' (8.8.12). The reversion to the past is a theme which in a sense is the central one of Hadrian's policy, and is at its most obvious with such changes. This event is dated by Pausanias 'ten generations later' than the time of Antigonos Doson (8.8.11), namely c.263–221 BC (with a parenthetic reference to Actium), thus enhancing the notion of Hadrian making an impact on a long-established practice.

The same idea of enhancing antiquity is further illustrated at Mantinea by Hadrian's building a sanctuary of Poseidon Hippios

[128] Cartledge and Spawforth (1989) 108.

(the principal deity of Mantinea) round the ruins of an ancient (*archaios*) one (8.10.2):[129]

> this sanctuary I, like all who have made mention of it, can only describe from hearsay. The present sanctuary was built by the emperor Hadrian. He set overseers over the workmen that no man might look into the ancient sanctuary, and that none of its ruins might be removed, and he commanded them to build a wall round the new temple. This sanctuary of Poseidon is said to have been originally built by Agamedes and Trophonios out of oak logs which they fashioned and fitted together.

The passage exudes concern for antiquities, of a kind which would appeal strongly to Pausanias, and which would endear Hadrian to him, as well as provide him with a sharp point of contrast with some of his predecessors. It may be argued that this is a case of chickens and eggs, and that his belief that concern was shown arises from his preconceptions about Hadrian. But the event is recent in the memory, and he, like all visitors, must have gone by what he was told since he was not allowed into the sanctuary itself. The final sentence juxtaposes Hadrian with two of the most ancient artists, Trophonios and Agamedes, most renowned for the fourth temple of Apollo at Delphi (10.5.13; see above, p. 41). The building as it existed in Pausanias' day was, therefore, a combination of the efforts of Trophonios, Agamedes and Hadrian, an association from which Hadrian could only have benefited in the eyes of antiquarians like Pausanias, and, no doubt, those of contemporary Mantineans.

The same method of combining antiquity and modernity is apparent also on the grave of Epaminondas at Mantinea: 'on the tomb are two slabs: one of them is old, and has a Boiotian inscription; the other was set up by the emperor Hadrian, who composed the inscription on it'.

But there was more than antiquity to Hadrian's policy in respect of Mantinea: it was here that he established the worship of Antinoos in what Pausanias calls 'the newest' temple at Mantinea (8.9.7–8). Pausanias' phrasing makes it quite clear that the establishment of the cult of Antinoos was Hadrian's personal initiative and, although he does not explicitly attribute the building of the temple to Hadrian, nor even to the Hadrianic period, both are strongly implicit in his words. And unless the temple of Antinoos is a re-used one – most

[129] Frazer IV.216–17 on the comparison with Polybios' location of the sanctuary.

improbable for 'the newest' temple – it must date from soon after his death. Pausanias mentions mysteries and games in Antinoos' honour, again without specifically attributing their introduction to Hadrian. In this case also, it is hard not to see this as a contemporary innovation, part of a threefold package of cult (with temple), mysteries and games, introduced at the personal instigation of Hadrian.

Pausanias also says that in the gymnasium at Mantinea there were *agalmata* (an unspecific plural) of Antinoos; these will surely have been of Hadrianic date, although again this is not made explicit. Pausanias does not offer a date for the gymnasium itself, nor suggest any association with Hadrian. This building is 'worth seeing', not for the statues of Antinoos it contained, but for 'the stones with which it is adorned'. Lastly, although Pausanias does not mention it, an inscription from Mantinea reveals that a stoa was built there by Eurykles in honour of Antinoos.[130] Despite this last omission, this unusually extensive coverage of contemporary buildings by Pausanias speaks in favour of his 'special relationship' with Hadrian (perhaps all the more so in the latter case, since the stoa was not itself built by Hadrian although linked with him by association with Antinoos).

This group of Hadrianic foundations at Mantinea is revealing of both the emperor's policy and Pausanias' narrative method. The foundation of mysteries is compatible with Hadrian's particular attachment to the Eleusinian Mysteries, which he attended more often than any other emperor (see above, p. 164), once in the company of Antinoos; and the interest in founding (or re-founding) games has been remarked on as a frequent instrument of imperial policy, employed on several occasions by Hadrian. This passage comes at the end of a list of sanctuaries built by the Mantineans, including one they built to commemorate Actium (cf. 8.46.1).

It is not surprising that the temple of Antinoos should be 'the newest at Mantinea' in Pausanias' day, and it is certainly one of the most recent buildings he discusses. There is no long-standing cult interest for Pausanias, no sacred spot on which it was built which would arouse his curiosity, and no decorative importance to the temple (in contrast to the gymnasium). The fact that he mentions the temple at all is, therefore, striking, and should be taken as a further indication of his particular interest in Hadrian. It may be this that

[130] Sherk (1988) no. 149C = *SIG*³ 841; Frazer IV.213. On the Hadrianic Eurykles, see below, p. 193.

prompts Pausanias to continue with an explanation of why Antinoos is honoured at Mantinea, explaining that Antinoos was of Bithynian origin and that the Bithynians were of Mantinean stock. Here, as so often, the local element comes to the fore in Pausanias' narrative; furthermore, a common origin between the Bithynians and the Arkadians of Asia Minor may have stimulated Pausanias' interest.[131] This is another aspect of his sense of appropriateness, causing him to mention Antinoos here for the first time, despite the many earlier references to Hadrian.

The mingling just noted of ancient and modern in Hadrian's works is again evident in the final reference in Pausanias to Hadrian, which is near the end of the final book, in Phokis. At Abai, we are told, there was a temple to Apollo built by Hadrian:[132] the town had been sacred to Apollo 'from old' (*ek palaiou*), and possessed an oracle of Apollo, 'but the god did not receive the same respectful treatment from the Persians as from the Romans. For whereas the Romans, out of reverence for Apollo, allowed the Abaians to retain their independence, the army of Xerxes burned down the very sanctuary at Abai' (10.35.1–2).

Of the temple built by Hadrian (*epoiese* rather than *anetheke* indicating Hadrian's personal involvement in the construction), Pausanias says that it is smaller than 'the great' temple – perhaps conspicuous modesty on the emperor's part – and that 'the images are older, and were dedicated by the Abaians themselves . . .' (10.35.4). So again, there is a combination of the ancient and the modern, with Hadrian's building housing ancient works.

The other modern building in the vicinity is the stoa at Hyampolis, which was, as Pausanias specifically tells us, built and dedicated by, and named after, Hadrian (10.35.6).

ANTONINUS PIUS

Pausanias in all probability spent half or more of his working life under the reign of Antoninus Pius, and praises him fulsomely (8.43), saying that he was 'called Pius because he was known to be most devout. In my judgement, the title borne by the elder Cyrus might well be applied to him – the Father of Mankind'. The use of the past

[131] Robert (1980) 135–8, with particular reference to links between Arkadia, Pergamon and Aizanoi.

[132] On Hadrian's possible personal role in the building of the temple, Zahrnt (1979) 103.

tense marks the passage as post-161. The context is the expansion of Pallanteion in Arkadia under Antoninus, and his granting it 'freedom and immunity from taxes'.

In detailing Antoninus' actions, Pausanias says that he 'never voluntarily involved the Romans in war', but stresses that he was a good leader when required – as perhaps on the occasion of the rebellion in the province of Achaia, known only through a passing mention in a much later source (*HA Ant.* 5.5). This same passage contains one more point of interest, in noting a law introduced by Antoninus Pius whereby provincials who were Roman citizens, but whose children were Greeks, were allowed to pass their property to their children, where previously they had been obliged to pass it either to strangers or 'to swell the emperor's wealth'. This clearly met with Pausanias' approval, and may even have been of particular personal interest to him.[133]

As noted (see above, p. 41), at 2.27.6–7 Pausanias refers to the buildings erected by the Roman senator Antoninus in the sanctuary of Asklepios at Epidauros. There is no comment on the buildings, just a brief statement of their existence. This passage has aroused most interest because of the possibility that the senator referred to is the future emperor Antoninus Pius. However, that theory is no longer sustainable.[134] For present purposes, the relevant point is that this is a modern dedication, and thus a further proof that Pausanias' interest was not confined to matters ancient. It should be noted that two of the buildings referred to are religious, and one civic. Pausanias also tells us that Antoninus rebuilt 'the Lycian and Carian cities, also Kos and Rhodes', and notes his buildings in Greece, Ionia, Carthage and Syria, but gives no further details since 'they have been very exactly recorded by other writers' (8.43.4).

MARCUS AURELIUS

The only mention of Marcus Aurelius is at 8.43.6, where Pausanias says that Antoninus Pius 'bequeathed the throne to a son of the same name, Antoninus the Second, who inflicted punishment on the Germans, the most numerous and warlike barbarians in Europe, and on the Sarmatian nation, both of whom had wantonly broken the

[133] Frazer IV.410–11.
[134] On the identity of Antoninus, see below, p. 194; Pollitt assumes that the emperor is meant (Pollitt (1983) 181).

peace'.[135] His activities in Greece were limited, and included interest in Eleusis, manifest not only in the Greater Propylaia at the sanctuary (omitted by Pausanias, like most things Eleusinian),[136] but also becoming involved in decisions on Eleusinian priesthoods.[137] In any case, his activities would have been at the very end of Pausanias' period of travelling in Greece, and we should not be surprised at the complete lack of references to his buildings.

The 'Sarmatian nation' Pausanias refers to at 8.43.6 are later characterized as 'the robber horde of the Kostoboks, who overran Greece in my time' (10.34.5). By reference to an Olympic winner, Mnesiboulos, this incursion is datable to after AD 161. No other writer mentions this attack on Greece, but further evidence for it comes from inscriptions.[138] Although Pausanias' reference to the Sarmatians arises from his praise of Marcus Aurelius, he had a wider interest in them: his knowledge of the materials of which their military equipment is made has been noted (see above, p. 52, with reference to 1.21.5) and suggests that he had had autopsy of such weapons. In the same passage he says that 'the Sarmatians neither dig nor import iron, being the most isolated of all the barbarous peoples in these regions'. It may be, therefore, that his reference to Marcus' suppression of their incursion arises more from his curiosity about the Sarmatians than from his tactfully fulsome enthusiasm for the emperor.

[135] Habicht (1985) 10, 18, on identity; Frazer IV.411 on the argument for and against a chronological indication in this passage of AD 176; it seems best not to take it that way.

[136] Travlos (1988) 97–8. [137] Millar (1977) 450.

[138] See von Premerstein (1912) esp. 145–64; an inscription from Eleusis, referring to an incursion of the Sauromati in the time of Antoninus, is best taken to mean the Kostoboks (p. 153). It was almost certainly this incident that prompted Aelius Aristides to write his Eleusinian Oration. On the origins and date of the Kostoboks, Frazer V.429–30.

Pausanias on Herodes Atticus and other benefactors

In this chapter I consider the benefactors, or *euergetai*[1], whom
Pausanias mentions, other than the emperors. They comprise the
Augustan and the Hadrianic Eurykles of Sparta; Philopappos of
Commagene, whose monument in Athens was erected in c.114–6;
'Aithidas' of Messene (mid second century AD); 'the Roman senator
Antoninus' (a contemporary of Pausanias, whose *floruit* was in the
160s); and Herodes Atticus (c.AD 103–79). The length of this chapter
reflects the markedly small number of such benefactors, and the
proportion of it devoted to Herodes Atticus also reflects Pausanias'
own attentions. Both of these aspects are worth examination.

Herodes Atticus was a contemporary of Pausanias and a man
whose activities in Greece – well attested by Pausanias – are unique in
their scope for a private individual in this period. These activities
(and those of Herodes elsewhere) reveal a man who acted in many
respects in the manner of an emperor, and shed an informative light
on the practice of private benefaction in Pausanias' day. It is the sheer
scale of Herodes' capacity to act as a benefactor that makes him so
exceptional, allowing him, for example, to create his own private
projects such as his estates at Marathon and Loukou, as well as the
more conspicuous public monuments.

The primary purpose of such benefactions is publicity for the
benefactor: one acts thus in order to be noticed. Hence being
mentioned by writers such as Pausanias was part of the purpose of
these benefactions, part of the pay-off. Consequently, the effect of a

[1] Although the words *euergetes* and euergetism are used in this chapter with reference to private
citizens, they are by no means confined to private citizens in conventional usage. *Euergetes* is
used, for example, of Tiberius (see above, p. 83). Note also the word *euergesia* on the base of a
statue of Mummius set up at Olympia by the cities of Elis (Dittenberger and Purgold (1896)
no.319; Philipp and Koenigs (1979) 211 fig. 5; most recently on the Mummian inscriptions at
Olympia, Tzifopoulos (1993) esp. 98–100). On aspects of euergetism in the second century BC
and its relevance to relations between Greece and Rome, Erskine (1994).

major benefactor is likely to be diminution of the potential publicity given to a lesser one. It may well be for this reason that there are so few private benefactors; after all, such donors – even Herodes Atticus – were of lesser status and ability to make such benefactions than the emperors.

It is not coincidental that all but one of the figures considered in this chapter date from the second century AD. It has already been argued in chapter 1 that the Hadrianic period saw the growing ability of the upper classes to express their increasing prosperity by travelling, and that the Panhellenion may have been in part a response to the demands of such people. Certainly travel to mainland Greece had long been an integral part of their cultural expectations. Combined with these expectations was the conspicuous tendency of the time towards self-promotion to which reference has already been made. Against this background, the practice of benefaction among the very wealthy is readily comprehensible.

PHILOPAPPOS

In his brief note on the Mouseion hill in Athens, Pausanias mentions that 'a monument was built here to a Syrian man' (1.25.8). The only other piece of information offered is that it dates from after 294 BC, the time of Demetrios son of Antigonos ('Poliorketes'). The reference is to the monument of Caius Julius Antiochos Epiphanes Philopappos, whose grandfather was the last king of Commagene. Philopappos himself used the title of 'king', and became suffect consul and archon of Athens. His monument dates from AD 114–16.[2]

The monument is exceptionally prominent, its topographical position giving Philopappos more familiarity than he might otherwise command. Pausanias mentions that the tomb is 'within the ancient circuit of the city', a rarity which Spawforth has called 'a privilege associated with citizens practising euergetism on a large scale', drawing a pertinent parallel with the intramural burials of Herodes Atticus and his daughter (Philostratos, *VS* 565–6, 557–8).[3] Diana Kleiner, in the most detailed study of the monument, believes that it derives from his birth rather than any benefactions he may have made, and she points out that no great public buildings can be

[2] Kleiner (1983), with reviews by Spawforth (1984) and Walker (1984). Frazer's discussion (II.326–8) includes a translation of the inscription on the monument. On Philopappos' career and titles, Kleiner (1983) 9–17. [3] Spawforth (1984) 215.

associated with him.[4] However, this is to use a narrow definition of euergetism excluding such benefactions as, for example, Philopappos' lavish *agonothesia* of the Dionysia recorded by Plutarch (*Mor.* 628A).

Philopappos' broader euergetism remains a matter of inference, and the uncertainty cannot be resolved here. But could it be that Pausanias gives Philopappos' monument such a brief mention because it was not in fact a reflection of his benefactions, and that therefore it was not relevant to his purpose except in that it currently occupied the hill whose history he was engaged in detailing? Or could it be that such benefactions as there were did not seem to Pausanias to qualify their sponsor for discussion, nor to be worth description in themselves? That, too, remains speculative, but it is worth noting that Pausanias does not discuss other forms of euergetism (other than imperial).

The phrasing used by Pausanias is striking, since he fails to name Philopappos. Unless Pausanias did not actually visit the Mouseion, but merely saw it from the Akropolis, as Wycherley has suggested,[5] he cannot have been unaware of Philopappos' identity, so prominent is his name on the monument.

EURYKLES

References have already been made to the Spartan benefactors named Eurykles and, while each is best considered in its context, some general remarks may be added here.

The Augustan Eurykles (see above, pp. 111, 132) is not mentioned by Pausanias despite his extensive building and the significant local political responsibilities given him by Augustus. His descendant, C. Julius Eurykles Herculanus, who is known to have died c.AD 136,[6] is not certainly mentioned by Pausanias, the only possible reference being to 'the most celebrated' baths at Corinth, for which 'Eurykles, a Spartan' was responsible (2.3.5; see above, p. 111). While the building itself is complimented, Pausanias says of Eurykles only that he was 'a Spartan' (*aner Spartiates*), the same kind of phrasing that he used of Philopappos, with the difference that here he names the person referred to. It is, then, the building that is of interest, not its

[4] Kleiner (1983) 17.
[5] Wycherley (1963) 160. As Kleiner ((1983) 37, 46) observes, the best view of the monument is, as it was in Pausanias' day, from the Akropolis.
[6] Cartledge and Spawforth (1989) 108–12; also, 185–6 on the games founded and endowed by Eurykles at Sparta.

donor. Indeed, the very fact that Pausanias picks out Eurykles' bath in preference to those of Hadrian and other (unspecified) donors clearly indicates that it is the buildings themselves which are his priority.

'THE ROMAN SENATOR ANTONINUS'

The passage in which Pausanias refers to the buildings erected at the sanctuary of Asklepios at Epidauros by 'the Roman senator Antoninus' (2.27.6–7) has been briefly mentioned in chapter 1 (see above, p. 41), where it was noted that these are buildings 'erected in our time', and that Pausanias makes no comment on the buildings themselves.

The donor's identity as the Roman senator Sextus Julius Maior Antoninus Pythodoros has now been firmly established, and his date as the 160s, contemporary with Pausanias.[7] Pausanias credits him with a bath, sanctuary and temple with no detail other than to name the deities to whom these were dedicated. He also mentions his restoration of the Stoa of Kotys, one of the roofless buildings Pausanias notes on occasion; and a house for the dying, built 'to remedy the inconvenience'.[8] Thus the notion of benefaction is explicitly mentioned only in connection with the building which is architecturally the humblest of those erected by Antoninus. And it recurs in the final reference to a work of Antoninus, the cistern in the nearby sanctuary of Apollo Maleatas, which 'is a gift of Antoninus to the Epidaurians'.[9]

'AITHIDAS'

In the course of describing the monuments of Messene, Pausanias refers to one 'Aithidas', saying that he was 'older than myself', with the clear implication that he was an older contemporary; he continues, 'because he was a man of some property the Messenians honour him as a hero. Some of the Messenians, indeed, said that Aithidas was certainly very wealthy, but that it is not he who is sculptured on this monument, but an ancestor and namesake of his' (4.32.2). He then adds that the ancestor, also named Aithidas,

[7] Habicht (1985) 10.

[8] Pausanias does not mention, and may not have known, that many buildings in the sanctuary were demolished at this period to provide material for priests' houses' (*AR* 1982–3, 28).

[9] Most accessibly, V. Lambrinoudakis in *AR* 1993–4, 16; *AR* 1991–2, 13; *AR* 1989–90, 15, in each case with references to excavation reports in Greek.

commanded the Messenians at the time of Demetrios, son of Philip. However, the latter identification is a confusion with Demetrios the Illyrian, associate, rather than, son, of Philip V.[10] Similarly, Pausanias seems to have misnamed 'Aithidas', who is one of several generations bearing the name and is to be identified with the Tiberius Claudius Saithida Caelianus known from epigraphical evidence to have been a Roman citizen, high priest of the imperial cult, and 'Helladarch' of the Achaeans.[11]

Unfortunately, a lacuna has robbed us of the 'prompt' that caused Pausanias to mention Saithida, but his statement that 'because he was a man of some property the Messenians honour him as a hero' carries the implication that it was the benefactions he made with his wealth, rather than his wealth *per se*, which brought him this honour. The form of the monument is not clear,[12] but the fact that he was 'sculptured on this monument' suggests a prominent work.

The passage as we have it is notable as a rare reference to a contemporary benefactor, although this is not the point of interest for Pausanias: rather, it is the fact that he is honoured as a hero. His status is thus unparalleled among contemporary figures mentioned by Pausanias.

HERODES ATTICUS

As mentioned at the beginning of this chapter, Herodes Atticus was by no means an ordinary private citizen; nor, as was noted in the discussion of Philopappos, was he buried as such, being granted the exceptional honour of intramural burial in recognition of his benefactions. He was consul in AD 143, and as an exceptionally wealthy aristocrat, he was well placed to play the role of benefactor to the fullest, and to this Pausanias is one of our most valuable witnesses. In the nature and extent of his benefactions, Herodes was in many respects playing at being an emperor, and his place in this study, complementary to that of the emperors themselves, is therefore appropriate.

The best-known passage of Pausanias concerning Herodes was

[10] Habicht (1985) 98, giving other examples of minor slips of nomenclature in Pausanias.
[11] On the men named Saithida, Habicht (1985) 18 n.75, 58–9; Halfmann (1979) 174 no. 93a, 196 nos. 126–7; Musti and Torelli (1991) 259–60; Papahatzis 3.129 n.2; Frazer III.434–5. For a recently published Hellenistic inscription from Messene referring to one of the family, *Ergon* 1988, 37–9. [12] Musti and Torelli (1991) 259 suggest a stele with Saithida's portrait.

written during his description of Patrai, but with a retrospective eye
to Athens: 'This music hall is the grandest in Greece, except the one at
Athens, which excels it both in size and in its whole style. The latter
was erected by the Athenian Herodes in memory of his dead wife. In
my book on Attica this music hall is not mentioned, because my
description of Athens was finished before Herodes began to build the
hall' (7.20.6).

While this is of broad interest for the rare detail of Pausanias'
compositional method, it is of more interest for present purposes for
the fact that Pausanias says he would have mentioned the Odeion at
Athens if he had had the opportunity. Whether he would have given
us anything more than the simple passing mention here we cannot
know, but in any case this constitutes another exception to the
often-stated rule that he generally disdains modern buildings.

This is true also of the stadium in Athens, which Pausanias says was
built 'of white marble' by Herodes, and which he rather curiously
says was 'wonderful to see, though not so impressive to hear of'
(1.19.6).[13] It reinforces the point made repeatedly above that
Pausanias puts great stress on autopsy, as he had obviously heard of
the stadium before his visit, but nonetheless he characteristically
decided that on this occasion he would go against the advice of his
source, see it for himself and make up his own mind. It obviously paid
off.

The passage contains one further phrase of great interest concerning
the stadium, in which Pausanias adds that 'the greater part of the
Pentelic quarries was used up in its construction'. This is clearly
untrue – the Pentelic quarries are still being used today – and it may
be a simple case of Pausanias getting it wrong. Or it may be that a
more accurate translation would be 'his Pentelic quarries': the
phrasing used by Pausanias certainly allows such a translation,[14] and
an inscription on a marble block and datable to AD 166 by the names
of the consuls mentioned in it, may also indicate that Herodes did in
fact own part of a quarry.[15] The inscription is as follows:

[13] On the location of the stadium, Romano (1985). For the Herodean monuments associated
with the stadium area, Tobin (1993).

[14] Robinson (1944), seeing οἱ as the key word. To his argument may be added the proximity of
this word in the text to the name of Herodes, and its being masculine. Ameling (1983) 2.216,
follows this reading, and gives further references. The translation as 'the Pentelic quarries'
given by Frazer is followed by Jones (Loeb edn), Levi (1971), and Pollitt (1983) 183.

[15] The inscription is Ameling (1983) 2.216 no.199.

SERBILIO PUDENTE
ET FUFIDIO POLLIONE
COS. CAESURA CLA.
HIER. ATTICI ET APOLLO
NI LUPI

Ameling gives parallels for the use of 'caesura' as a technical term in stone-cutting. Objections to the idea of Herodes owning a quarry have centred on the reading of the inscription, and the idea that only emperors could own quarries.[16] While the word 'HIER' where one would expect 'HER' does raise a difficulty, there is no other obvious candidate, and the exceptional nature of Herodes' wealth and position makes such a claim not at all incredible. In fact, the ownership of quarries by private individuals was not impossible, whether or not one takes this inscription as evidence for it.[17] However, it must be stressed that, if Herodes did indeed own a quarry, this would constitute a highly exceptional example of an individual other than an emperor owning a quarry, even in part. Indeed, as Stephen Mitchell has stressed, the emperors 'owned many of the major sources of building materials in the empire'.[18] That this would apparently be unique says much for the status, as well as the wealth, of Herodes.

Pentelic marble also features in Pausanias' reference to Herodes' rebuilding of the stadium at Delphi: classing it among 'the notable objects', he says that it was 'made of the common stone of Parnassus, until Herodes the Athenian rebuilt it of Pentelic marble' (10.32.1). Philostratos refers to Herodes dedicating the stadium at Delphi (*VS* 551). In fact, Pausanias is wrong to make this claim, unless the limestone of which the stadium was constructed had been faced with Pentelic by Pausanias' time, and this has subsequently disappeared.[19] This is by no means impossible – after all, the sanctuary of Athena Pronoia at Delphi became known as the Marmaria precisely because it was from the ancient buildings that one would help oneself to marble in the Middle Ages. The passage is of interest as the only occasion on which Pausanias mentions a Roman building – and even then it is a rebuilding – at Delphi; the only other mention of Roman

[16] Gasparri (1974–5) 390–2, followed by Tobin (1991) 29–30.
[17] This inscription has most recently been discussed by Clayton Fant, who concludes that it reflects imperial ownership; however, he also accepts the wider possibility of private ownership (Fant (1993) 167; cf. 158–9, in the context of the second century AD).
[18] Mitchell (1987b) 344. He goes on to discuss the implications of imperial ownership for the mechanism of building.
[19] On possible reasons for Pausanias' error, Tobin (1991) 237, Aupert (1979) 92–3.

artefacts is of imperial portraits in the sanctuary of Athena Pronoia (10.8.6; see p. 125 above).

Herodes also built one of the most famous omissions from Pausanias' account, the nymphaion at Olympia. Possible reasons for its omission were discussed in chapter 1 (see above, pp. 37–8). In fact, all Pausanias has to say of Herodes at Olympia is that at the sanctuary of Demeter Chamyne near the hippodrome, 'instead of the old images, Herodes the Athenian dedicated new images of the Maid and Demeter, made of Pentelic marble' (6.21.2). This implies the replacement of old statues by new, an unusual procedure which may be taken to show a lack of respect, although replacement is a different matter from the removal or looting that Pausanias has so often documented elsewhere. If such replacement did constitute inappropriate behaviour, it is perhaps surprising that Pausanias does not remark on this, merely reporting the fact without comment, since he has assiduously documented previous removals of ancient statues. It would amount to allowing his opinion of the individual concerned to affect his view of the morality of their deeds in relation to the antiquities. However this may appear to us, we can be fairly sure of the reason for Herodes' interest in this sanctuary, since his wife Regilla was priestess of Demeter Chamyne in AD 153.[20] Herodes' updating of the cult statues can, therefore, be seen as part of the same programme of promotion of his family that pervades his public and private works.

As Herodes replaced statues at the shrine of Demeter Chamyne at Olympia, so he may also have replaced ancient statues with modern in the temple of Poseidon at Isthmia (2.1.7).[21] It is clear from Pausanias' description that he is referring to the cult statues as dedications by Herodes, and they are described in unusual detail for contemporary dedications. Their material, gold and ivory, is commensurate with his wealth and propensity to the ostentatious gesture. As noted, this is the only case in Pausanias' text where his reference to a contemporary artefact contains a significant element of description.

The 'Music-Hall' Pausanias briefly mentions at Corinth (2.3.6) has been discussed (see above, p. 111) as probably the one built in the late first century AD and remodelled by Herodes, perhaps after Pausanias' visit. Whether he saw it before or after Herodes' remodelling, it is a near-contemporary building, and its very mention is of interest, although it is only a topographical indicator.

[20] Ameling (1983) 2.128, using the evidence of the inscription referred to above, p. 38 n.105; Bol (1984) 99. [21] Sturgeon (1987) 4, 84.

Herodes was responsible for many other buildings, particularly in Attica.[22] Pausanias mentions none of these, but one is of interest for present purposes nonetheless: an inscription found at Myrrhinous in Attica shows that Herodes 'repaired the temple and dedicated the statue to Athena'.[23] Pausanias saw a wooden image of Kolainis at Myrrhinous (1.31.4). 'Kolainis' was a cult title of Artemis,[24] and what Pausanias saw would have been the cult-statue of the temple of Artemis Kolainis at Myrrhinous: it is certainly extremely unlikely that Herodes would have dedicated in his newly rebuilt temple a statue made of wood, and the reference to a wooden statue is much more likely to be to an ancient statue.

Unfortunately, apart from this inscription, there is no known reference to the temple of Athena at Myrrhinous, and we cannot, therefore, know when it was rebuilt. In consequence, we cannot be sure whether Pausanias would have seen it. If, by the time of Pausanias' visit, the temple had not been repaired, Pausanias might have mentioned it as he does a good number of ruinous temples. If the temple had been repaired by then, he made a decision to mention the ancient wooden statue of Kolainis – and it is only the statue he mentions, not the temple – but to ignore the temple of Athena, newly refurbished by Herodes and equipped by him with a statue. In that case, this would be a neat example of Pausanias' preference for the ancient over the modern, but the issue must remain speculative on present evidence.

The most ambitious project we hear of Herodes considering, the cutting of the Corinth canal, remained untried because he had been deterred by Nero's experience, according to Philostratos (*VS* 551–2), who also says, in the context of Herodes' attempt, that cutting the Isthmus 'calls for Poseidon rather than a mere man'. Despite a certain similarity in the sentiment, there appears to be none of the association of impiety found in references to attempts to cut the canal by Caesar, Caligula and Nero; it must, however, be admitted that since Pliny's list (*NH* 4.10) comprises all attempts known to him, there is no reason to suppose that he would have exempted Herodes had he lived in that era. It is interesting that Pausanias makes no reference to Herodes'

[22] Herodes' buildings in Attica (as elsewhere) are best documented and discussed in Tobin (1991).

[23] Ameling (1983) 2.214 no. 196.

[24] Frazer II.412–3. Epigraphic evidence shows that the priest of Artemis Kolainis had a seat at the theatre of Dionysos (Maass (1972) 126), as did, for example, the priests of Roma and Augustus (see above, pp. 123–4), and of Hadrian Eleutherios (see above, p. 163).

interest in cutting the canal; he may not have known of it. Whether he would have been as condemnatory of it as he is of Nero's attempt (see above, pp. 151–2) we cannot know.

Herodes was a sophist, almost by definition wealthy,[25] but with the great additional benefit of considerable inheritances, particularly after the death of his father, as well as having the luck to find a fortune in a house he had just bought (Philostr. *VS* 547–9). He was enabled by his wealth to pursue his aims and to make benefactions on a considerable scale. Bowersock is right that 'the benefactions of sophists are a palpable expression of the union of literary, political and economic influence, so characteristic of the Second Sophistic',[26] but wrong to imply that these benefactors (including Herodes) acted *qua* sophists. Rather, it is the case that, in Bowie's words, 'the sophist should be seen as a species of the genus Greek aristocrat and that his membership of that genus is the greatest factor contributing to his success'.[27]

For intellectuals and benefactors to avow a close relationship with the emperor was not uncommon, and Herodes, an extreme example of a benefactor in extent although typical in intent, regarded himself as being on especially good terms with the emperor, particularly Marcus Aurelius.[28] His claims can also be seen in many aspects of his building, and a few examples may briefly be noted here. The specific allusions and parallels with imperial building in Herodes' works are to those of Hadrian: perhaps the most obvious (although not the most conspicuous) is the Gate of Eternal Harmony on his estate at Marathon, which incorporated two inscriptions in clear imitation of that on the arch of Hadrian at Athens:

> The Gate of Eternal Harmony. The place you enter is Regilla's
> The Gate of Eternal Harmony. The place you enter is Herodes'

And a third inscription, on a pillar of the arch, reads 'Happy is he who has built a new city, calling it by name Regilla's'.[29] It is hard not to see in these inscriptions a deliberate echo of the claims for Hadrian's impact on Athens. If they also echo faithfully the intention behind the inscriptions on the arch of Hadrian, they suggest that Hadrian was intended to be seen as complementing, rather than replacing, Theseus, as Herodes complements Regilla.

The scale of the parallels with Hadrian which Herodes incorporated

[25] Bowie (1982) 30; Bowersock (1969) 21–5. [26] Bowersock (1969) 27.
[27] Bowie (1982) 53. [28] Bowie (1982) 51–3. [29] Tobin (1991) 113–19.

into his buildings is considerable: in addition to the above may briefly be noted the building technique of the Odeion at Athens, and its use of marble of different colours, both features which parallel the library of Hadrian; Herodes' calling an area of one of his estates the Canopus, and probably a second, adorning both with Egyptianizing sculpture, unmistakable reminiscences of Hadrian's villa at Tivoli; and his use of gold and ivory at Isthmia, all the more striking because it had recently been revived as a medium for sculpture by Hadrian for the temple of Olympian Zeus (see above, p. 174).[30]

The above examples have been quoted at some length, not as a Pausanian digression, but to explain the statement, made at the beginning of this chapter, that Herodes acted in many respects like an emperor. Clearly, many of the actions of an emperor were not open to him, but some were, most conspicuously euergetism, and that he practised on a truly imperial scale.

[30] Tobin (1991) 51, 294–5, 211; also 395–7.

Conclusions

Having looked in detail at the text of Pausanias and particularly at his words concerning the leading figures of the later Republic and early Empire, I wish here to stand back from the details in order to look at the overall picture, at what Pausanias actually thought of Rome and all that it had brought to Greece. Also to bring together his approaches to past and present, to assess whether he regards the latter as lesser than the former, whether he denigrates the present better to promote the past; how far he seeks to glorify the past, and how far he ignores the present, following the archaizing tendency in the culture of his age which has repeatedly been stressed in the preceding pages.

Pausanias does not feel negatively towards Rome *per se* – he had visited Rome and wondered at its sights (8.17.4, 9.21.1), as well as at those of other parts of Italy. In saying that Pausanias does not feel negatively towards Rome, I follow Palm (and others) in supporting Clavier's emendation of the text at 8.27.1, to include *epi*, with the meaning that the inhabitants were overtaken by 'disaster under the Roman Empire' (i.e. as a chronological statement) rather than meaning the 'disaster *of* the Roman Empire'.[1] This is an important point for present purposes since, as Palm observes, it has been the key element in any view of Pausanias as anti-Roman. This is supported by the fact that Pausanias also does not feel negatively towards Roman intervention in Greece *per se*: there had been significant Roman intervention between the Macedonians and Mummius, my starting-point, and he regards that period as one of revival for Greece.

This is not to say that he passes over Roman maltreatment of Greece in those years: explaining that over a thousand Greeks had

[1] Palm (1959) 74, followed by Habicht (1985) 119–20; Bearzot (1992) 19 and n.28; also Rocha-Pereira, in the Teubner text which has been used throughout this book. Frazer's translation (on which, Palm (1959) 74 n.2) gives no hint of the problem (and no discussion in the commentary). On Pausanias' travels in Italy, Frazer I.xxi–ii.

been taken to Rome on suspicion of having favoured Perseus (and some kept prisoner for sixteen years), he says that 'never before had this been done to Greeks', going on to add that not even the Macedonians had behaved thus (7.10.10–12). Again, he says of Flamininus, who was no less than the liberator of Greece from the Macedonians, and of 'Otilius' (see above, p. 81 n.4), who had been sent by the Romans because of Athenian weakness, to help the Athenians against Philip (7.7.7–8, 10.36.6), that they 'behaved with merciless severity to ancient Greek cities that had never done the Romans any harm' (7.8.2). Nonetheless, Flamininus instigated the (as it turned out, short-lived) revival of Greece. If Pausanias' intent had been to glorify the Classical, Greek, past, he would surely have painted this era as black as possible for contrast. The fact that he does not, but that he also mentions Roman faults, suggests that he is more concerned with reporting the results of an honest assessment than with striking a pose.

Pausanias sees the crucial turning-point in the history of Greece as the sack of Corinth by Mummius in 146 BC, paving the way for the re-foundation of Corinth in 44 BC, and with it the change in the balance of Greek and Roman in what became the chief city of the newly annexed province of Achaia. For Pausanias the demise of Corinth is closely associated with Mummius personally, as it is in other accounts. But while the other sources have much to say of Mummius' personal avariciousness, Pausanias makes no mention of this; he is, however, the only writer to raise the issue of Mummius' impiety.

Pausanias' emphasis on sanctuaries has been noted, and his repeated stress on piety and impiety are consistent with it. Religious respect and the lack of it are recurrent factors in forming Pausanias' attitude to the Romans, both individually and collectively; in that, he is simply reflecting the varying approaches of the Romans to Greece, and at every point he documents the actions of these figures and explains exactly why his attitude is as it is. There is no sense in which he is employing gratuitous abuse – nor, in other cases, gratuitous praise – rather, he is relaying to us his views as they arise naturally from the course of his narrative. This is true of his approach to Mummius, and I believe it remains so throughout.

Pausanias sees the Mummian invasion as 'the period when Greece sank to the lowest depths of weakness' (7.17.1). Among the acts of Mummius which he lists, Pausanias says that he 'put down the

democracies' (7.16.9); the context makes it quite clear that he did not
approve. The accuracy of this bald statement is questionable, but
there is nothing to suggest that Pausanias is not sincerely giving his
opinion here, rather than deliberately putting an anti-Roman
construction on events.[2]Another comment of Pausanias' on democracy
is worth recalling here, namely that the Athenians were the only
people who had ever thrived under a democracy (4.35.5; *demokratia* is
used in both cases). Palm takes this latter comment as indicating
Pausanias' scepticism of democracy, which he sees as typical of 'die
anderen Sophisten'.[3]As far as this latter point is concerned, there is no
evidence that can be adduced to demonstrate that Pausanias was a
sophist apart from what is revealed in his writings of his interests,
approaches and attitudes; and I have suggested on several occasions
that they can often be seen to be distinct from those of the sophists.

In responding to Palm's suggestion that Pausanias is sceptical of
democracy, I would note that, while generally true, it is not
universally so: first, Pausanias continues by saying 'and they certainly
flourished under it', an admission that the system could work.
Further, it is significant that it worked at Athens, which was much
admired by Pausanias; his phrase that 'even a democracy is capable of
a just decision' (1.29.7) is used in connection with Athens, and serves
to show how exceptional he thought Athens in this respect. Secondly,
Mummius' suppression of 'the democracies' is incorporated by
Pausanias into a list of his misdeeds. The inference I draw is that
Pausanias thought democracy capable of working well, and that he
concluded that it was undeserving of the treatment it received from
Mummius.

It is also indicative of Pausanias' interests that he does not dwell on
Athenian democracy: if his intention had been to glorify the Classical
past of Greece, he would surely have mused nostalgically, if briefly, on
the now defunct system, perhaps noting its advantages over the
present, Roman, one. While a sense of political tactfulness, allied with
the extent of its relevance to his project, may have prevented this
becoming a major theme, it is not at all unthinkable for him to have
included some such thoughts. But he does not. This is clear from his
treatment of Julius Caesar's political reforms – there is certainly no
place for it in his discussion of Mummius. Pausanias identifies Caesar
as the one who 'instituted at Rome the system of government under

[2] Ferrary (1988) 203: Pausanias' phrase is called 'une formule qui prend l'exact contrepied de
la thèse romaine officielle'; also 191–5. [3] Palm (1959) 69.

which we live' (2.1.2; cf. 3.11.4). The comment is made in a neutral tone and, since he nowhere shows signs of regarding this 'system of government' as tyrannical or even oppressive, either intrinsically or in practice, we can only conclude that no disdain towards Caesar is intended.

It may also be that this is effectively a reminder to his readers of an element of political history which Pausanias may not have felt able to assume familiar to everyone. As I argued in the first chapter, one should not take for granted too much knowledge of this kind around two hundred years after the fact. The wider implications of the passage extend to his own day since he saw Augustus as the successor of Caesar in this as in other respects – as, of course, he was – and then followed the line of the emperors to Hadrian, all of them employing the same system right up to his own time, as the quotation just given makes clear. Thus it is not exaggerated to argue that Pausanias is here reflecting content (perhaps no more) with the political system of his own day; and since he traces it explicitly to Caesar, his view of Caesar must be regarded as at least no worse than neutral.

Pausanias sees Caesar's re-foundation of Corinth as an effective 'antidote' to Mummius' destruction of it, and in the purely physical sense it was indeed a reversal of what Mummius had accomplished. But the theme goes deeper, stemming from the political and administrative system which Pausanias tells us Caesar had introduced. Pausanias notes that some of Mummius' actions were reversed 'not long afterwards' (7.16.10); another reversal of policy, that by Vespasian of Nero's, occasions a brief contrast of character (7.17.3–4). The partial reversal of Mummius' policies was undertaken because 'the Romans took pity on Greece', a further indication of how low the fortunes of Greece had sunk, and a point in favour of the Romans. While there is an implicit contrast of Mummius and the Roman actions which followed soon after him, the strongest contrast comes in the comparison with Caesar's actions. The disparity between Mummius and Caesar was exemplified by Corinth, the Caesarian re-foundation of which constituted a genuine case of the re-invention of an ancient and once-glorious city in a modern Roman form. Pausanias sees the Mummian–Caesarian history of Corinth in two phases: the destruction and its effects, and the re-foundation, closely and exclusively associated with Caesar, the *oikistes* (2.3.1).

For Pausanias, Corinth encapsulated the contrast between past and present – the Greek population had gone, as also some of their

cults, in both cases Greek replaced by Roman. This is a significant difference from the Athenocentricity of the contemporary sophists. Although Pausanias' disdain for the importing of modern Romans to take the place of displaced Greeks is clear, and is the result of the founding of the veteran colony by Caesar, the conditions for it were created by Mummius just over a century earlier, and it is on Mummius that Pausanias' opprobrium falls in considerable measure. We do not have here parallel lives in the manner of Plutarch, but there is a studied antithesis.

In other sources, there is an opposition of character, essentially between the boorish Mummius and the cultured Caesar. This is not apparent in Pausanias, which may be counted an example of a characteristically Pausanian policy of not gratuitously denigrating the character of whichever individual he is dealing with. If commenting on someone's character is not pertinent to what he is discussing at the time, he will not do so. It cannot be the case that he was unaware of the stories about the character of Mummius (or of figures in comparable cases): this is, rather, deliberate self-restraint arising from a certain single-mindedness in fulfilling the task he has set himself.

Between Mummius and Caesar comes Sulla, politically irrelevant in the sense that the 'system of government' which prevailed in Achaia dated from after his time, but nonetheless an important figure in the history of Roman Greece. Sulla is portrayed as cruel, repressive, and suffering under divine disfavour, all of which is commensurate with other sources. Sulla was an important focus of Greek–Roman relations since he sacked Athens – in itself a heinous act – in revenge for the Athenians' siding against the Romans (1.20.4). Pausanias also has much to say on the looting of cities and sanctuaries by Sulla. It is, therefore, very significant for Pausanias' view of Romanness that he twice explicitly distances Sulla from 'the Roman character' (9.33.6, 1.20.7). The opportunity presented itself to use Sulla's deeds as a stick with which to beat the Romans in respect of their actions in Greece, and Pausanias not only rejected the opportunity, but positively distanced the Romans from such associations.

Here too is another illustration of the point made already apropos of Mummius, that Pausanias will only comment on someone's character if doing so arises naturally from his narrative. If his primary concern had been with Sulla rather than with the visible monuments of Athens, he would undoubtedly have mentioned Sulla's removal of the library, of which Plutarch (*Sulla* 26.1) and Strabo (13.1.54) write

(see above, p. 101). To an educated man like Pausanias, familiar with libraries (perhaps those of Pergamon and elsewhere, as suggested above, p. 34), this would have been an appalling act, and yet he does not mention it. Again, I think this can be attributed to his focusing firmly on his aims, and not allowing himself to digress in order to add what for him would be gratuitous details of character.

Before leaving Sulla, it is worth returning to the passage in which Pausanias details the events leading to the Sullan invasion of Athens, partly quoted in chapter 3 (above, p. 100). Aristion 'persuaded the Athenians to prefer Mithridates to the Romans; but he did not persuade all of them, only the turbulent part of the populace: the respectable Athenians fled to the Romans' (1.20.5). While acknowledging the sense of Palm's view that this is a natural opinion after a long period of Roman rule,[4] I wonder if there is more to it: Pausanias continues by saying that one of Mithridates' generals, Archelaos, had once 'overrun the territory of the Magnesians of Sipylos'. If, as I believe is the case, this is Pausanias' home town (and it is at the least a town he is familiar with and has affection for), it is not improbable that his approval for the Athenians' action stems from his dislike of Mithridates as much as from his approval of the Romans.

I mentioned that Sulla is irrelevant in terms of politics and government, and with Augustus we pick up threads from the discussion of Caesar, his adoptive father. The majority of Pausanias' references to Augustus concern politics and government. Pausanias sees continuity from Caesar to Augustus who, building on the institution of 'the present system of government', 'placed the empire on a firmer basis, and attained a height of dignity and power which his father never reached' (3.11.4). This is a more than accepting attitude – more so than the attitude I detected in his reference to Caesar – and that is as it should be, since he is now dealing with a system developed (more satisfactorily in his view) from that instituted by Caesar. Given the link that he is stressing, Pausanias cannot be unfavourable to Caesar if he is to be favourable to Augustus, but he can, and does, vary the extent of his approval.

The re-foundation of Corinth as a veteran colony by Caesar is paralleled by the formation (rather than re-foundation) of Patrai by a combination of veteran colony and synoikism of local villages, with the consequent movement of population. The parallels between

[4] Palm (1959) 70. Frazer (1.221) gives other ancient references.

Corinth and Patrai are there to be made, not least in terms of the personal roles of Caesar and Augustus. But Pausanias makes no overt comparison, although the picture of Augustus as successor of Caesar might be thought sufficient – it should at least be borne in mind. If Pausanias felt that the Greek populations moved to Patrai were maltreated in the way that he thinks the Greek population of Corinth had been, he does not say so. The neutrality of his attitude may reflect the differing circumstances of the two cases – the population of Patrai is moved rather than removed and replaced. But he also refers neutrally to the depopulation of Aitolia to create Nikopolis (10.38.4), a city where he closely identifies Augustus personally with the political system (10.8.3).

Nor does Pausanias condemn the removal of cult objects from 'synoikised' Pharai to Rome (7.22.5, 9), as we would expect of someone so frequently damning of those who remove objects, particularly religious ones, from their places of origin. Here again it appears that an exception is being made for Augustus: as I mentioned (see above, p. 129), I find his excusing Augustus' removal of antiquities from Greece fawning, a rare instance of his inherently admiring attitude to an individual, in this case Augustus, being allowed to override his natural, and often exprèsssed, distaste for such looting. Not only did he admire Augustus' role in forming the political and governmental system of his day, but he would have been aware that Augustus was the first ruler who was broadly active in the provinces, and that he had had a considerable impact on Asia Minor as well as Greece. The very fact that Pausanias says more about Augustus than about any emperor other than Hadrian is indicative of the importance of Augustus to him. And if he is favourable toward Augustus, he will inevitably be favourable towards the Romans, since the Roman Empire as Pausanias knew it was, by his own account, largely instituted by Augustus.

Of the rest of the Julio-Claudian dynasty, only Nero receives much attention in Pausanias' writings – Tiberius and Caligula, although they had limited involvement in Greece, were not significant figures for Pausanias' purposes and, in keeping with the policy I have mentioned above, he avoided gratuitously writing of their characters in the manner of most of our sources for their lives and works. He speaks of Caligula's impiety – recalling his view of Sulla – in removing a statue from Greece to Rome (9.27.3), a passage in which his action is contrasted with that of Claudius (mentioned only here by Pausanias),

who returned the statue, and Nero who again stole it (see above, p. 86). Thus the accompanying comments on the characters of Caligula and Nero arise directly from the narration of the removal of the statue.

Nero was the second most philhellene emperor after Hadrian, although not of an unimpeachable philhellenism, as he was not above stealing antiquities, as Pausanias forcefully tells us. Nero's character has been stressed as being central to the approach to him of Pausanias as of other writers – but again, Pausanias is consistent in giving attention to Nero's character only when such attention does not require a digression. The overwhelming impression is of Pausanias' negative attitude towards Nero – the theft of a statue already stolen by Caligula and restored by Claudius is a representative example. And again the theme of impiety surfaces, in Nero's case noted as unnatural, as in his unsuccessful attempt to violate nature by cutting the Corinth canal (2.1.5) and his treatment of his family (9.27.4).

Pausanias remarks that the Eleusinian Mysteries and the Olympic games enjoyed the 'blessing of god' (5.10.1), and both were clearly dear to his heart, so it is interesting that he mentions neither Nero's probable disqualification from the Mysteries nor his corruption of the Olympic games (see above, pp. 143–4, 150). Indeed, he is silent on Nero's tour of Greece with the exception of the reference to his plumbing the depths (literally) at Stymphalos. It is not that Pausanias omits his actions at Olympia altogether, rather that he confines them, characteristically, to what is relevant to his set purpose – in this case, that Nero is 'said to have' taken statues from Olympia. The phrase 'said to have', or variations of it, appears on innumerable occasions, and indicates Pausanias' unwillingness to accept what he is told, or has read, unless he can verify it for himself – and indeed, it may serve the further purpose of suggesting to the reader that Pausanias has come across the particular point in the course of his reading.

In this instance, he is being scrupulously fair in reporting what he has heard as no more than that, although he could readily have gone along with received belief. It would, after all, have fitted in well with Nero's depriving Delphi of 500 statues, the only action of Nero's at Delphi that Pausanias mentions (10.7.1). In that passage, he lists previous depredations from Delphi much as he listed previous examples in the context of Augustus' removal of art from Greece (8.46.2). As noted, this is the same technique put to differing ends, according to Pausanias' own conception of the different individuals

involved. If we were in doubt as to what that conception is, the memorable phrase that Nero had 'a noble nature depraved by a vicious upbringing' is revealing. The context of the remark is that of Nero's declaration of freedom for Achaia, reversed soon after, as Pausanias tells us in his only reference to Vespasian, but indicative for him of what Nero could have been and what he could have done for Greece.

Of the succeeding emperors until Hadrian, most play no part (Galba, Otho, Vitellius, Domitian, and probably Titus), and that is entirely to be expected in view of their known lack of interest in Greece. Vespasian is mentioned once, without comment, and effectively only as a footnote to Nero's declaration of freedom, which he reversed (see above, pp. 155–6). Trajan, whose interests were decidedly elsewhere, fares a little better, being mentioned twice, once for his gift of freedom to Mothone (4.35.2), and once for his statue in the temple of Zeus at Olympia (5.12.6), as well as his military exploits. The latter statue is strikingly placed, but the fact that it is next to one of Hadrian, his adopted son, suggests that the statue was erected by virtue of his association with Hadrian, rather than in his own right.

With Hadrian, we reach the most philhellene of all the figures Pausanias describes, the one whom he mentions most often, and the one whose impact on both Greece and Asia Minor was greatest. Of Pausanias' attitude to him there can be no doubt: he was 'the benefactor of his subjects and especially of Athens' (1.3.2), and he 'did most for the glory of God and the happiness of his subjects' (1.5.5). The contrast with the impiety of Sulla, Caligula and Nero could not be clearer. Pausanias' attitude is one of undisguised and undiluted reverence and admiration. This was, of course, not unjustified praise – the length of the section on Hadrian above suffices to prove that – and there were many benefactions besides.

Two small points may here be adduced to bring out the subtleties in Pausanias' treatment of Hadrian. First, he mentions Hadrian's re-introduction to the winter Nemean games of the double length horse race (6.16.4). Previously, he has omitted Nero's addition of the musical competition at Olympia, which Suetonius (*Nero* 23.1) does mention, calling it 'contrary to custom'. It may be that while Nero was here imposing a new idea on an ancient tradition, Hadrian was re-introducing something which had lapsed – re-creation perhaps, but at least with a claim to authenticity. Secondly, the promotion of a parallel between Hadrian and Theseus has been seen to be part of

Hadrian's intention, an end towards which he made considerable investment in Athens in particular. Pausanias' treatment of the subject makes an important contribution to this impression, which shows that Pausanias was at the least content to see Hadrian in that light: the most obvious case is on the Megara–Corinth road, first made passable by Skiron, and subsequently made wide enough for chariots by Hadrian (1.44.6; see above, p. 182). As mentioned, this is not made explicit by Pausanias, but the allusion would have been clear to his educated contemporaries, that is, to those whom he had in mind when writing.

In summary, Pausanias' adulatory attitude to Hadrian is not surprising, nor is it unjustified. For him, the Hadrianic period is the climax of Roman benefactions to Greece, and all previous benefactions are put in perspective by Pausanias' remark that under Hadrian Athens flourished again for the first time since Sulla's invasion, that is, in over two hundred years (1.20.7). And Pausanias believed this of the rest of Greece (apart from the benighted Megarians). It is perhaps only by assessing the extent of Roman benefactions in the period before Hadrian that one can realize the full extent of the feeling for Hadrian that this belief of Pausanias' reveals.

Not surprisingly, Pausanias has little to say on the period after Hadrian – his own time in the most literal sense. Antoninus Pius is mentioned briefly but reverently, Marcus Aurelius only in passing for his relationship to Antoninus and his military successes (the latter reference reminiscent of that to Trajan), and Herodes Atticus for his benefactions.

Related to Pausanias' view of the Roman individuals he discusses is his view of Roman dedications. As briefly noted, there are strikingly few occasions on which Pausanias refers to any Roman dedicating objects or buildings in Achaia, in fact only ten: Mummius twice (5.10.5, 5.24.4); Sulla (9.30.1); Nero twice (2.17.6, 5.12.8); Hadrian twice (1.18.6, 2.17.6); Herodes twice (2.1.7, 6.21.2); and an unnamed Corinthian (5.25.1).

These all refer to the dedication of statues; the first Hadrianic reference also includes the Olympieion in Athens, one of only two occasions on which Pausanias refers to a building in Greece dedicated by a Roman; the other is the stoa at Hyampolis in Phokis, also Hadrianic in both construction and dedication (10.35.6; see above, p. 177). This statistic in itself gives little impression of Roman piety or benefaction towards Achaia, and closer analysis of the list indicates

that even this surface impression is exaggerated. Pausanias' phrasing makes it clear that he regards three of the dedications as tainted: Mummius' dedications celebrated, or were spoils from, his conquest of Achaia; and Sulla's dedication was of a stolen statue. This reinforces the impression already argued for that Pausanias' disdain for Mummius and Sulla is considerable. Of the remaining eight Roman dedications, he passes over six without comment, refers to Herodes' dedications at Olympia as being 'instead of the old images', perhaps a negative phrase, and calls Hadrian's cult-statue for the Olympieion 'worth seeing'. Thus only one of the Roman dedications is given any sort of praise, a mark of his feeling towards Hadrian, whose statue of Zeus this was. This is a limited description and, as noted in chapter 1, the dedications of Herodes at Isthmia are the only Roman examples described in any detail.

Apart from the above references, which arise from the discussion of the individuals on whom chapter 3 concentrates, there are other clues in Pausanias to his view of Roman piety. His dislike of the imperial cult has already been noted (see above, p. 121). Of his other references to Roman piety, perhaps most striking is the support for the Romans under Metellus given by no less than 'the gods of Greece', all the more so since this is against the Arkadians (7.15.6). Of pious Roman actions, their respect for Apollo at Abai (10.35.2; see above, p. 188) is contrasted favourably with the actions of the Persians. Contrasts with the Persians are almost inevitably favourable, but it is the very inclusion of this point that is noteworthy.

The observed preference for Greek over Roman noted in the discussion of dedications discussed by Pausanias is applicable also to his choice of which buildings to describe. He also omits Greek buildings, among them some of the Classical period: the Hephaisteion, one of the most prominent buildings in the Agora of Athens, for example. And he omits parts of buildings that the modern scholar would dearly love him to have included, such as the architectural sculpture of the Parthenon bar the unique and invaluable identification of the pedimental themes. In other words, he has his own agenda, as he makes clear on several occasions, centring his approach on the selectivity necessitated by the sheer quantity of buildings and objects. This process is applied to the Greek artefacts as well as to the Roman, so that we should not single out the Roman as his only omissions. Nonetheless, there are considerably fewer Roman than Greek buildings and objects. For the sculptures on which he expends so much effort

this need be no surprise, given that so much imperial sculpture, freestanding above all, was derivative of Classical originals. Why spend time on the copies and imitations if he can describe the originals?

Where Pausanias can be shown to have omitted a building or object, there are two logical explanations: he did not see it, or he deliberately ignored it. Each example needs to be considered in its place, and a combination of the two explanations may be required, although there are many cases where we cannot be sure of the reason. On several occasions, I have suggested that the greater familiarity of a particular architectural form in Asia Minor than in mainland Greece might be the cause of his omitting mainland examples: a colonnaded street (see above, pp. 41–2); an arch (see above, p. 179); stage reliefs, an aqueduct (see above, p. 183). One could call this an expression of preference, but I would argue that it owes more to his awareness of his intended readership, who would want to hear more of what was not familiar than of what was, a common enough human attribute. Thus I would not see this aspect of his work as arising from the archaizing trends of the period. Here his relationship to those trends needs considering in further detail.

Second-century Rome's emphasis on the glorious past of Classical Greece, and the manifestation of this in the Second Sophistic, have formed a thread running throughout this book. Here I wish to examine more closely how far Pausanias' attitude can be said to have been moulded by the view of Greece then current at Rome, and how far he may have diverged from it.

There is no doubt that the past is of more interest to Pausanias than the present, even loosely defined. In this his attitude is commensurate with the prevailing one of his day, manifest at its most extreme in the total avoidance of reference to the post-Classical in the works of his contemporary Maximus of Tyre (see above, p. 26 n.66). Pausanias does not avoid the present – I hope that this book has shown that – but he undeniably gives it a considerably lower profile than he does the past. However, in dealing with the past, he does not confine himself to the favoured period of concentration of his contemporaries, the fifth and fourth centuries. Instead, he not only consistently shows awareness of the period before the Classical, but attempts to trace it as far back as possible and to differentiate phases within it, as chapter 2 has shown. This is a personal interest, different from those interests which motivate the writers of the Second Sophistic.

Pausanias' own sense of difference – even alienation – from the

currents of his day is clear from his stated reluctance to reveal the
conclusions of his researches into the dates of Homer and Hesiod,
'knowing as I do the carping disposition of some people, especially of
the professors of poetry of the present day' (9.30.3). I have suggested
(pp. 67) that he may have had the sophists in mind here – they are the
obvious target, and their spirit of competition would suit this
sentiment well. And if he did, he would not be alone in expressing
some scepticism over them and their preoccupations: apart from the
satirizing of Atticizing language found in Lucian (*Rhetorum praeceptor*
16–17) and Athenaios (*Deip.* 1.1.e), Plutarch, in the context of
discussing behaving in the manner of one's ancestors, says 'Marathon,
the Eurymedon, Plataiai, and all the other examples which make the
common folk vainly to swell with pride and kick up their heels, should
be left to the schools of the sophists' (*Mor.* 814C). This sentiment
would have found a supporter in Pausanias: showy references to the
Classical age of Greece were no part of his purpose.

It might be argued that in searching to analyse the history of art as
far back beyond the Classical as he did, Pausanias was only taking to
its logical conclusion the contemporary stress on the past. But that
interest was in what one might call the 'good period', namely the fifth
and fourth centuries, whereas Pausanias' interests are broader, less
restricted. He is selective in what he reports – that has been repeatedly
emphasized – but he nonetheless concerns himself with a far greater
chronological range in much greater detail than do his contemporaries.
And that brings us back to what I called in the first chapter the single
most distinctive feature in his work, namely autopsy. It is because of
his insistence on recording what he saw (albeit not all that he saw),
that for him a contrast of glorious past and imitative second-rate
present did not apply: the past that he relates consists of, or arises
from, the buildings and objects that he saw on the ground that he
walked. They constituted a physical reality in the present, not a
rhetorical fiction or an idealizing construct. As I argued in a previous
chapter (pp. 32–3), he had no need to evoke a Greek past by reference
to what is no longer there, since his purpose was fulfilled simply by
description of what was there.

If Pausanias had been following the idealizing trends of his day,
with their emphasis on the past to the virtual exclusion of the present,
we would have been given far less on the Roman period than this
book has, I hope, shown we in fact have. We would also have been
given a view of Rome prejudiced by 'a sense of inevitable decline and

fall', in Elsner's phrase (p. 141). As I observed in discussing whether this phrase is appropriate to Pausanias (in whom Elsner detects it), Pausanias' own detailing of Greek history makes it clear that Mummius represented the depths of the decline, and that Hadrian represented the zenith of prosperity, material and cultural. It is striking indeed that Pausanias sees the peak of Greece's fortunes as occurring in his own lifetime; no clearer answer to charges of archaism, of idealizing the past, could be given.

As I argued in chapter 2 that Pausanias was attempting to layer and structure the period of and before Classical Greece, so I would argue here that he is approaching the Roman period in the same way. In dealing with both periods he sees much of his task in terms of the individuals concerned – the Greek artists whose works he saw, and the Roman rulers whose actions had an impact on Greece. And in both cases he sees gradations and differences, viewing each figure according to the evidence that he found and that he painstakingly sets out for his readers. While agreeing that Pausanias' preference for the past is manifest, I suggest that by understanding that he employs the same criteria for his analysis of the present as he does for that of the past, the modern reader may find in Pausanias a more even-handed view of matters Greek and Roman than is generally acknowledged.

Bibliography of works consulted

Abramson, H. (1974) 'The Olympieion in Athens and its connection with Rome', *CSCA* 7: 1–25.

Accame, S. (1946) *Il dominio Romano in Grecia dalla guerra Acaica ad Augusto* (Rome).

Adam, S. (1966) *The technique of Greek sculpture in the archaic and classical periods* (London).

Adams, A. (1989) 'The arch of Hadrian at Athens', in Walker and Cameron (1989), 10–16.

Adams, L.T. (1978) *Orientalizing sculpture in soft limestone from Crete and mainland Greece* (*BAR* S42, Oxford).

Africa, T. (1982) 'Worms and the death of kings: a cautionary note on disease and history', *Cl. Ant.* 1: 1–17.

Albini, U. (1958) 'Pausania 1.4.5', *Maia* 10: 240.

Alcock, S.E. (1989) 'Roman imperialism in the Greek landscape', *JRA* 2: 5–34.

Alcock, S.E. (1993) *Graecia capta: the landscapes of Roman Greece* (Cambridge).

Alcock, S.E. (1994) 'Nero at play? The emperor's Grecian odyssey', in Elsner, J. and Masters, J., eds. *Reflections of Nero* (London), 98–111.

Alderink, L.J. (1989) 'The Eleusinian Mysteries in Roman Imperial times', *ANRW* II.18.2, 1457–98.

Amandry, P. (1980) 'Sur les concours argiens', *BCH* suppl. 6: 211–53.

Amandry, P. (1988) *Le monnayage des duovirs Corinthiens*, *BCH* suppl. 15.

Ameling, W. (1983) *Herodes Atticus. I: Biographie. II: Inschriftenkatalog* (Hildesheim).

Anderson, G. (1982) 'Lucian: a sophist's sophist', *YCS* 27: 61–92.

Anderson, G. (1990) 'The Second Sophistic: some problems of perspective', in Russell (1990a), 91–110.

Anderson, G. (1993) *The Second Sophistic: a cultural phenomenon in the Roman Empire* (London).

André, J.-M. (1993) 'Hadrien littérateur et protecteur des lettres', *ANRW* II.34.1, 583–611.

Arafat, K.W. (1990a) *Classical Zeus: a study in art and literature* (Oxford).

Arafat, K.W. (1990b) 'Fact and artefact: texts and archaeology', *Hermathena* 148: 45–67.

Arafat, K.W. (1992) 'Pausanias' attitude to antiquities', *BSA* 87: 387–409.

Arafat, K.W. (1995) 'Pausanias and the temple of Hera at Olympia', *BSA* 90: 461–73.

Aupert, P. (1987) 'Pausanias et l'Asclépieion d'Argos', *BCH* 111: 511–17.

Barnes, T.D. (1978) *The sources of the* Historia Augusta (Brussels).

Barnes, T.D. (1989) 'Emperors on the move', rev. Halfmann (1988), *JRA* 2: 247–61.

Barrett, A.A. (1989) *Caligula: the corruption of power* (London).

Bastet, F.L. and de Vos, M. (1979) *Proposta per una classificazione del terzo stile Pompeiano* ('s Gravenhage).

Bearzot, C. (1992) *Storia e storiografia ellenistica in Pausania il periegeta* (Venice).

Benario, H.W. (1980) *A commentary on the* Vita Hadriani *in the* Historia Augusta (Ann Arbor).

Benjamin, A.S. (1963) 'The altars of Hadrian in Athens and Hadrian's panhellenic program', *Hesperia* 32: 57–86.

Beschi, L. and Musti, D. (1987) *Pausania guida della Grecia* I (2nd edn, Rome).

Bieber, M. (1977) *Ancient copies: contributions to the history of Greek and Roman art* (New York).

Birley, E. (1978) 'Fresh thoughts on the dating of the *Historia Augusta*', in Alföldi, A., ed., *Bonner Historia–Augusta–Colloquium 1975–6* (Bonn), 99–105.

Blouet, A. *et al.* (1831) *Expédition scientifique de Morée I* (Paris).

Boardman, J. (1980) 'Daedalus and monumental sculpture', in *Proceedings of the Fourth International Cretological Congress, Heraklion 1976* (Athens) 1.43–7.

Boatwright, M.T. (1983) 'Further thoughts on Hadrianic Athens', *Hesperia* 52: 173–6.

Boatwright, M.T. (1987) *Hadrian and the city of Rome* (Princeton).

Boatwright, M.T. (1994) 'Hadrian, Athens and the Panhellenion', *JRA* 7: 426–31.

Boeckh, A. (1874) *De Pausaniae stilo Asiano* (Leipzig).

Bol, R. (1984) *Olympische Forschungen XV. Das Statuenprogramm des Herodes–Atticus–Nymphäums* (Berlin).

Bookidis, N. (1983) 'The priest's house in the Marmaria at Delphi', *BCH* 107: 149–55.

Bosworth, A.B. (1973) 'Vespasian and the provinces: some problems of the early 70s AD', *Athenaeum* 51: 49–78.

Bowersock, G.W. (1964) 'Augustus on Aigina', *CQ* 58 (n.s. 14): 120–1.

Bowersock, G.W. (1969) *Greek sophists in the Roman Empire* (Oxford).

Bowersock, G.W. (1979) 'Historical problems in late Republican and Augustan classicism', in Flashar (1979), 57–78.

Bowersock, G.W. (1985) 'Philostratus and the Second Sophistic', in Easterling and Knox (1985), 655–62.

Bowie, E.L. (1970) rev. B. Levick (1967), *Roman colonies in southern Asia Minor* (Oxford), *JRS* 60: 202–7.

Bowie, E.L. (1974) 'The Greeks and their past in the second sophistic', in Finley, M., ed., *Studies in ancient society* (London) 166–209 = *Past &*

Present 46 (1970) 3–41.

Bowie, E.L. (1982) 'The importance of sophists', *YCS* 27: 29–59.

Bowie, E.L. (1989) 'Greek sophists and Greek poetry in the second sophistic', *ANRW* II.33.1, 209–58.

Bowie, E.L. (1990) 'Greek poetry in the Antonine age', in Russell (1990a), 53–90.

Bradley, K.R. (1978a) *Suetonius' life of Nero* (Brussels).

Bradley, K.R. (1978b) 'The chronology of Nero's visit to Greece AD 66/67', *Latomus* 37: 61–72.

Bradley, K.R. (1979) 'Nero's retinue in Greece, AD 66/67', *Illinois Classical Studies* 4: 152–7.

Braund, D. (1984) *Rome and the friendly king: the character of the client kingship* (London and Canberra).

Briscoe, A. (1985) rev. Keaveney (1982), *JRS* 75: 238–9.

Brodersen, K. (1994) *Das Lied von der Welt* (Hildesheim).

Broneer, O. (1932) *Corinth* x. *The Odeum* (Cambridge, Mass.).

Broneer, O. (1973) *Isthmia* II. *Topography and architecture* (Princeton).

Brunt, P.A. and Moore, J.M. (1967) *Res Gestae divi Augusti: the achievements of the divine Augustus* (Oxford).

Bucher, W. (1919) *De Pausaniae studiis Homericis* (diss., Halle).

Buckler, J. (1992) 'Plutarch and autopsy', *ANRW* II.33.6, 4788–830.

Bulloch, A.W. (1985) 'Hellenistic poetry', in Easterling and Knox (1985) 541–621.

Bultrighini, U. (1990) *Pausania e le tradizioni democratiche: Argo ed Elide* (Padua).

Burford, A. (1969) *The Greek temple builders at Epidauros* (Liverpool).

Burns, A. (1976) 'Hippodamus and the planned city', *Historia* 25: 414–28.

Burton, G.P. (1976) 'Proconsuls, assizes and the administration of justice under the Empire', *JRS* 66: 92–106.

Camp, J.M. (1986) *The Athenian Agora. Excavations in the heart of Classical Athens* (London).

Carney, T.F. (1961) 'The death of Sulla', *Acta Classica* 4: 64–79.

Carroll, K.K. (1982) *The Parthenon inscription, GRBS* Monograph 9.

Carter, J.C. (1983) *The sculpture of the sanctuary of Athena Polias at Priene* (London).

Cartledge, P. (1978) 'Literacy in the Spartan oligarchy', *JHS* 98: 25–37.

Cartledge, P. and Spawforth, A. (1989) *Hellenistic and Roman Sparta: a tale of two cities* (London and New York).

Casevitz, M. (1979) 'Un fragment de Pausanias dans le Vaticanus gr.2236', *Revue d'Histoire des Textes* 9: 239–42.

Casevitz, M., ed. (1992) *Pausanias description de la Grèce* I (Paris, Budé edn).

Casson, L. (1974) *Travel in the ancient world* (London).

Casson, L. (1989) *The Periplus maris Erythraei* (Princeton).

Cecioni, N. (1993) 'Octavian and Orestes in Pausanias', *CQ* 87 (n.s. 43): 506.

Clinton, K. (1989a) 'Hadrian's contribution to the renaissance of Eleusis', in Walker and Cameron (1989), 56–68.

Clinton, K. (1989b) 'The Eleusinian mysteries: Roman initiates and

benefactors, second century BC to AD 267', *ANRW* ii.18.2, 1499–1539.

Cook, A.B. (1940) *Zeus. A study in ancient religion* iii (Cambridge).

Corbett, P.E. (1970) 'Greek temples and Greek worshippers: the literary and archaeological evidence', *BICS* 17: 149–58.

Coulton, J.J. (1977) *Greek architects at work* (Ithaca, New York).

Crawford, M. (1978) *The Roman Republic* (Glasgow).

Crook, J.A., Lintott, A., and Rawson, E., eds. (1994) *CAH²* ix. *The last age of the Roman Republic, 146–43 BC* (Cambridge)

Daux, G. (1936) *Pausanias à Delphes* (Paris).

Daux, G. (1975) 'Les empereurs romains et l'amphictionie pyléo-delphique', *CRAI*: 348–62.

Day, J. (1942) *An economic history of Athens under Roman domination* (New York).

Delz, J. (1950) *Lukians Kenntnis der Athenischen Antiquitäten* (Freiburg).

Dewar, M.J. (1988) 'Octavian and Orestes in the finale of the first Georgic', *CQ* 81 (n.s. 38): 563–5.

Dewar, M.J. (1990) 'Octavian and Orestes again', *CQ* 84 (n.s. 40): 580–2.

Dihle, A. (1989) *Die griechische und lateinische Literatur der Kaiserzeit von Augustus bis Justinian* (Munich).

Dihle, A. (1994) *Greek and Latin literature of the Roman empire from Augustus to Justinian* (tr. of Dihle (1989), London and New York).

Diller, A. (1952) *The tradition of the minor Greek geographers* (Monograph 14, American Philological Association).

Diller, A. (1955) 'The authors named Pausanias', *TAPA* 86: 268–79.

Diller, A. (1956) 'Pausanias in the Middle Ages', *TAPA* 87: 84–97.

Diller, A. (1957) 'The manuscripts of Pausanias', *TAPA* 88: 169–88.

Dillon, M.P.J. (1993) 'Restoring a manuscript reading at Paus. 9.3.7', *CQ* 87 (n.s. 43): 327–9.

Dinsmoor, W.B. (1950) *The architecture of ancient Greece* (3rd edn, London and Sydney).

Dittenberger, W. and Purgold, K. (1896) *Olympia v. Die Inschriften* (Berlin).

Donohue, A.A. (1988) *Xoana and the origins of Greek sculpture* (Atlanta, Ga.).

Easterling, P.E. and Knox, B.M.W., eds (1985) *The Cambridge history of Classical literature* i (Cambridge).

Ebeling, H.L. (1913) 'Pausanias as an historian', *Classical Weekly* 7: 138–41, 146–50.

Edelstein, E.J. and Edelstein, L. (1945) *Asclepius: a collection and interpretation of the testimonia* i–ii (Baltimore).

Eickstedt, K.-V. von (1991) *Beiträge zur Topographie des antiken Piräus* (Athens).

Eisner, R. (1991) *Travelers to an antique land: the history and literature of travel to Greece* (Ann Arbor).

Eliot, C.W.J. (1967) 'The meaning of *Episema* in Pausanias 1.17.1', *Hesperia* 36: 121–3.

Elsner, J. (1992) 'Pausanias: a Greek pilgrim in the Roman world', *Past & Present* 135: 5–29.

Elsner, J. (1994) 'From the pyramids to Pausanias and Piglet: monuments,

writing and travel', in Goldhill, S. and Osborne, R., eds., *Art and text in ancient Greek culture* (Cambridge), 224–54.

Engels, D. (1990) *Roman Corinth: an alternative model for the Classical city* (Chicago).

Erskine, A. (1994), 'The Romans as common benefactors', *Historia* 43: 70–87.

Fant, J.C. (1993) 'Ideology, gift and trade: a distribution model for the Roman imperial marbles', in Harris, W.V., ed., *The inscribed economy: production and distribution in the Roman empire in the light of the* instrumentum domesticum (*JRA* suppl. 6), 145–70.

Farnell, L.R. (1896) *The cults of the Greek states* 1 (Oxford).

Fellmann, B. (1972) 'Antiker Sport', in Burck, E., ed. (1972) *100 Jahre deutsche Ausgrabung in Olympia* (Munich), 110–27.

Ferrary, J.-L. (1988) *Philhellénisme et impérialisme: aspects idéologiques de la conquête romaine du monde hellénistique, de la seconde guerre de Macédoine à la guerre contre Mithridate* (Rome).

Flacelière, R. (1971) 'Hadrien et Delphes', *CRAI*: 168–85.

Flashar, H., ed. (1979) *Le classicisme à Rome aux Iers siècles avant et après J.-C.* (*Entretiens* xxv, Fondation Hardt, Geneva).

Follett, S. (1976) *Athènes au IIe et au IIIe siècle: études chronologiques et prosopographiques* (Paris).

Forte, B. (1972) *Rome and the Romans as the Greeks saw them* (American Academy, Rome).

Frazer, J.G. (1900) *Pausanias and other Greek sketches* (London).

Frazer, J.G. (1923) *Sur les traces de Pausanias à travers la Grèce ancienne* (tr. of Frazer (1900), Paris).

Frösén, J. (1974) *Prolegomena to a study of the Greek language in the 1st centuries* AD; *the problem of Koine and Atticism* (Helsinki).

Gabba, E. (1982) 'Political and cultural aspects of the Classicistic revival in the Augustan age', *Cl. Ant.* 1: 43–65.

Gallivan, P. (1973) 'Nero's liberation of Greece', *Hermes* 101: 230–4.

Gardner, E.A. (1890) 'The processes of Greek sculpture, as shown by some unfinished statues in Athens', *JHS* 11: 129–42.

Garland, R. (1987) *The Piraeus* (London).

Garnsey, P. (1988) *Famine and food supply in the Graeco-Roman world. Responses to risk and crisis* (Cambridge).

Garnsey, P. and Saller, R. (1987) *The Roman empire: economy, society and culture* (London).

Gasparri, C. (1974–5) 'Lo stadio Panatenaico. Documenti e testimonianze per una riconsiderazione dell'edificio di Erode Attico', *Annuario* 52–3 (n.s. 36–7): 313–92.

Geagan, D.J. (1979) 'Roman Athens: some aspects of life and culture 1. 86 BC – AD 267', *ANRW* ii.7.1, 371–437.

Gebhard, E.R. (1993) 'The Isthmian games and the sanctuary of Poseidon in the early empire', in Gregory (1993a), 78–94.

Gelzer, T. (1979) 'Klassizismus, Attizismus und Asianismus', in Flashar (1979), 1–41.

Georgiadou, A. and Larmour, D.H.J. (1994) 'Lucian and historiography: "De historia conscribenda" and "Verae historiae"', *ANRW* II.34.2, 1448–1509.

Giffler, M. (1940) 'Two confirmations of Pausanias', *Philologische Wochenschrift* 60: 474–6.

Goody, J.R. (1977) *The domestication of the savage mind* (Cambridge).

Goody, J.R. and Watt, I. (1968) 'The consequences of literacy' in Goody, J.R., ed., *Literacy in traditional societies* (Cambridge), 27–68.

Gordon, R.L. (1979) 'The real and the imaginary: production and religion in the Graeco-Roman world', *Art History* 2: 5–34.

Graf, F. (1992) 'Heiligtum und Ritual: das Beispiel der griechisch-römischen Asklepieia', in Schachter, A., ed., *Le sanctuaire grec* (*Entretiens* XXXVII, Fondation Hardt, Geneva), 159–203.

Graindor, P. (1924) *Album d'inscriptions attiques d'époque impériale* I–II (Paris).

Graindor, P. (1927) *Athènes sous Auguste* (Cairo).

Graindor, P. (1931) *Athènes de Tibère à Trajan* (Cairo).

Graindor, P. (1934) *Athènes sous Hadrien* (Cairo).

Gregory, T.E., ed. (1993a) *The Corinthia in the Roman period* (*JRA* suppl. 8, Ann Arbor).

Gregory, T.E. (1993b) 'An early Byzantine (dark-age) settlement at Isthmia: preliminary report', in Gregory (1993a), 149–60.

Gregory, T.E. and Mills, H. (1984) 'The Roman arch at Isthmia', *Hesperia* 53: 407–45.

Griffin, M.T. (1984) *Nero: the end of a dynasty* (London).

Griffin, M.T. (1994) 'The intellectual developments of the Ciceronian age', in Crook, Lintott, and Rawson (1994), 689–728.

Groningen, B.A. van (1965) 'General literary tendencies in the second century AD', *Mnemosyne* 18: 41–56.

Gros, P. (1978) 'Vie et mort de l'art hellénistique selon Vitruve et Pline', *REL* 56: 289–313.

Gruen, E.S. (1992) *Culture and national identity in Republican Rome* (London).

Habicht, C. (1985) *Pausanias' guide to ancient Greece* (California).

Habicht, C. (1989) 'Athen und die Seleukiden', *Chiron* 19: 7–26.

Habicht, C. (1990) 'Athens and the Attalids in the second century BC', *Hesperia* 59: 561–77.

Habicht, C. (1992) 'Athens and the Ptolemies', *Cl.Ant.* 11: 68–90.

Halfmann, H. (1979) *Die Senatoren aus dem östlichen Teil des Imperium Romanum bis zum Ende des 2. Jh. n. Chr.* (Göttingen).

Halfmann, H. (1988) *Itinera principum: Geschichte und Typologie der Kaiserreisen im römischen Reich* (Stuttgart).

Harris, H.A. (1972) *Sport in Greece and Rome* (London).

Harris, W.V. (1980) 'Towards a study of the Roman slave trade', in D.'Arms, J.H. and Kopff, E.C., eds., *The seaborne commerce of ancient Rome: studies in archaeology and history*, Memoirs of the American Academy in Rome 36 (Rome), 117–40.

Harris, W.V. (1989) *Ancient literacy* (Cambridge, Mass.).

Harrison, E.B. (1953) *The Athenian Agora I. Portrait sculpture* (Princeton).

Harrison, E.B. (1965) *The Athenian Agora XI. Archaic and archaistic sculpture* (Princeton).

Harvey, F.D. (1966) 'Literacy in the Athenian democracy', *REG* 79: 585–635.

Haynes, D. (1992) *The technique of Greek bronze statuary* (Mainz).

Heer, J. (1979) *La personnalité de Pausanias* (Paris).

Hejnic, J. (1961) *Pausanias the perieget and the archaic history of Arcadia* (Prague).

Henig, M., ed. (1983) *A handbook of Roman art* (Oxford).

Hind, J.G.F. (1994), 'Mithridates', in Crook, Lintott, and Rawson (1994), 129–64.

Hitzl, K. (1991) *Olympische Forschungen XIX. Die kaiserzeitliche Statuenausstattung des Metroon* (Berlin).

Hoff, M. (1989a) 'The early history of the Roman Agora at Athens', in Walker and Cameron (1989), 1–8.

Hoff, M. (1989b) 'Civil disobedience and unrest in Augustan Athens', *Hesperia* 58: 267–76.

Hoff, M. (1994) 'The so-called Agoranomion and the Imperial cult in Julio-Claudian Athens', *AA*: 93–117.

Hopper, R.J. (1952) rev. Delz (1950), *CR* 66 (n.s. 2): 47–8.

Hornblower, S. (1982) *Mausolus* (Oxford).

Hornblower, S., ed. (1994a) *Greek Historiography* (Oxford).

Hornblower, S. (1994b) Introduction to Hornblower (1994a), 1–72.

How, W.W. and Wells, J. (1928), *A commentary on Herodotus* (2nd edn, 2 vols, Oxford).

Howatson, M.C., ed. (1989) *The Oxford companion to Classical literature* (2nd edn, Oxford).

Hunt, E.D. (1984) 'Travel, tourism and piety in the Roman empire', *Echos du monde classique/Classical views* 28: 391–417.

Huxley, G. (1979) 'Bones for Orestes', *GRBS* 20: 145–8.

Huzar, E. (1984) 'Claudius – the erudite emperor', *ANRW* II.32.1, 612–50.

Isaac, B. (1992) *The limits of empire* (rev. edn, Oxford).

Isager, J. (1991) *Pliny on art and society: the elder Pliny's chapters on the history of art* (Odense).

Isager, J. (1993) 'Alexander the Great in Roman literature from Pompey to Vespasian', in Carlsen, J. *et al.*, eds., *Alexander the Great: reality and myth* (Rome) 75–83.

Jacob, C. (1980) 'The Greek traveler's areas of knowledge: myths and other discourses in Pausanias' description of Greece', *Yale French Studies* 59: 65–85.

Jacob, C. (1980–1) 'Paysages hantés et jardins merveilleux: la Grèce imaginaire de Pausanias', *L'Ethnographie* 1980–1: 35–67.

Jacob, C. (1981) 'L'oeil et la mémoire: sur la *Périégèse de la Terre habitée* de Denys', in Jacob, C. and Lestringant, F., eds., *Arts et légendes d'espaces:*

figures du voyage et rhétoriques du monde (Paris), 21–97.

Jacoby, F. (1944) 'Patrios nomos: state burial in Athens and the public cemetery in the Kerameikos', *JHS* 64: 37–66.

Jeffery, L.H. (1990) *The local scripts of Archaic Greece* (2nd edn, rev. Johnston, A.W. (Oxford)).

Jex-Blake, K. and Sellers, E. (1896) *The elder Pliny's chapters on the history of art* (London).

Jones, B.W. (1992) *The emperor Domitian* (London).

Jones, C.P. (1966) 'Towards a chronology of Plutarch's works', *JRS* 56: 61–74.

Jones, C.P. (1971) *Plutarch and Rome* (Oxford).

Jones, C.P. (1972a) 'Aelius Aristides, ΕΙΣ ΒΑΣΙΛΕΙΑ', *JRS* 62: 134–52.

Jones, C.P. (1972b) 'Two enemies of Lucian', *GRBS* 13: 475–87.

Jones, C.P. (1978) *The Roman world of Dio Chrysostom* (Cambridge, Mass.).

Jones, C.P. (1986) *Culture and society in Lucian* (Harvard).

Kahrstedt, U. (1950) 'Die Territorien von Patrai und Nikopolis in der Kaiserzeit', *Historia* 1: 549–61.

Kaimio, J. (1979) *The Romans and the Greek language* (Helsinki).

Karageorgia-Stathakopoulou, Th. (1976) 'Other sports and games', in Yalouris (1976), 242–63.

Keaveney, A. (1982) *Sulla: the last Republican* (London).

Keaveney, A. and Madden, J.A. (1982) 'Phthiriasis and its victims', *Symbolae Osloenses* 57: 87–99.

Kennell, N.M. (1988) 'ΝΕΡΩΝ ΠΕΡΙΟΔΟΝΙΚΕΣ', *AJP* 109: 239–51.

Kent, J.H. (1966) *Corinth VIII.3. The inscriptions 1926–1950* (Princeton).

Kleiner, D.E.E. (1983) *The monument of Philopappos in Athens* (Rome).

Kleingünther, A. (1934) 'ΠΡΩΤΟΣ ΕΥΡΕΤΗΣ. Untersuchungen zur Geschichte einer Fragestellung', *Philologus* suppl. 26: 1–155.

Kraay, C.M. (1976) *Archaic and Classical Greek coins* (London).

Kron, U. (1976) *Die zehn attischen Phylenheroen, AM* Beiheft 5.

Kron, U. (1992) 'Heilige Steine' in Froning, H., Hölscher, T., Mielsch, H., eds., *Kotinos. Festschrift für Erika Simon* (Mainz), 56–70.

Kyle, D.G. (1987) *Athletics in ancient Athens* (Leiden).

Lane Fox, R. (1986) *Pagans and Christians* (Harmondsworth).

Larsen, J.A.O. (1938) 'Roman Greece', in Frank, T., ed., *An economic survey of ancient Rome* IV, 259–498 (Baltimore).

Larsen, J.A.O. (1958) 'The policy of Augustus in Greece', *Acta Classica* 1: 123–30.

Larsen, J.A.O. (1966) *Representative government in Greek and Roman history* (California).

Lawrence, A.W. (1983) *Greek architecture* (revised with additions by R.A. Tomlinson, 4th edn, Harmondsworth).

Leahy, D.M. (1955) 'The bones of Tisamenus', *Historia* 4: 26–38.

Leipen, N. (1971) *Athena Parthenos: a reconstruction* (Toronto).

Lerat, L. (1985) 'Les 'énigmes' de Marmaria', *BCH* 109: 255–64.

LeRoy, C. (1977) 'Pausanias à Marmaria', *BCH* suppl. 4: 247–71.

Levi, P. (1971) *Pausanias. Guide to Greece* i–ii (tr., Harmondsworth).

Levick, B. (1990) *Claudius* (London).

Levick, B., *et al.*, eds. (1988) *Monuments from the Aezanitis* (*Monumenta Asiae Minoris Antiqua* ix).

Levin, S. (1989) 'The old Greek oracles in decline', *ANRW* ii.18.2, 1599–1649.

Levy, B. (1991) 'When did Nero liberate Achaea and why?', in Rizakis (1991), 189–4.

Lewis, N. and Reinhold, M., eds. (1990a) *Roman civilization. Sourcebook I: the Republic* (3rd edn, New York).

Lewis, N. and Reinhold, M., eds. (1990b), *Roman civilization. Sourcebook II: the Empire* (3rd edn, New York).

Lewis, R.G. (1993) 'Imperial autobiography, Augustus to Hadrian', *ANRW* ii.34.1, 629–706.

Librale, D. (1994) 'L'Εἰς βασιλέα' dello pseudo-Aristide e l'ideologia traianea', *ANRW* ii.34.2, 1271–1313.

Ling, R. (1991) *Roman painting* (Cambridge).

Lintott, A.W. (1972) 'Imperial expansion and moral decline in the Roman Republic', *Historia* 21: 626–38.

Lippold, G. (1956) 'Zweite Sophistik', *RE* suppl. 8: 720–82.

Luttwak, E.N. (1976) *The grand strategy of the Roman Empire from the first century AD to the third* (Baltimore).

Maass, M. (1972) *Die Prohedrie des Dionysostheaters in Athen* (Munich).

MacMullen, R. (1959) 'Roman imperial building in the provinces', *HSCP* 64: 207–35.

Macready S. and Thompson F.S., eds. (1987) *Roman architecture in the Greek world* (The Society of Antiquaries, occasional papers 10, London).

Magie, D. (1950) *Roman rule in Asia Minor* 1–2 (Princeton).

Mallwitz, A. (1972) *Olympia und seine Bauten* (Munich).

Martin, R. (1974) *L'Urbanisme dans la Grèce antique* (2nd edn, Paris).

Mattusch, C.C. (1988) *Greek bronze statuary from the beginning through the fifth century* BC (Cornell).

McCredie, J.R. (1971) 'Hippodamos of Miletos', in Mitten, D.G., Pedley, J.G., Scott, J.A., eds., *Studies presented to G.M.A. Hanfmann* (Cambridge, Mass.), 95–100.

Meiggs, R. and Lewis, D.M. (1988) *A selection of Greek historical inscriptions to the end of the fifth century* BC (2nd edn, Oxford).

Mellor, R. (1975) ΘΕΑ ΡΩΜΗ. *The worship of the goddess Roma* (Göttingen).

Meyer, H. (1991) *Antinoos* (Munich).

Michel, A. (1993) 'Rhétorique et philosophie au second siècle ap. J.-C.', *ANRW* ii.34.1, 3–78.

Millar, F. (1964) *A study of Cassius Dio* (Oxford).

Millar, F. (1977) *The emperor in the Roman world* (London).

Millar, F. (1987) Introduction to Macready and Thompson (1987), ix–xv.

Millett, M. (1990) *The Romanization of Britain* (Cambridge).

Mitchell, S. (1987a) 'Imperial building in the eastern Roman provinces', in

Macready and Thompson (1987), 18–25.

Mitchell, S. (1987b) 'Imperial building in the eastern Roman provinces', *HSCP* 91: 333–65.

Mitchell, S. (1990) 'Festivals, games and civic life in Roman Asia Minor', *JRS* 80: 183–93.

Momigliano, A. (1975) *Alien wisdom: the limits of Hellenization* (Cambridge).

Morford, M. (1985) 'Nero's patronage and participation in literature and the arts', *ANRW* II.32.3, 2003–31.

Morgan, C. and Whitelaw, T. (1991) 'Pots and politics: ceramic evidence for the rise of the Argive state', *AJA* 95: 79–108.

Morris, S.P. (1992) *Daidalos and the origins of Greek art* (Princeton).

Munn, M.H. (1993) *The defense of Attica: the Dema wall and the Boiotian war of 378–375 BC* (California).

Musti, D. (1987), Introduction to Beschi and Musti (1987), ix–lv.

Musti, D. and Torelli, M. (1991) *Pausania guida della Grecia IV. La Messenia* (Rome).

Mylonas, G.E. (1962) *Eleusis and the Eleusinian Mysteries* (Princeton).

Nesselrath, H.G. (1990) 'Lucian's introductions', in Russell (1990a), 111–40.

Nörenberg, H.-W. (1973) 'Untersuchungen zum Schluss der Περιήγησις τῆς Ἑλλάδος des Pausanias', *Hermes* 101: 225–52.

Oikonomides, A.N. (1960) 'Κριτικά εἰς Παυσανίαν', Πλάτων 23/24: 49–54.

Oliver, J.H. (1940) 'Julia Domna as Athena Polias', *HSCP* suppl. 1: 521–30.

Oliver, J.H. (1951) rev. Delz (1950), *AJP* 62: 216–19.

Oliver, J.H. (1965) 'The Athens of Hadrian', in Piganiol and Terrasse (1965), 123–33.

Oliver, J.H. (1970) *Marcus Aurelius. Aspects of civic and cultural policy in the east*, *Hesperia* suppl. 13.

Oliver, J.H. (1972a) 'The conversion of the Periegete Pausanias', in *Homenaje a A. Tovar* (Madrid), 319–21.

Oliver, J.H. (1972b) 'On the Hellenic policy of Augustus and Agrippa in 27 BC', *AJP* 93: 190–7.

Oliver, J.H. (1981) 'Roman emperors and Athens', *Historia* 30: 412–23.

Oliver, J.H. (1983) *The civic tradition and Roman Athens* (Baltimore).

Packard, P.M. (1980) 'A monochrome mosaic at Isthmia', *Hesperia* 31: 326–46.

Page, D.L. (1951) *Alcman: the Partheneion* (Oxford).

Palm, J. (1959) *Rom, Römertum und Imperium in der griechischen Literatur der Kaiserzeit* (Lund).

Papadopoulos, J. (1980) *Xoana e sphyrelata: testimonianza delle fonti scritte* (Rome).

Papapostolou, J. (1986) 'Aedes Augustalium στήν Πάτρα', Δωδώνη 15: 261–84.

Parker, R. (1983) *Miasma: pollution and purification in early Greek religion* (Oxford).

Paul, G.M. (1982) 'Urbs capta: a sketch of an ancient literary motif', *Phoenix* 36: 144–55.

Pearson, L. (1960) 'Pausanias on the temple of Poseidon at Isthmia (2,1,7)', *Hermes* 88: 498–502.

Pearson, L. (1962) 'The pseudo-history of Messenia and its authors', *Historia* 11: 397–426.

Pelling, C. (1990) 'Truth and fiction in Plutarch's Lives', in Russell (1990a), 19–52.

Peppas-Delmousou, D. (1979) 'A statue base for Augustus', *AJP* 100: 125–32.

Pfundtner, O. (1866) *Pausanias periegeta imitator Herodoti* (diss., Königsberg).

Philipp, H. and Koenigs, W. (1979) 'Zu den Basen des L. Mummius in Olympia', *AM* 94: 193–216.

Pietilä-Castrén, L. (1978) 'Some aspects of the life of Lucius Mummius Achaicus', *Arctos* 12: 115–23.

Pietilä-Castrén, L. (1982) 'New men and the Greek war booty in the 2nd century BC', *Arctos* 16: 121–43.

Piganiol, A. and Terrasse, H. (1965) *Les empereurs romains d'Espagne* (Paris).

Pollitt, J.J. (1974) *The ancient view of Greek art: criticism, history, and terminology* (Yale).

Pollitt, J.J. (1978) 'The impact of Greek art on Rome', *TAPA* 108: 155–74.

Pollitt, J.J. (1983) *The art of Rome c.753 B.C. – A.D. 337: sources and documents* (Cambridge).

Pollitt, J.J. (1986) *Art in the Hellenistic age* (Cambridge).

Pollitt, J.J. (1990) *The art of ancient Greece: sources and documents* (Cambridge).

Pouilloux, J. (1980) 'Delphes et les Romains', in ΣΤΗΛΗ. Τόμος εἰς μνήμην Ν. Κοντολέοντος (Athens).

Preisshofen, F. (1979) 'Kunsttheorie und Kunstbetrachtung', in Flashar (1979), 263–82.

Preller, L., ed. (1838, reprinted 1964) *Polemonis periegetae fragmenta* (Amsterdam).

Premerstein, A. von (1912) 'Untersuchungen zur Geschichte des Kaisers Marcus. II', *Klio* 12, 139–78.

Price, S.R.F. (1984a) *Rituals and power: the Roman Imperial cult in Asia Minor* (Cambridge).

Price, S.R.F. (1984b) 'Gods and emperors: the Greek language of the Roman imperial cult', *JHS* 104: 79–95.

Raubitschek, A.E. (1945) 'Hadrian as the son of Zeus Eleutherios', *AJA* 49: 128–33.

Raubitschek, A.E. (1949) *Dedications from the Athenian Acropolis* (Cambridge, Mass.).

Reardon, B. (1971) *Courants littéraires grecs du IIe et IIIe siècles après J.-C.* (Paris).

Regenbogen, O. (1956) 'Pausanias', *RE* suppl. 8: 1008–97.

Reitzenstein, R. (1894) 'Zu den Pausanias-Scholien', *Hermes* 29: 231–9.

Reynolds, J. (1982) *Aphrodisias and Rome* (London, Society for the Promotion of Roman Studies, Monograph 1).

Reynolds, L.D. and Wilson, N.G. (1991) *Scribes and scholars: a guide to the transmission of Greek and Latin literature* (3rd edn, Oxford).

Richter, G.M.A. (1970) *Kouroi* (London and New York).

Ridgway, B.S. (1970) *The severe style in Greek sculpture* (Princeton).

Ridgway, B.S. (1984) *Roman copies of Greek sculpture: the problem of the originals* (Ann Arbor, Michigan).

Ridgway, B.S. (1990) *Hellenistic sculpture I. The styles of ca. 331–200 BC* (Bristol).

Ridgway, B.S. (1991) 'The bronze Granikos group of Alexander and the companions at the Porticus Octaviae', rev. G. Calcani (1989) *Cavalieri di bronzo. La torma di Alessandro opera di Lisippo* (Rome), *JRA* 4: 206–9.

Ridgway, B.S. (1993) *The archaic style in Greek sculpture* (2nd edn, Chicago).

Rizakis, A.D. (1989) 'La colonie romaine de Patras en Achaie: le témoignage épigraphique', in Walker and Cameron (1989), 180–6.

Rizakis, A.D., ed. (1991) Ἀρχαῖα Ἀχαΐα καὶ Ἠλεία *Achaia und Elis in der Antike* (Athens).

Rizakis, A.D., ed. (1992) *Paysages d'Achaie I: le bassin du Epeiros et la plaine occidentale* (Athens).

Robert, C. (1909) *Pausanias als Schriftsteller: Studien und Beobachtungen* (Berlin).

Robert, L. (1937) *Études Anatoliennes* (Paris).

Robert, L. (1980) *A travers l'Asie Mineure* (Paris).

Robinson, D.M. (1910) rev. Robert (1909), *AJP* 31: 213–22.

Robinson, D.M. (1944) 'A plea for Pausanias', *Classical Weekly* 37: 165–6.

Rocha-Pereira, M.H. (1965–6) 'Sobre a importância das informações de Pausânias para a história da língua grega', *Humanitas* 17–18: 180–97.

Rodgers, G.M. (1991) rev. Cartledge and Spawforth (1989), *JRS* 81: 203–4.

Rolley, C. (1986) *Greek bronzes* (London).

Romano, D.G. (1985) 'The Panathenaic stadium and theater of Lykourgos: a re-examination of the facilities on the Pnyx hill', *AJA* 89: 441–54.

Roueché, C. (1989) 'Floreat Perge', in Mackenzie, M.M. and Roueché, C., eds., *Images of authority: papers presented to Joyce Reynolds on the occasion of her 70th birthday* (Cambridge, Philological Society), 206–28.

Roux, G. (1958) *Pausanias en Corinthie* (Paris).

Roy, J. (1968) 'The sons of Lycaon in Pausanias' Arcadian King-list', *BSA* 63: 287–92.

Rudich, V. (1993) *Political dissidence under Nero: the price of dissimulation* (London).

Rüger, A. (1889) *Die Präpositionen bei Pausanias. Beitrag zur historischen Syntax der griechischen Sprache* (diss., (Erlangen) Bamberg).

Russell, D.A. (1983) *Greek declamation* (Cambridge).

Russell, D.A., ed. (1990a) *Antonine literature* (Oxford).

Russell, D.A. (1990b), Introduction to Russell (1990a), 1–18.

Russell, D.A. and Wilson, N.G. (1981) *Menander Rhetor* (Oxford).

Salmon, J. (1977) 'Political hoplites?', *JHS* 97: 84–101.

Salowey, C.A. (1994) 'Herakles and the waterworks: Mycenaean dams, Classical fountains, Roman aqueducts', in Sheedy, K.A., ed., *Archaeology in the Peloponnese: new excavations and research* (Oxford), 77–94.

Schmid, W. (1887–97, repr. 1964) *Der Atticismus in seinen Hauptvertretern von Dionysius von Halikarnass bis auf den zweiten Philostratus* i–v (Hildesheim).

Schubart, A. (1866) 'Die Wörter εἰκών, ξόανον, ἀνδριὰς und verwandte, in ihren verschiedenen Beziehungen. Nach Pausanias', *Philologus* 24: 561–87.

Seager, R. (1994) 'Sulla', in Crook, Lintott, and Rawson (1994), 165–207.

Segre, M. (1927) 'Pausanias come fonte storica', *Historia* 1: 202–34.

Seiler, F. (1986) *Die griechische Tholos* (Mainz).

Settis, S. (1968) 'Il ninfeo di Erode Attico a Olimpia e il problema della composizione della Periegesi di Pausania', *Annuario della Scuola Normale Superiore di Pisa* 37: 1–63.

Shear, T.L. (1933) 'Excavations in the Athenian Agora. The sculpture', *Hesperia* 2: 178–83.

Shear, T.L. Jr. (1970) 'The monument of the Eponymous Heroes in the Athenian Agora', *Hesperia* 39: 145–222.

Shear, T.L. Jr. (1971) 'The Athenian Agora: excavations of 1970', *Hesperia* 40: 241–79.

Shear, T.L. Jr. (1973) 'The Athenian Agora: excavations of 1971', *Hesperia* 42: 131–79.

Shear, T.L. Jr. (1981) 'Athens: from city-state to provincial town', *Hesperia* 50: 356–77.

Shear, T.L. Jr. (1994) "Ἰσονόμους τ᾽ Ἀθήνας ἐποιησάτην: the Agora and the Democracy', in W.D.E. Coulson *et al.*, eds., *The archaeology of Athens and Attica under the democracy* (Oxford), 225–48.

Sherk, R.K. (1969) *Roman documents from the Greek East* (Baltimore).

Sherk, R.K., ed. (1988) *The Roman Empire. Augustus to Hadrian* (Cambridge).

Sihler, E.G. (1905) 'On the personality of Pausanias the Periegete', *TAPA* 30: xxxi–ii.

Sinn, U. (1991) '"Ὁ ΝΕΡΩΝΑΣ" καὶ ΟΙ ΕΡΟΥΛΟΙ": δύο μοιραία γεγονότα στὴν ἱστορία τῆς Ὀλυμπίας;', in Rizakis (1991), 365–71.

Smith, R.R.R. (1991) *Hellenistic sculpture* (London).

Snodgrass, A.M. (1987) *An archaeology of Greece: the present state and future scope of a discipline* (California).

Sourvinou-Inwood, C. (1990) rev. Donohue (1988), *CR* 104 (n.s. 40): 129–31.

Spawforth, A.J.S. (1984) rev. Ameling (1983), Kleiner (1983) and other books, *JRS* 74: 214–17.

Spawforth, A.J.S. (1989) 'Agonistic festivals in Roman Greece', in Walker and Cameron (1989), 193–7.

Spawforth, A.J.S. (1992) rev. Willers (1990), *CR* 106 (n.s. 42): 372–4.

Spawforth, A.J.S. (1994a) 'Corinth, Argos, and the Imperial cult. Pseudo-Julian, *Letters* 198', *Hesperia* 63: 211–32.

Spawforth, A.J.S. (1994b) 'Symbol of unity? The Persian-Wars tradition in the Roman Empire', in Hornblower (1994a), 233–47.

Spawforth, A.J.S. (forthcoming) 'Le berceau' in Bowie, E.L. and Said, S. (forthcoming) *L'Athènes des Antonins* (Paris).

Spawforth, A.J.S. and Walker, S. (1985). 'The world of the Panhellenion I. Athens and Eleusis', *JRS* 75: 78–104.

Spawforth, A.J.S. and Walker, S. (1986) 'The world of the Panhellenion II. Three Dorian cities', *JRS* 76: 88–105.

Stanzl, G. (1993) 'Das sogenannte Ptolemaion in Limyra – Ergebnisse der

Ausgrabungen 1984–9', in Borchhardt, J. and Dobesch, G., eds., *Akten des II. Internationalen Lykien-Symposions* I–II (Vienna), II.183–90.

Stertz, S.A. (1979) 'Pseudo-Aristides, ΕΙΣ ΒΑΣΙΛΕΙΑ', *CQ* 73 (n.s. 29): 172–9.

Stertz, S.A. (1993) '*Semper in omnibus varius*: the emperor Hadrian and intellectuals', *ANRW* II.34.1, 612–28.

Stewart, A. (1978) 'The canon of Polykleitos: a question of evidence', *JHS* 98: 122–31.

Stewart, A. (1979) *Attika: studies in Athenian sculpture of the Hellenistic age* (London).

Stewart, A. (1990a) *Greek sculpture: an exploration* (Yale).

Stewart, A. (1990b) rev. Donohue (1988), *AJA* 94: 158–9.

Stewart, A. (1993) *Faces of power: Alexander's image and Hellenistic politics* (California).

Stockton, D.L. (1984) rev. Keaveney (1982) *CR* 98 (n.s. 34): 348–9.

Stone, S.C. (1985) 'The imperial sculptural group in the Metroon at Olympia', *AM* 100: 377–91.

Strid, O. (1976) *Über Sprache und Stil des Periegeten Pausanias* (Uppsala).

Strong, D.E. (1973) 'Roman museums', in D.E. Strong, ed., *Archaeological theory and practice: essays presented to W.F. Grimes* (London), 247–64.

Strong, D.E. (1976) *Roman art* (Harmondsworth).

Stuart Jones, H. (1895) *Select passages from ancient writers illustrative of the history of Greek sculpture* (London), revised by A.N. Oikonomides (Chicago 1966).

Sturgeon, M.C. (1977) 'The reliefs on the theater of Dionysos in Athens', *AJA* 81: 31–53.

Sturgeon, M.C. (1987) *Isthmia IV. Sculpture I: 1952 – 1967* (Princeton).

Swain, S. (1991) 'Plutarch, Hadrian, and Delphi', *Historia* 40: 318–30.

Syme, R. (1939) *The Roman revolution* (Oxford).

Syme, R. (1965) 'Hadrian the intellectual', in Piganiol and Terrasse (1965), 243–53.

Syme, R. (1985) 'Hadrian as philhellene. Neglected aspects', in Straub, J., ed., *Bonner Historia–Augusta–Colloquium 1982–83* (Bonn), 341–62.

Szelest, H. (1953) *De Pausaniae clausulis* (Warsaw).

Taylor, T. (1794) *The description of Greece, by Pausanias. Translated from the Greek. With notes, in which much of the Mythology of the Greeks is unfolded from a Theory which has been for many Ages unknown* (London).

Thomas, R. (1989) *Oral tradition and written record in Classical Athens* (Cambridge).

Thomas, R. (1992) *Literacy and orality in ancient Greece* (Cambridge).

Thompson, H.A. (1961) 'The Panathenaic festival', *AA* 76: 224–31.

Thompson, H.A. (1962) 'Itinerant temples of Attica', *AJA* 66: 200.

Thompson, H.A. (1976) *The Athenian Agora* (3rd edn, American School of Classical Studies, Athens).

Thompson, H.A. (1987) 'The impact of Roman architects and architecture on Athens: 170 BC – AD 170', in Macready and Thompson (1987), 1–17.

Thompson, H.A. and Wycherley, R.E. (1972) *The Athenian Agora XIV. The Agora of Athens* (Princeton).

Tobin, J. (1991) *The monuments of Herodes Atticus* (diss., University of Pennsylvania, University microfilms international, Ann Arbor, Michigan).

Tobin, J. (1993) 'Some new thoughts on Herodes Atticus's tomb, his stadium of 143/4, and Philostratus *VS* 2.550', *AJA* 97: 81–9.

Trapp, M.B. (forthcoming) 'Philosophical sermons: the "Dialexeis" of Maximus of Tyre', *ANRW* II.34.

Travlos, J. (1971) *A pictorial dictionary of ancient Athens* (London).

Travlos, J. (1988) *Bildlexikon zur Topographie des antiken Attika* (Tübingen).

Tsavari, I.O. (1990) Διονυσίου Ἀλεξάνδρεως Οἰκουμένης Περιήγησις (Ioannina).

Tzifopoulos, Y.Z. (1993) 'Mummius' dedications at Olympia and Pausanias' attitude to the Romans', *GRBS* 34: 93–100.

Vanderpool, E. (1959) 'Athens honors the emperor Tiberius', *Hesperia* 28: 86–90.

Vermeule, C.C. (1968) *Roman Imperial art in Greece and Asia Minor* (Cambridge, Mass.).

Veyne, P. (1988) *Did the Greeks believe in their myths? An essay on the constitutive imagination* (Chicago).

Wace, A.J.B. (1954) 'Pausanias and Mycenae', in Lullies, R., ed., *Festschrift B. Schweitzer* (Stuttgart), 19–26.

Walker, A.D. (1993) '*Enargeia* and the spectator in Greek historiography', *TAPA* 123: 353–77.

Walker, S. (1984) rev. Kleiner (1983), *JHS* 104: 252.

Walker, S. (1987) 'Roman nymphaea in the Greek world', in Macready and Thompson (1987), 60–71.

Walker, S. (1989) rev. Boatwright (1987), *JRA* 2: 221.

Walker, S. and Cameron, A., eds. (1989) *The Greek Renaissance in the Roman Empire*, *BICS* suppl. 55.

Walsh, J. (1986) 'The date of the Athenian stoa at Delphi', *AJA* 90: 319–36.

Walsh, M. (1980) *An illustrated history of the Popes* (London).

Ward-Perkins, J.B. (1981) *Roman imperial architecture* (2nd edn, Harmondsworth).

Waywell, G.B. and Wilkes, J.J. (1994) 'Excavations at Sparta: the Roman stoa, 1988–91. Part 2', *BSA* 89: 377–432.

Webb, R.H. (1992) *The transmission of the* Eikones *of Philostratos and the development of* Ekphrasis *from late Antiquity to the Renaissance* (unpublished PhD thesis, London, Warburg Institute).

Webb, R.H. (forthcoming) 'Imagination and the arousal of the emotions in Greco-Roman rhetoric', in Braund, S. and Gill, C. *The passions in Roman thought and literature* (Cambridge).

Wells, C. (1992) *The Roman Empire* (2nd edn, London).

Wilkes, J.J. (1991) rev. Cartledge and Spawforth (1989), *JRA* 4: 231–4.

Willers, D. (1989) 'The redesigning of Athens under Hadrian', in Walker and Cameron (1989), 9.

Willers, D. (1990) *Hadrians panhellenisches Programm: Archäologische Beiträge zur Neugestaltung Athens durch Hadrian* (Basle).

Williams, C.K. II (1975) 'Corinth 1974: Forum Southwest', *Hesperia* 44: 25–9.

Williams, C.K. II (1987) 'The refounding of Corinth: some Roman religious attitudes', in Macready and Thompson (1987), 26–37.

Williams, C.K. II (1989) 'A re-evaluation of Temple E and the west end of the Forum of Corinth', in Walker and Cameron (1989), 156–62.

Wiseman, J. (1978) *The land of the ancient Corinthians* (Göteborg).

Wiseman, J. (1979) 'Corinth and Rome 228 BC – AD 267', *ANRW* II.7.1, 438–548.

Woodman, A. (1988) *Rhetoric in Classical historiography* (London).

Wörrle, M. (1992) 'Neue Inschriftenfunde aus Aizanoi 1', *Chiron* 22: 337–76.

Wycherley, R.E. (1957) *The Athenian Agora III. Literary and epigraphical testimonia* (Princeton).

Wycherley, R.E. (1959) 'Pausanias in the Agora of Athens', *GRBS* 2: 23–44.

Wycherley, R.E. (1962) *How the Greeks built cities* (2nd edn, London).

Wycherley, R.E. (1963) 'Pausanias at Athens, II. A commentary on Book I, chapters 18–19', *GRBS* 4: 157–75.

Wycherley, R.E. (1964a) 'The Olympieion at Athens', *GRBS* 5: 161–79.

Wycherley, R.E. (1964b) 'Hippodamus and Rhodes', *Historia* 13: 135–9.

Wycherley, R.E., (1982) 'Pausanias and Praxiteles', *Studies in Athenian architecture, sculpture and topography, Hesperia* suppl. 20. (Princeton) 182–91.

Yalouris, N. (1968) 'The mosaic pavement of the temple of Zeus at Olympia', *AAA* 1: 78–82.

Yalouris, N., ed. (1976) *Athletics in ancient Greece: ancient Olympia and the Olympic games* (Athens).

Yegül, F.K. (1993) 'The Roman baths at Isthmia in their Mediterranean context', in Gregory (1993a), 95–113.

Zagdoun, M.-A. (1989) *La sculpture archaïsante dans l'art hellénistique* (Paris).

Zahrnt, M. (1979) *Ktistes – conditor – restitutor: Untersuchungen zur Städtepolitik des Kaisers Hadrian* (diss., Kiel).

Zanker, P. (1988) *The Power of images in the age of Augustus* (Ann Arbor).

Index of Pausanias passages cited

232

Index of other authors and passages cited

General index

241